THE GLOVER COLLECTION

The David W. and Katherine M. Glover Collection
of Rookwood Pottery

Auction
June 7, 8 and 9, 1991 from 9:30 AM - 5:30 PM
each day in the Music Hall Ballroom
14th and Elm Streets, Cincinnati, Ohio

Preview
June 4, 5 and 6 from 12:00 PM - 8:00 PM
each day in the Music Hall Ballroom

Auctioneer
J. Louis Karp

Guest Auctioneer
Louis Aronoff

Cincinnati Art Galleries

Michele and Randy Sandler
635 Main Street
Cincinnati, OH 45202
(513) 381-2128
Fax (513) 381-7527

ISBN: 0-943633-01-X
Library of Congress Catalog Card Number:
91-72241

Terms of Sale

The buyer is the person making the final and highest bid. In the event of a disputed bid, the auctioneer shall determine who is the successful bidder, or the auctioneer may resell the lot in dispute, but in all instances the judgment of the auctioneer shall be final.

Sales Tax

A 5.5% Ohio Sales Tax applies to all retail purchases. Ohio Sales Tax exemption forms must be executed and filed with the auction clerk at the time of auction registration.

Withdrawal

The auctioneer reserves the right to withdraw any lot before or at the time of the sale.

Credit, Methods of Payment

Cash, Visa, Mastercard, certified check and bank letters of credit are acceptable methods of payment. If you are known to us, your credit, and your credit only, can be established. Please check with the sale clerk. No company or personal references are accepted. We would appreciate credit arrangements being made in advance of the auction dates. Persons not making prior credit arrangements can pay by personal check, but no merchandise can be removed until all checks have cleared. Any packing and shipping expenses will be borne by the purchaser.

Bidding

Lots will be sold in the order in which they appear in the catalog. The bidding shall be in increments as follows:

Up to $500	Bids will increase in $25 increments
$500-$1000	Bids will increase in $50 increments
$1000-$5000	Bids will increase in $100 increments
$5000-$10000	Bids will increase in $250 increments
$10000 up	Bids will increase in $500 increments

The final bid is the price at which the lot is knocked down to the buyer.

This final bid, in all cases, is subject to a 10% buyer premium, the purchase price being the total of the two sums.

If the purchase price is not paid in full, the auctioneer may either cancel the sale, and any partial payment already made shall be there upon forfeited as liquidated damages or the auctioneer may resell the lot, without notice to the buyer.

Absentee, Written and Telephone bids

Absentee bids are welcomed. Absentee bids will be executed as if the bidder were present at the auction with the earliest bid received having preference in case of a tie between absentee bidders. Floor bids will be taken over absentee bids in case of a tie. Absentee, written or telephone bids are subject to the same 10% buyer's premium, and all credit requirements as listed above. The auctioneer, Cincinnati Art Galleries, and their employees are not responsible for absentee, written or telephone bids that are not properly executed. Telephone bidding is only available upon lots bearing a minimum $1000 (lower estimate) in this catalog. All packing and shipping costs will be borne by the purchaser.

Buyer's Premium

The final bid ("hammer" price) is subject to a 10% premium. The purchase price is the total of these two sums.

Reserves and Estimates

The estimated value of each lot is printed in the catalog, and merely reflects the price range into which a lot might fall. All lots have a reserve price below which they will not be sold. The reserve price is not published in the catalog, but in no case is it higher than the lower amount of the estimated price.

Removal

All lots are to be removed by their buyers not later than Sunday, June 9, 1991 7PM. Lots are released to buyers upon presentation of proof of payment. All packing and shipping is the responsibility of the buyer.

Packing and Shipping

We have made arrangements with P.K.G.'s to be on hand to assist in packing and shipping your purchases should you desire. P.K.G.'s will pack any item and arrange shipping through U.P.S., Federal Express or other shippers, as long as the items are insured. International shipping is available through P.K.G.'s. Should you wish information about their capabilities, call Jeff Sizer, the Cincinnati Area Manager for P.K.G.'s at (513) 489-7547 or fax (513) 489-7559. Contractual arrangements for packing and shipping are the responsibility of the buyer and shipper. For those of you who wish to pack and carry, we will have limited packing materials available, such as boxes and wraps.

Guarantee

All lots in this catalogue are guaranteed as described and are guaranteed to be free of other problems or repairs. Crazing is only mentioned if objectionable. Sizes are approximate. (See Peck Book II for shape number references). We guarantee the authenticity of all lots in this auction.

Advice to Bidders

The Cincinnati Art Galleries staff is available to discuss all lots with intending buyers at all presale exhibitions, or by telephone (513-381-2128) Monday thru Friday 9AM-5PM, Saturday 9AM-4PM.

Prices Realized

The list of prices realized at the auction will be mailed shortly after the sale. Lots that have been withdrawn from the sale or that have failed to reach the reserve price will be excluded from the prices realized.

DAVID AND KAY GLOVER AND "THE COLLECTION"

In the early fall of 1973, I personally owned two pieces of Rookwood Pottery and had a glowing desire to acquire more and learn everything possible about the subject. The obvious place to go was Cincinnati. I drove up from Louisville with a friend, planning to stay two days and absorb all the Rookwood and Rookwood information possible. One of the more interesting ads in the Yellow Pages led me to Americantiques in Glendale, a beautiful suburb of Cincinnati with stately homes and quiet streets. The shop yielded a few interesting examples of pottery which we quickly perused. As we were about to leave, the proprietor asked if I had an interest in Rookwood. "Certainly", I replied." My husband and I have the world's largest and finest collection of Rookwood, would you like to see it"? she asked.

I had been antiquing long enough to realize that some dealers tend to exaggerate on occasion, but curiosity and my aforementioned desire to see and know all, made me say yes. After all, it would only take an hour or so to have a look and then we could make the rest of the shops on my list.

The woman introduced herself as Kay Glover. She made a quick call to her husband David who readily agreed to take two strangers into his home and show them "the Collection". The house was only a few blocks from the shop and in five minutes, we were there. David Glover greeted us at the door and after determining that we were not on the fringe of anything, began to show us his prized pottery.

In the living room, we saw several incredible examples, most of which were overwhelming for a neophyte, but Mr. Glover made the showing eventful with stories about the pottery and the people who worked there. We saw Rookwood plaques on all the walls and even in the bathroom, vases big enough to hide your cat in and pieces with portraits of Native Americans and Presidents. Glover showed us the upstairs in a half an hour or so and I was amazed. Truly this was an impressive collection, certainly the finest I had ever seen.

As I began to make noises about leaving, thanking our host for his hospitality, David got a quizzical look on his face. "Don't you want to see the rest of the Collection"? he asked. "You mean there's more"? my companion asked. At that, Glover took us down a twisty set of stairs to the basement. I assumed we would see a bit more of the same, a few plaques and some neat vases, but I had no idea of what lay ahead. The first room we came to was full of paintings and pottery. Sharps and Casinellis lined the floor, Glover explained his collecting interest included paintings as well. But there was Rookwood everywhere. Shelves of wood and metal held literally hundreds of vases and where the walls weren't covered with paintings, there were Rookwood plaques, dozens of them.

Glover proceeded to show us every single piece, taking time to tell us about the artist, the glaze, the decoration, and most of all, why a particular piece was rare and interesting to him. We looked at so many vases that my head was swimming, unable to keep up with the infusion of information, but still too excited to leave.

The next room yielded more and more incredible pieces of Rookwood and more and more stories, facts and yarns. David Glover loved to talk about as much as he loved to collect and the two hobbies kept us going past noon and well into the afternoon. David was too excited to stop for lunch or anything short of a nuclear attack. My companion, who did not completely share my enthusiasm for Rookwood grumbled about having a headache for lack of food, but Glover was going strong and I was not about to stop him. I had wanted to see and learn and thoughts of going elsewhere were not only inconsequential, they were gone from my head. In short, I was in Rookwood Heaven. I don't suppose I knew enough to realize what a rare and unusual opportunity I had fallen into. To this day, I can't imagine anyone having a total stranger over for several hours of what we were doing, but David Glover loved an audience and at that moment, I was in awe.

I can faintly remember moving through the labrynthian basement, each new room yielding a fresh group of surprises. By dinner time, I was beginning to suffer from stimulus overload, and my friend was starting to moan audibly. Specific pieces didn't stick in my memory bank but I do recall seeing great large vases coming out of wall cabinets, pieces with dragons or ships or nudes or metal overlays, each one better than the last.

Eventually we reached the final recesses of the basement, having seen approximately two thousand pieces of Rookwood Pottery. It was now dark outside, we had been in the house for about ten hours and we were numb. Glover was still going strong and I now realize that we could have probably stayed until dawn as far as David was concerned. I only wish the experience could have been spread over a period of days, with intermissions for food and rest, because never before or since had such an opportunity presented itself.

I was to visit the house in Glendale one other time, several years later, but was unable to see the bulk of the collection. Glover had been cataloging the pieces in hopes of doing a book and most of the vases were on metal shelves covered with cloth. It would be several years before another chance to see the collection came along, and unfortunately, because of his untimely death, David Glover was no longer able to conduct the "grand tour".

For years, collectors and dealers have talked about the incredible collection and the man in Glendale who took care of it. Speculation abounded about what would become of the "Worlds Largest and Most Important Collection of Rookwood Pottery". Now the need for speculation is over. The once rare opportunity to see and learn will occur for a week in June of 1991. I personally can't imagine not taking advantage because this will never happen again.

—Riley Humler

We wish to thank Kay Glover for her help in this endeavor.

SELECTED BIBLIOGRAPHY

ROOKWOOD: ITS GOLDEN ERA OF ART POTTERY 1880-1929, Edwin J. Kircher and Barbara and Joseph Agranoff, Cincinnati, Ohio, Privately Published, 1969.

THE BOOK OF ROOKWOOD POTTERY, Herbert Peck, Cincinnati, Ohio, Cincinnati Art Galleries, Publisher, reprinted 1991.

THE SECOND BOOK OF ROOKWOOD POTTERY, Herbert Peck, Cincinnati, Ohio, Cincinnati Art Galleries, Publisher, 1985.

ROOKWOOD POTTERY POTPOURRI, Virginia Cummins, Cincinnati, Ohio, Cincinnati Art Galleries, Publisher, Reprinted in 1991.

FROM OUR NATIVE CLAY, Martin Eidelberg, editor for the American Ceramic Arts Society, New York, Published by Turn of the Century Editions, 1987.

MR. S.G. BURT'S RECORD BOOK OF WARE AT ART MUSEUM, 2292 PIECES OF EARLY ROOKWOOD POTTERY IN THE CINCINNATI ART MUSEUM IN 1916. Reprinted for the Cincinnati Historical Society by Herbert Peck, 1978.

THE KOVELS' COLLECTOR'S GUIDE TO AMERICAN ART POTTERY, Ralph and Terry Kovel, New York, Crown Publishers, Inc., 1974.

ART POTTERY OF THE UNITED STATES, Second Edition, Paul Evans, New York, New York, Feingold & Lewis Publishing Corp., 1987.

ROOKWOOD POTTERY, AN EXPLANATION OF ITS MARKS AND SYMBOLS, Edwin J. Kircher, Cincinnati, Ohio, Published by the Author, 1984.

We would also like to acknowledge the invaluable assistance of Anita Ellis, Curator of Decorative Arts at the Cincinnati Art Museum and Kenneth Trapp, Curator of Decorative Arts at the Oakland Art Museum. Anita and Ken work diligently and carefully to uncover scholarly information about Rookwood Pottery and are always ready to share that information, cheerfully.

ROOKWOOD POTTERY
An Explanation of Its Marks and Symbols
by Edwin J. Kircher

HISTORY

The Rookwood Pottery was founded in 1880 at Cincinnati, Ohio by Mrs. Maria Longworth Storer. The establishment was named for the Longworth Estate in the nearby countryside. The family home had large numbers of crows roosting in the trees on its grounds, and acquired its name from their presence.

The first plant was an abandoned schoolhouse at 207 Eastern Avenue. This address has been changed due to street renumbering, and the building has been razed, but the location was near the present intersection of Kemper Lane and Eastern Avenue. The factory remained in this location until construction of its Mount Adams site in 1893.

Mrs. Storer was the granddaughter of Nicholas Longworth, a wealthy pillar of the early Cincinnati community, and daughter of Joseph Longworth who endowed the Cincinnati Art School. Her husband, Bellamy Storer, was the son of a prominent judge, and himself a barrister. He served two terms as Congressional Representative before being appointed in 1887 by President McKinley to the post of Ambassador to Belgium. He later became Minister to Spain.

Mrs. Storer had been an active participant in the development of artistic interest in Cincinnati in the decade preceding the founding of Rookwood. She had worked at the Frederick Dallas Pottery as did members of the Cincinnati Women's "Pottery Club" of which Mrs. Storer was not a member, but from which she later drew heavily for artists with which to stock her company.

Admiration of the Japanese ceramics exhibit at the 1876 Centennial Exposition in Philadelphia crystallized Mrs. Storer's intention to manufacture "Art Pottery" in Cincinnati. Her experience made her realize that the existing local equipment and potteries were not adequately designed to fulfill this objective. She then set about assembling her plant and equipment, and Rookwood Pottery was born.

Mrs. Storer gathered around her the finest chemists, potters and decorators available in the local area. She also brought in the Japanese artist, Kataro Shirayamadani, to inject the influence of an advanced pottery technique which she had admired so much.

At the Paris Exposition of 1889 Rookwood Pottery received a gold medal and "the world awakened" to Rookwood. The Pottery began to pay its own way by 1890 and monetary support by the Longworth family was no longer necessary. In 1891 Mrs. Storer turned over management of the Pottery to the capable direction of W. W. Taylor. It was under the leadership of Mr. Taylor that the Pottery attained its greatest significance in pursuit of a unique American contribution to western culture.

During the years 1890-1925 Rookwood probably realized its greatest profit both in money and talent. At this time the Vellum finish was developed; the Iris glaze and Rookwood Porcelain came into being. It was also at this time that the Rookwood Faience architectural tiles and ornaments were fully developed. Such talents as Carl Schmidt, E. T. Hurley, Fred Rothenbusch, Ed. Diers, and Sturgis Lawrence were at their zenith. Kataro Shirayamadani, Matt Daly, and A. R. Valentien enjoyed international reputations. An extraordinary array of experience and talent underpinned by the many years of technical development had built the finest Art Pottery the world has ever known.

FACTORY MARKS

The factory mark identifies the manufacturer of the ware. Rookwood has used a number of factory marks. It has employed both its name, in various forms, as well as the picture-symbol type of representation associated with most European furnaces. The symbol that comes quickly to mind is the world famous monogram mark of the reversed R and P, with its wreath of flames.

This unique factory mark was used longer than any other, and was in use at the time the pottery enjoyed its greatest prestige. As a result it is this mark that is most often found on the finest of Rookwood productions. Prior to its institution the factory marks were widely varied in design and survived but a short time. They are herein explained and illustrated in the order of their occurrence, beginning with the earliest.

The most common marks prior to 1882 were the name of the pottery and the date of manufacture, either painted or incised on the base of the piece by perhaps the decorators or potters. A variation of this consisted of the initials of the Pottery, and of the founder: R.P.C.O.M.L.N. (Rookwood Pottery, Cincinnati, Ohio, Maria Longworth Nichols. Mrs. Nichols remarried in 1886 and became Mrs. Storer.) Illustrations of two of these marks are below:

From 1880 to 1882 another design used was that prepared by the famous Cincinnati artist, H. F. Farny. This factory mark was printed in black beneath the glaze, and represents a kiln with two Rooks.

The following oval mark bearing the name and address of the factory was also used for a short time.

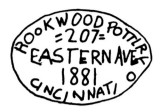

In 1882 the following two types of marks were used. Both were impressed in a raised ribbon, and the upper one appeared on a commercial project - a large beer tankard made for the Cincinnati Cooperage Company.

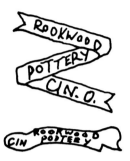

Prior to 1883 an anchor was sometimes impressed or placed in relief. It occasionally occurred in connection with an impressed date, and often in conjunction with a decorator's mark. (The illustration to the left is impressed; the one to the right appears in relief.)

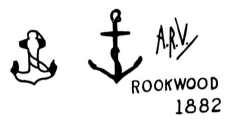

The regular mark adopted in 1882 was the word ROOKWOOD and the date in arabic numerals, impressed. This mark was in continuous use until 1886, the date being changed each year.

ROOKWOOD
1882

In the year 1883 a small kiln mark was impressed in the ware, and may or may not appear with the word ROOKWOOD and the date, also impressed.

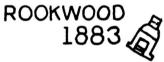

The monogram mark of the reversed R, and P was adopted in 1886, although it has been found upon ware dated as early as 1882. The monogram mark and the "ROOKWOOD 1886" both exist denoting the year 1886, the ROOKWOOD mark having been used in the earlier part of the year. In 1887 a flame point was placed above the RP monogram, and one point was added each year until 1900, at which time the monogram mark was encircled by 14 flame points.

In 1901 the same mark used to indicate 1900 was continued, and the Roman numeral I was added below, to indicate the first year of the new century. The Roman numeral was subsequently changed to denote the correct year.

SHAPE NUMBERS AND SIZE SYMBOLS

Shape numbers are impressed in the clay just below the factory mark, and are usually followed by the size symbol if applicable. These numbers were assigned consecutively, and bear no direct relationship to year of manufacture or quantity produced. On early pieces the size symbol sometimes precedes the pattern number. It is also known to have appeared immediately below the pattern number, particularly on items upon which the area available for marking is limited. An example of each arrangement is shown on the following page:

568B A7 9 0 1 C

There are three categories of shapes. 1.) The regular series which comprise the majority of the pieces produced. 2.) The "Trial" series, in which the pattern number is preceded by a "T". ("E" for experimental could not be used — "E" is a size symbol.) 3.) Those items bearing no pattern numbers at all. (These were often the result of gifts for friends, etc., and in these cases were singular items.) Each of the categories excepting #3 were numbered consecutively.

2191 T1250

Clarence Cook, in "The Studio," said "Rookwood Pottery shows good taste in adhering to the principles which are the foundation of the system of forms called classical." In later years some patterns were duplicated, (same shape different pattern number) but despite exceptions, the patterns over the years have been generally quite artistic and tastefully executed.

Size symbols are impressed in the clay next to the pattern number and are represented by six letters. The sizes of the patterns were always lettered with A representing the largest, diminishing through F. If no size letter is shown, only the one size of the pattern exists. If an A exists, at least a B must have been constructed. However, there is no basis for assuming a C existed. Likewise, if an E is encountered, an A, B, C, and D were created, but not necessarily an F. Occasionally another was created at a later date, necessitating an insertion of a new size, such as "BB". An example of each single letter is shown:

A B C D E F

Different pattern numbers having the same size letters bear no relation to each other. That is, a 907C and a 6308C have no relation in size, the former being a 14" high vase, and the latter a 7" high vase. Size ratio exists only within the category of a particular pattern or shape and is of no defined scale.

CLAY SYMBOLS

Rookwood Pottery employed a series of letter-symbols to indicate the clay used in the manufacture of the body. The clays were classified only in regard to color. The symbols were six in number and were impressed. The following letters were employed:

G O R S W Y

These indicate Ginger, Olive, Red, Sage Green, White, and Yellow. The Ginger colored clay is one that would be termed a "Buff" clay. The letter "G" and the title Ginger" were employed to avoid confusion with the size symbol "B". The letter "S" is also used in another category, that of a special symbol.

The symbols refer only to the color of the various bodies, and as such do not take into consideration the possible chemical variations within a color. The White body was the most popular and undoubtedly the one most frequently used by the potters. This color was developed and compounded in at least seven chemically different varieties to fit glazes in use at the Pottery. Often no distinction was made in them when marking the ware. In later years the clay symbol "W" was sometimes omitted.

Rookwood experimented with artificially tinted bodies as have most of the world's leading potteries, but their existence in relation to the total production is quite small. Tinted grey, blue and black bodies were utilized for the most part after 1920.

Rookwood also experimented with foreign clays to some extent; but domestic clays, and particularly those from the Ohio Valley, were most popular. The Ohio region is rich in fine clays. These are naturally colored, having been stained by the mineral deposits of the area. The Red clay was from Buena Vista, Ohio and the Yellow from Hanging Rock, Ohio.

A Yellow clay was obtained from Georgia, and a Cream colored one from Chattanooga, Tennessee; still another clay came from Florida. The existence of a Cream colored clay, as well as examples of Cream colored ware, creates speculation that there may have been a symbol for "Cream" clay in use at one time, for relatively early pieces have been found marked with a double "C".

PROCESS MARKS

At Rookwood all experiments or changes in clay, decorative materials, and glaze were carefully recorded and studied. To do so, it was necessary to identify the items after their return from the fire. Therefore the chemists, and sometimes the potters, placed identifying symbols on the pieces. They did this by incising or impressing impromptu, but recognizable designs, much as Westerners brand cattle. The precise meaning of these symbols could only be known through access to the notebooks kept by these men. For the benefit of those who may come across such symbols a few are illustrated:

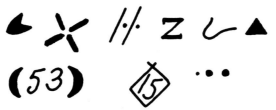

SPECIAL MARKS AND SYMBOLS

In the following paragraphs are collected and defined those marks and symbols which do not fit precisely into a prior category. These marks are not to be considered of any lesser importance than those comprising the other categories, because they also contribute invaluably to the understanding of the history and significance of the piece of Rookwood Pottery in question. Some are old. Others are of more recent composition. None are without precise meaning and purpose, though that be temporarily unknown.

The first mark to be considered, is the one that will be encountered most frequently. This is the "X" mark used to indicate a piece of secondary quality. Rookwood ware from its inception was graded into three classifications. These are: (1.) Those items of the best quality, that is, most nearly flawless. (No critisism of art work was involved, according to my friend Virginia Cummins, who was employed in the salesroom.) (2.) Those items displaying obvious technical faults, such as glaze bubbles, minor discolorations, kiln cracks, warp, and other manufacturing defects. It was this category of ware which was so designated by the "X" mark. (3.) Those items defective to the point of ruination of either their utility, decoration, or both. These were destroyed.

The "X" mark indicating secondary quality was usually cut into the underside of the piece, by means of a grinding wheel, much the same as that used to remove excess glaze from the resting surface of an item. The mark was also known to have been cut into the decorated surface of some pieces, and in these cases, undoubtedly contributes additionally to the undesirableness of the piece. The mark was not generally accurately cut, and as a result may appear as a "V" like score in the body, however, there is no reason to confuse this with the Vellum "V" mark, which is explained later in this same category. The "X" mark is generally large, and appears as a deeply ground score in the body, as follows:

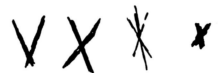

The category of second quality was usually determined in the showroom, by those in charge. The sales personnel had access to a grinding wheel, and cut the second mark themselves. It is presumed that the decorators could also request that an item of their work be adjudged as secondary quality. The extent to which this was done, if any, is not known. The third example from the left is a wheel ground "X" with an additional cut through the center which was used for items to be given away. "Give away" recipients ranged from visitors of note to unsold pieces "raffled" at company sponsored parties for employees. In later examples (circa 1940) a single wheel ground line has been found, which may have been the equivalent of an "X".

As any collector can attest, the judgment of secondary items over a period of years as represented by pieces of varying age, appears rather whimsical. Many items so marked contain only flaws of a very minor nature. In contrast, items are known with kiln cracks of several inches or more, and are not marked seconds. Regardless of the apparent overlapping of categories, and inconsistent application of standards, a second is less valuable. The second quality items were placed on a separate table at the Pottery, and marked down, in relation to items of first quality.

The examples above show the two varieties of the "V" mark which was used to designate the Vellum line. This particular glaze was first introduced in 1904 and is credited to the efforts of the plant chemist Stanley G. Burt.

The Vellum mark always appears on the bottom of the item, apart from the factory mark, so that it can never be confused with the date 1905 (V). It is either impressed, in which case it is in the form of a printed "V", or incised. It is believed the impressed "V" refers to a "vellum" body, and the hand incised "V" refers to the decorators desire to have the piece "vellum" glazed. This explanation is based upon empirical evidence, and the double "V" occurs mostly within the mid-range years of vellum production. The possibility of mismarked items is rather remote, and although this has undoubtedly occurred, the Pottery was rather well organized at the time Vellum was manufactured, and an error of this type would be unusual. After seeing several Vellum pieces and examining them closely, it becomes increasingly easier to identify, and reference to the "V" mark serves only as a verification of one's knowledge.

The Vellums are one of the most beautiful and unusual of all the Rookwood creations. To describe Vellum in its simplest terms Rookwood's master potter, Earl Menzel, said, "It is merely a transparent mat, developed in the fire." The implication of this, is that Rookwood was the first pottery to develop this glaze without the aid of chemical or mechanical means. The Vellum glaze won a Gold Medal at the St. Louis World's Fair in 1904.

S

The above letter "S" was impressed in the clay of Rookwood as an indication that the particular item had been created as a "special" shape (perhaps at the request of a decorator) and was not assigned a normal sequential shape number. However, one must be careful to distinguish between the "S" indicating the Sage Green clay (see: clay marks) and the "S" indicating the potter's handiwork. This is a relatively easy distinction to make, for the Sage Green clay is a pale olive color, and is easily recognized on the unglazed portions of the under surface. In addition, Sage Green bodies usually lent themselves to decoration in tones of green, brown, and yellow.

In the case of a Sage Green clay piece which was thrown by hand, the piece would bear two "S's". Examples of this nature do in fact exist, as do all the other combinations of clay marks and the potter's "S".

P

The above letter, impressed in the paste, represents the term, "Porcelain." It was introduced at Easter, 1915, after Rookwood had developed a "porcelainized" body, and accompanying high gloss glaze. The body is not a true porcelain, but should be more correctly termed a "soft-porcelain" or "semi-porcelain."

These pieces were generally decorated in light colors. This was probably due to the high glaze maturity and body vitrification temperatures, conditions which tend to "burn out" deeper colors. This body has a slightly irridescent appearance, and in the thinner pieces a translucence will be evident when exposed to a strong light. The colors and manner of decoration surpassed those of the Copenhagen furnaces, and magnificent blues had been developed. The ware was quite costly to produce, and was subsequently abandoned for a ware referred to as "Jewel Porcelain."

Jewel Porcelain was also a "porcelainized" or vitreous body, but employed a distinctively different glaze, which was characterized by a running of the colors. This ware was manufactured for quite some time. It bore no body or glaze mark of its own, nor did it bear the "P" mark.

The "L" mark, as illustrated above, is found incised into older pieces of Rookwood in conjunction with the "Standard" glaze. The items are decorated, and the "L" is often under the decorator's mark, as shown in the second example, having been incised by the decorator himself. There is no apparent relationship between this mark and that of a specific decorator. It is found with the marks of all decorators of the period.

The letter refers to the decorator's choice of glaze to be employed. "L" refers to a lightly colored standard glaze and an M (not illustrated) refers to a Mahogany tinted standard glaze, The "D" for a dark standard glaze, was also used, and the script "G" (example 3) refers to the sea green glaze. The sea green glaze "G" is also found impressed as a capital G.

 ROOKWOOD CINTI,O. ROOKWOOD CINTI,O.

The above examples of the printed name "CINCINNATI" were used in an effort to identify the name of Rookwood with the city in which it was founded and had prospered. The impressions were always used in addition to the other standard symbols, factory marks, etc. This practice was originated circa 1920, and the symbol used from time to time on various productions. The mark on the extreme left appeared as a wreath over the factory symbol, RP with flames. The marks to the right appeared as later examples. The correlation between years and the use of these marks does not have any significance beyond the fact that the Pottery was attempting to hold its position of prestige in relation to its competitors; hence the inclusion of the name of the Pottery. Other varieties of the city name are known to exist.

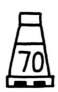

The above marks were created for the pieces of Rookwood ware produced during the year of an anniversary. The first such anniversary mark is the one signifying Rookwood's Fiftieth Year, 1930. This mark was usually applied in the form of an underglaze color, (blue or black) and represents a kiln with the number 50 within it. The mark used for the Seventieth Year is also a kiln with the number 70 contained in it, but differs in that it is also found impressed in the clay, and often accompanied by the name ROOKWOOD impressed alongside. The third anniversary mark at the right took the form of a diamond and signified Rookwood Pottery's 75th birthday.

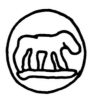

This mark appears on the underside of a Rookwood ashtray depicting one of the masks of drama, but is not a Rookwood mark. The pattern is an exact reproduction of an item brought from Italy by Mr. J.D. Wareham, director of the Pottery. The original pattern bore the mark in question, and therefore, it was preserved in the reproduction. The relief form represents Romulus, Remus and their Wolf Mother of Roman Mythology.

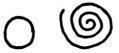

The above marks were instituted by Rookwood's master potter, Earl Menzel. The whorl was impressed on the underside of many thrown pieces and was merely an idiosyncrasy of the potter. The mark was made on the lathe, and is usually unaccompanied by Mr. Menzel's signature. It can be assumed to be a synonym for his mark, for these pieces were produced by his hand. The circle was applied, as an impression, to pieces whose shape might make them suitable for use as lamps, and was intended as a guide for drilling.

Initials, names, and inscriptions are also found incised into the decorative surface of some Rookwood. These are not marks, but the results of creation of pieces for friends, and commemoration of special events, and as such do not require further explanation.

ARTISTS' AND DECORATORS' MARKS

It became the custom at the Rookwood Pottery for the artists to incise or paint their initials or monograms on the pieces decorated or sculptured by them but this was not always so. In the fledgling days of the Pottery the signing of work was discouraged. Soon, however, a preference for the signed pieces made itself felt in the market, and the Pottery changes its policy. One must remember that these Artists' initials are presented here in their most ideal state — many hurriedly written examples exist, making the commonest of monograms sometimes impossible to decipher.

The artists not only cut their initials into the bottom of the ware, but painted them on, using some of the underglaze "paint" or engobe that was in use at the moment. This method was also employed when the artists signed pieces on the decorated surface. Many used their full names if their pieces were a special effort.

Marks were also impressed. This was done through the construction of a die, much the same as that employed to impress the factory mark. The decorators or potters formed these from clay, and once fired, they were permanent in nature and could be used repeatedly. It was necessary, of course, to construct them in reverse, the same as a rubber stamp. One artist intentionally failed to observe this rule, and as a result Carl Schmidt's mark is "mirrored," or reversed.

The use of dies was practiced primarily by the decorators of later years. Readily recognizable examples of these dies are the marks of Margaret Helen McDonald and Mary Graze Denzler.

There are decorators in the accompanying list. Some of these have as many as four different marks attributed to them. They are presented in the order of what is believed to be their earliest mark, first. An effort has been made to limit this presentation to only those marks and symbols which have been positively identified, and no full signatures have been included for these are self-explanatory.

Approximately one dozen other "decorators" marks will be found accompanying ware, circa 1946. These people are not identified in the following listing for they were designated as "junior artists" and did not participate in projects of original composition as did the staff artists. Their marks are found applied in underglaze color, and their duties consisted of applying specific colors to prepared designs.

Name	Mark
Abel, Edward	E.A.
Abel, Louise	(A)
Altman, Howard	HA.
Asbury, Lenore	LA.
Auckland, Fannie	FA
Auckland, William	WA WA
Baker, Constance A.	C.A.B.
Barrett, Elizabeth	EB
Bishop, Irene	I.B.
Bonsall, Caroline F.	C.F.B.
Bookprinter, Anna M.	AMB AB
Brain, Elizabeth W.	EwB
Brennan, Alfred	AB
Breuer, W. H.	WHB WB
Caven, Alice	AC
Conant, Arthur P.	C
Conant, Patti M.	PC
Cook, Daniel	DC
Covalenco, Catherine	CC
Coyne, Sallie E.	S.E.C. SE
Crabtree, Catherine	C
Cranch, E. Bertha I.	E.B.I.C.
Cranch, Edward P.	E.P.C EP
Crofton, Cora	C
Daly, Matt A.	MAD MDa
Demarest, Virginia B.	VBD
Denzler, Mary Grace	MG
Dibowski, Charles John	C.J.D.
Diers, Edward	ED.
Duell, Cecil A.	CAD
Epply, Lorinda	L
Fechheimer, Rose	R.F. F
Felten, Edith R.	E.R.F.
Foertmeyer, Emma D.	E.D.F.
Foglesong, Mattie	MF
Fry, Laura A.	LA LA
Furukawa, Lois	LF
Glass, William T.	WG
Goetting, Arthur	AG
Hall, Grace M.	G.H.
Hanscom, Lena E.	L.E.H.
Harris, Janet	JH

Name		Name	
Hentschel, W. E.		Lindeman, Laura E.	L.E.L.
Hickman, Katharine		Lunt, Tom	TOM
Hicks, Orville		Lyons, Helen M.	
Hirschfeld, N. J.	N.J.H.	Markland, Sadie	
Holtkamp, Loretta		Matchette, Kate C.	K.C.M.
Horsfall, Bruce		McDermott, Elizabeth F.	
Horton, Hattie	H.H.	McDonald, Margaret Helen	
Humphreys, Albert	A.H.	McDonald, William P.	
Hurley, Edward T.		McLaughlin, Charles J.	
Jensen, Jens		Menzel, Reuben Earl	
Jones, Katherine		Mitchell, Marianne D.	
King, Flora		Moos, Herman	
King, Ora		Munson, Albert	
Klemm, William		Newton, Clara Chipman	C.N
Klinger, Charles		Nichols, Maria Longworth	M L N
Koehler, F. D.	K	Noonan, Edith	
Laurence, Sturgis	S.L.	Nourse, Mary	
Lawrence, ELiza C.	ECL	Perkins, Mary Luella	
Ley, Kay		Peters-Baurer, Pauline	
Lincoln, Elizabeth N.	LNL	Pons, Albert	
Lindeman, Clara C.		Pullman, J. Wesley	

Name	Mark
Rauchfuss, Marie	MR.
Reed, O. Geneva	O.G.R.
Rehm, Wilhelmine	WR
Rettig, Martin	MR
Rothenbusch, Fred	R
Sacksteder, Jane	S
Sax, Sara	S.S.
Scalf, Virginia	VS
Schmidt, Carl	
Sehon, Adeliza D.	A.D.S.
Seyler, David W.	DWS
Shirayamadani, Kataro	KS
Smalley, Marian H.	M.H.S
Sprague, Amelia B.	ABS
Stegner, Carolyn	
Steinle, Carrie F.	S C.F.S. C.S.
Storer, Maria Longworth (Nichols)	MLS M.L.N.
Strafer, Harriet R.	H.R.S.
Stuntz, H. Pabodie	
Swing, Jeannette	
Taylor, Mary A.	
Tischler, Vera	VT
Todd, Charles S.	C.S.T.
Toohey, Sallie	
Valentien, Albert R.	A.R.V.
Valentien, Anna M.	amv.
Van Briggle, Artus	AVB AB
Van Briggle, Leona	LV.B.
Van Horne, Katherine	KH.
Vreeland, Francis W.	F.V.
Wareham, John D.	JDb.
Wenderoth, Harriet	H.W.
Wilcox, Harriet E.	H.E.W.
Wildman, Edith L.	ELW
Willitts, Alice	W
Workum, Delia	WD
Young, Grace	
Zanetta, Clotilda	CZ.
Zettel, Josephine E.	

ALPHABETICAL LIST OF ARTISTS AND THEIR WORKS BY CATALOG NUMBER

ALPHABETICAL LIST OF ARTISTS AND THEIR WORKS BY CATALOG NUMBER

Noonan, Edith, 203, 522, 586, 791, 797, 806, 814, 991

Nourse, Mary, 2, 15, 58, 74, 115, 379, 686, 731, 840, 875, 894, 911, 961, 1002

Perkins, Mary Luella, 23, 31, 370, 410, 587, 758, 1140, 1166

Pons, Albert, 422, 464, 1201

Reed, Olga Geneva, 100, 147, 218, 506, 677, 782, 783, 901, 959, 1061, 1168

Rehm, Wilhelmine, 264, 430, 431, 518

Rettig, Martin, 288, 477, 479, 596, 622, 662, 795, 1135, 1139

Rothenbusch, Fred, 52, 78, 116, 148, 300, 369, 372, 377, 385, 440, 484, 565, 590, 637, 678, 706, 883, 902, 921, 928, 936, 1077, 1098, 1107, 1161, 1169, 1190

Ryden, W.H., 847

Sacksteder, Jane, 224, 371, 629

Sax, Sara, 132, 138, 146, 209, 210, 223, 273, 299, 321, 326, 347, 359, 361, 394, 409, 465, 467, 499, 523, 549, 644, 736, 737, 742, 743, 876, 954, 989, 1044, 1085, 1147, 1185, 1207

Schmidt, Carl, 10, 66, 181, 193, 324, 328, 386, 502, 557, 723, 935, 944, 987, 1050, 1055, 1075, 1114, 1115, 1120, 1121, 1204

Sehon, Adeliza D., 53, 353, 567, 808, 1067

Shirayamadani, Kataro, 26, 46, 49, 71, 92, 97, 111, 118, 149, 162, 164, 179, 241, 285, 306, 319, 338, 344, 345, 364, 378, 407, 486, 493, 504, 553, 603, 631, 643, 655, 658, 696, 724, 739, 760, 809, 904, 918, 931, 937, 979, 986, 1007, 1046, 1108, 1112, 1154, 1181, 1196, 1210

Sprague, Amelia B., 60, 127, 175, 192, 205, 238, 544, 547, 740, 779, 800, 820, 826, 848, 1030, 1063, 1103, 1148, 1160

Stegner, Caroline, 852

Steinle, Carrie, 5, 87, 156, 170, 172, 186, 233, 292, 438, 463, 495, 516, 647, 680, 764, 789, 810, 850, 891, 933, 1005, 1054

Strafer, Harriet R., 25, 126, 367, 490, 872, 938

Stuntz, Helen P., 155, 473

Swing, Jeanette, 399, 412, 766, 822

Taylor, Mary L., 598

Tischler, Vera, 120, 1051

Todd, C.S., 48, 291, 548, 562, 651, 824, 849, 990, 1109, 1124, 1155, 1173, 1195

Toohey, Sallie, 90, 119, 187, 251, 297, 302, 331, 358, 402, 437, 442, 446, 475, 521, 536, 572, 591, 595, 652, 684, 712, 735, 794, 825, 905, 948, 953, 956, 1013, 1017, 1022

Unknown, 106, 124, 133, 157, 185, 189, 195, 231, 234, 259, 267, 280, 309, 314, 348, 375, 376, 393, 421, 449, 454, 470, 528, 530, 539, 552, 554, 600, 628, 630, 632, 633, 666, 667, 668, 714, 738, 755, 792, 873, 877, 878, 914, 916, 917, 969, 981, 1012, 1052, 1079, 1084, 1088, 1094, 1128, 1164

Valentien, Albert R., 24, 38, 82, 88, 98, 113, 232, 240, 261, 266, 281, 293, 354, 404, 416, 435, 448, 474, 501, 513, 534, 546, 576, 610, 626, 694, 698, 700, 701, 786, 790, 815, 818, 947, 962, 968, 970, 976, 982, 998, 1000, 1057, 1078, 1083, 1087, 1113, 1123, 1129, 1153, 1163, 1182, 1192, 1206

Valentien, Anna Marie, 30, 40, 117, 346, 366, 384, 397, 419, 469, 531, 559, 563, 573, 604, 657, 669, 853, 889, 1081, 1133, 1189

Van Briggle, Artus, 28, 37, 73, 163, 198, 246, 624, 627, 837, 963, 975, 1070, 1072, 1174, 1193

Van Briggle, Leona, 202, 508, 759, 863, 892, 929

Van Horne, Katherine, 62, 279, 318, 400, 483, 505, 509, 568, 881

Wareham, John Dee, 182, 294, 444, 645, 772, 943, 1008, 1058, 1059, 1093, 1106, 1118, 1144

Welterer, L., 1111

Wenderoth, Harriet, 20, 76, 571, 801

Wilcox, Harriet E., 55, 136, 140, 165, 217, 221, 276, 277, 325, 341, 411, 441, 621, 716, 973, 988, 992, 1015, 1027, 1101, 1152, 1188

Willitts, Alice, 316, 781

Wilson, Nettie, 888, 1037

Workum, Delia, 879

Young, Grace, 21, 122, 154, 196, 236, 274, 320, 356, 532, 653, 689, 703, 748, 785, 882, 884, 1091, 1158, 1183

Zettel, Josephine, 244, 362, 636, 688, 762, 828, 843, 866, 922, 977, 1041

FRIDAY
JUNE 7th
1991
LOTS 1-407

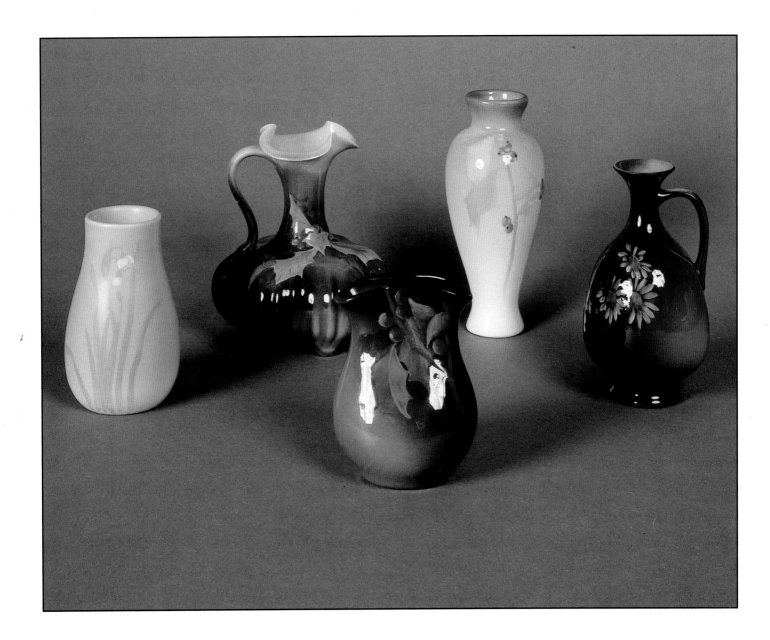

1. Vellum glaze vase with floral decoration, done by Margaret McDonald in 1913. Marks on the base include the $300-400
Rookwood logo, the date, shape number 1096, V for Vellum glaze body and the artist's initials. Height 5 inches.

2. Standard glaze three footed, ribbed ewer with holly decoration, painted by Mary Nourse in 1892. Marks on the $500-700
base include the Rookwood logo, the date, shape number 675 C, W for white clay, the artist's initials and L for
light Standard glaze. Height 6½ inches.

3. Standard glaze pocket vase with holly decoration, done by Caroline Bonsall in 1902. Marks on the base include $200-300
the Rookwood logo, the date, shape number 883 F and the artist's initials. Height 4¾ inches.

4. Iris glaze vase with holly decor, done by Irene Bishop in 1903. Marks on the base include the Rookwood logo, $400-600
the date, shape number 792 D, the artist's initials and W for white glaze. Height 7¼ inches.

5. Standard glaze ewer decorated by Carrie Steinle in 1895 with daisies. Marks on the base include the Rookwood $300-500
logo, the date, shape number 657 D and the artist's initials. Height 6¼ inches.

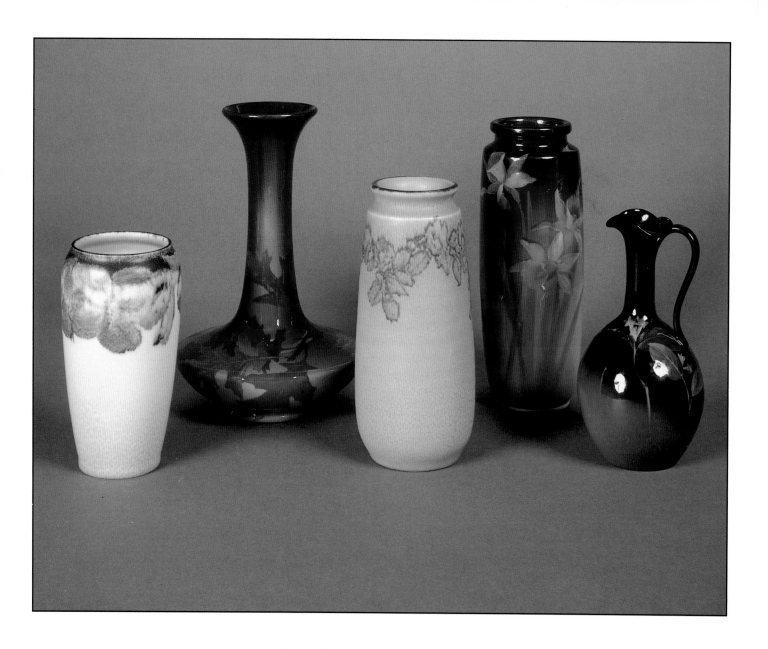

6 Mat glaze vase painted with pink dogwood flowers by Elizabeth Lincoln in 1930. Marks on the base include the $400-600
Rookwood logo, the date, shape number 1359 F, a small fan shaped esoteric mark and the artist's initials. Height
6⅛ inches. Rough from grinding on the base.

7 Standard glaze vase decorated with oak leaves, oak branches and acorns by Eliza Lawrence in 1901. Marks on $400-600
the base include the Rookwood logo, the date, shape number 566 C, a small wheel ground X and the artist's
initials. Height 9¼ inches.

8 Mat glaze vase with floral decoration, done in 1925 by Katherine Jones. Marks on the base include the $300-500
Rookwood logo, the date, shape number 2069 and the artist's initials. Height 7½ inches.

9 Standard glaze vase decorated with daffodils by Lenore Asbury in 1900. Marks on the base include the $500-700
Rookwood logo, the date, shape number 589 E and the artist's initials. Height 8¾ inches.

10 Standard glaze ewer with honeysuckle decoration, done by Carl Schmidt in 1899. Marks on the base include the $300-500
Rookwood logo, the date, shape number 864 and the artist's monogram. Height 6⅞ inches.

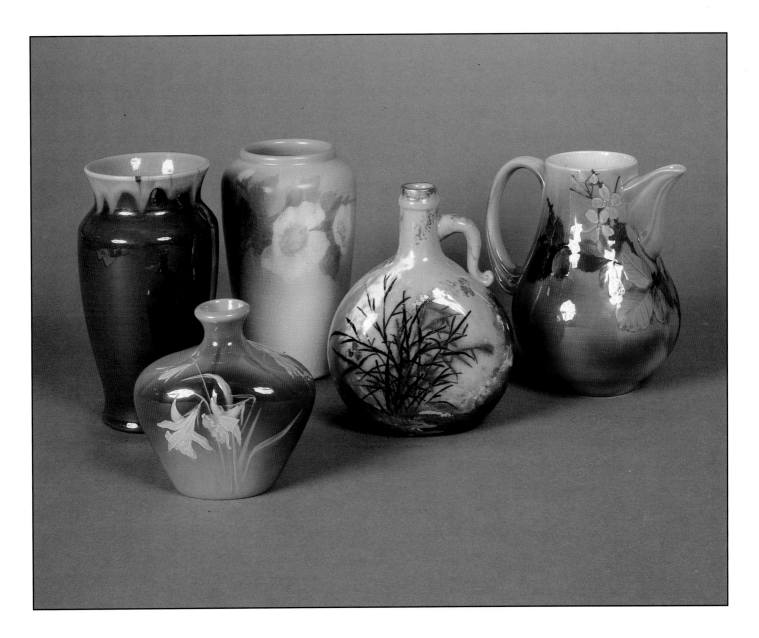

11 Standard glaze flat sided vase decorated with lillies by Bruce Horsfall in 1893. Marks on the base include the Rookwood logo, the date, shape number 706, W for white clay and the artist's monogram. Height 4¾ inches. $300-400

12 Vase with drip glaze decoration and some crystalline effect done at Rookwood in 1933. Marks on the base include the Rookwood logo, the date and S for special shape number. Height 7¼ inches. $150-250

13 Vellum glaze vase decorated with wild roses by Ed Diers in 1915. Marks on the base include the Rookwood logo, the date, shape number 938 D, V for Vellum glaze body and the artist's initials. Height 7 inches. $500-700

14 Limoges style glaze pilgrim flask decorated with flowers and grasses by L. Johnston in 1883. Marks on the base include Rookwood in block letters, the date and the artist's name. Height 6¾ inches. $300-500

15 Standard glaze chocolate pot decorated by Mary Nourse in 1893 with blackberry canes, leaves and flowers. Marks on the base include the Rookwood logo, the date, shape number 620, W for white clay, the artist's initials and L for light Standard glaze. Height 6¾ inches. Lid missing. $300-500

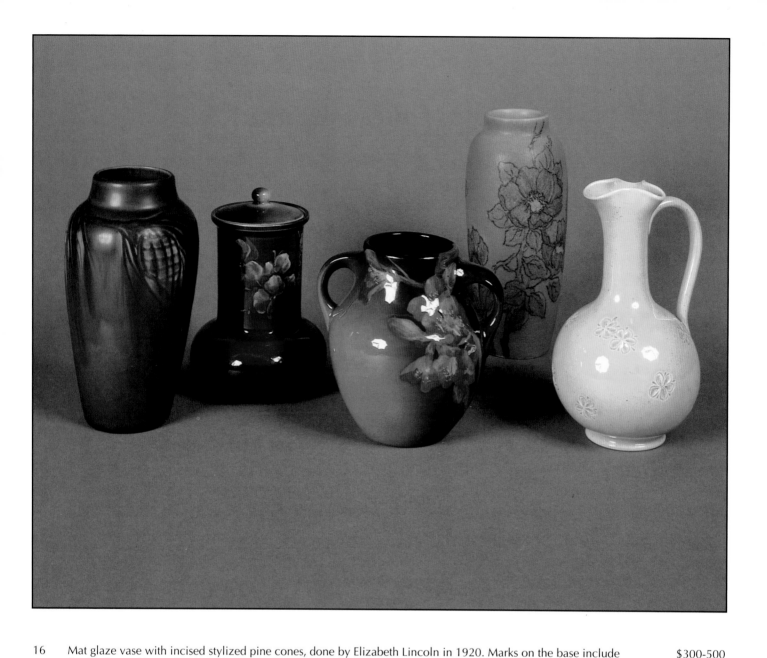

16 Mat glaze vase with incised stylized pine cones, done by Elizabeth Lincoln in 1920. Marks on the base include the Rookwood logo, the date, shape number 943 E and the artist's initials. Height 7 inches. $300-500

17 Standard glaze scent jar with reversible lid and floral decoration, done by Bertha Cranch in 1889. Marks on the base include the Rookwood logo, the date, shape number 479, W for white clay, the artist's initials and a rare paper label remnant from the 1889 Exposition Universelle in Paris. Height 6 inches. Lid has hairline. $500-700

18 Standard glaze vase with two loop handles, decorated in 1901 by Clara Lindeman with cherry blossoms. Marks on the base include the Rookwood logo, the date, shape number 914 and the artist's initials. Height 5⅛ inches. $400-600

19 Mat glaze vase with crisply decorated red flowers and green leaves, done in 1923 by Katherine Jones. Marks on the base include the Rookwood logo, the date, shape number 907 F and the artist's initials. Height 7¾ inches. $500-700

20 High glaze ewer with incised floral decoration, done by Harriet Wenderoth in 1884. Marks on the base include Rookwood in block letters, the date, shape number 101 D, W for white clay and the artist's initials. Height 7 inches. $200-300

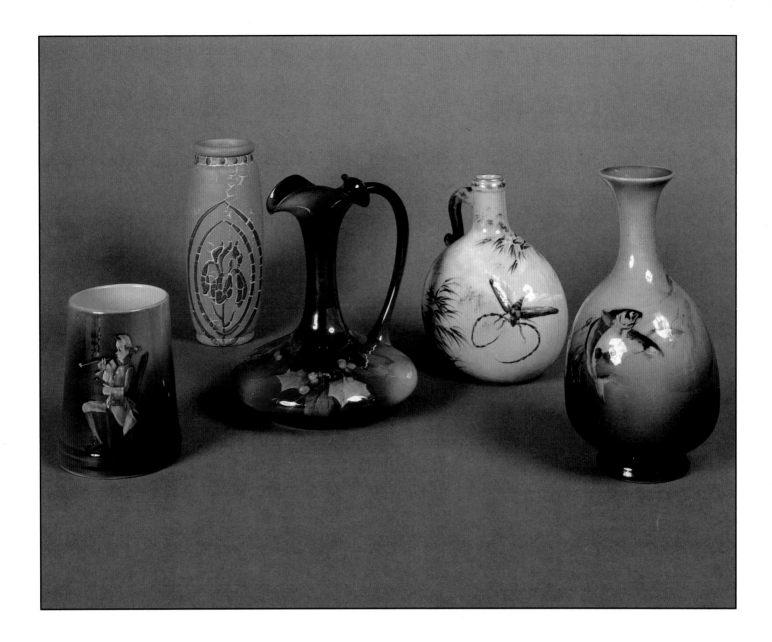

21 Standard glaze mug decorated with caricature of colonial figure smoking a clay pipe, done by Grace Young in 1891. Marks on the base include the Rookwood logo, the date, shape number 587, W for white clay, the artist's monogram and L for light Standard glaze. Height 4½ inches. Repaired crack descends from the rim. $500-700

22 Early mat glaze vase with stylized iris decoration, probably the work of M.A. Daly in 1894. Marks on the base include the Rookwood logo, the date, shape number 589 F and W for white clay. Height 7⅛ inches. We have seen several similarly decorated mat glaze pieces from this period signed by Daly. $300-500

23 Standard glaze ewer decorated by Luella Perkins in 1896 with holly. Marks on the base include the Rookwood logo, the date, shape number 715 D and the artist's initials. Height 7¼ inches. $400-600

24 Limoges style glaze pilgrim flask decorated with oriental grasses and a large flying insect, done by Albert Valentien in 1883. Marks on the base include Rookwood in block letters, the date, shape number 85, G for ginger clay and the artist's initials. Height 6½ inches. $700-900

25 Unusual Sea Green glaze vase decorated with a school of fish in under sea grass, done by Harriet Strafer in 1895. Marks on the base include the Rookwood logo, the date, shape number 357 C, the number 8, the artist's initials and G for Sea Green glaze. Height 8¼ inches. Old repair to lip. $600-800

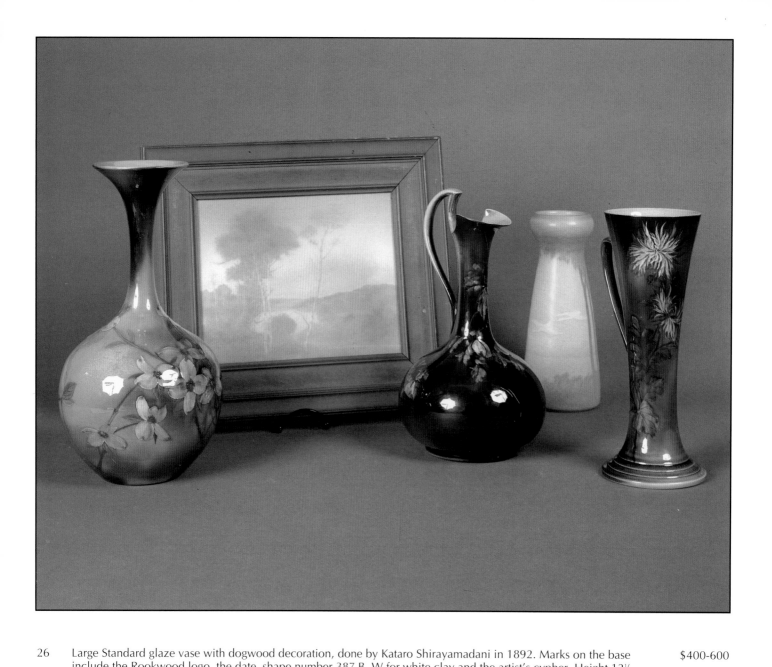

26 Large Standard glaze vase with dogwood decoration, done by Kataro Shirayamadani in 1892. Marks on the base $400-600
 include the Rookwood logo, the date, shape number 387 B, W for white clay and the artist's cypher. Height 12½
 inches. Roughness at base and a group of cracks in the round body of the piece. Discoloration in areas of the
 glaze.

27 Vellum glaze scenic plaque decorated by E.T. Hurley in 1920. The artist's initials appear in the lower left hand $3000-4000
 corner. Marks on the back include the Rookwood logo and the date. On the frame is an original paper label with
 the title, "A Michigan Scene". Size 7¾ x 9¾ inches.

28 Standard glaze ewer with leaf decoration done by Artus Van Briggle in 1889. Marks on the base include the $800-1200
 Rookwood logo, the date, shape number 462, S for sage green clay, the artist's initials and L for light Standard
 glaze. Height 11 inches.

29 Vellum glaze vase decorated with trees and geese descending on a lake by Lenore Asbury. Marks on the base $1200-1500
 include the Rookwood logo, the date, shape number 1656D, the artist's initials and V for vellum glaze. Height 9¼
 inches.

30 Standard glaze two handled vase with chrysanthemum decoration, done by Anna Valentien in 1889. Marks on $800-1200
 the base include the Rookwood logo, the date, shape number 292 C, S for sage green clay, the artist's initials and
 L for light Standard glaze. Height 10½ inches.

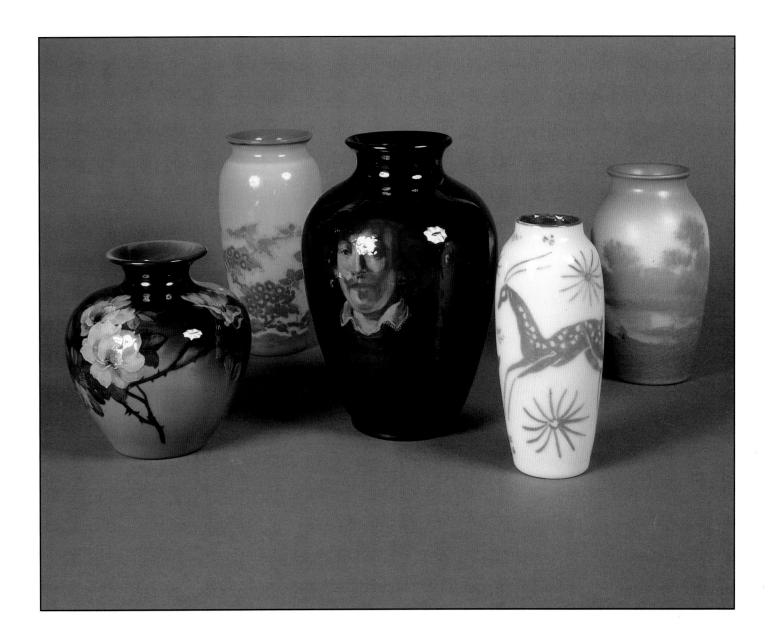

31 Standard glaze vase decorated with yellow roses by Luella Perkins in 1894. Marks on the base include the Rookwood logo, the date, shape number 488 E, W for white clay and the artist's initials. Height 6¼ inches.　　$600-800

32 Blue tinted high glaze vase done by Lorinda Epply in 1922 with floral decoration. Marks on the base include the Rookwood logo, the date, shape number 2544 and the artist's initials. Height 8¼ inches.　　$500-700

33 Standard glaze vase with portrait of a cavalier after Rembrandt, done by Sturgis Laurence in 1898. Marks on the base include the Rookwood logo, the date, shape number 814 A, the artist's full signature and the title, "After Rembrandt - ,98". Height 9¼ inches.　　$2000-3000

34 High glaze vase decorated by Elizabeth Barrett in 1945 with floral designs and a single gazelle. Marks on the base include the Rookwood logo, the date, shape number 907 F, the number 3080 and the artist's monogram. Height 7⅛ inches.　　$500-700

35 Vellum glaze vase decorated by E.T. Hurley in 1912 with a wooded lake scene in which a person in a small boat appears to be fishing. Marks on the base include the Rookwood logo, the date, shape number 586 C, V for Vellum glaze body and the artist's initials. Height 7¼ inches.　　$800-1200

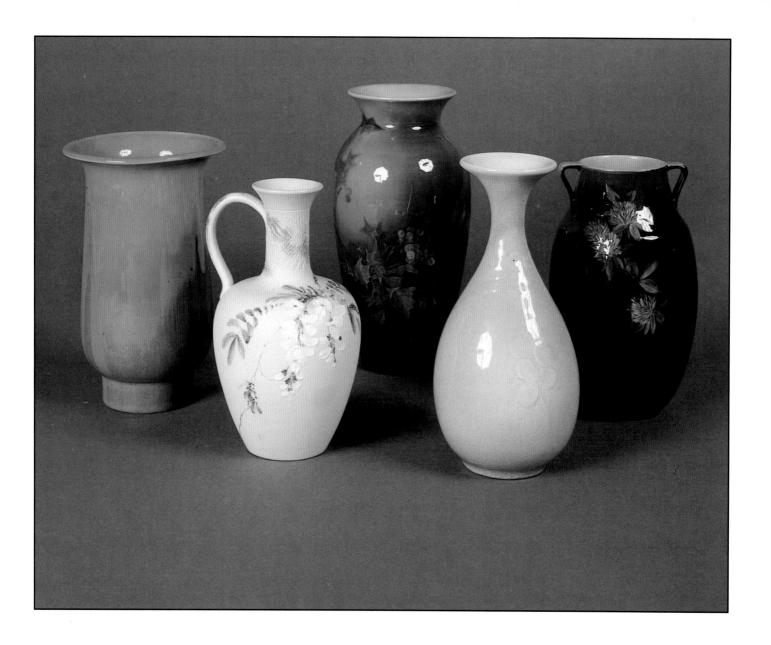

36 Vase with drip glaze decoration and some crystalline effect, done at Rookwood in 1932. Marks on the base $250-350
 include the Rookwood logo, the date, shape number 6309 and a small cross shaped esoteric mark. Height 8
 inches.

37 Bisque finish ewer with wisteria decoration by Artus Van Briggle, done in 1887. Marks on the base include the $700-900
 Rookwood logo, the date, shape number 299, W 7 for a particular type of white clay, the artist's initials and S for
 an unknown glaze designation. Height 7½ inches.

38 Standard glaze vase with holly decoration, done by Albert Valentien in 1891. Marks on the base include the $800-1000
 Rookwood logo, the date, shape number 568 D, W for white clay, the artist's initials and L for light Standard
 glaze. Height 9¼ inches. One burst glaze bubble on the back side of the vase.

39 Iris glaze vase with trillium decoration by Constance Baker, done in 1901. Marks on the base include the $500-700
 Rookwood logo, the date, shape number 799, a wheel ground X and the artist's initials. Height 8½ inches.

40 Standard glaze vase with two small loop handles painted in 1891 by Anna Valentien in 1891 with clover. Marks $600-800
 on the base include the Rookwood logo, the date, shape number 77 A, W for white clay, the artist's initials and L
 for light Standard glaze. Height 7½ inches.

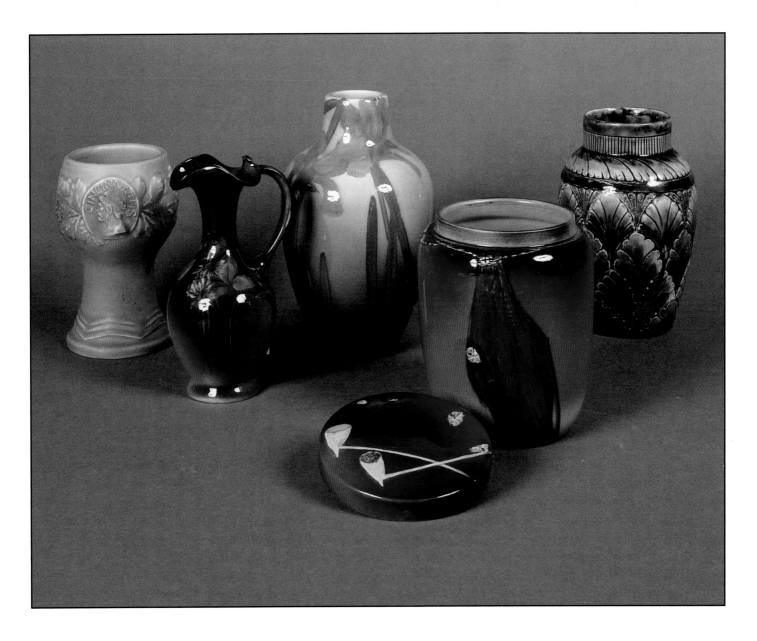

41 Mat glaze goblet, made for an unknown national convention which took place in Cincinnati in 1906. The goblet $300-500
has molded floral decoration and two circular medalions, one with a picture of Cincinnatus and the other with
the letter C. Marks on the base include the Rookwood logo, the date, the conjoined initials of the organization,
the initials of Rookwood decorators, William McDonald and Rose Fechheimer and the words, "National
Convention Cincinnati". Height 5¾ inches.

42 Standard glaze ewer decorated with clover by an artist's whose initials appear to be KHL in 1898. Marks on the $300-500
base include the Rookwood logo, the date, shape number 639 D and the artist's initials. Height 6¼ inches.

43 Sea Green glaze vase decorated with jonquils by Sallie Coyne in 1901. Marks on the base include the Rookwood $800-1200
logo, the date, shape number 905 D, G for Sea Green glaze, a small wheel ground X and the artist's initials.
Height 7⅝ inches. Tiny chip off base.

44 Standard glaze humidor decorated by Edward Abel in 1893 with pipes on the lid and tied hands of tobacco on $1200-1500
the base. Marks on the base include the Rookwood logo, the date, shape number 728, W for white clay, the
artist's initials and L for light Standard glaze. Height 6 inches. The lid is also marked with the artist's initials and L
for light Standard glaze.

45 Rare and unusual vase decorated in the style of Doulton Lambeth Pottery by Laura Fry as a member of the $500-700
Cincinnati Pottery Club in 1882. Marks on the base include Rookwood in block letters, the date, the artist's
monogram and the notation, "1882 Cincinnati Pottery Club". Height 6⅝ inches. Minor glaze flake on rim.

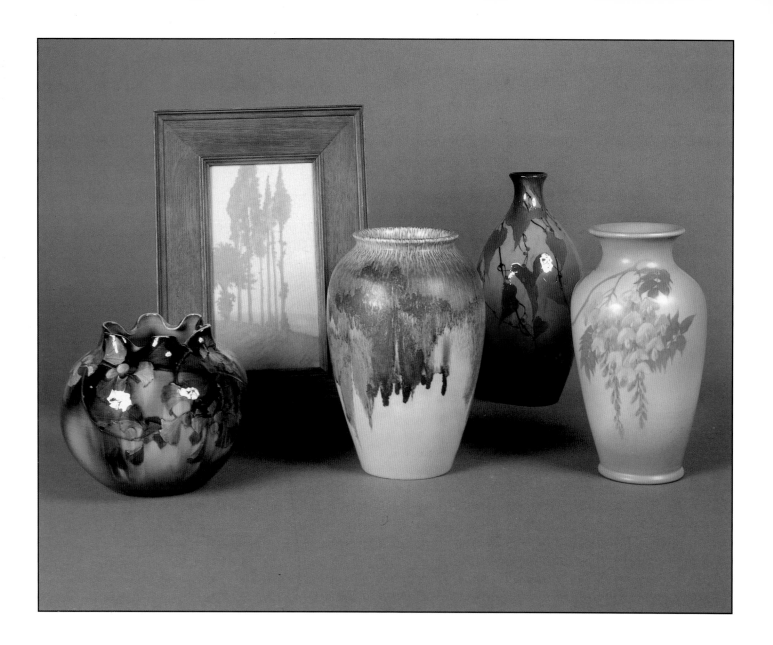

46 Standard glaze vase with fluted top, decorated by Kataro Shirayamadani with ginko leaves, stems and fruit in 1892. Marks on the base include the Rookwood logo, the date, shape number 346 B, W for white clay and the artist's cypher. Height 6 inches. $1200-1500

47 Vellum glaze scenic plaque painted in 1914 by Mary Grace Denzler. The artist's initials appear in the lower right hand corner. Marks on the back include the Rookwood logo, the date, V for Vellum glaze body and the title in pencil, "Tall Trees". On the frame is an original paper Rookwood logo. Size 9⅛ x 5⅛ inches. $2500-3500

48 Mat glaze vase with floral decoration, done by both Elizabeth Lincoln and C.S. Todd. Marks on the base include the Rookwood logo, the date, shape number 581 E and both artist's initials. Height 9⅜ inches. Grinding chips on the base. $400-600

49 Standard glaze vase decorated with trailing vines, berries and leaves by Kataro Shirayamadani in 1898. Marks on the base include the Rookwood logo, the date, shape number 745 A, a wheel ground X and the artist's cypher. Height 11 inches. A few glaze blisters are present. $700-900

50 Vellum glaze vase with wisteria decoration, painted by Ed Diers in 1926. Marks on the base include the Rookwood logo, the date, shape number 546 C, the artist's initials and V for Vellum glaze. Height 9¼ inches. Two chips at base. $600-800

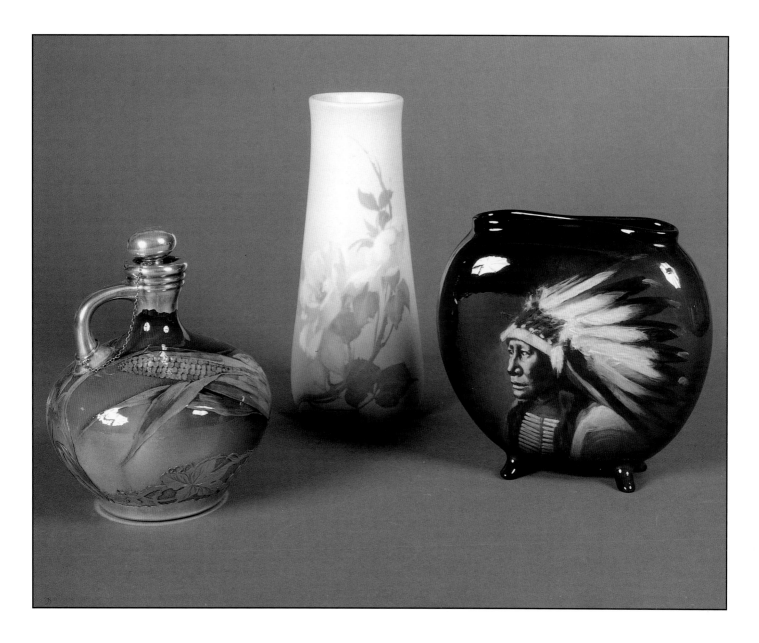

51 Standard glaze stoppered whiskey jug with very compatable silver overlay, decorated with ears of corn by $3000-5000
 Edward Abel in 1892. The silver overlay continues with the theme of fermentation by having wheat, corn and
 grapes as part of its design. The stopper has intertwined initials. Marks on the silver include R 352 and Gorham
 Mfg. Co. Marks on the base include the Rookwood logo, the date, shape number S 975, W for white clay, the
 artist's initials and L for light Standard glaze. Height 7¼ inches. Some minor breaks in the silver near the handle.
 This piece was a special shape at Rookwood and Gorham obviously crafted the silver to match.

52 Vellum glaze vase decorated with large white roses by Fred Rothenbusch in 1907. Marks on the base include the $1500-2000
 Rookwood logo, the date, shape number X 1889 X, the artist's initials and V for Vellum glaze. Height 10 inches.
 Glaze peppering on the inside rim.

53 Standard glaze footed pocket vase decorated with the portrait of a Native American by Adeliza Sehon in 1901. $2500-3500
 Marks on the base includes the Rookwood logo, the date, shape number 90, the artist's initial's and the
 inscription, "Chief Hollow Horn Bear. Sioux". Height 7 inches.

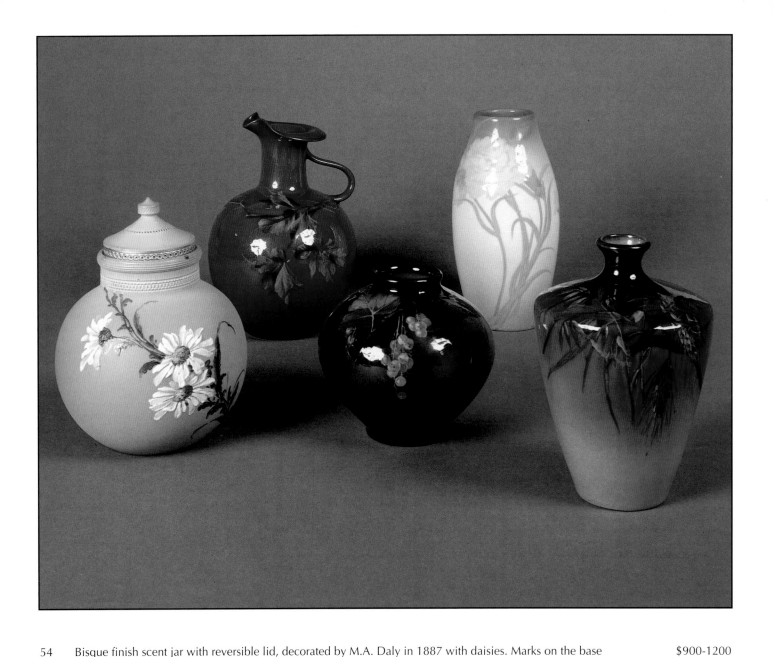

54 Bisque finish scent jar with reversible lid, decorated by M.A. Daly in 1887 with daisies. Marks on the base $900-1200
 include the Rookwood logo, the date, shape number 282 C, Y for yellow clay and the artist's initials. Height
 7 inches.

55 Standard glaze ewer with chestnut decoration by Harriet Wilcox, done circa 1890. Marks on the base include the $700-900
 Rookwood logo, the partially obscured date, shape number 62 B, R for red clay, the artist's initials and D for dark
 Standard glaze. Height 8¼ inches. One glaze bubble.

56 Standard glaze vase with leaves and berries decorated by Sadie Markland in 1898. Marks on the base include $300-500
 the Rookwood logo, the date, shape number 764 C, the artist's initials and L for light Standard glaze. Height
 4⅞ inches.

57 Iris glaze vase decorated with pink peonies by Ed Diers in 1904. Marks on the base include the Rookwood logo, $600-800
 the date, shape number 939 C, a wheel ground X and the artist's initials. Height 8 inches. Minor slip loss covered
 in the making. Horizontal crack.

58 Standard glaze vase decorated by Mary Nourse in 1893 with grasses and seeds. Marks on the base include the $500-700
 Rookwood logo, the date, shape number 679, W for white clay, the artist's initials and L for light Standard glaze.
 Height 7 inches.

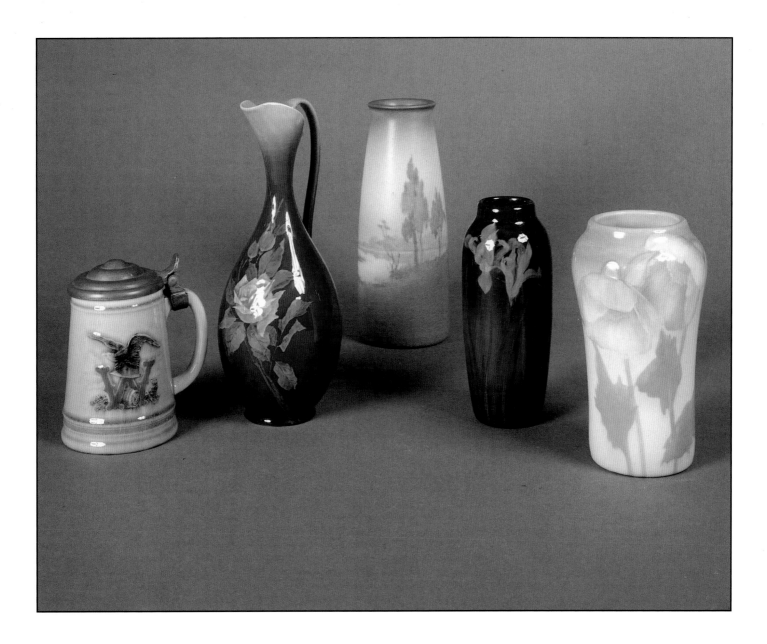

59 High glaze mug with pewter lid and embossed company logo on side in color. Made in 1948 for the George Wiedemann Brewing Company of Newport, Kentucky. Marks on base include the Rookwood logo, "THE GEO. WEIDEMANN BREWING CO. INC." and the date, 1948. Height, 5.5 inches. $250-350

60 Standard glaze ewer decorated with yellow roses by Amelia Sprague in 1899. Marks on the base include the Rookwood logo, the date, shape number 496B, the artist's initials and L for light Standard glaze. Height 10¼ inches. $700-900

61 Vellum glaze scenic vase decorated with trees and pond by Lenore Asbury in 1911. Marks on the base include the Rookwood logo, the date, shape number 1660D, V for Vellum glaze body, the artist's initials and V for Vellum glaze. Height 9¼ inches. $1250-1750

62 Standard glaze vase decorated with long stemmed flowers by Katherine Van Horne in 1908. Marks on the base include the Rookwood logo, the date, shape number 907 F and the artist's initials. Height 7 inches. $400-600

63 Iris glaze vase with poppy decoration, done by Elizabeth Lincoln in 1906. Marks on the base include the Rookwood logo, the date, shape number 935 D, a wheel ground X, the artist's initials and W for white glaze. Height 7⅜ inches. $700-900

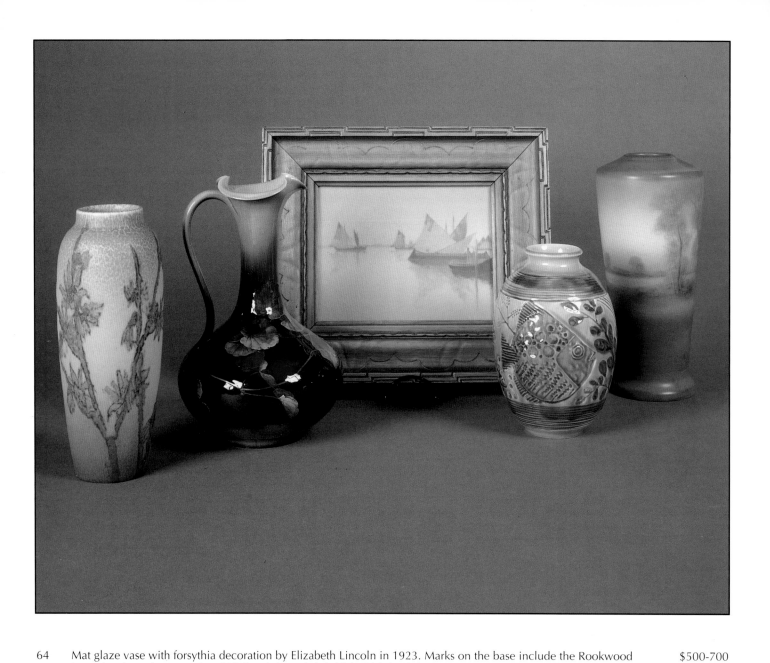

64 Mat glaze vase with forsythia decoration by Elizabeth Lincoln in 1923. Marks on the base include the Rookwood $500-700
 logo, the date, shape number 907 E and the artist's initials. Height 9¼ inches.

65 Standard glaze ewer decorated with leaves and small blue flowers by M.A. Daly in 1892. Marks on base include $250-450
 the Rookwood logo, the date, shape number 537 D, W for white clay, and the artist's initials. Height 9½ inches.
 Repair to handle.

66 Vellum glaze scenic plaque painted by Carl Schmidt in 1916. The artist's name appears in the lower right hand $3000-4000
 corner. Marks on the back include the Rookwood logo, the date and V for Vellum glaze body. On the frame is an
 original paper label with the title, "Boats at Anchor - Venice C. Schmidt". Size 6⅛ x 8⅛ inches.

67 Aventurine glaze vase with art deco design of fish and parallel lines. Marks on the base include the Rookwood $400-600
 logo, the date, and the shape number 6295. Height 7 inches.

68 Vellum glaze vase decorated by Ed Diers in 1919 with a banded woodland scene. Marks on the base include the $500-700
 Rookwood logo, the date, the partially obscured shape number which appears to be 1652 D, a wheel ground X
 and the artist's initials. Height 9⅞ inches. Drilled.

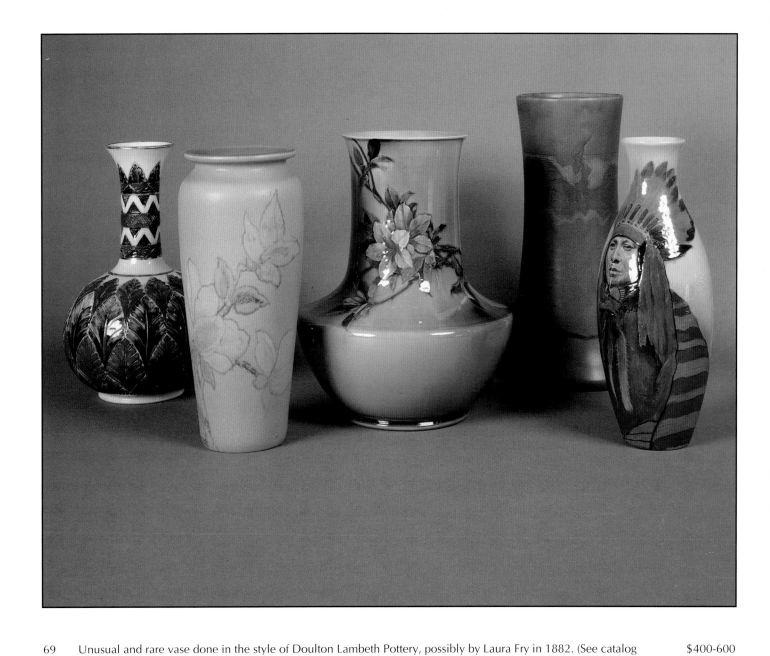

69 Unusual and rare vase done in the style of Doulton Lambeth Pottery, possibly by Laura Fry in 1882. (See catalog $400-600
 number 45). Marks on the base include Rookwood in block letters, an impressed anchor, the date and Y for
 yellow clay. Height 11⅜ inches.

70 Large and showy mat glaze vase with magnolia decoration, done by Katherine Jones in 1930. Marks on the base $900-1200
 include the Rookwood logo, the date, shape number 2790, a fan shaped esoteric mark and the artist's initials.
 Height 11¼ inches.

71 Large and impressive Standard glaze vase decorated with white rhododendron by Kataro Shirayamadani in 1890. $2500-3500
 Marks on the base include the Rookwood logo, the date, shape number 491 B, W for white clay, the artist's
 cypher and L for light Standard glaze. Height 12 inches.

72 Large mat glaze vase decorated with a band of three incised cranes by William Hentschel in 1911. Marks on the $400-600
 base include the Rookwood logo, the date, shape number 1358 B, a wheel ground X and the artist's initials.
 Height 13⅜ inches.

73 Unusual and colorful Standard glaze vase decorated by Artus Van Briggle with a portrait of a Native American in $2000-3000
 full headdress and related regalia in 1897. Marks on the base include the Rookwood logo, the date, shape number
 218 A, a small diamond shaped esoteric mark, the artist's initials and L for light Standard glaze. Height 12 inches.
 Moderate sized chip at lip has been repaired.

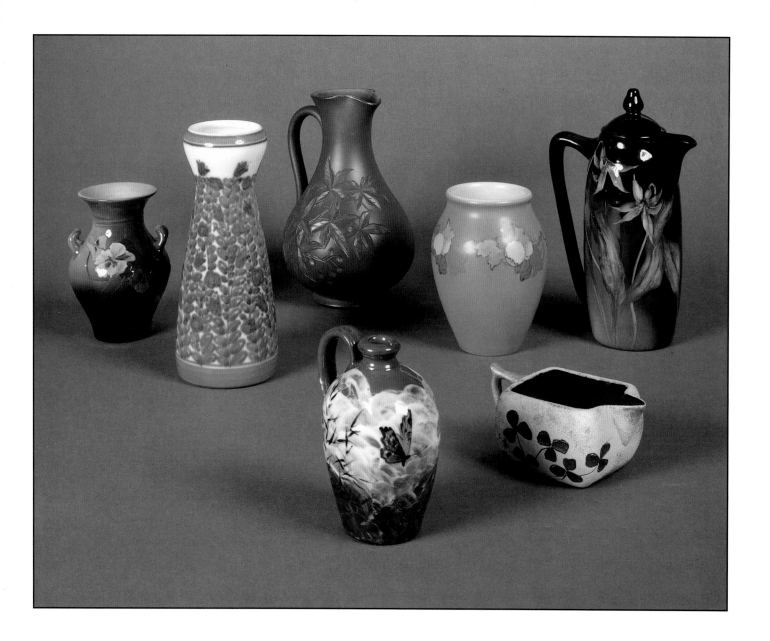

74 Standard glaze vase decorated with pansies by Mary Nourse in 1891. Marks on the base include the Rookwood logo, the date, shape number 583 F, W for white clay, the artist's initials and L for light Standard glaze. Height 4⅝ inches. $400-500

75 High glaze vase decorated with blue and white flowers by William Hentschel in 1921. Marks on the base include the Rookwood logo, the date, shape number 1656 E and the artist's initials. Height 7½ inches. $400-600

76 Bisque finish ewer with incised decoration of Virginia creepers, done by Harriet Wenderoth in 1882. Marks on the base include Rookwood in block letters, the date and the artist's initials. Height 7¼ inches. $300-500

77 Limoges style glaze perfume jug decorated with oriental grasses and an orange butterfly by M.A. Daly in 1882. Marks on the base include Rookwood in block letters, the date, shape number 60, R for red clay, a small impressed anchor and the artist's initials. Height 4⅝ inches. $300-500

78 Vellum glaze vase with a band of repeating floral decoration, done in 1921 by Fred Rothenbusch. Marks on the base include the Rookwood logo, the date, shape number 915 F, V for Vellum glaze body and the artist's initials. Height 5 inches. $400-600

79 Bisque finish creamer decorated with incised clover by Laura Fry in 1884. Marks on the base include Rookwood in block letters, the date, shape number 74, R for red clay and the artist's initials. Height 2 inches. $150-250

80 Standard glaze lidded chocolate pot decorated with adders tongue by Edith Felten in 1899. Marks on the base include the Rookwood logo, the date, shape number 771 C and the artist's initials. Height 8 inches. Lid has the initials S.E.C. and may be a marriage, but the colors match perfectly. Some scratches on the lid. $600-800

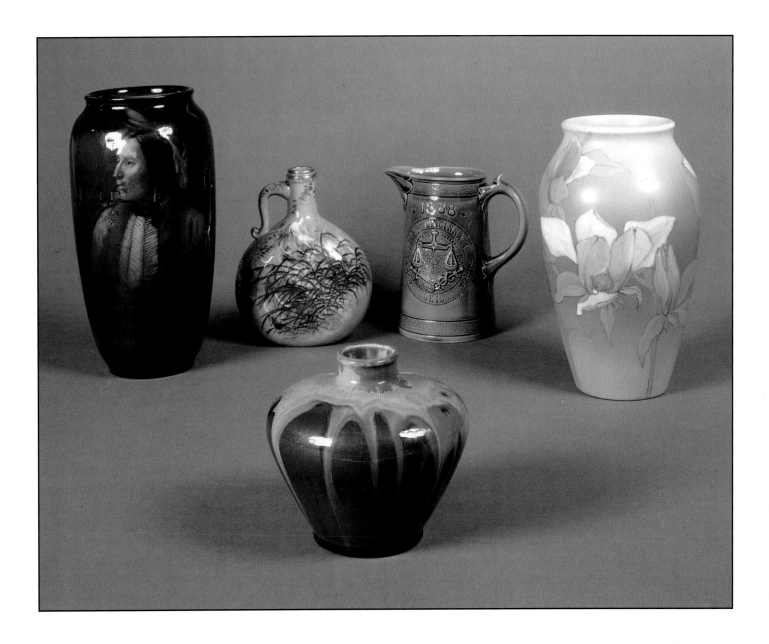

81 Standard glazed vase decorated with a portrait of a Native American by Sturgis Laurence in 1900. Marks on the base include the Rookwood logo, the date, shape number 892B, a wheel ground X, the inscription "Chief White Man Kiowa" and the artist's initials. Height 11¼ inches. $3000-4000

82 Limoges style glaze pilgrim flask with oriental grasses and clouds, done by Albert Valentien in 1882. Marks on the base include Rookwood in block letters, the date, an impressed anchor and the artist's initials. Height 6⅞ inches. $300-500

83 Unusual drip glaze vase with crystalline inclusions, made at Rookwood in 1932. Marks on the base include the Rookwood logo, the date, shape number 6310 and a cross shaped esoteric mark. Height 5 inches. $400-600

84 Rare commemorative high glaze pitcher done by Rookwood for the Cincinnati Centennial in 1888. The pitcher is adorned with the Great Seal of the State of Ohio and the date 1788 on one side and the seal of the City of Cincinnati and the date 1888 on the obverse. Marks on the base include the Rookwood logo and W for white clay. Height 6½ inches. $500-700

85 Very clean and impressive Vellum glaze vase decorated by Lenore Asbury in 1929 with magnolia. Marks on the base include the Rookwood logo, the date, shape number 913 C, V for vellum glaze and the artist's initials. Height 9⅜ inches. $1500-2500

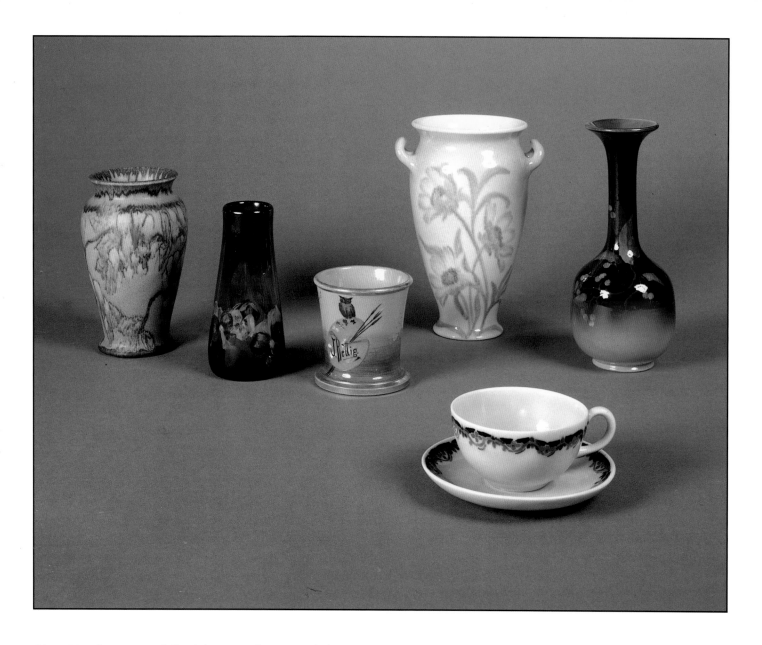

86 Mat glaze vase wtih floral decoration by Louise Abel, painted in 1924. Marks on the base include the Rookwood $300-500
 logo, the date, shape number 2720 and the artist's monogram. Height 6⅜ inches.

87 Late Standard glaze vase with pansy decoration, done by Carrie Steinle in 1908. Marks on the base include the $250-350
 Rookwood logo, the date, shape number 950 F and the artist's initials. Height 5¼ inches.

88 Unusual limoges style glaze shaving mug decorated by Albert Valentien for his friend John Rettig in 1883. $300-500
 Decoration consists of artist's brushes and a palette signed J. Rettig. An owl sits atop the palette. Marks on the
 base include the artist's initials and the date. Height 3⅝ inches. The handle has been broken and glued.

89 High glaze vase with two small loop handles, decorated with daisies by Margaret McDonald in 1936. Marks $500-700
 on the base include the Rookwood logo, the date, S for special shape and the artist's initials. Height
 8 inches.

90 High glaze cup and saucer with floral border, decorated by Sallie Toohey in 1918. Marks on the base include the $200-300
 Rookwood logo, the date, shape number X 6039 X and the artist's initials. Height 2⅜ inches.

91 Standard glaze vase with leaf and berry decoration, done by Constance Baker in 1898. Marks on the base include $300-400
 the Rookwood logo, the date, shape number 172 C, a small wheel ground X and the artist's initials. Height 8½
 inches. Glaze scuff.

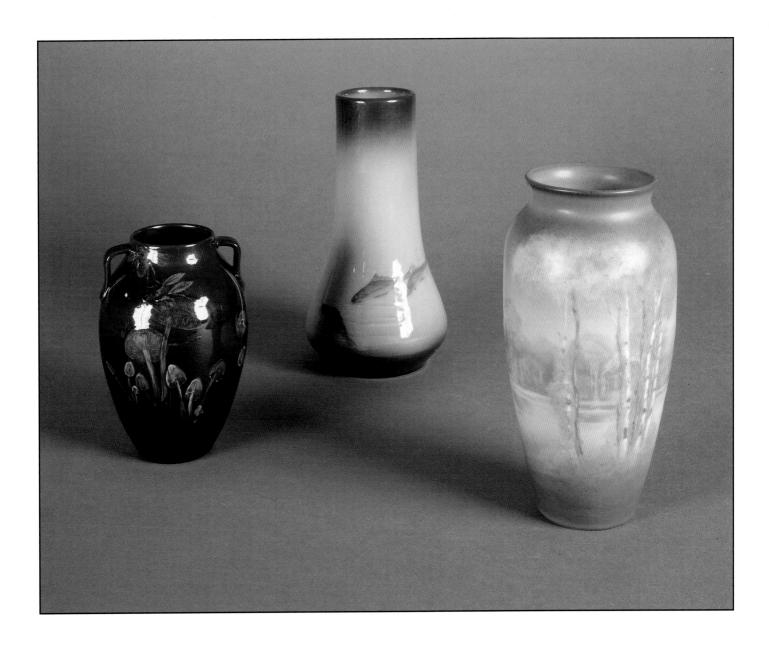

92 Small but spectacular Standard glaze vase with two ribbon handles, showing much Goldstone and Tiger Eye $4000-6000
 effect, decorated by Kataro Shirayamadani in 1894 with mushrooms and two bees. Marks on the base include the
 Rookwood logo, the date, the artist's cypher and a paper label which reads: "Rookwood Pottery Cincinnati USA
 1904 Louisiana Purchase Exposition St. Louis". Height 5¾ inches.

93 Iris glazed vase decorated with five fish by Sallie Coyne in 1910. Marks on the base include th Rookwood logo, $1750-2250
 the date, shape number 1278 E, the artist's initials and W for white glaze. Height 8¼ inches.

94 Vellum glaze scenic vase decorated by E.T. Hurley in 1946. Marks on the base include the Rookwood logo, the $1250-1750
 date, S for special shape, the number 5337 and the artist's initials. Height 8 inches. Uncrazed.

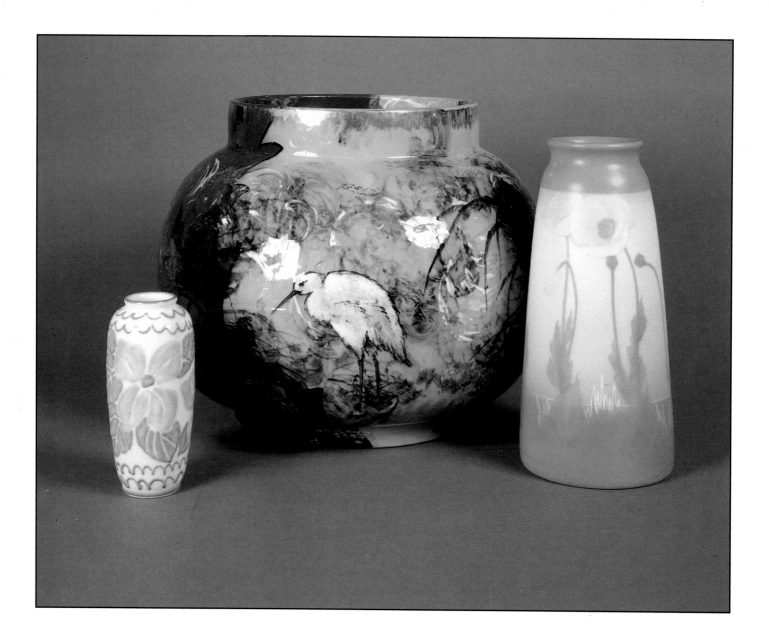

95 High glazed vase decorated with stylized pink flowers by Elizabeth Barrett in 1945. Marks on the base include the Rookwood logo, the date, shape number 6644 E and the artist's monogram. Height 6½ inches. $300-500

96 Monumental limoges style glaze floor vase, decorated in the manner of Maria Longworth Nichols with oriental grasses and wading cranes. The base is marked in script, Rookwood 1882. Height 12⅞ inches, diameter 17 inches. $3000-4000

97 Tall Vellum glaze vase decorated with a band of white poppies by Kataro Shirayamadani in 1909. Marks on the base include the Rookwood logo, the date, shape number 1658 C, a V for Vellum glaze body and the artist's cypher. Height 12 inches. $1500-2000

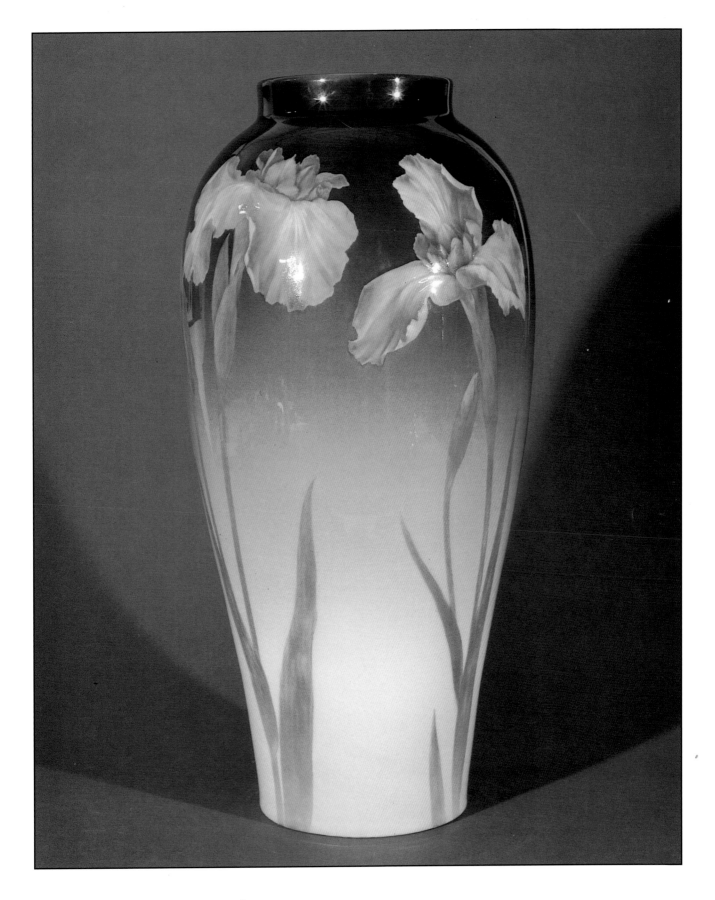

98 Large and impressive Iris glaze vase painted with beautiful blue irises and green leaves by Albert Valentien in $10000-15000
 1903. The artist's full signature appears on the side near the base. Marks on the base include the Rookwood
 logo, the date and shape number 901 XX. Height 20½ inches. Drilled.

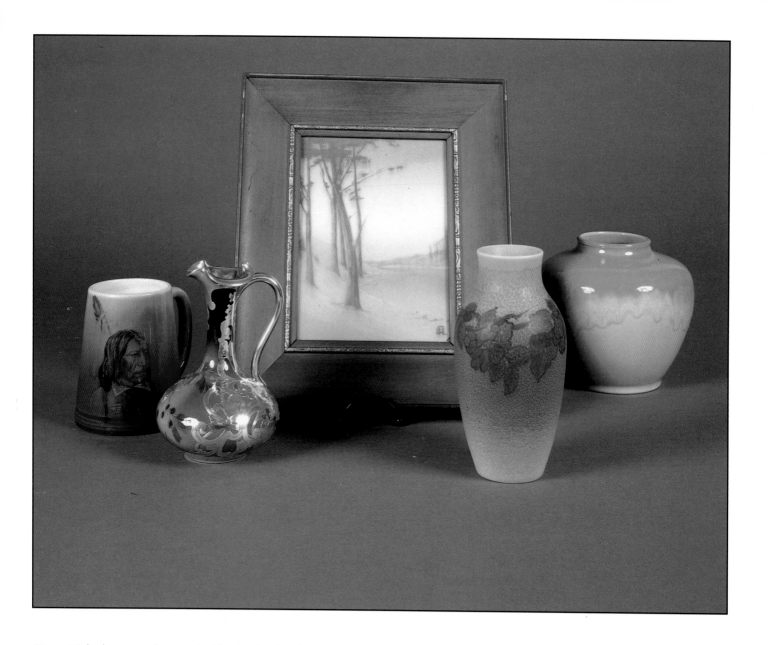

99　High glaze mug decorated with a Native American portrait by Flora King in 1946. Marks on the base include the Rookwood logo, the date, shape number 587C, the inscription, "John Elk", the numbers "212", "62" and the artist's initials. Height 5 inches.　$600-800

100　Standard glaze ewer with silver overlay decorated with a floral and berry design by Olga Geneva Reed in 1890. The silver overlay is engraved and signed "GORHAM MGF CO". Marks on the base include the Rookwood logo, the date, shape number 537, the artist's initials and W for white clay. Height 6½ inches.　$2500-3000

101　Vellum glaze scenic plaque done by Sallie Coyne in 1916. The artist's initials appear in the lower right hand corner. Marks on the back include the Rookwood logo, the date, V for Vellum glaze body and the title in pencil, "Cabin Accrost (sic) the Creek". Size 8⅛ x 6¼ inches.　$2000-3000

102　Mat glaze vase with floral decoration done by Margaret McDonald in 1922. Marks on the base include the Rookwood logo, the date, shape number 926 D and the artist's initials. Height 7½ inches.　$300-400

103　Bowl with multicolored drip glaze, done in 1932. Marks on the base include the Rookwood logo, the date, shape number 6307 C and a small cross shaped esoteric mark. Height 6 inches　$300-500

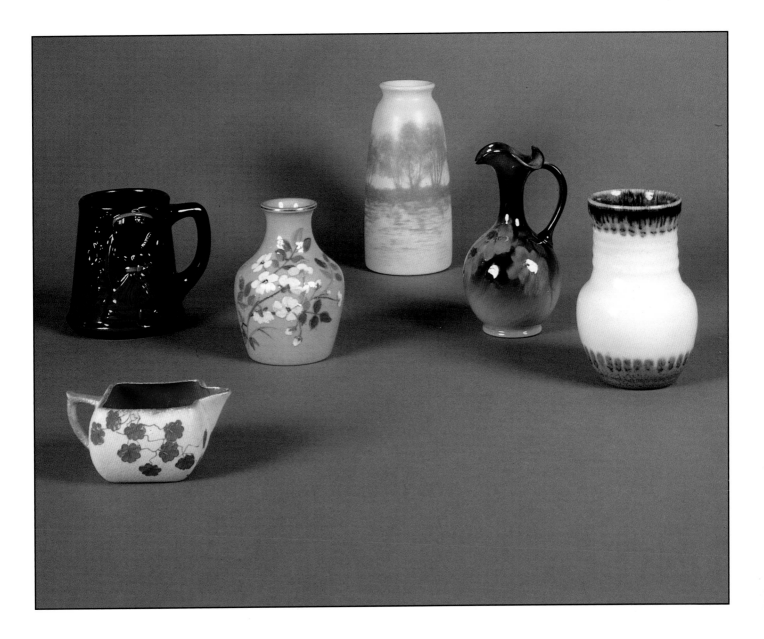

104 Standard glaze souvenir mug with an embossed decoration of a locked railway mail pouch with wings, done by $300-500
Sallie Coyne in 1905. Marks on the base include the Rookwood logo, the date, the artist's initials and the
following inscription: "Compliments of Fifth Division Railway Mail Service to Delegates Attending Annual
Convention Cincinnati, Ohio 1905". Height 4¾ inches.

105 Bisque finish creamer with incised and painted ivy decoration, done by Anna Bookprinter in 1885. Marks on the $150-250
base include Rookwood in block letters, the date, shape number 43, G for ginger clay (although this piece is red
clay) and the artist's initials. Height 2 inches.

106 Matt Morgan Pottery Company vase, decorated by an unknown artist circa 1883 with flowers under a high glaze. $400-600
Marks on the base include the impressed oval mark, Matt Morgan Art Pottery Co. Cinti, O. and the artist initials.
Height 5⅛ inches.

107 Vellum glaze scenic vase done by E.T. Hurley in 1910, showing a line of trees reflecting in water. Marks on the $1200-1500
base include the Rookwood logo, the date, shape number 1658 E, the artist's initials and V for Vellum glaze.
Height 7⅞ inches.

108 Standard glaze ewer with wild rose decoration, done by Marianne Mitchell in 1902. Marks on the base include $300-500
the Rookwood logo, the date, shape number 617 F and the artist's initials. Height 7¾ inches.

109 High glaze vase with gray borders at top and botton, done in 1933 by Lorinda Epply. Marks on the base include $300-400
the Rookwood logo, the date, S for special shape number and the artist's initials. Height 5⅞ inches.

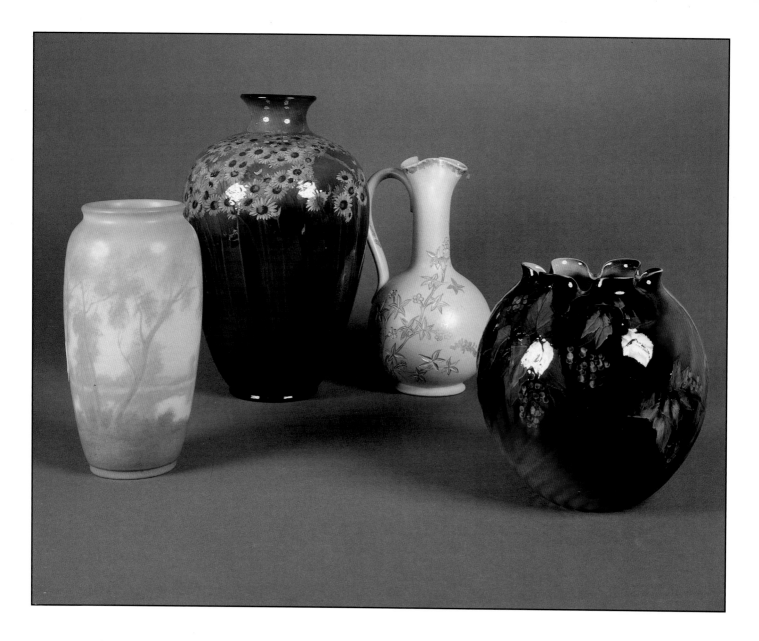

110 Very clean and crisp Vellum glaze vase with an overall woodland scene, done by Ed Diers in 1931. Marks on the base include the Rookwood logo, the date, shape number 892 B, a small fan shaped esoteric mark, the artist's initials and V for Vellum glaze. Height 10½ inches. Uncrazed. $2500-3500

111 Very large and impressive Standard glaze vase decorated by Kataro Shirayamadani in 1897 with a showy profusion of long stemmed black eyed susans. Marks on the base include the Rookwood logo, the date, shape number 787 B and the artist's cypher. Height 14¾ inches. Some glaze scratches. $3000-4000

112 Bisque finish ewer with painted and incised floral design and several butterflies, decorated by an artist whose initials appear to be DWB in 1881. Marks on the base in script include the initials DWB and Rookwood Pottery Cin O 1881. Height 11¾ inches. $400-600

113 Standard glaze ribbed bulbous vase with fluted top, painted with leaves and berries by Albert Valentien in 1892. Marks on the base include the Rookwood logo, the date, shape number 612 A, W for white clay, a small wheel ground X, the artist's initials and L for light Standard glaze. Height 8¾ inches. Small chip on the outside edge of the lip. $800-1000

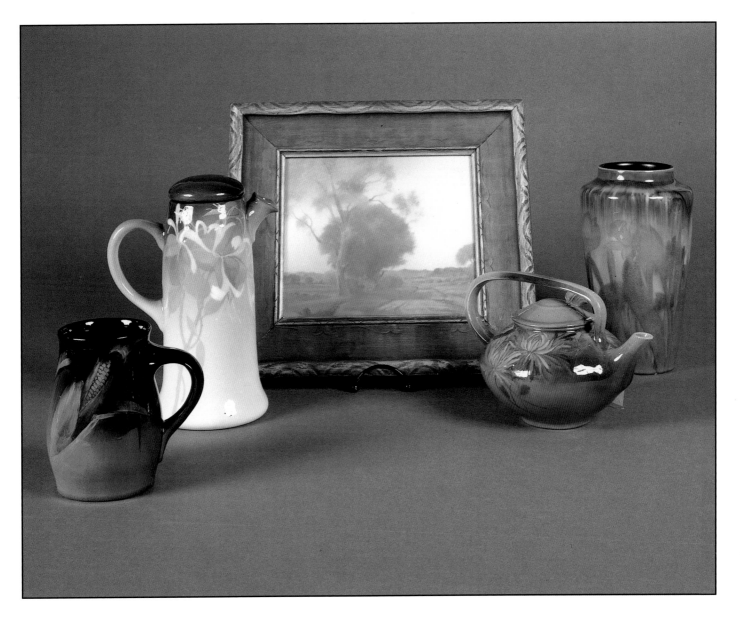

114 Standard glaze mug decorated with ears of corn by Lenore Asbury in 1896. Marks on the base include the Rookwood logo, the date, shape number 337, a small triangular esoteric mark and the artist's initials. Height 5¼ inches. Line at rim. $200-400

115 Rare lidded Iris glaze chocolate pot with honeysuckle decoration, done by Mary Nourse in 1905. Marks on the base include the Rookwood logo, the date, shape number 772, the artist's initials and W for white glaze. Height 9¼ inches. $1500-2000

116 Vellum glaze scenic plaque done by Fred Rothenbusch in 1921. The artist's initials appear in the lower left hand corner. Marks on the back include the Rookwood logo, the date and a title in pencil, "Afternoon". Size 7¼ x 8⅜ inches. Slight glaze chips at two corners which are covered by the frame and a large area of loose glaze in mid sky. $1000-1500

117 Standard glaze lidded teapot with long loop handle, decorated by Anna Valentien with spider mums in 1893. Marks on the base include the Rookwood logo, the date, shape number 404, W for white clay, the artist's initials and L for light Standard glaze. The lid is decorated with corresponding leaves but is not initialled by the artist. Height 5½ inches. $600-800

118 Unusual high glaze vase with jonquils and bleeding hearts, done by Kataro Shirayamadani in 1924. Marks on the base include the Rookwood logo, the date, shape number 1918 and the artist's cypher. Height 8½ inches. $800-1000

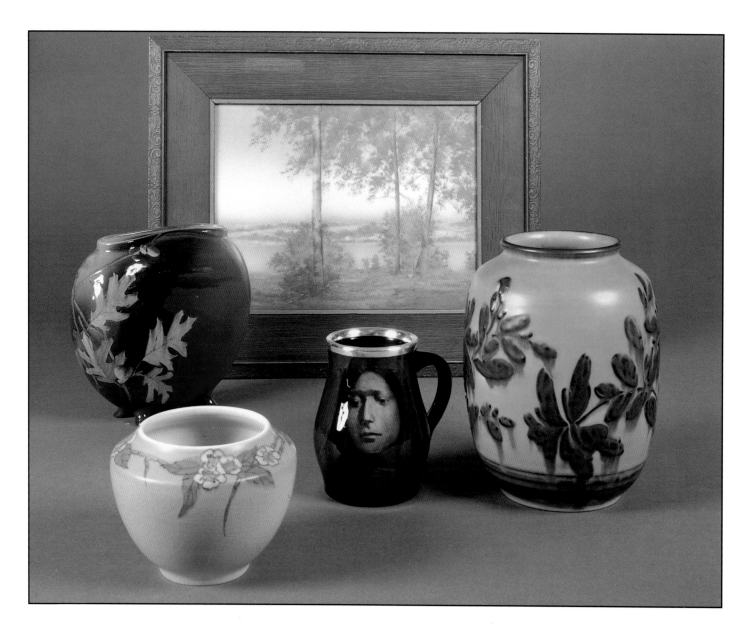

119 Standard glaze footed pillow vase with oak leaf and acorn decoration, done by Sallie Toohey in 1892. Marks on the base include the Rookwood logo, the date, shape number 90 A, W for white clay, the artist's initials and L for light Standard glaze. Height 7¼ inches. $400-600

120 Vellum glaze bowl decorated with a band of cherry blossoms near the shoulder by Vera Tischler in 1922. Marks on the base include the Rookwood logo, the date, shape number 1927, V for Vellum glaze body and the artist's initials. Height 4¼ inches. $400-600

121 Vellum glaze plaque decorated by Ed Diers in 1916. The artist's initials appear in the lower right hand corner. Marks on the back include the Rookwood logo, the date and V for Vellum glaze body. Size 9⅜ x 12⅛ inches. $3500-5000

122 Standard glazed mug decorated with a Native American portrait by Grace Young in 1899. The rim is encircled with a silver band. The base includes the Rookwood logo, date, artist's initials, shape number 837, and the inscription "Kiowa Woman". Height 5⅛ inches. $1500-2500

123 Mat glaze vase decorated with floral designs in very heavy slip, done by Elizabeth Barrett in 1931. Marks on the base include the Rookwood logo, the date, shape number 6197 C, a small fan shaped esoteric mark, a partial Rookwood paper sales label and the artist's monogram. Height 8¾ inches. $700-900

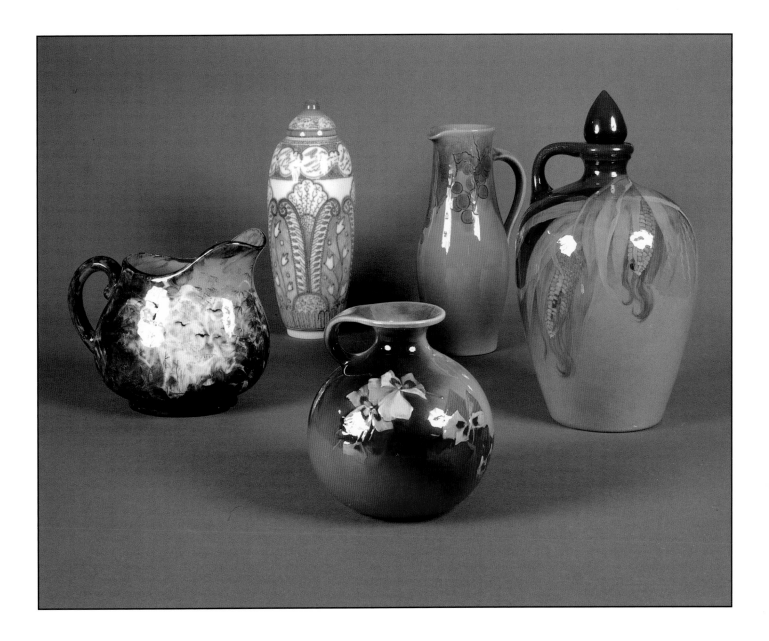

124 Limoges style glaze pitcher decorated with bats and grasses, done by an unknown decorator in 1883. Marks on $600-800
the base include Rookwood in block letters, the date and the number 3. Height 6⅞ inches.

125 Unusual high glaze lidded vase decorated in blue and white with arabic designs by William Hentschel in 1921. $1000-1500
Marks on the base include the Rookwood logo, the date, shape number 2547 and the artist's initials. Height 11½
inches.

126 Standard glaze pitcher with pansy decoration, done by Harriet Strafer in 1892. Marks on the base include the $500-700
Rookwood logo, the date, shape number 669, the number 138, W for white clay, the artist's initials and L for light
Standard glaze. Height 6⅛ inches.

127 Sea Green glaze pitcher decorated with incised and painted grape leaves and fruit, done by Amelia Sprague in $700-900
1899. Marks on the base include the Rookwood logo, the date, shape number 838 C, a wheel ground X, the
artist's initials and G for Sea Green glaze. Height 10⅜ inches. Repair to lip.

128 Large Standard glaze whiskey jug with stopper decorated by Lenore Asbury in 1907 with ears of corn and wheat. $1500-1800
Marks on the base include the Rookwood logo, the date, shape number 513 X and the artist's initials. Height 12½
inches. Chip at base of stopper.

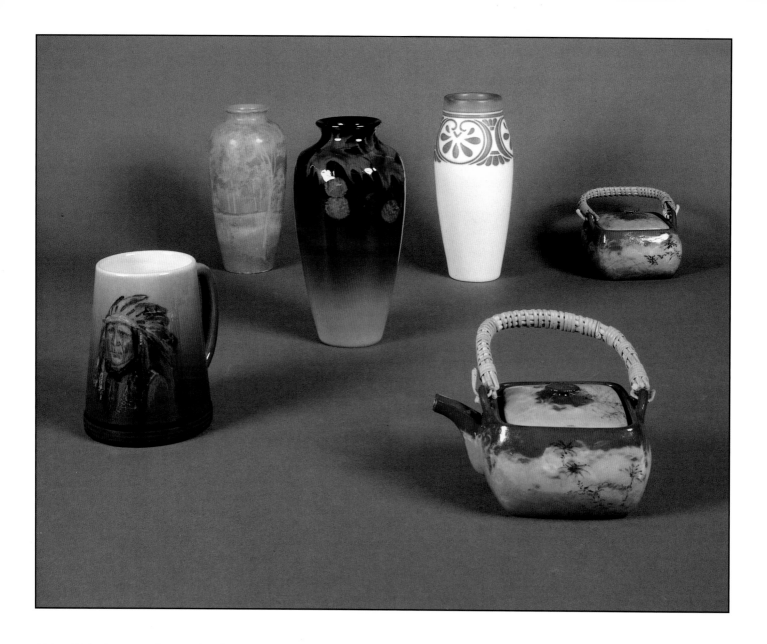

129 High glaze mug decorated with a Native American portrait by Flora King in 1946. Marks on the base include the Rookwood logo, the date, shape number 587 C, the inscription, "Owns - A Dog", the number "214" and the artist's initials. Height 5 inches.　　　$600-800

130 Vellum glaze scenic vase decorated by Charles Klinger in 1917. Marks on the base include the Rookwood logo, the date, shape number 614 F, the artist's initials and V for Vellum glaze. Height 7¼ inches.　　　$800-1200

131 Standard glaze vase decorated with sycamore leaves and seed balls by Sallie Coyne in 1898. Marks on the base include the Rookwood logo, the date, shape number 614 E, a small star shaped esoteric mark and the artist's initials. Height 8 inches.　　　$500-700

132 Early Vellum glaze vase decorated with repeating stylized design by Sara Sax in 1905. Marks on the base include the Rookwood logo, the date, shape number 80 E, V for Vellum glaze body, the artist's monogram and V for Vellum glaze. Height 7⅞ inches.　　　$500-700

133 Limoges style glaze teapot and sugar bowl decorated by an unknown artist in 1884 with clouds, vegitation and butterflies. Marks on the base of the teapot include Rookwood in block letters, the date, shape number 87 and R for red clay. Height 3 inches. Marks on the base of the sugar bowl include Rookwood in block letters, the date, shape number 43 C and R for red clay. Height 3 inches. The lid of the sugar bowl has been repaired.　　　$400-600

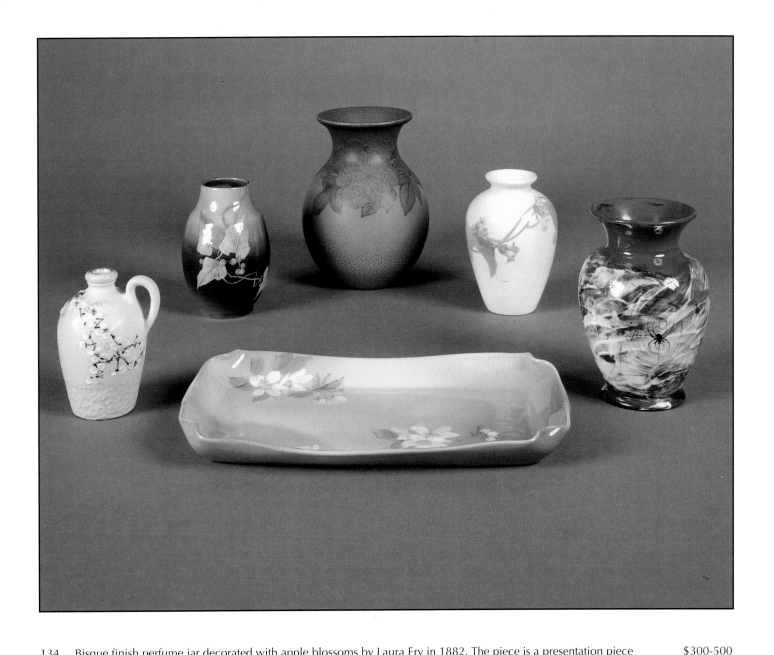

134 Bisque finish perfume jar decorated with apple blossoms by Laura Fry in 1882. The piece is a presentation piece for a member of the Cincinnati Commercial Club and is inscrbed as follows: "H.L. Dousmann Oct 13th 1883" and carries the logo of the club. Marks on the base include Rookwood in block letters, the date, shape number 61, S for sage green clay, a small kiln and the artist's initials. Also printed in red paint, '93-264 which may be an accession number from the Cincinnati Art Museum. Height 4 inches. $300-500

135 Standard glaze vase decorated with leaves and berries by Sallie Coyne in 1893. Marks on the base include the Rookwood logo, the date, shape number 77 C, W for white clay and the artist's initials. Height 4¾ inches. $300-400

136 Cameo glaze tray with apple blossom decoration by Harriet Wilcox circa 1887. Marks on the base include the artist's initials and W for white glaze. The tray may have been part of a set and consequently does not carry the Rookwood logo. Length 11 inches. Glaze burn. $200-300

137 Mat glaze vase with floral decoration by Elizabeth Lincoln, done in 1928. Marks on the base include the Rookwood logo, the date, shape number 402 and the artist's initials. Height 6⅜ inches. $300-500

138 Iris glaze vase decorated with small pink flowers and leaves by Sara Sax in 1900. Marks on the base include the Rookwood logo, the date, shape number 605, the artist's monogram and W for white glaze. Height 4¾ inches. $300-500

139 Limoges style glaze vase decorated by N.J. Hirschfeld in 1882, showing clouds, grasses and several spiders in webs. Marks on the base include Rookwood in block letters, the date, an impressed anchor and the artist's initials. Height 5⅝ inches. $500-700

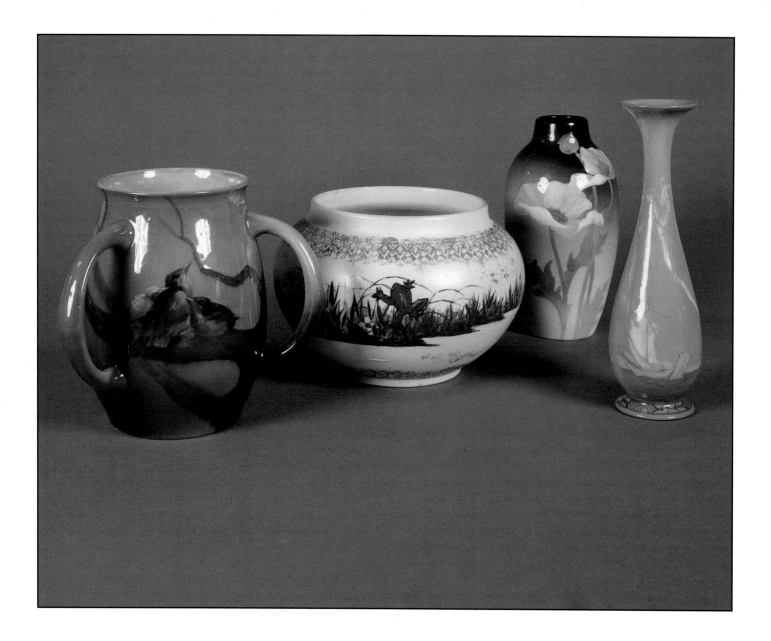

140 Standard glaze three handled loving cup decorated by Harriet Wilcox in 1893 with three small huddling birds on $2000-3000
the branch of a large leafless tree. Marks on the base include the Rookwood logo, the date, shape number 659, W
for white clay and the artist's initials. Height 8⅛ inches.

141 Limoges style glaze jardiniere decorated with a pond scene complete with grasses, cattails, flowers and frolicking $800-1200
frogs, done in 1882 by William McDonald. An elaborate die impressed border encircles the top and bottom and
is colored with fired on gold. Marks on the base inclued Rookwood in block letters, the date, shape number 95, C
for cream clay, an impressed anchor and the artist's initials. Height 6¼ inches, diameter 9⅜ inches. Some very
tight cracks descend from the rim but these may have occurred in the firing.

142 Iris glaze vase decorated with poppies by Lenore Asbury in 1903. Marks on the base include the Rookwood logo, $1800-2500
the date, shape number 940 D, W for white glaze and the artist's initials. Height 8⅞ inches.

143 Good high glaze scenic vase on gray clay, decorated with an oriental panorama by Arthur Conant in 1921. Marks $2500-3000
on the base include the Rookwood logo, the date, shape number 2545 C, the number 7907 which refers to the
gray clay body and the artist's monogram. Height 10½ inches.

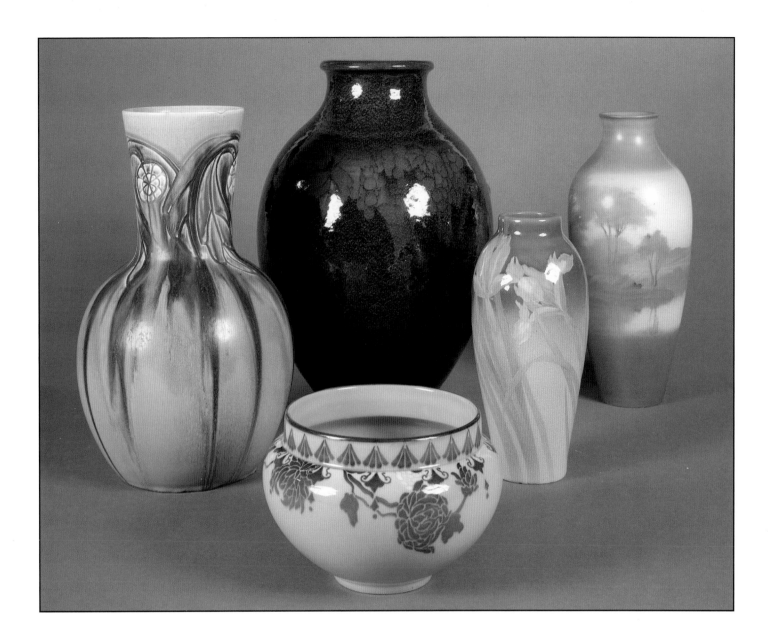

144 large transmutational mat glaze vase with some crystalline formations, painted and incised with stylized flowers $700-900
by Elizabeth Lincoln in 1918. Marks on the base include the Rookwood logo, the date, shape number 161, a
wheel ground X, P for porcelain body and the artist's initials. Height 12¾ inches. Firing flaw at rim. Grinding
flakes on base.

145 High glaze porcelain bodied bowl decorated with a border of chrysanthemums and lined in salmon pink by $1200-1500
Arthur Conant in 1917. Marks on the base include the Rookwood logo, the date, shape number 2259 D, P for
porcelain body and the artist's monogram. Height 4¾ inches.

146 Blue tinted high glaze vase with grape decor, done in 1920 by Sara Sax. Marks on the base include the $400-600
Rookwood logo, the date, shape number 2246 C and the artist's monogram. Height 14¼ inches. Glaze bulges.

147 Iris glaze vase decorated by Olga Geneva Reed in 1902 with pink irises. Marks on the base include the $1200-1500
Rookwood logo, the date, shape number 901 C, a small wheel ground X, the artist's initials and W for white
glaze. Height 9 inches.

148 Vellum glaze vase with a banded scene of woods and a lake, decorated by Fred Rothenbusch in 1921. Marks on $1500-2000
the base include the Rookwood logo, the date, shape number 170, V for Vellum glaze body and the artist's
initials. Height 11⅞ inches.

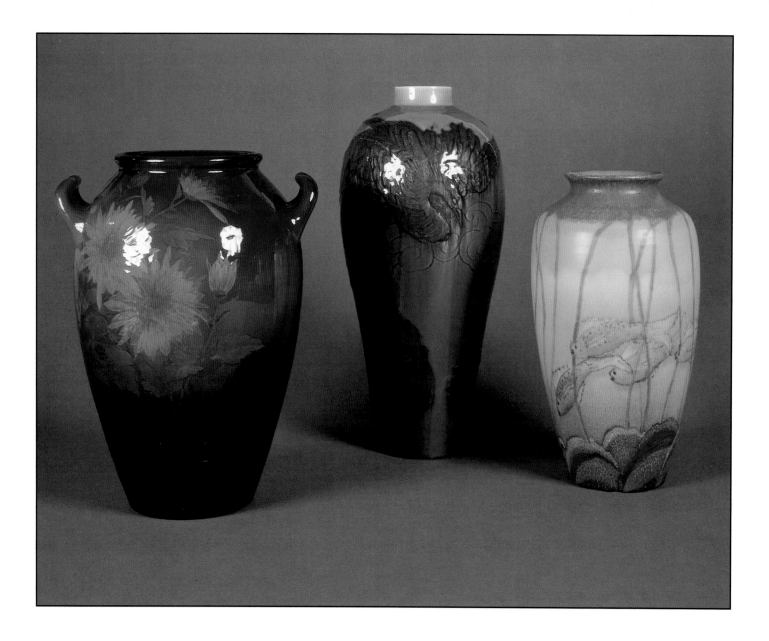

149 Large and handsome Standard glaze vase with two loop handles decorated by Kataro Shirayamadani with orange $2500-3500
chrysanthemums in 1899. Marks on the base include the Rookwood logo, the date, shape number 581 C, a small
wheel ground X and the artist's cypher. Height 13⅛ inches.

150 Large and rare decorated aventurine glaze vase, carved with two rising phoenix birds by William McDonald in $6000-8000
1920. Marks on the base include the Rookwood logo, the date, shape number 2368 and the artist's initials.
Height 16 inches. Decorated aventurine pieces are rare and this one is certainly the largest and most exotic to
come on the market in years.

151 Nice mat glaze vase with an underwater scene of fish and seaweed, done by Margaret McDonald in 1931. Marks $2000-2500
on the base include the Rookwood logo, the date, shape number 614 C, a small fan shaped esoteric mark and the
artist's initials. Height 12½ inches.

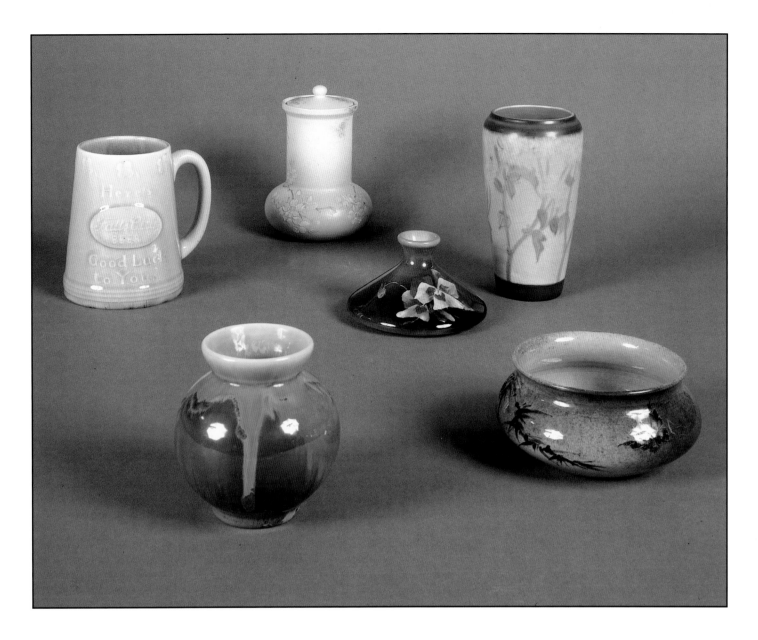

152 High glaze advertising mug, made for Falls City Brewing Company in Louisville by Rookwood in 1948. Marks on the base include the Rookwood logo and the date. Height 5 inches. $200-300

153 Vase with drip glaze decoration, made at Rookwood in 1932. Marks on the base include the Rookwood logo, the date and shape number 6303. Height 4 inches. $150-250

154 Bisque finish lidded rose jar painted by Grace Young in 1889 with cherry blossoms. Marks on the base include the Rookwood logo, the date, shape number 479, W for white clay, the artist's initials and S for an unknown glaze designation. Height 5⅞ inches. Chip on edge of rim. The lid is reversible. $400-600

155 Standard glaze three footed vase with pansy decoration, done by Helen Stuntz in 1893. Marks on the base include the Rookwood logo, the date, shape number 688, W for white clay and the artist's initials. Height 2¼ inches. $300-400

156 Vellum glaze vase decorated with daisies by Carrie Steinle in 1917. Marks on the base include the Rookwood logo, the date, shape number 1369 F, V for Vellum glaze body, a small wheel ground X and the artist's initials. Height 6¼ inches. $300-500

157 Standard glaze bowl decorated with oriental grasses and a single butterfly by an unknown artist in 1885. Marks on the base include Rookwood in block letters, the date, shape number 82 and S for sage green clay. Height 2½ inches. $300-500

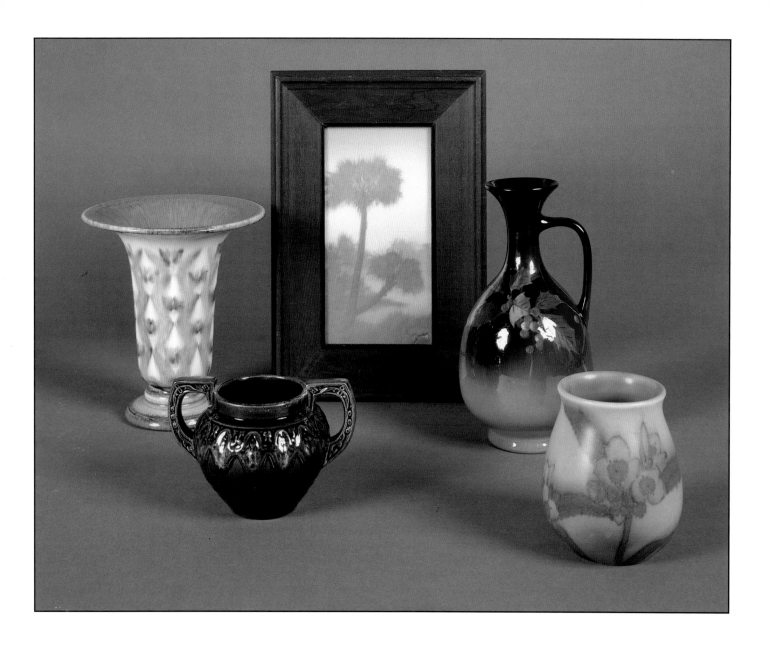

158 High glaze flaired vase with floral decoration, done by Lorinda Epply in 1929. Marks on the base include the Rookwood logo, the date, shape number 6002 and the artist's initials. Height 7 inches. $400-600

159 Matt Morgan Pottery vase with two large handles, done in a moresque style high glaze with fired on gold accents. Marks on the base include Matt Morgan Pottery Company in block letters. Height 3¾ inches. $300-400

160 Vellum glaze scenic plaque decorated by E.T. Hurley in 1913. The artist's initials appear in the lower right hand corner. Marks on the back include the Rookwood logo, the date, V for Vellum glaze body and the title, "The Tropics". Size 8 x 4¼ inches. $1250-1750

161 Standard glaze ewer with holly decoration, done by Lenore Asbury in 1897. Marks on the base include the Rookwood logo, the date, shape number 657 C, a small diamond shaped esoteric mark and the artist's initials. Height 8¼ inches. $400-600

162 Mat glaze vase with blossoms decorated by Kataro Shirayamadani in 1931. Marks on the base include the Rookwood logo, the date, shape number 63 and the artist's cypher. Height 4¼ inches. $400-600

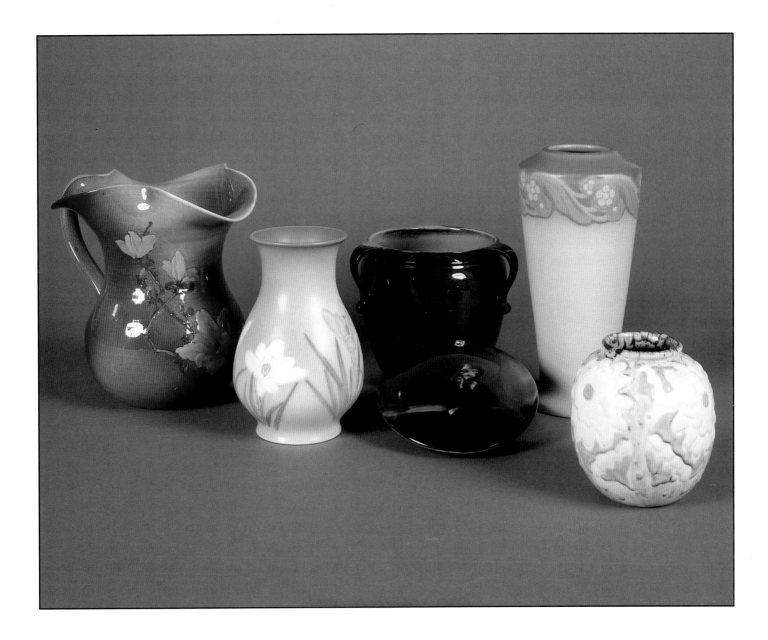

163 Standard glaze pitcher with floral decoration, done by Artus Van Briggle in 1887. Marks on the base include the Rookwood logo, the date, shape number 332, W 7 for a particular type of white clay, the artist's initials and L for light Standard glaze. Height 8 inches. $800-1200

164 Mat glaze vase decorated with yellow crocuses by Kataro Shirayamadani in 1943. Marks on the base include the Rookwood logo, the date, shape number 6827 and the artist's initials. Height 6¾ inches. $700-900

165 Unusual Standard glaze three handled humidor decorated on the lid by Harriet Wilcox in 1892 with a ghoul smoking by candlelight. Marks on the base include the Rookwood logo, the date, shape number 234, W for white clay, the artist's initials and L for light Standard glaze. Height 5¾ inches. $2000-3000

166 Vellum glaze vase decorated by Lorinda Epply in 1915 with a band of stylized flowers near the shoulder. Marks on the base include the Rookwood logo, the date, shape number 1663 D, V for Vellum glaze body, the artist's initials and V for Vellum glaze. Height 9¼ inches. $500-700

167 High glaze vase with heavy slip decoration of large white flowers, done in 1943 by Elizabeth Barrett. Marks on the base include the Rookwood logo, the date, shape number 6183 F and the artist's monogram. Height 4½ inches. $500-700

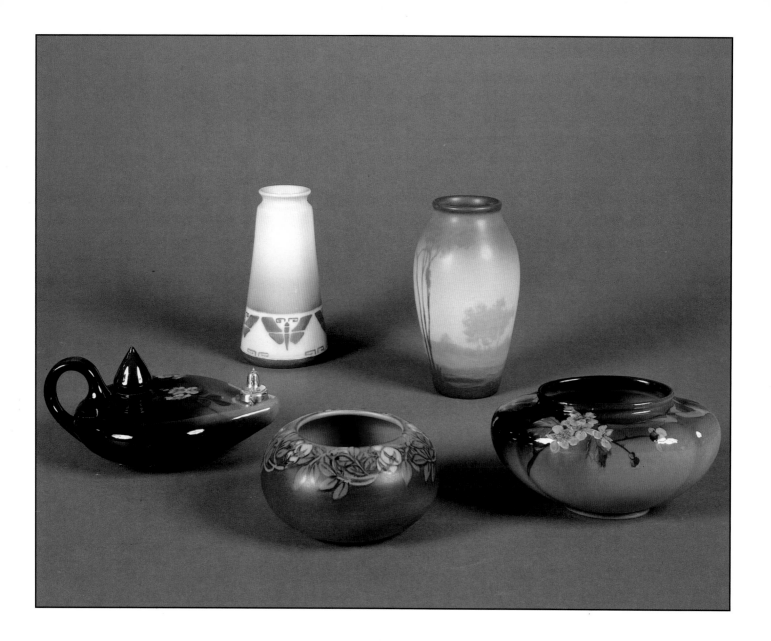

168 Standard glaze cigar lamp decorated with wild roses by Sallie Coyne in 1897. Marks on the base include the $500-700
Rookwood logo, the date, shape number 841, a small diamond esoteric mark, and the artist's initials. Height 3¼
inches.

169 Iris glaze vase with stylized butterfly decoration, done by Elizabeth Lincoln in 1911. Marks on the base include $600-800
the Rookwood logo, the date, shape number 1655 F, a small wheel ground X, the artist's initials and W for white
glaze. Height 6¼ inches.

170 Vellum glaze bowl with floral decoration done by Carrie Steinle in 1918. Marks on the base include the $300-500
Rookwood logo, the date, shape number 214 D, the artist's initials and most of a Rookwood showroom paper
label. Height 2½ inches, diameter 4¾ inches.

171 Vellum glaze scenic vase done by Alice Caven in 1917. Marks on the base include the Rookwood logo, the date, $900-1200
shape number 913 E, V for Vellum glaze body and the artist's initials. Height 6 ⅝ inches.

172 Standard glaze bowl with fruit blossom decoration, done by Carrie Steinle in 1895. Marks on the base include the $300-500
Rookwood logo, the date, shape number 708 B and the artist's initials. Height 3¼ inches.

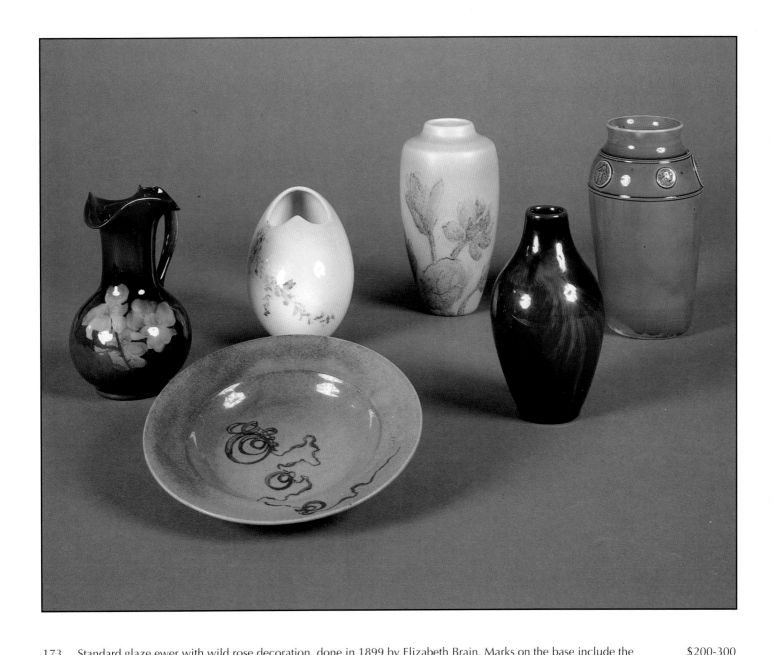

173 Standard glaze ewer with wild rose decoration, done in 1899 by Elizabeth Brain. Marks on the base include the $200-300
Rookwood logo, the date, shape number 40 and the artist's initials. Height 5½ inches. Minute flake at rim.

174 Standard glaze coupe dish with oriental ribbon decoration done by William McDonald in 1885. Marks on the $200-300
base include Rookwood in block letters, the date, shape number 201, S for sage green clay and the artist's initials.
Diameter 6⅞ inches.

175 Cameo glaze egg shaped vase having two small feet, decorated with chrysanthemums by Amelia Sprague in $500-700
1888. Marks on the surface include the Rookwood logo, the date, the artist's initials and W for white glaze.
Height 4⅜ inches.

176 Mat glaze vase with floral decoration, done by Elizabeth Barrett in 1923. Marks on the base include the $300-400
Rookwood logo, the date, shape number 1926 and the artist's monogram. Height 6¼ inches.

177 Small but nice Standard glaze vase, decorated by M.A. Daly circa 1890 with a single flying quetzal bird. The vase $1000-1500
is covered with a rich, dark glaze that evidences much goldstone effect. Marks on the base include the Rookwood
logo and date which are partially obscured by the glaze, shape number 741 C and the artist's initials. Height 5½
inches.

178 Unusual high glaze vase decorated with cast copies of ancient Roman coins, made at Rookwood in 1884. Marks $200-300
on the base include Rookwood in block letters, the date and shape number 80 B. Height 6¾ inches.

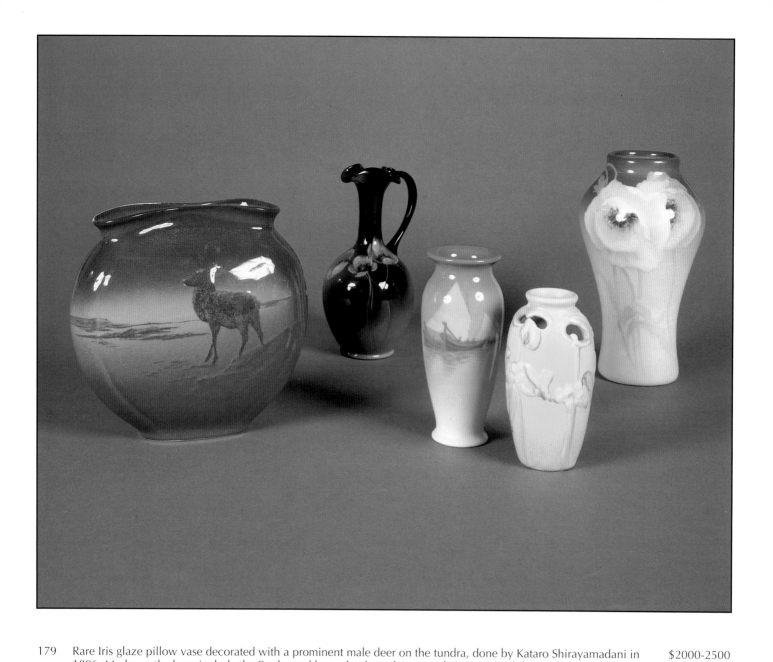

179 Rare Iris glaze pillow vase decorated with a prominent male deer on the tundra, done by Kataro Shirayamadani in 1896. Marks on the base include the Rookwood logo, the date, shape number 707 A and the artist's cypher. Height 7½ inches. Underglaze color loss at rim. $2000-2500

180 Standard glaze ewer with poppy decoration, painted in 1899 by Edith Felten. Marks on the base include the Rookwood logo, the date, shape number 738 C and the artist's initials. Height 7½ inches. $500-700

181 Good high glaze scenic vase decorated by Carl Schmidt in 1924 with a view of boat in the harbor at Venice. Marks on the base include the Rookwood logo, the date, shape number 2721 and the artist's monogram. Height 6¼ inches. $2000-3000

182 Rare carved and reticulated mat glaze vase with mistletoe decoration, done by John Dee Wareham in 1902. Marks on the base include the Rookwood logo, the date, shape number 922 and the artist's initials. Height 5⅛ inches $500-700

183 Iris glaze vase decorated with poppies by Laura Lindeman in 1904. Marks on the base include the Rookwood logo, the date, shape number 909 C, the artist's initials and W for white glaze. Height 8½ inches. $1500-2500

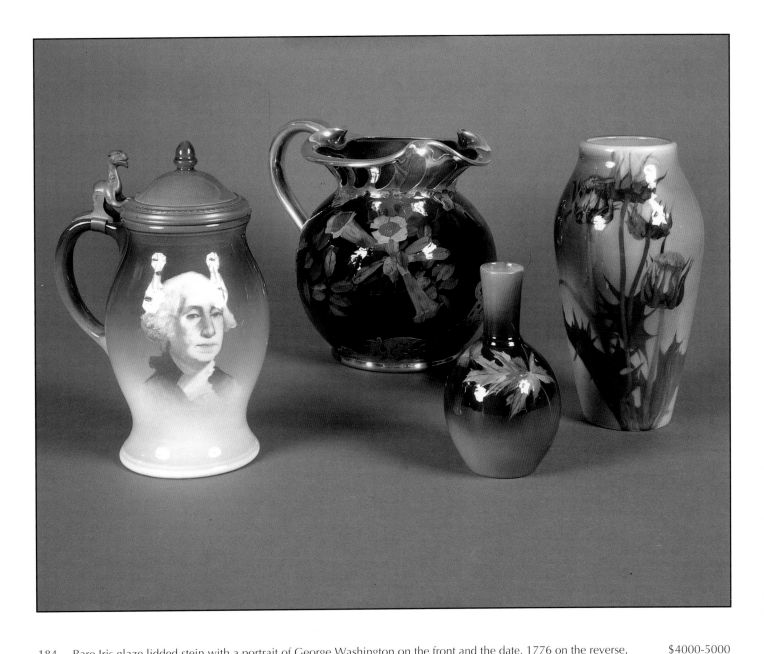

184 Rare Iris glaze lidded stein with a portrait of George Washington on the front and the date, 1776 on the reverse, done by William McDonald in 1896. Marks on the base include the Rookwood logo, the date, shape number S 1236, W for white glaze and the artist's initials. The pewter mount securing the lid to the base has an interesting griffin figure for a thumb piece. Height 9¼ inches. Some glaze separation under the handle and a ¼ inch burst glaze bubble in the same area. $4000-5000

185 Good Standard glaze pitcher with silver overlay, decorated with trumpet creepers by an unknown artist in 1892. Marks on the silver include R 294. Marks on the base include the Rookwood logo, the date, shape number 255 and W for white clay. Height 9 inches. Several areas of broken or missing silver. Small glaze flaw on surface. $2500-3000

186 Standard glaze vase with autumn leaf decoration, done by Carrie Steinle in 1894. Marks on the base include the Rookwood logo, the date, shape number 352, the artist's initials and remnants of a Rookwood sales label, a sales label of a retail store in New York and an unidentified label. Height 6 inches. $300-500

187 Good Sea Green glaze vase decorated with showy thistles by Sallie Toohey in 1901. Marks on the base include the Rookwood logo, the date, shape number 925 C, G for Sea Green glaze and the artist's initials. Height 9⅛ inches. Two lines descend from the rim, one about one inch long, the other about 1½ inches long. $800-1200

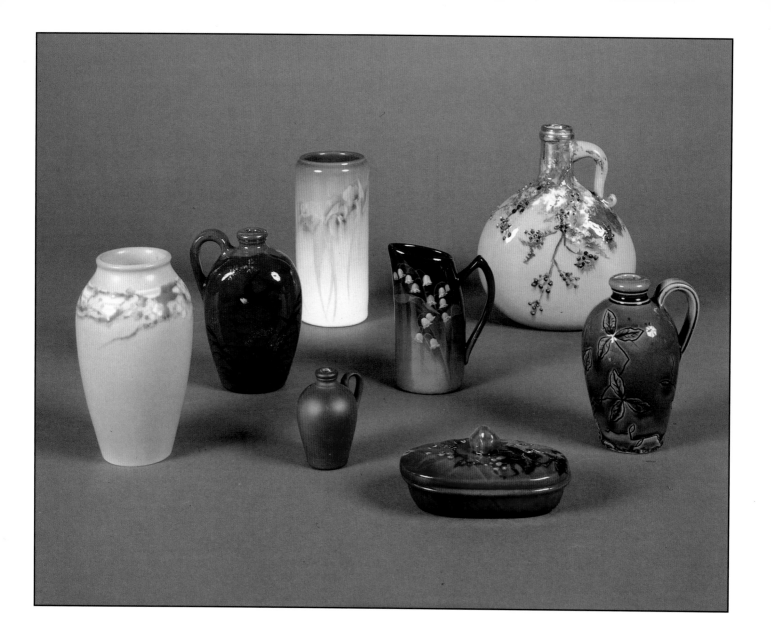

188 Vellum glaze vase decorated with a band of cherry blossoms by E.T. Hurley in 1923. Marks on the base include $300-400
 the Rookwood logo, the date, shape number 913 F, a wheel ground X, the artist's initials and V for Vellum glaze.
 Height 5⅜ inches. Slight bulge on side but uncrazed.

189 Limoges style glaze perfume jug with decoration of oriental grasses and two small birds, done by an unknown $300-500
 artist in 1883. Marks on the base include Rookwood in block letters, the date, shape number 60, R for red clay
 and a small impressed kiln. Height 4½ inches.

190 The smallest piece in the collection. A bisque finish jug with tiny handle, made at Rookwood in 1884. Marks on $100-150
 the base include Rookwood in block letters, the date, shape number 12 F and R for Red clay. Height 2⅛ inches.

191 Iris glaze cylinder shaped vase decorated with pansies by Irene Bishop in 1906. Marks on the base include the $800-1000
 Rookwood logo, the date, shape number 952 F, the artist's initials and W for white glaze. Height 5¾ inches.

192 Standard glaze lidded match safe with some goldstone effect, decorated with leaves and berries on the lid by $300-400
 Amelia Sprague in 1888. Marks on the base include the Rookwood logo, the date, shape number 430, R for red
 clay, the artist's initials and D for dark Standard glaze. Height 1¾ inches.

193 Standard glaze pitcher decorated by Carl Schmidt with lillies of the valley in 1899. Marks on the base include the $300-500
 Rookwood logo, the date, shape number 647 and the artist's monogram. Height 4¼ inches.

194 Limoge style glaze cruet decorated by Laura Fry in 1882. Marks on the base include Rookwood in block letters, $400-700
 the date, the artist's initials and the inscription, "Cin Pottery Club". Height 6¾ inches.

195 High glaze perfume jar decorated by an unknown artist in 1883 with carved and incised leaves and vines. Marks $250-450
 on the base include Rookwood in block letters, the date, shape number 61, W for white clay and a small
 impressed kiln mark. Height 4½ inches.

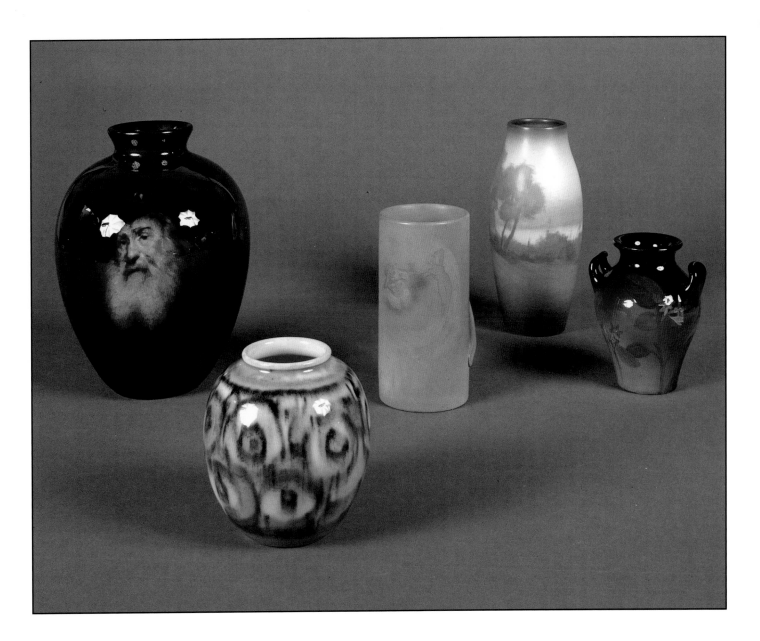

196 Standard glaze portrait vase, decorated by Grace Young with the face of an old man in 1903. Marks on the base include the Rookwood logo, the date, shape number 902 C, the artist's monogram and the notation, "After Rembrandt". Height 8½ inches. $2500-3500

197 High glaze vase with abstract floral decoration done by Elizabeth Barrett in 1945. Marks on the base include the Rookwood logo, the date, shape number 6183 F, the number 3095 and the artist's monogram. Height 4½ inches. $300-500

198 Mat glaze mug with spiral handle painted with a man who appears to be dreaming about a nymph. The decoration was done by Artus Van Briggle in 1897. Marks on the base include the Rookwood logo, the date, shape number 328, the artist's initials and L which normally would indicate a request for light Standard glaze. Height 6 inches. A repaired crack descends from the rim. $500-700

199 Vellum glaze vase decorated with a woodland scene by Sallie Coyne in 1921. Marks on the base include the Rookwood logo, the date, shape number 939 D, V for Vellum glaze body and the artist's initials. Height 7¼ inches. $900-1200

200 Standard glaze vase with two small loop handles, decorated with flowers and leaves by Eliza Lawrence in 1901. Marks on base include the Rookwood logo, the date, shape number 533 F, and the artist's initials. Height 4⅞ inches. $250-350

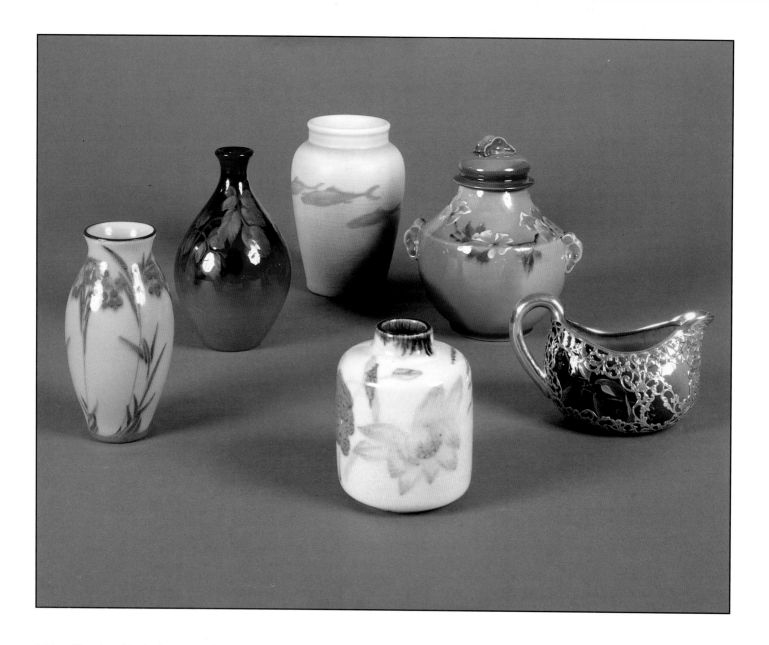

201 Blue tinted high glaze vase decorated by Lorinda Epply in 1920 with leaves and berries in a repeating pattern. Marks on the base include the Rookwood logo, the date, shape number 356 F, the number 5484 and the artist's initials. Height 5½ inches. $200-400

202 Standard glaze vase with grapes and grape leaves, decorated by Leona Van Briggle in 1903. Marks on base include the Rookwood logo, the date, shape number 861, and the artist's initials. Height 6¼ inches. Small flake on base. $200-300

203 Vellum glaze vase with four swimming fish, decorated by Edith Noonan in 1908. Marks on the base include the Rookwood logo, the date, shape number 1123, V for Vellum glaze body, the artist's initials and V for Vellum glaze. Height 6⅛ inches. $700-900

204 High glaze vase with floral decoration done by William Hentschel in 1923. Marks on the base include the Rookwood logo, the date, shape number 2717 and the artist's initials. Height 4¼ inches. $300-500

205 Standard glaze covered jar decorated with wild roses by Amelia Sprague in 1889. Marks on the base include the Rookwood logo, the date, shape number 400, G for ginger clay, the artist's initials and L for light Standard glaze. Height 6½ inches. Minor flake on one handle and tiny chip on lid. $300-500

206 Standard glaze creamer decorated with leaves and berries and covered with extensive silver overlay. The piece was decorated by Bertha Cranch in 1894 and carries on the silver the dates 1870 and 1895 and conjoined initials. Also on the silver the words, Patn'd Jan 5 '86 Solid Silver. Marks on the base include the Rookwood logo, the date, shape number 82, W for white clay, the artist's initials and L for light Standard glaze. Height 3½ inches. Many cracks run through the pottery portion of this creamer. $500-700

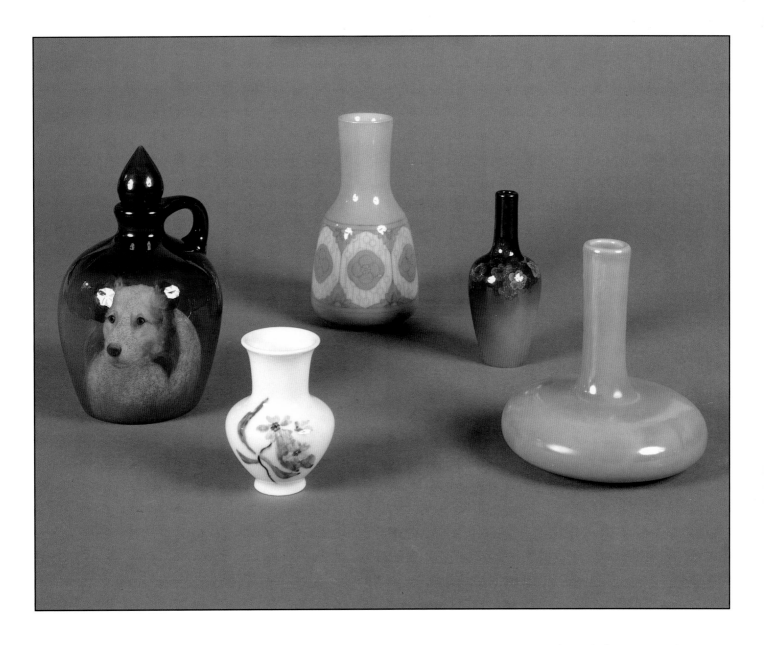

207 Standard glaze stoppered whiskey jug decorated with a watchful dog by E.T. Hurley in 1902. Marks on the base $800-1200
include the Rookwood logo, the date, shape number 512 and the artist's initials. Height 7½ inches. Some
scratches and some discoloration in the glaze.

208 Small high glaze vase with floral decoration, done by Loretta Holtkamp in 1952. Marks on the base include the $200-300
Rookwood logo, the date, shape number 6621 and the artist's initials. Height 3¾ inches.

209 High glaze bottle shaped vase decorated with a repeating band of stylized flowers by Sara Sax in 1919. Marks on $500-700
the base include the Rookwood logo, the date, shape number 2042 E, P for porcelain body and the artist's
monogram. Height 7 inches.

210 Standard glaze vase with fruit blossoms, done by Sara Sax in 1898. Marks on the base include the Rookwood $300-500
logo, the date, shape number 765 E and the artist's initials. Height 5¼ inches.

211 Unusual Nacreous glaze porcelain bodied vase made by Rookwood in 1915. Marks on the base include the $250-350
Rookwood logo, the date, shape number 763 C and P for porcelain body. Height 5⅝ inches.

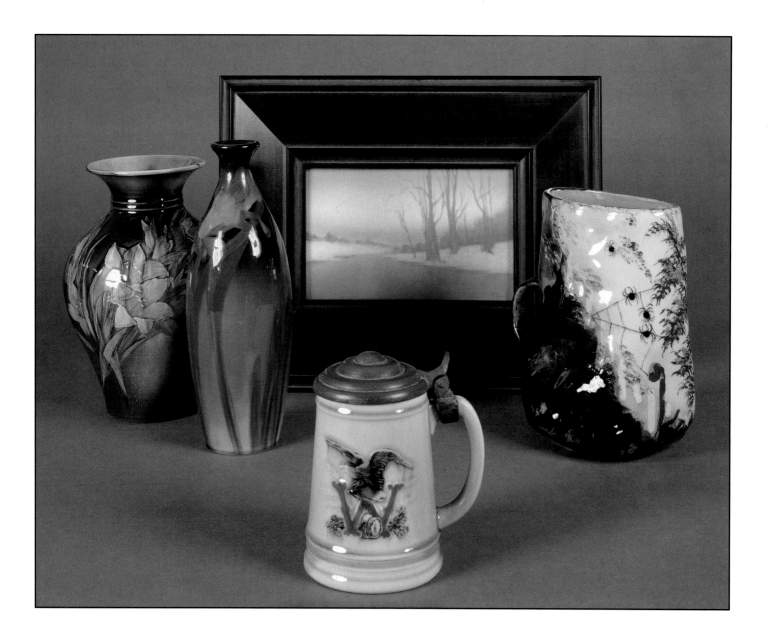

212 Standard glaze vase painted by Tom Lunt in 1891, depicting gladiolas. Marks on the base include the Rookwood logo, the date, shape number 583 D, W for white clay and the artist's cypher. Height 9 inches. $500-700

213 Sea Green glaze vase decorated with daffodils by Sallie Coyne in 1901. Marks on the base include the Rookwood logo, the date, shape number 796 B, the artist's initials and G for Sea Green Glaze. Height 9¼ inches. $1250-1750

214 High glaze mug with pewter lid and embossed company logo on side in color. Made in 1948 for the George Wiedemann Brewing Company of Newport, Kentucky. Marks on base include the Rookwood logo, "THE GEO. WEIDEMANN BREWING CO. INC." and the date. Height, 5½ inches. $250-350

215 Vellum glaze scenic plaque painted by Elizabeth McDermott in 1918. The artist's name appears in the lower right hand corner. Marks on the back include the Rookwood logo and date. On the frame is an original paper label with the title, "Pond at Sunset E. McDermott". Size 5⅛ x 8¼ inches. $1250-1750

216 Limoges style glaze French crushed pitcher, probably decorated by Maria Longworth Nichols in 1883 with spiders and various vegitation. Marks on the base inclued Rookwood in block letters, the date, G for ginger clay and a small kiln mark. Height 7⅞ inches. The reason for an attribution to Mrs. Nichols is a remark in the Rookwood Shape Record for number 115 (apparently the shape for this piece) which states: "All ware to date (Nov. 19, 1883) dec. by MLN." The style is certainly in keeping with Mrs. Nichols taste. $2000-3000

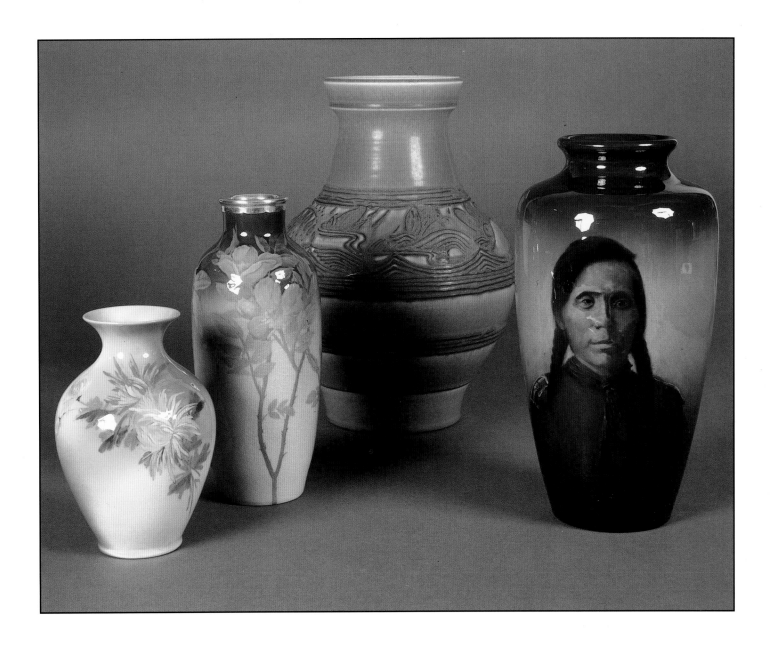

217 Cameo glaze vase decorated with chrysanthemums by Harriet Wilcox circa 1888. Marks on the base include the partially obscured Rookwood logo, shape number 565, S for sage green clay, the artist's initials and W for white glaze. Height 7⅜ inches. $700-900

218 Unusual Iris glaze vase decorated with pink wild roses by Olga Geneva Reed in 1903. The vase is chased with a silver fluted rim which carries the initials, E.H.A., thought to be E.H. Asano a metal worker in Mrs. Storer's employ. Marks on the base include the Rookwood logo, the date, shape number S 1732 D, a wheel ground X, the artist's initials and W for white glaze. Height 10½ inches. $4000-6000

219 Large mat glaze vase with squeezebag decoration of Art Deco flowers and patterns, done by William Hentschel in 1927. Marks on the base include the Rookwood logo, the date, shape number 2991, the artist's initials and remnants of two paper sales labels. Height 14 inches. Drilled in a crude manner. $1200-1500

220 Standard glaze vase decorated with the portrait of a Native American by Matt Daly in 1899. Marks on the base include the Rookwood logo, the date, shape number 614 C, the inscription "ENERS MICHEL FLATHEAD" and the artist's initials. Drilled. Height 12½ inches. $3000-4000

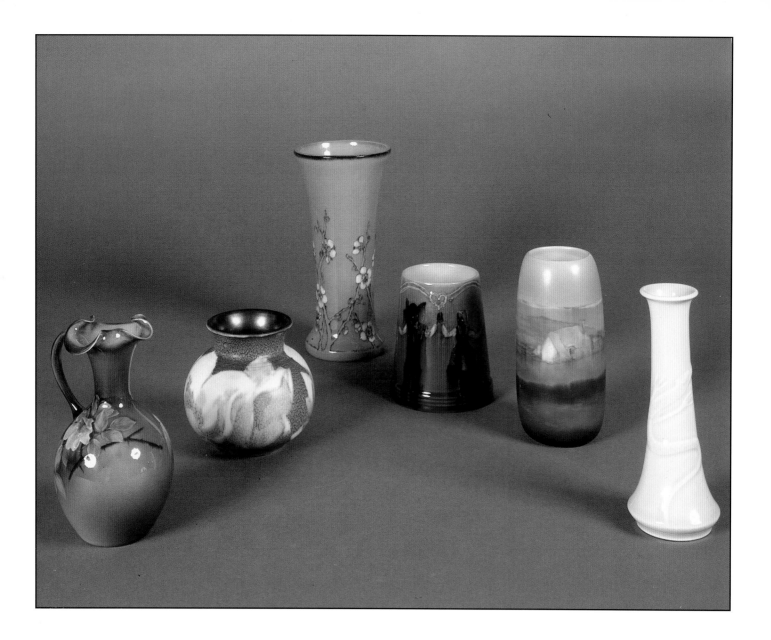

221 Standard glaze ewer decorated by Harriet Wilcox in 1894 with wild roses. Marks on the base include the $300-500
Rookwood logo, the date, shape number 685, W for white clay and the artist's initials. Height 6½ inches.

222 Mat glaze vase decorated with magnolias by Jens Jensen in 1934. Marks on the base include the Rookwood logo, $500-700
the date, S for special shape and the artist's monogram. Height 4½ inches.

223 High glaze vase with cherry blossom decoration on a gray body, done by Sara Sax circa 1921. Marks on the base $500-700
include the Rookwood logo, number 7914 which refers to the gray clay and the artist's monogram. The shape
number has been partially obscured by a drill hole. Height 8⅞ inches.

224 High glaze mug with two dancing figures, decorated by Jane Sacksteder in 1946. Marks on the base include the $200-400
Rookwood logo, the date, shape number 587, the number 530 A and the artist's initials. Height 4⅞ inches.

225 Vellum glaze scenic vase decorated with a small house on a lake by Kate Curry in 1917. Marks on the base $800-1000
include the Rookwood logo, the date, shape number 2102, the artist's initials and V for vellum. Height 6½ inches.
Uncrazed

226 High glaze bud vase with a dragon in high relief cast in 1958. Marks on the base include the Rookwood logo, the $100-150
date, S 2206 for special shape and the Rookwood 75th Anniversary diamond mark. Height 7⅛ inches.

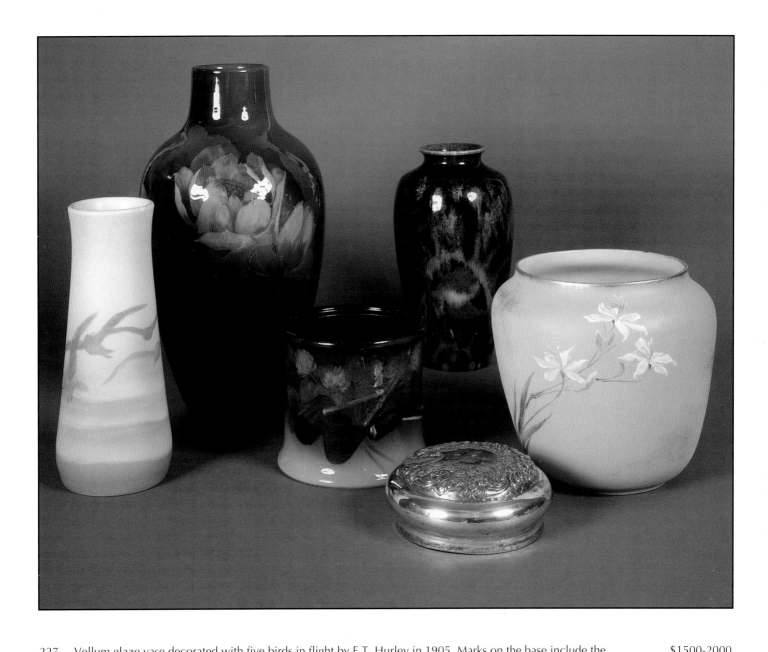

227　Vellum glaze vase decorated with five birds in flight by E.T. Hurley in 1905. Marks on the base include the Rookwood logo, the date, shape number 950 C, V for Vellum glaze body and the artist's full name in script. Height 10½ inches.　$1500-2000

228　Large and impressive treatment of lotus flowers and leaves, done by M.A. Daly in 1902. Marks on the base include the Rookwood logo, the date, shape number 905 B, the artist's full signature and Y for yellow (Standard) glaze. Height 15 inches.　$3000-4000

229　Standard glaze humidor with a silver lid, decorated with two pipes, cigar, matches, and clover by Ed Diers in 1900. The lid which is not original is decorated with a raised floral design with the inscription "My Segars" and signed inside "Victor Silver Company, Quadruple Plate". Marks on the base include the Rookwood logo, the date, shape number 801 B and the artist's initials. Height 7½ inches. Two inch line descends from rim.　$300-500

230　High glaze vase with abstract highly colored designs, done by E.T. Hurley in 1933. Marks on the base include the Rookwood logo, the date, shape number 614 D and the artist's initials. Height 10½ inches.　$1000-1500

231　Bisque finish jardiniere decorated with white lilies. Marks on the base include the Rookwood logo, the date, shape number 180 C and Y for yellow clay. No artist initials appear on the piece. Height 7⅞ inches.　$500-700

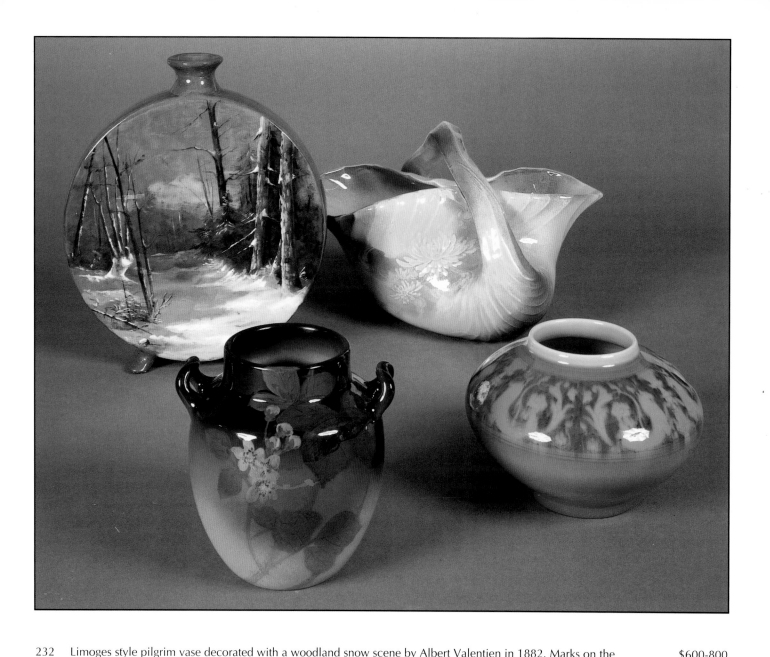

232 Limoges style pilgrim vase decorated with a woodland snow scene by Albert Valentien in 1882. Marks on the base include Rookwood in block letters, the date, shape number 49, R for red clay, an impressed anchor mark and the artist's initials. Height 10¾ inches. Repair to two of the feet. $600-800

233 Standard glaze vase with two loop handles, decorated with black berry leaves, flowers and stalks by Carrie Steinle in 1902. Marks on the base include the Rookwood logo, the date, shape number 459 D and the artist's initials. Height 5¼ inches. $400-600

234 Standard glaze flower basket with oriental decoration of chrysanthemums, done by an unknown artist in 1887. Marks on the base include the Rookwood logo, the date, shape number 360 and W 7 for a particular type of white clay. Height 7¾ inches, length 11¾ inches. $600-800

235 High glaze bowl decorated with a repeating border of griffins and large planters by Arthur Conant in 1922. Marks on the base include the Rookwood logo, the date, shape number 16 and the artist's monogram. Height 4½ inches, diameter 6¾ inches. $600-800

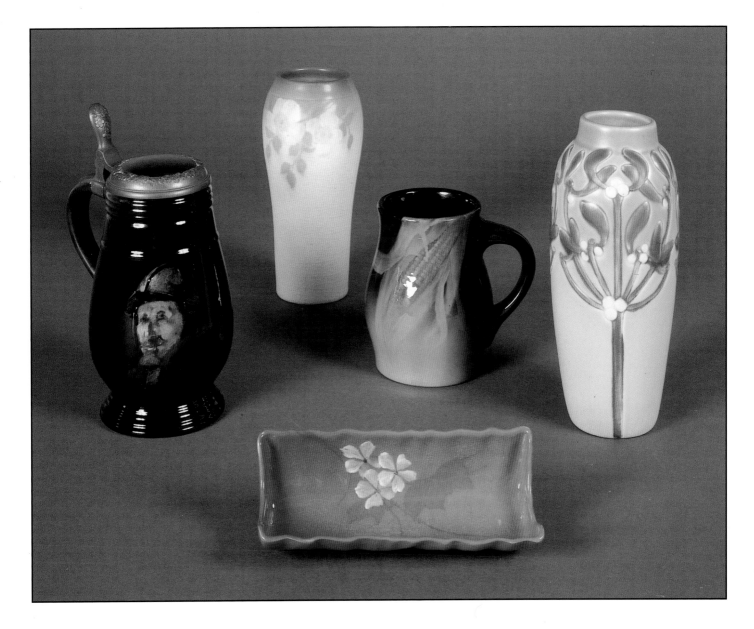

236 Standard glaze mug with pewter mounted lid, decorated with a portrait of a conquistador by Grace Young in 1895. Marks on the base include the Rookwood logo, the date, shape number 791 and the artist's monogram. Height 8⅛ inches. Repaired handle. $500-700

237 Vellum glaze vase with floral decoration by Elizabeth McDermott, done in 1913. Marks on the base include the Rookwood logo, the date, shape number 2039 E, V for Vellum glaze body, the artist's monogram and V for Vellum glaze. Height 7⅝ inches. $400-600

238 Cameo glaze pin tray with floral decoration by Amelia Sprague, done in 1889. Marks on the base include the Rookwood logo, the date, shape number 421, W for white clay, the artist's initials and W for white glaze. Height 1⅝ inches. $200-300

239 Standard glaze mug decorated with an ear of corn by Sallie Coyne in 1899. Marks on the base include the Rookwood logo, the date, shape number 837 and the artist's initials. Height 5 inches. Line at rim near handle. $200-300

240 Rare carved mat glaze vase decorated with stylized Art Nouveau treatment of mistletoe by Albert Valentien in 1900. Marks on the base include the Rookwood logo, the date, shape number 907 E and the artist's full signature. Height 8½ inches. $1200-1500

241 Rare and important standard glaze vase decorated by Kataro Shirayamadani in 1900 with swirling oriental $30000-$40000
designs and a wonderful three dimensional carved and electroplated copper dragon climbing up the side of the
piece, resting on the shoulder. Marks on the base include the Rookwood logo, the date, shape number 787 C and
the artist's cypher. Height 11½ inches.

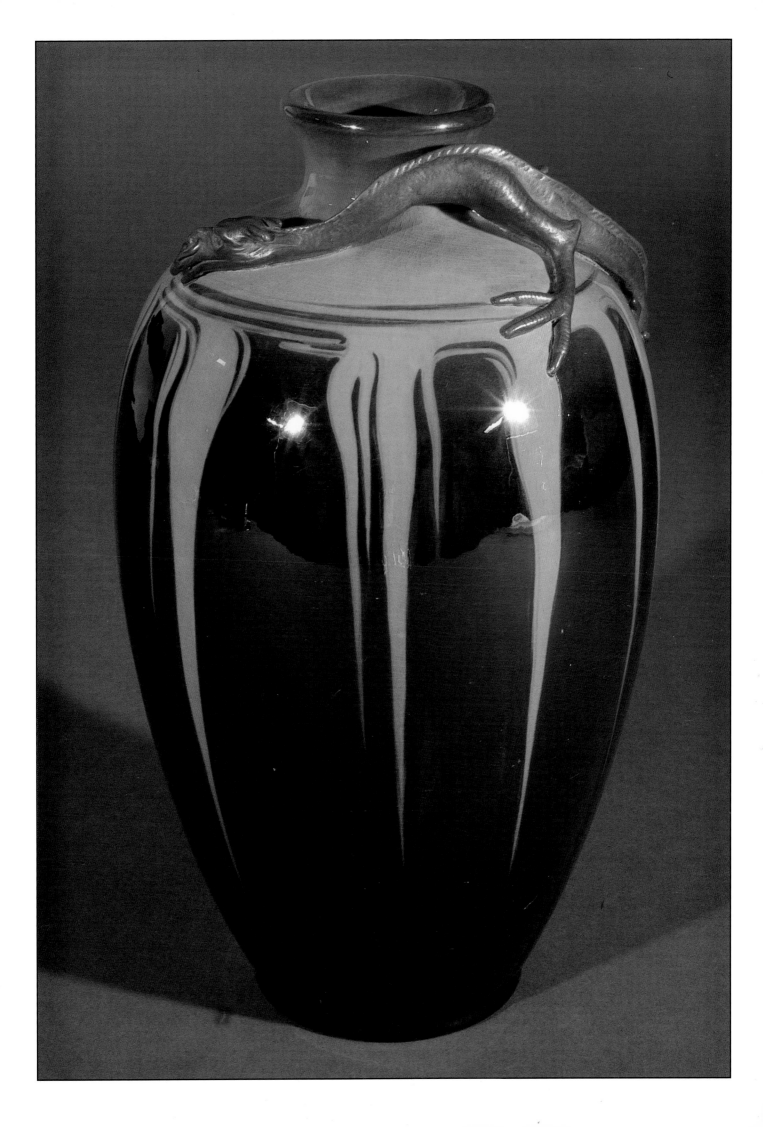

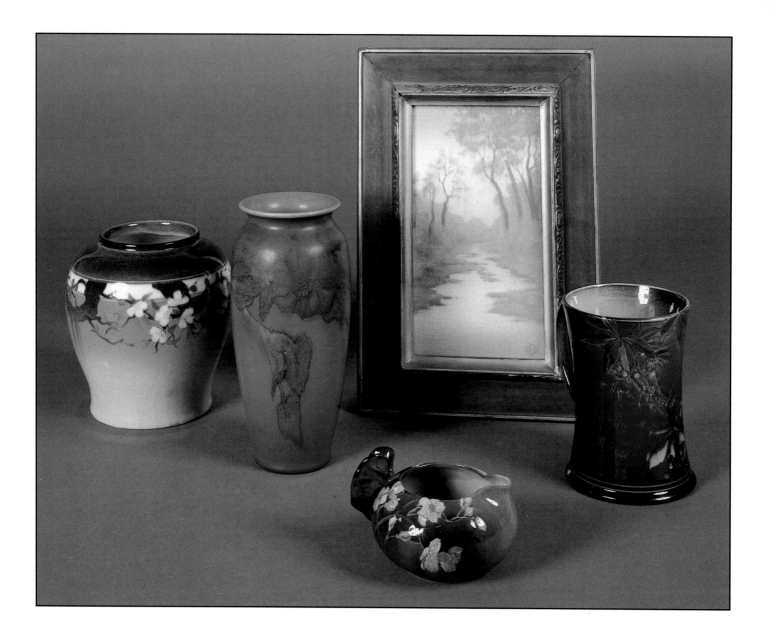

242 High glaze vase with cherry blossom decoration by Kay Ley, done in 1945. Marks on the base include the Rookwood logo, the date, shape number 6878, the number 1372 twice in pink block letters and the artist's monogram which also appears twice. Height 6¼ inches. $500-700

243 Mat glaze floral vase painted by Elizabeth Lincoln in 1924. Marks on the base include the Rookwood logo, the date, shape number 2544 and the artist's initials. Height 8¼ inches. $300-400

244 Standard glaze creamer decorated with wild roses by Josephine Zettel in 1894. Marks on the base include the Rookwood logo, the date, shape number 329 and the artist's initials. Height 2⅝ inches. $200-300

245 Vellum glaze scenic plaque decorated by Mary Grace Denzler in 1914. The artist's initials appear in the lower right hand corner. Marks on the back include the Rookwood logo, the date, V for Vellum glaze body and the title, "The Brook". Size 9¼ x 5 inches. $1250-1750

246 Standard glaze mug decorated with Virginia creepers by Artus Van Briggle in 1890. The mug is inscribed on the side, "E.W. Robbins Mch 17 1890". Marks on the base include the Rookwood logo, the date, two impressed W's for white clay, the artist's initials and L for light Standard glaze. Height 5½ inches. $400-600

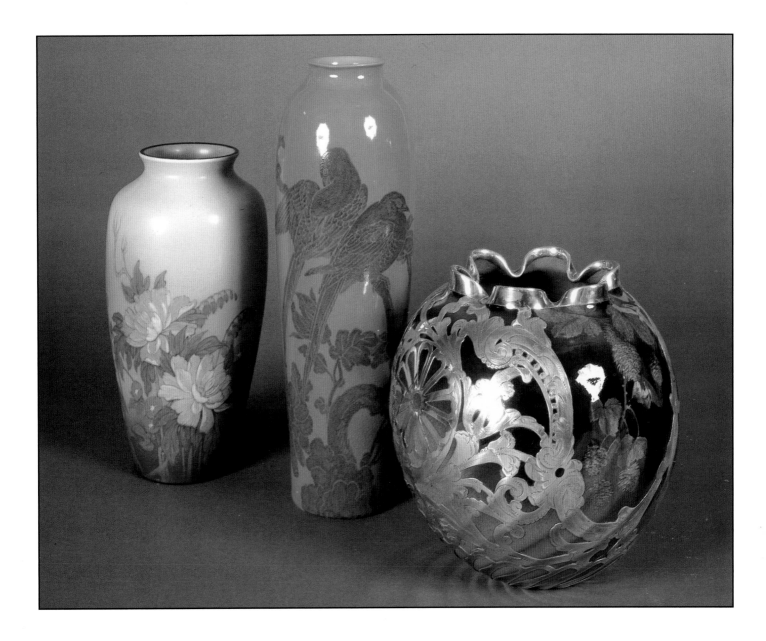

247 Nice Vellum glaze vase with morning glories, blue bells and chrysanthemums done by Lenore Asbury in 1922. $1500-2000
Marks on the base include the Rookwood logo, the date, shape number 614 D, a small V shaped esoteric mark
and the artist's initials. Height 10⅞ inches.

248 High glaze vase decorated with two birds on a branch by Arthur Conant in 1920. Marks on the base include the $2500-3500
Rookwood logo, the date, shape number 2499 C and the artist's monogram. Height 14¼ inches.

249 Large Standard glaze vase with applied silver overlay, decorated with hops by M.A. Daly in 1892. Marks on the $4000-5000
base include the Rookwood logo, the date, shape number 612, W for white clay and the artist's initials. The silver
overlay is marked with the number R 542 and the name Gorham Mfg. Co. Height 8¾ inches.

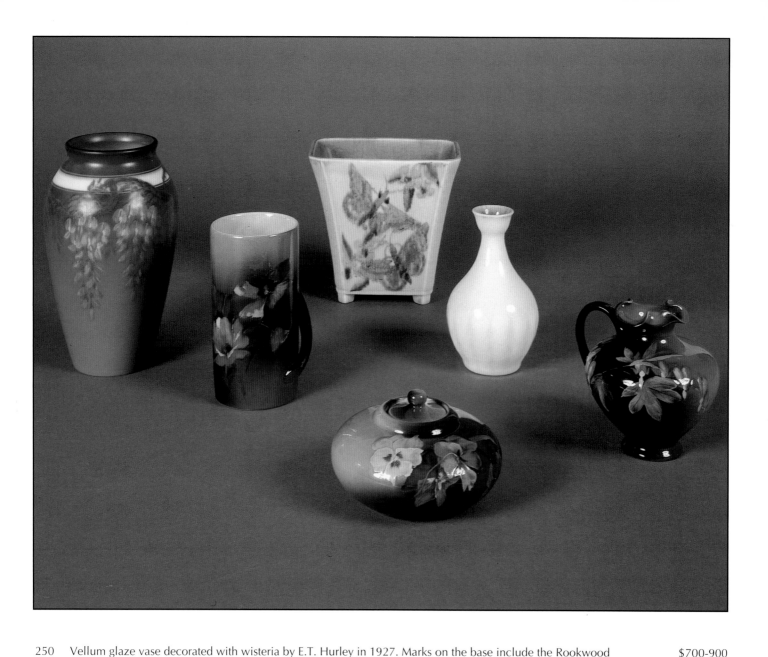

250 Vellum glaze vase decorated with wisteria by E.T. Hurley in 1927. Marks on the base include the Rookwood logo, the date, the artist's initials and V for Vellum glaze. The shape number is obscured by a drill hole in the base. Height 8 inches. Uncrazed with some minor glaze bubbles. — $700-900

251 Standard glaze mug decorated with poppies by Sallie Toohey in 1891. Marks on the base include the Rookwood logo, the date, shape number 328 C, W for white clay, the artist's initials and L for light Standard glaze. Height 5⅞ inches. — $300-500

252 Standard glaze inkwell decorated with pansies by Constance Baker in 1893. The ink cup and original lid are also present with the well. Marks on the base include the Rookwood logo, the date, shape number 418, W for white clay and the artist's initials. Height 3 inches. — $300-500

253 Mat glaze footed vase decorated with butterflies by Louise Abel in 1931. Marks on the base include the Rookwood logo, the date, shape number 6036 and the artist's monogram. Height 6 inches. — $400-600

254 High glaze vase decorated by William Hentschel in 1931 with an art deco design. Marks on the base include the Rookwood logo, the date, shape number 6276 F, a small fan shaped esoteric mark and the artist's initials. Height 5½ inches. — $200-300

255 Standard glaze ewer decorated with bleeding hearts by Bertha Cranch in 1894. Marks on the base include the Rookwood logo, the date, shape number 498 D, W for white clay, the artist's initials and L for light Standard glaze. Height 4½ inches. — $300-500

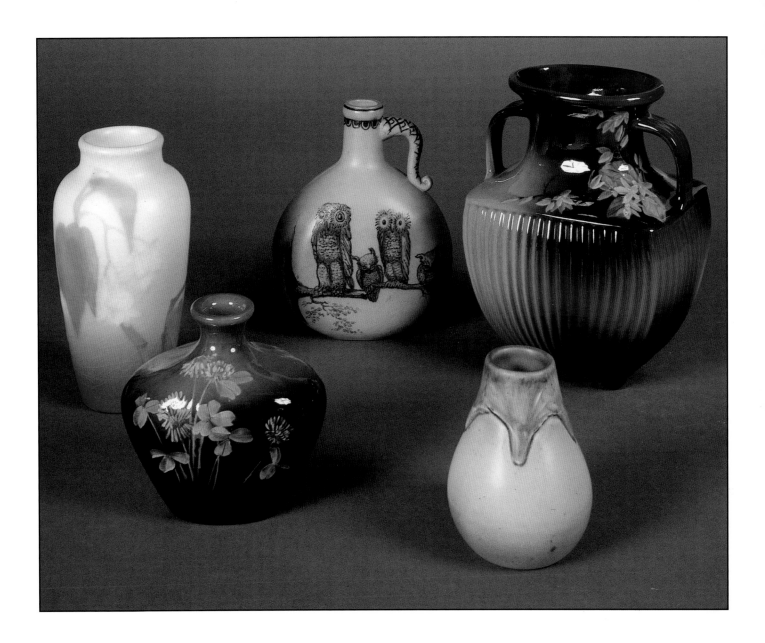

256 Vellum glaze vase with floral decoration done by Elizabeth Lincoln in 1910. Marks on the base include the $400-600
 Rookwood logo, the date, shape number 943 E, V for Vellum glaze body, the artist's initials and V for Vellum
 glaze. Height 6¾ inches.

257 Standard glaze vase decorated with clover by Daniel Cook in 1894. Marks on the base include the Rookwood $300-400
 logo, the date, shape number 706, W for white clay and the artist's initials. Height 4⅝ inches.

258 Rare and interesting pilgrim flask decorated in a bisque finish by E.P. Cranch, showing four perched owls on one $1000-1500
 side and three vultures on the opposite side. Marks on the base include Rookwood in block letters, the date,
 shape number 85, G for ginger clay and artist's last name impressed in block letters. Height 6½ inches.

259 Mat glaze vase decorated with a high relief border at the top by an unknown artist in 1904. Marks on the base $200-300
 include the Rookwood logo, the date, shape number 969 E, a wheel ground X and the artist's initials. Height 4⅛
 inches.

260 Standard glaze square ribbed vase with two ribbon handles, decorated with small yellow flowers by Sadie $500-700
 Markland in 1894. Marks on the base include the Rookwood logo, the date, shape number 195, W for white clay,
 the number 142, the artist's initials and L for light Standard glaze. Height 8 inches.

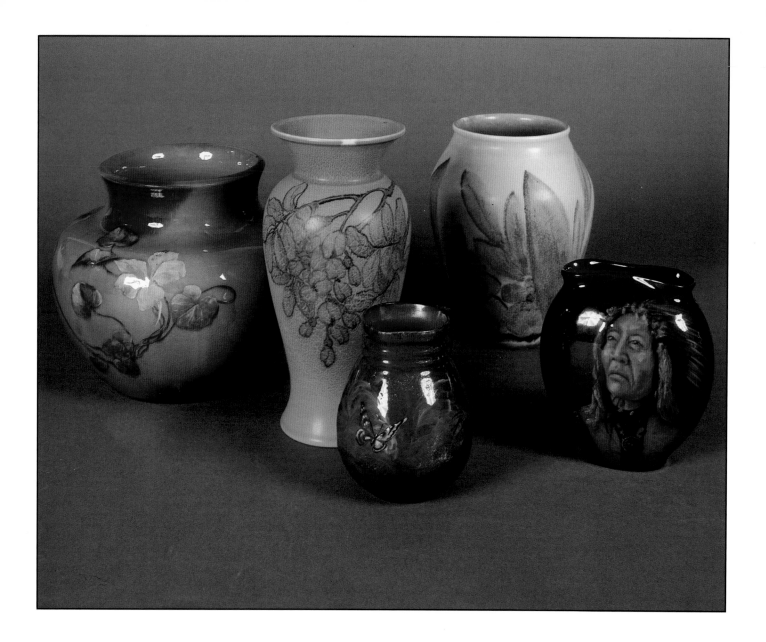

261 Standard glaze vase decorated with nasturtium leaves and flowers by Albert Valentien in 1887. Marks on the base include the Rookwood logo, the date, shape number 286, G for ginger clay, L for light standard glaze, and the artist's initials. Height 7½ inches. Several burst glaze blisters. $500-700

262 Mat glaze vase with wisteria decoration, done by Margaret McDonald in 1927. Marks on the base include the Rookwood logo, the date, shape number 2745 and the artist's initials. Height 9½ inches. $600-800

263 Limoges style glaze pitcher decorated with oriental grasses and a single butterfly by M.A. Daly in 1883. Marks on the base include Rookwood in block letters, the date, shape number 54, the number 3, R for red clay and the artist's initials. Height 5 inches. $400-600

264 Mat glaze vase with floral design, done by Wilhelmine Rehm in 1929. Marks on the base include the Rookwood logo, the date, shape number 915 C and the artist's initials. Height 8 inches. $400-600

265 Standard glaze pillow vase decorated with a Native American portrait by E.T. Hurley in 1900. Marks on the base include the Rookwood logo, the date, shape number 707 B, the number 611, the artist's initials, and the inscription, "High Bear Sioux". Height 5¾ inches. $2000-3000

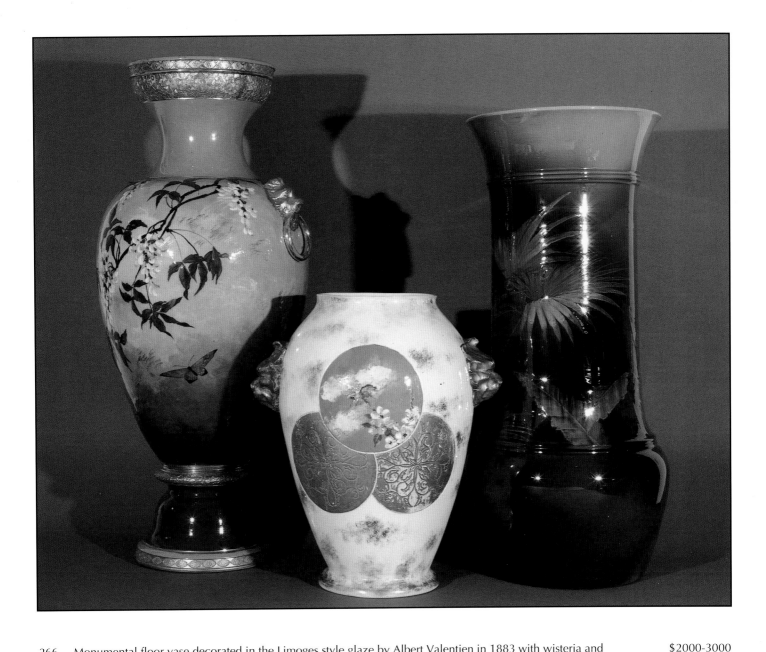

266 Monumental floor vase decorated in the Limoges style glaze by Albert Valentien in 1883 with wisteria and $2000-3000
butterflies. Marks on the base include Rookwood in block letters, the date, a small kiln mark, G for ginger clay
and W A, possibly for William Auckland the potter at Rookwood. Albert Valentien's initials and the date appear
on the side of the piece. Height 28⅝ inches. A crack extends from the rim downward for several inches. A smaller
line also appears at the rim. Several small areas of glaze problems on the base.

267 Large high glaze vase with lion head handles, decorated by an unknown artist in 1882. The piece has three $600-800
overlapping circles on each side, two done with incised lines and the third with fruit blossoms. Marks on the base
include Rookwood in block letters and the date. Height 15½ inches. Some lines at the rim and minor flaws.

268 Very large Standard glaze umbrella stand decorated with palm fronds by M.A. Daly in 1891. Marks on the base $3500-4500
include the Rookwood logo, the date, shape number 609, W for white clay, the artist's initials and a small
Rookwood showroom paper label. Height 25 inches.

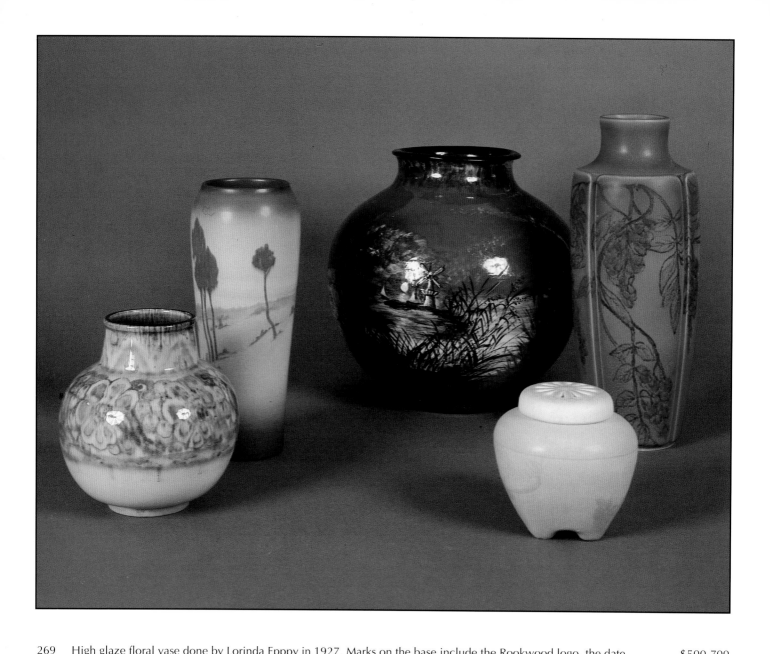

269 High glaze floral vase done by Lorinda Epppy in 1927. Marks on the base include the Rookwood logo, the date, shape number 2969 and the artist's initials. Height 7¼ inches. $500-700

270 Tall Vellum glaze vase with an attractive woodland scene, painted by Sallie Coyne in 1916. Marks on the base include the Rookwood logo, the date, shape number 2039 C, V for Vellum clay body and the artist's initials. Height 11½ inches. Cracks descend from two opposite sides of the rim. $700-900

271 Large limoges style glaze vase decorated in 1882 with a Dutch scene on one side and a large spray of daffodils on the reverse. Marks on the base include Rookwood in block letters and the date. A note by David Glover accompanying the vase indicates the piece was made especially for a family in Hyde Park by Maria Longworth Nichols. Height 12¼ inches. $1200-1500

272 Large mat glaze panelled vase decorated overall with wisteria by Lousie Abel in 1927. Marks on the base include the Rookwood logo, the date, shape number 2932 and the artist's monogram. Height 14⅛ inches. $1200-1500

273 Vellum glaze potpourri with stylized dandelion decoration, done by Sara Sax in 1907. Marks on base include the Rookwood logo, the date, shape number 1322, V for Vellum glaze body, a wheel ground X, the artist's monogram and V for Vellum glaze. Height 5¼ inches. $300-400

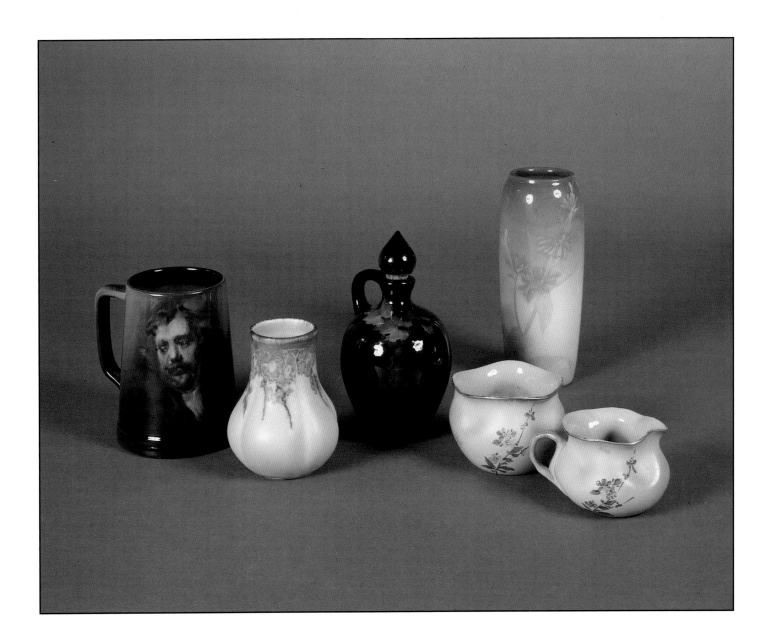

274 Standard glaze mug decorated with portrait of a gentleman by Grace Young in 1896. Marks on the base include the Rookwood logo, the date, shape number 537 B, and the artist's initials. Tight 1" hairline at side of rim. Height 5⅝ inches. $500-700

275 Mat glaze ribbed vase, decorated with fruit blossoms by Elizabeth Lincoln in 1929. Marks on the base include the Rookwood logo, the date, shape number 610 and the artist's initials. Height 4¾ inches. $275-375

276 Standard glaze stoppered whiskey jug decorated by Harriet Wilcox in 1896 with grapes. Marks on the base include the Rookwood logo, the date, shape number 767 and the artist's initials. Height 7¼ inches. $500-700

277 Bisque glaze creamer and sugar decorated with wild roses by Harriet E. Wilcox in 1887. Marks on the base include the Rookwood logo, the date, shape number 330 and 331, S for sage clay and the artist's initials. Height 3 inches for sugar and 2⅝ inches for creamer. $400-600

278 Iris glaze vase decorated with chicory by Lenore Asbury in 1905. Marks on the base include the Rookwood logo, the date, shape number 951 D, the artist's initials and W for white glaze. Height 8¼ inches. Small flake off base. $700-900

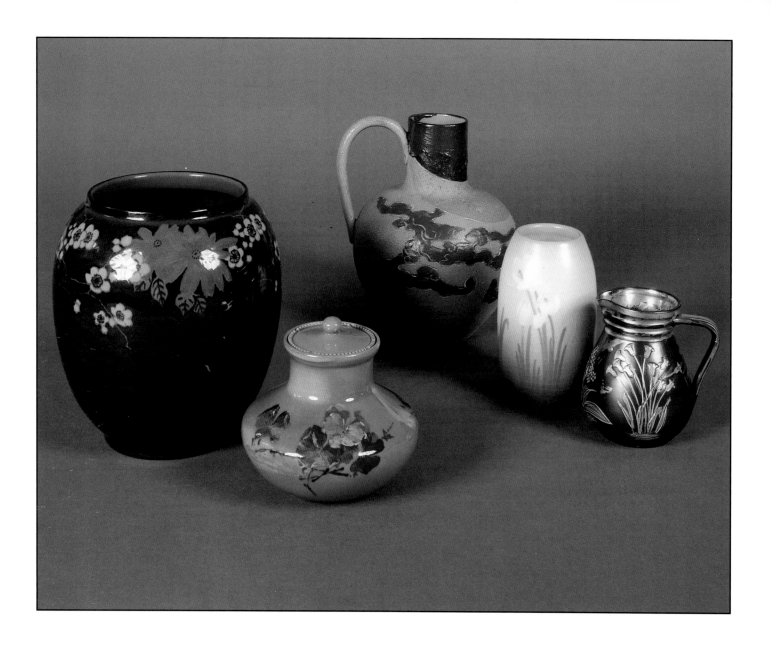

279 Blue tinted high glaze vase with floral decoration, done by Katherine Van Horne in 1917. Marks on the base include the Rookwood logo, the date, shape number 2245, P for porcelain body, a wheel ground X and the artist's initials. Height 7⅛ inches. $900-1200

280 Standard glaze lidded jar decorated with pansies in 1889 by an unknown artist. The lid is two sided and serrated on one side of the edge. Marks on the base include the Rookwood logo, the date, shape number 806 and G for ginger clay. Height 4⅜ inches. $300-400

281 Bisque finish ewer in the style of Chaplet with stylized clouds decorated by Albert Valentien in 1884. Marks on the base include Rookwood in block letters, the date and the artist's initials. Accession numbers in red also appear on the base, possibly from the Cincinnati Art Museum. Height 8¼ inches. $400-600

282 Vellum glaze vase decorated with crocuses by Margaret McDonald in 1914. Marks on the base includes the Rookwood logo, the date, shape number 2068, V for Vellum glaze body and the artist's initials. Height 6¼ inches. Glaze flake off base. $300-500

283 Glazed pitcher with incised and carved floral decoration by Fanny Auckland done in 1882. Marks on base include Rookwood in block letters, the date, and the artist's initials. Height 4⅛ inches. $600-800

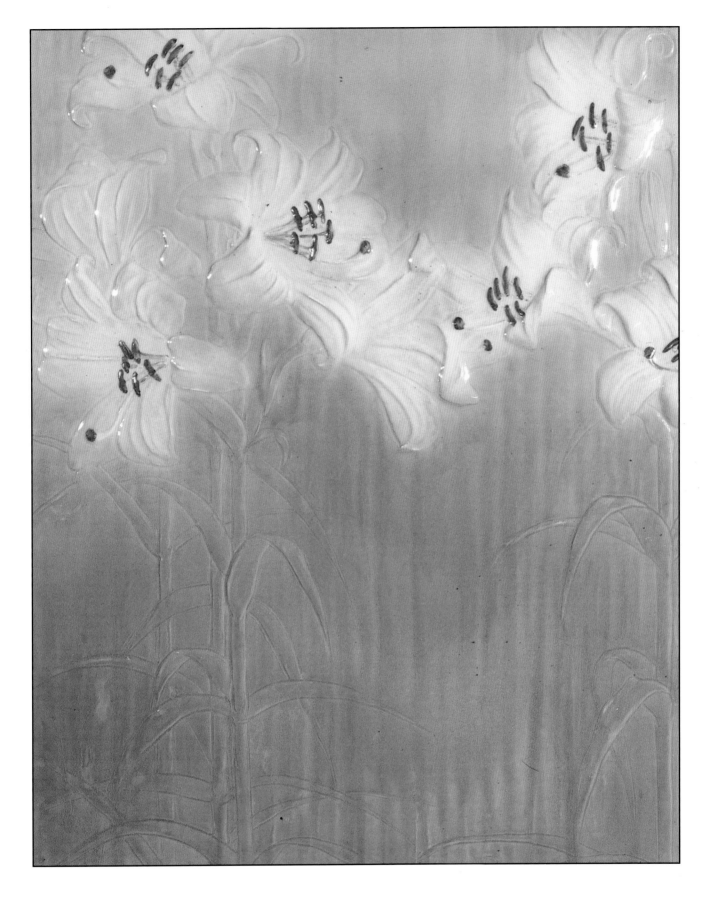

284 Extremely rare Iris glaze plaque carved and decorated with lillies by William McDonald in 1900. Marks on the $8000-12000
back include the Rookwood logo and date impressed four times and the shape number X 499 AX. The artist's
initials are incised on the edge of the plaque. Size 17½ x 14. This plaque appears to be uncrazed.

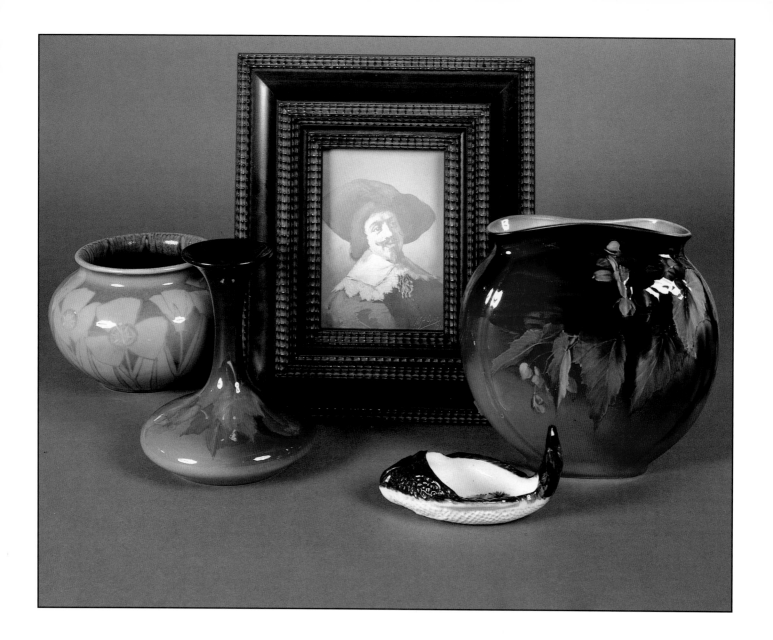

285 Nice high glaze vase decorated by Kataro Shirayamadani in 1929 with stylized blue flowers and green leaves. $1000-1500
Marks on the base include the Rookwood logo, the date, shape number 494 B and the artist's cypher. Height 4⅝ inches.

286 Standard glaze vase with maple leaf decoration, painted in 1900 by Lenore Asbury. Marks on the base include $300-400
the Rookwood logo, the date, shape number 715 D and the artist's initials. Height 6¾ inches.

287 Rare bisque finish plaque decorated with a portrait of a cavalier by M.A. Daly in 1896. The piece is signed on the $2000-3000
front, M.A. Daly '96. The reverse of the plaque carries the incised menu for the 1896 meeting of the Cincinnati
Art Club. Information on the back includes the following entries: "Cream of Celery Soup Olives Pickles Broiled
Quails (sic) Stewed Potatoes Roquefort and Camembert Cheese Coffee". Dimensions are approximately 6½ inches
by 4¾ inches. Daly was a member of the Art Club. We have not seen another of these menus, certainly decorated
and fired at Rookwood.

288 High glaze fish "entree dish" decorated in blue and white by Martin Rettig in 1884. Marks on the base include $400-600
Rookwood in block letters, the date, shape number 53, W for white clay and the artist's initials. Height 2¼ inches,
length 5½ inches.

289 Standard glaze pillow vase decorated with leaves and flowers by M.A. Daly in 1894. Marks on base include the $500-700
Rookwood logo, the date, shape number 707A, W for white clay and the artist's initials. Height 7¾ inches.

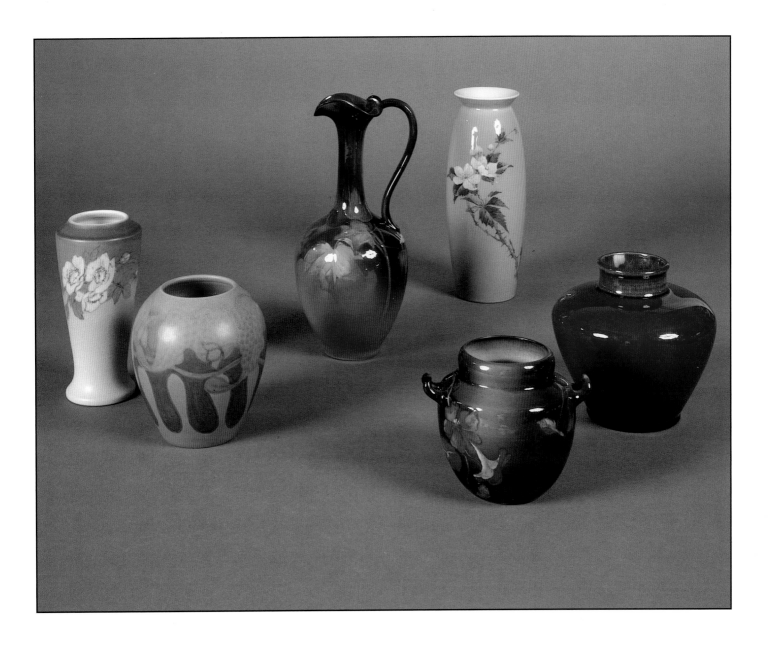

290 Vellum glaze vase with wild rose decoration, done by Ed Diers in 1922. Marks on the base include the $400-600
Rookwood logo, the date, shape number 1356 F, a small V shaped esoteric mark and the artist's initials. Height
6⅛ inches.

291 Mat glaze vase by C.S. Todd, decorated with stylized flowers in 1921. Marks on the base include the Rookwood $250-350
logo, the date, shape number 2100 and the artist's initials. Height 4⅞ inches.

292 Standard glaze ewer with maple leaf decoration, done by Caroline Steinle in 1900. Marks on base include the $400-600
Rookwood logo, the date, shape number 781 C and the artist's initials. Height 9½ inches.

293 Cameo glaze vase decorated with wild roses by Albert Valentien in 1887. Marks on the base include the $400-600
Rookwood logo, the date, shape number 271, 7 W for a particular type of white clay and the artist's initials.
Height 8½ inches. Repair to lip.

294 Standard glaze two-handled vase decorated with nasturtiums by John Wareham in 1893. Marks on the base $300-400
include the Rookwood logo, the date, shape number 459 E, W for white clay and the artist's initials. Height 4¼
inches.

295 Coromandel vase done in 1932 with much goldstone. Marks on the base include the Rookwood logo, the date $300-400
and shape number 6318 C. Height 5¼ inches.

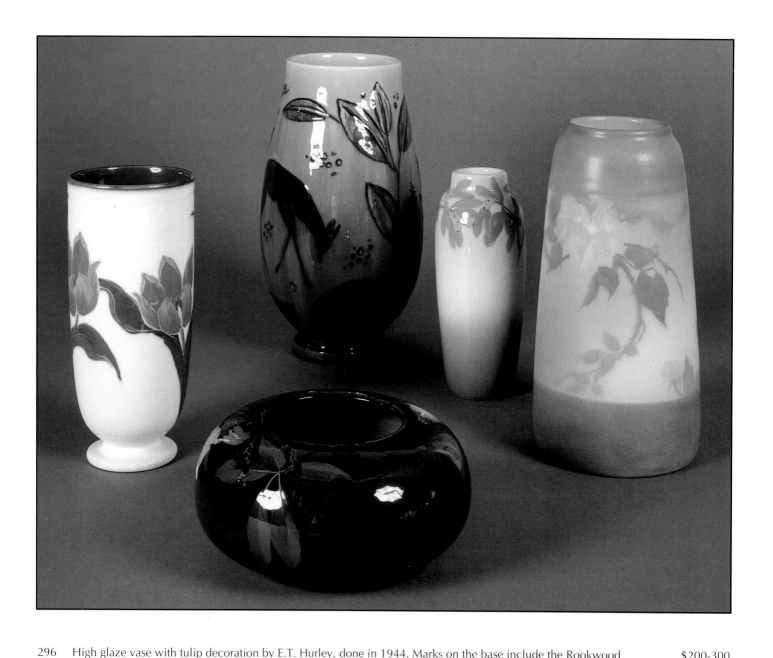

296 High glaze vase with tulip decoration by E.T. Hurley, done in 1944. Marks on the base include the Rookwood $200-300
logo, the date, shape number 2194 and the artist's initials. Height 9⅝ inches. Two lines descend form the rim.

297 Standard glaze bowl with Trumpet Creeper leaves and berries decorated by Sallie Toohey in 1897. Marks on the $300-500
base include the Rookwood logo, the date, shape 214 A, and the artist's initials. Height 4 inches. Base is also
marked with a wheel ground X.

298 Large high glaze vase with Art Deco flowers and deer decorated by Elizabeth Barrett in 1948. Marks on the base $800-1000
include the Rookwood logo, the date, shape number 6873 and the artist's monogram. Height 12¼ inches. Cast
hole in base.

299 Iris glaze vase decorated with a band of berries by Sara Sax in 1905. Marks on the base include the Rookwood $400-600
logo, the date, shape number 907 E, the artist's monogram and W for white glaze. Height 8¼ inches. Hairline
at rim.

300 Vellum glaze vase with a banded depiction of white roses, done by Fred Rothenbusch in 1909. Marks on the base $600-800
include the Rookwood logo, the date, shape number 1654 C, a V for Vellum compatible clay, the artist's initials
and V for Vellum glaze. Height 11½ inches. Two short and tight lines at rim.

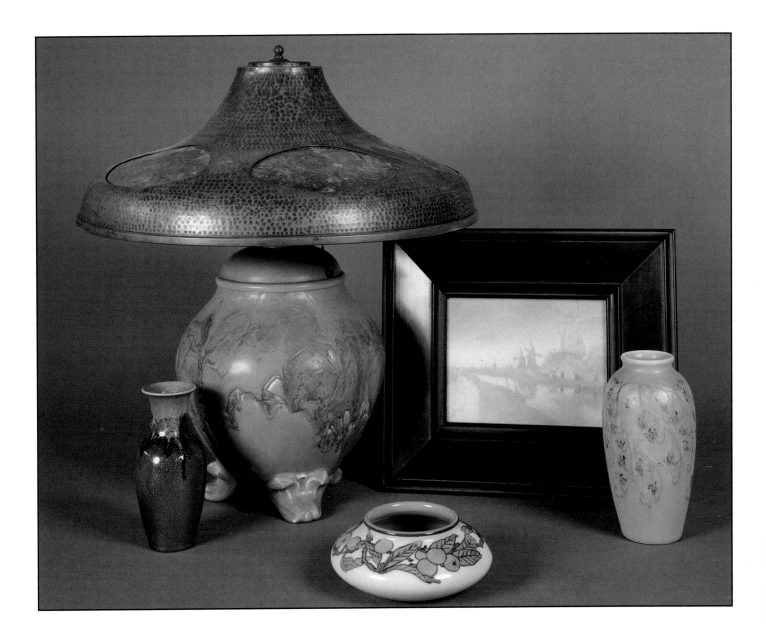

301 Unusual vase with drip glaze and goldstone decoration done in 1932. Marks on the base include the Rookwood $500-700
 logo, the date and shape number 6308 C. Height 6¼ inches.

302 Mat glaze lamp base decorated with incised and painted leaves and berries by Sallie Toohey in 1903. Marks on $1200-1500
 the base include the Rookwood logo, the date, shape number 51 AZ. Height of pottery only, 10 inches. This is a
 factory made lamp with a cast hole in the base. The hammered copper shade with mica inserts is not original nor
 signed, but is contemporary with the base.

303 High glaze, porcelain bodied bowl decorated with quince fruit, leaves, and stems by Arthur Conant in 1921. $800-1200
 Marks on the base include the Rookwood logo, the date, shape number 923, and the artist's monogram. Height
 2½ inches, diameter 6½ inches.

304 Vellum glaze scenic plaque decorated in 1915 by E.T. Hurley. The artist's initials appear in the lower left hand $3000-4000
 corner. Marks on the back include the Rookwood logo, the date, V for Vellum glaze body and the title in pencil,
 "Evening Amsterdam". Size 6¼ x 8¼ inches.

305 Mat glaze vase painted by Louise Abel in 1921 with hanging flowers. Marks on the base include the Rookwood $300-400
 logo, the date, shape number 922 D and the artist's monogram. Height 7⅝ inches.

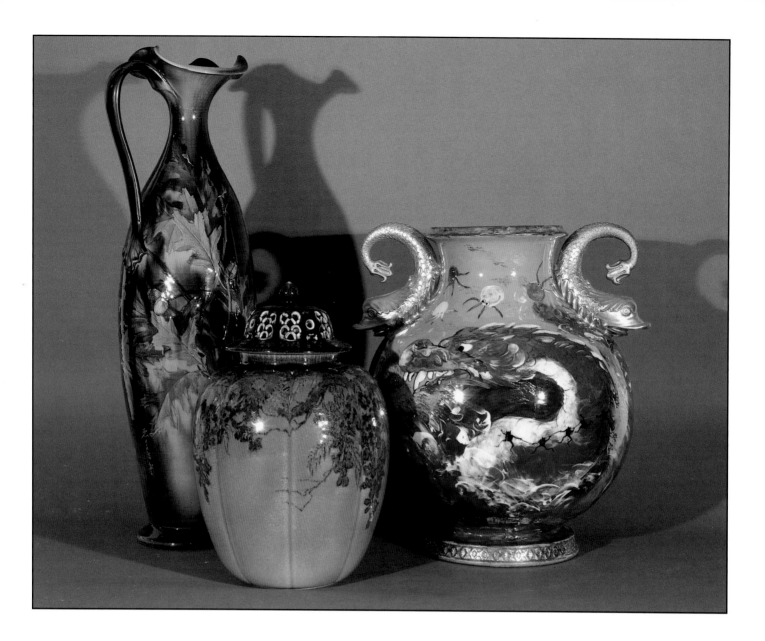

306 Monumental Standard glaze ewer decorated with oak leaves, branches and acorns by Kataro Shirayamadani in 1891. Marks on the base include the Rookwood logo, the date, shape number S960, and W for white clay. The artist's signature appears on the side of the ewer below the handle which has been repaired. Height 26½ inches. $3000-4000

307 Large lidded potpourri jar decorated with lushly colored wisteria by E.T. Hurley in 1924. Marks on the base include the Rookwood logo, the date, shape number 2582 and the artist's initials. Height 14 inches. Inner lid missing. $3000-5000

308 Large and important Limoges style glazed urn attributed to Maria Longworth Nichols, decorated at Rookwood circa 1882. The decoration itself is classic Nichols consisting of a large snarling dragon, a group of black devils trying to subdue the dragon, crabs, fish and several octopi. The piece is also adorned with two large dolphin handles. Marks on the base consists of Rookwood in block letters and the partially obscured date. Height 16⅞ inches. Both handles have evidence of repairs. $5000-7000

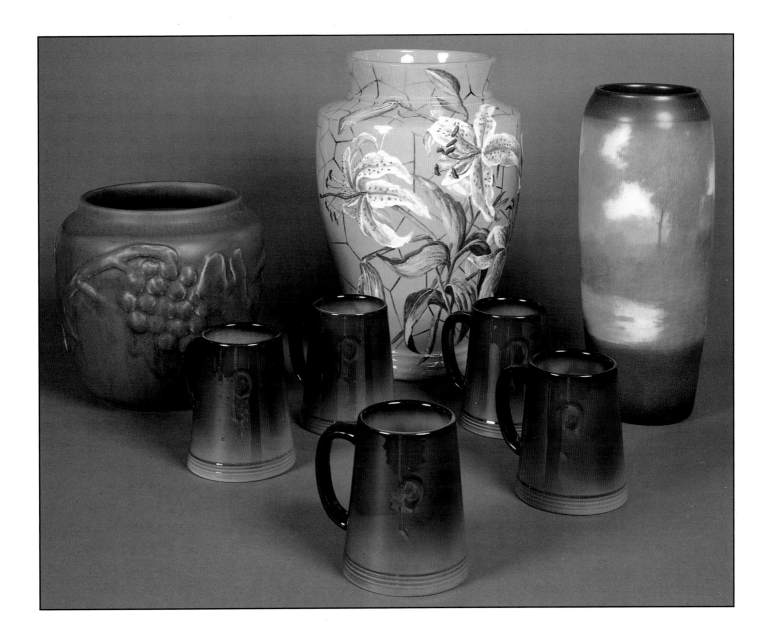

309 Group of five Standard glaze mugs monogrammed with the letter "P". Marks on the base include the Rookwood logo, the date and shape number 587 C. Height of each is 4½ inches. $600-800

310 Carved and painted mat glaze urn with grape decoration, done by William Hentschel in 1910. Marks on the base include the Rookwood logo, the date, shape number 180 C, V for Vellum glaze body and the artist's initials. Height 8¼ inches. $1000-1200

311 Large Limoges style glaze vase decorated with Japanese lillies by Henrietta Leonard in 1882. Marks on the base include Rookwood in script, the date and the artist's monogram. Height 13½ inches. $900-1200

312 Large Vellum glaze vase with a banded woodland scene, done by E.T. Hurley in 1914. Marks on the base include the Rookwood logo, the date, shape number 951 B, V for Vellum glaze body and the artist's initials. Height 12¾ inches. $1500-2000

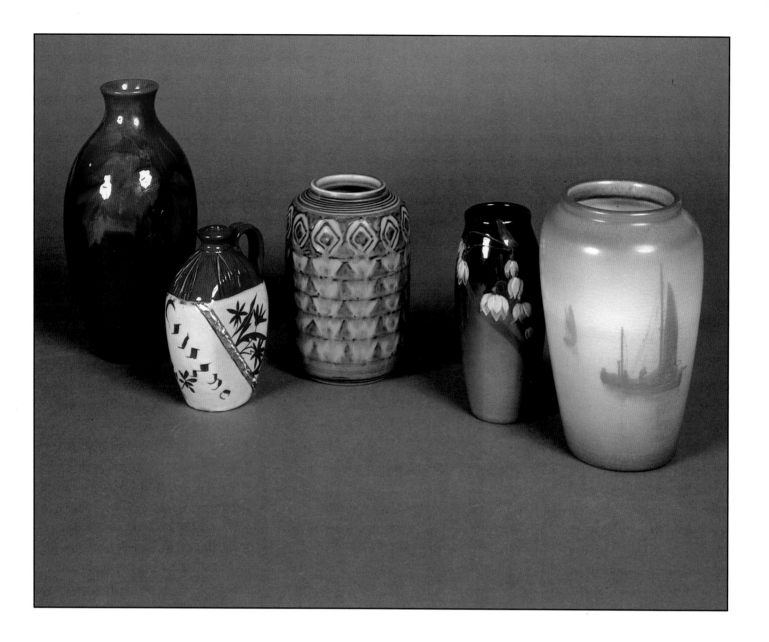

313 Standard glaze vase with maple leaf decoration, done by Lenore Asbury in 1903. Marks on the base include the $300-500
Rookwood logo, the date, shape number 732 BB and the artist's initials. Height 8¼ inches.

314 Limoges style glaze perfume jar decorated with incised and painted decoration of leaves and bamboo and the $350-550
word "Cologne" carved in the side of the piece under the spout. Marks on the base include Rookwood in block
letters and the date. Height 4¼ inches.

315 Mat glaze vase by Elizabeth Barrett, decorated with geometric repeating patterns in 1928. Marks on the base $300-500
include the Rookwood logo, the date, shape number 1873 and the artist's monogram. Height 5¼ inches.

316 Standard glaze vase with decoration of canterbury bells, done by Alice Willitts in 1905. Marks on the base $250-350
include the Rookwood logo, the date, shape number 917 E and the artist's initials. Height 5¼ inches.

317 Vellum glaze scenic vase decorated with three ships by Sallie Coyne in 1913. Marks on the base include the $1500-2000
Rookwood logo, the date, shape number 938 D, V for Vellum glaze body, the artist's initials and V for vellum
glaze. Height 6⅞ inches.

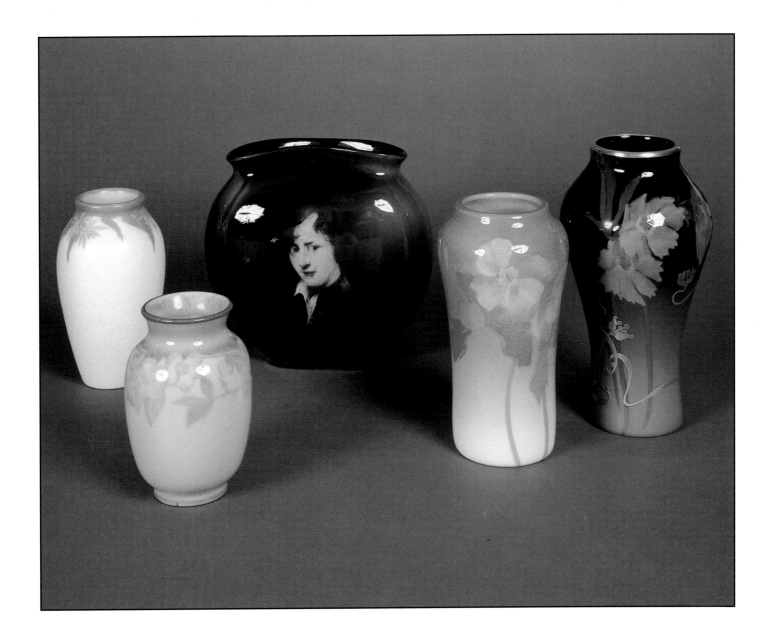

318 Vellum glaze vase decorated with a border of blue daisies by Katherine Van Horne in 1914. Marks on the base $400-600
include the Rookwood logo, the date, shape number 913 E, V for Vellum glaze body and the artist's initials.
Height 6½ inches.

319 High glaze vase decorated with pink blossoms by Kataro Shiryamadani in 1934. Marks on the base include the $600-800
Rookwood logo, the date, S for special shape and the artist's cypher. Height 5¼ inches.

320 Standard glaze pillow vase done with a portrait of a young man by Grace Young in 1895. Marks on the base $900-1200
include the Rookwood logo, the date, shape number 707 A, a small wheel ground X and the artist's monogram.
Height 7¾ inches.

321 Iris glaze vase decorated with flowers and leaves by Sara Sax in 1902. Marks on the base include the Rookwood $800-1200
logo, the date, shape number 935 D, the artist's monogram and W for white glaze. Height 7½ inches.

322 Standard glaze vase with Art Nouveau silver overlay, decorated with yellow flowers by Virginia Demarest in $900-1200
1902. Marks on the base include the Rookwood logo, the date, shape number 909 C and the artist's initials.
Height 8¾ inches. A six inch crack descends from the rim in back of piece.

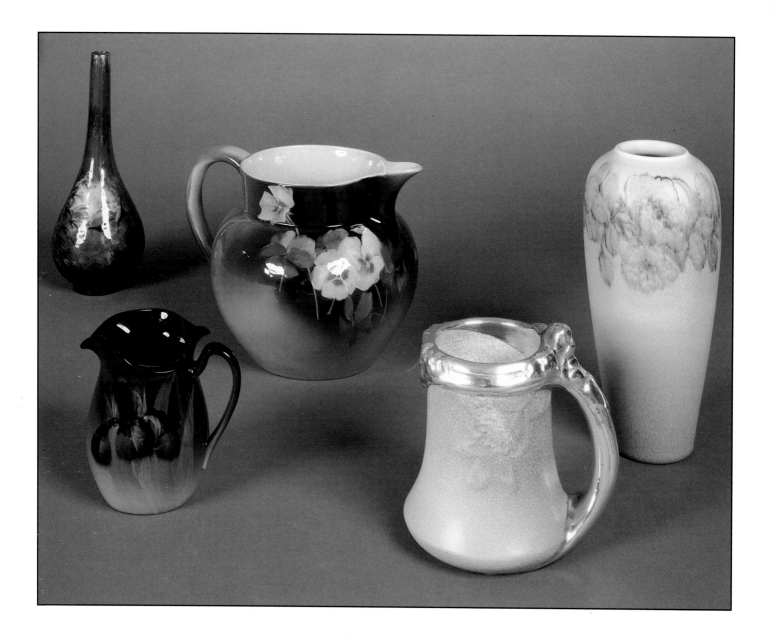

323 Limoge style glaze vase decorated with bats and reeds by N.J. Hirschfeld in 1882. Marks on the base include the Rookwood in block letters, the date, shape number 126, R for red clay, an anchor mark and the artist's initials. Height 8½ inches. $500-700

324 Standard glaze pitcher decorated with irises by Carl Schmidt in 1900. Marks on the base include the Rookwood logo, the date, shape number 456 and the artist's monogram. Height 4¼ inches. $400-600

325 Standard glaze pitcher decorated with pansies by Harriet Wilcox in 1893. Marks on the base include the Rookwood logo, the date, shape number 13, W for white clay and the artist's initials. Height 6½ inches. $500-700

326 Vellum glaze mug with eloctro-deposited silver decorated by Sara Sax in 1905. Marks on the base include the Rookwood logo, the date, V for Vellum glaze body, "Commercial Club of Cincinnati, 1880-1905", the artist's monogram and V for Vellum glaze. The name, "MR. MEACHAM" is engraved in the silver at the front of the mug. Height 5½ inches. Much discoloration in the glaze. $500-700

327 Mat glaze vase done by Katherine Jones in 1927 with a band of pink flowers and green leaves. Marks on the base include the Rookwood logo, the date, shape number 2033 E and the artist's initials. Height 8¼ inches. $300-400

328 Extremely rare Iris glaze scenic plaque by Carl Schmidt. Marks on the back include a very large Rookwood logo, $15000-20000
 the date, shape number X 499 AX and the artist's monogram impressed twice. Size 12½ x 10¼ inches. Beside its
 rarity, this plaque is wonderfully crisp and clean.

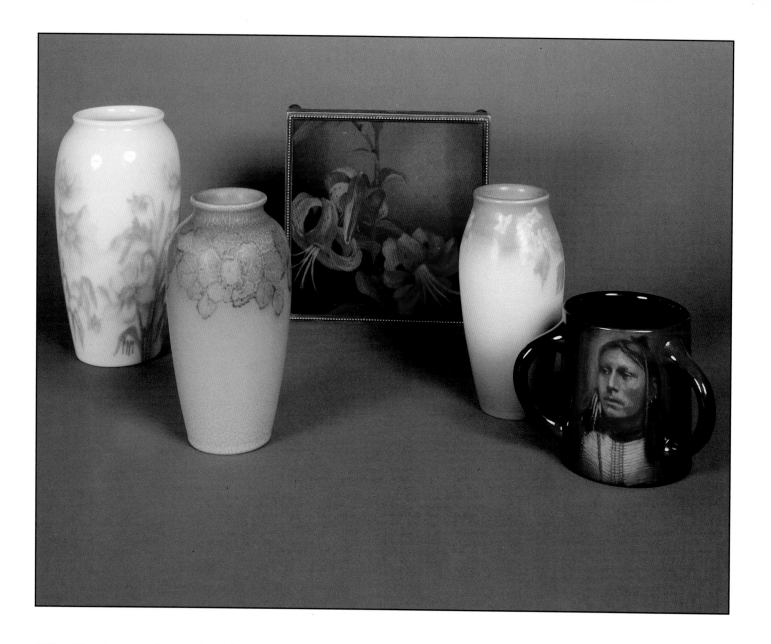

329 High glaze vase decorated with long stemmed flowers by Margaret McDonald in 1939. The artist's initials are on the side near the base. Marks on the base include the Rookwood logo, the date and shape number 892 C. Height 8¼ inches. $500-700

330 Mat glaze vase decorated with a stylized floral band by Katherine Jones in 1928. Marks on the base include the Rookwood logo, the date, shape number 332 D and the artist's initials. Height 7¼ inches. $300-500

331 Rare Standard glaze tile in metal mount holder, decorated with tiger lillies by Sallie Toohey in 1902. Marks on the back include the Rookwood logo, the date and the artist's initials. Size 8 x 8 inches. There are some minor surface scratches. $1250-1750

332 Vellum glaze vase with floral decoration done by Helen Lyons in 1915. Marks on the base include the Rookwood logo, the date, shape number 825 E, V for Vellum glaze body and the artist's initials. Height 7⅜ inches. Small glaze flake on base. $200-400

333 Standard glaze three-handled mug decorated with a Native American portrait by Sadie Markland in 1898. Marks on the base include the Rookwood logo, the date, shape number 830 E, a partial Rookwood label, a partial Davis Collamore label, part of an unidentified label and the artist's initials. Height 4¼ inches. $2000-3000

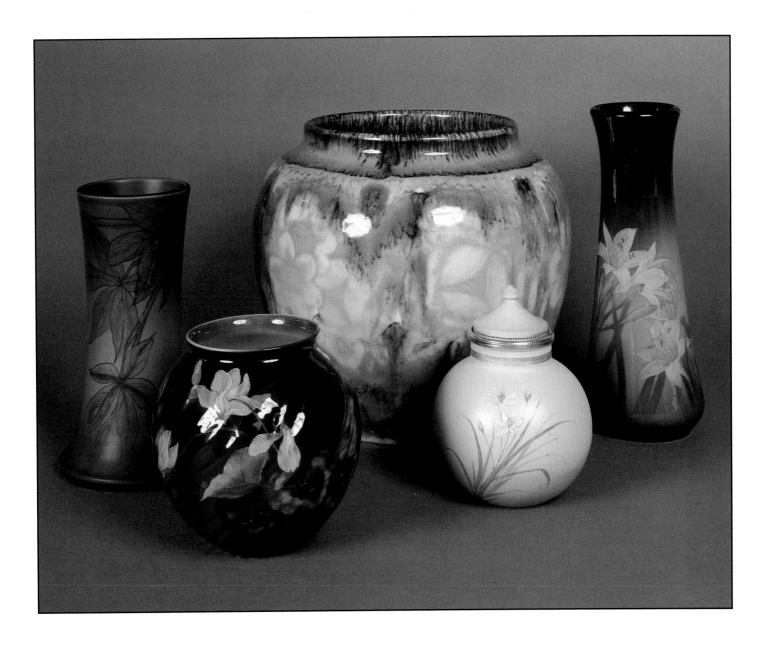

334 Mat glaze vase decorated by Elizabeth Lincoln in 1924 with Virginia creeper. Marks on the base include the $800-1200
Rookwood logo, the date, shape number 1358 C and the artist's initials. Height 10¾ inches.

335 Standard glaze ribbed vase, decorated with nasturtiums by Emma Foertmeyer in 1893. Marks on the base include $300-500
the Rookwood logo, the date, shape number 612 B, W for white clay and the artist's initials. Height 7 inches.
Spider cracks in base.

336 Very large high glaze jardiniere with abstract floral decoration done by William Hentschel in 1925. Marks on the $1500-2500
base include the Rookwood logo, the date, shape number S2056 and the artist's initials. Height 12½ inches.

337 Bisque finish reversible lidded rose jar decorated by Anna Bookprinter in 1887 with a spray of small white $900-1200
flowers and leaves. Marks on the base include the Rookwood logo, the date, shape number 282 C, W 3 for white
clay, the artist's initials and S for an unknown glaze designation. Height 7⅛ inches.

338 Large Standard glaze vase decorated with yellow lillies by Kataro Shirayamadani in 1902. Marks on the base $1500-2000
include the Rookwood logo, the date, shape number 804 C and the artist's cypher. Height 13⅜ inches.

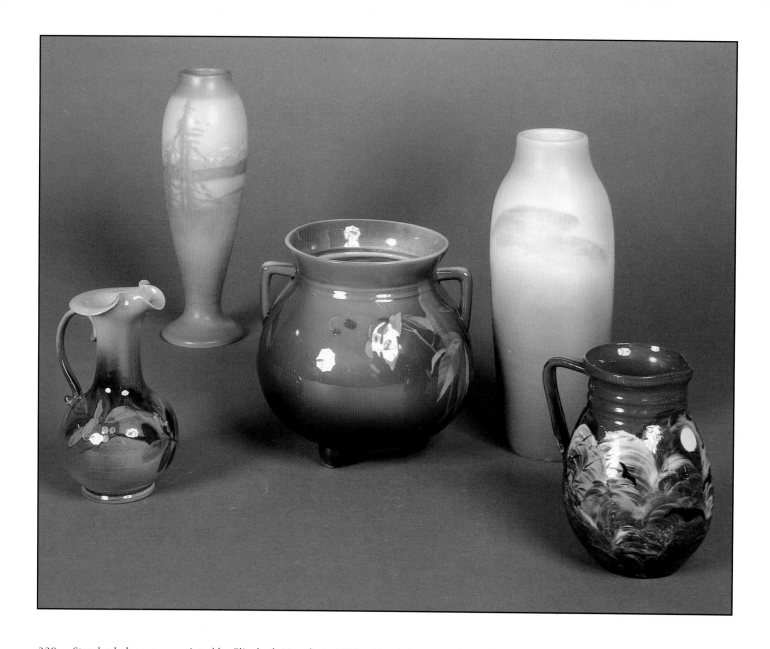

339 Standard glaze ewer painted by Elizabeth Lincoln in 1893 with mistletoe. Marks on the base include the $300-500
Rookwood logo, the date, shape number 40, W for white clay, the artist's initials and L for light Standard glaze.
Height 5½ inches.

340 Vellum glaze vase decorated with an arts and crafts scene of pine trees and snow capped mountains by Sallie $1000-1200
Coyne in 1912. Marks on the base include the Rookwood logo, the date, shape number 949 D, V for Vellum
glaze body, the artist's initials and V for Vellum glaze. Height 9⅜ inches.

341 Standard glaze three footed vase with two small handles, decorated with Virginia creeper berries and leaves, $600-800
done by Harriet Wilcox in 1890. Marks on the base include the Rookwood logo, the date, shape number 472, W
for white clay, the artist's initials and LY for light yellow (Standard) glaze. Height 6¼ inches. Some glaze
scratches. The shape record book shows this piece with a lid, but no handles.

342 Vellum glaze vase decorated with swimming fish by E.T. Hurley in 1905. Marks on the base include the $800-1000
Rookwood logo, the date, shape number 932 D, V for Vellum glaze body, a wheel ground X, the artist's full
signature and V for vellum glaze. Height 9¼ inches.

343 Limoges style glaze pitcher decorated with bats in the moonlight by M.A. Daly in 1882. Marks on the base include $500-700
Rookwood in block letters, the date, shape number 54, R for red clay and the artist's initials. Height 5 inches.

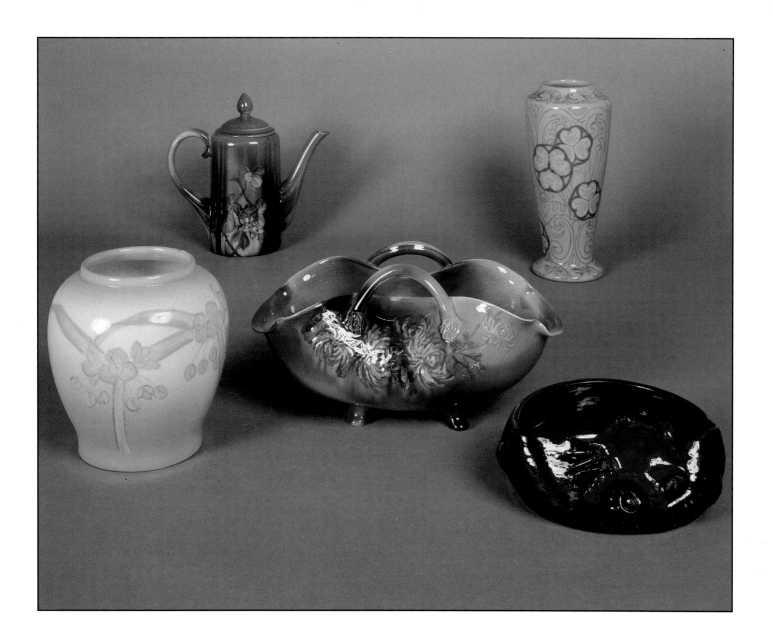

344 High glaze vase decorated with blue flowers by Kataro Shirayamadani in 1945. Marks on the base include the Rookwood logo, the date, shape number 6878, the number 6044 and the artist's initials. Height 6¼ inches. $600-800

345 Standard glaze lidded coffee pot with floral decoration, done by Kataro Shirayamadani in 1891. Marks on the base include the Rookwood logo, the date, shape number 552, W for white clay, the artist's cypher and L for light Standard glaze. Height 8 inches. One inch firing crack at rim which is glazed over. $500-700

346 Standard glaze four footed basket with large loop handles decorated with orange chrysanthemums by Anna Valentien in 1889. Marks on the base include the Rookwood logo, the date shape number 45 C, W for white clay, the artist's initials and L for light Standard glaze. Height 5¼ inches, length 11 inches. $900-1200

347 High glaze vase with floral decoration and repeating designs on a gray clay body, done by Sara Sax in 1921. Marks on the base include the Rookwood logo, the date, shape number 1356 D, the number 7914 which refers to the gray clay body, a small wheel ground X and the artist's monogram. Height 9⅛ inches. $700-900

348 Unusual high glaze bowl decorated by an unknown artist in 1884 with a life size, carved crab applied to one side. Marks on the base include Rookwood in block letters, the date, shape number 59 D and R for red clay. Height 2¾ inches, length 7 inches. Several legs are missing from the crab as well as his eyes. $300-500

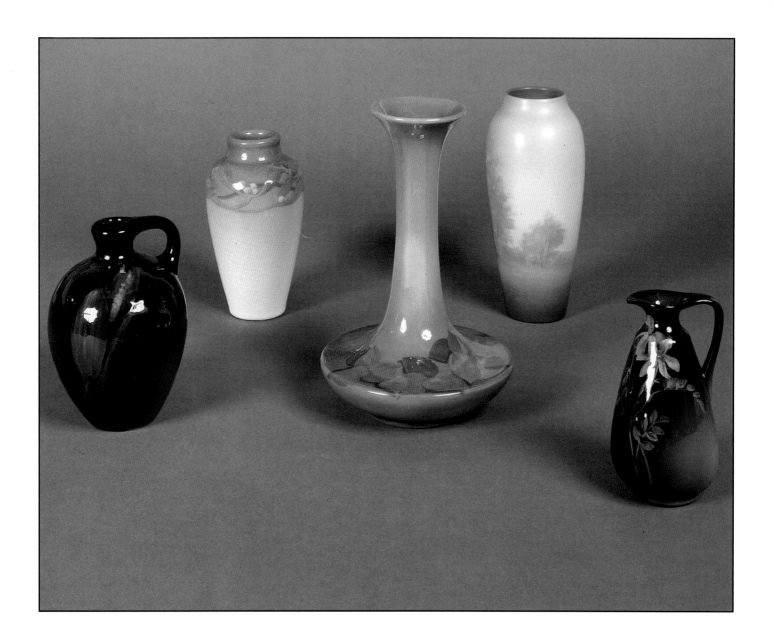

349 Standard glaze whiskey jug decorated with an ear of corn by Helen Lyons in 1898. Marks on the base include the Rookwood logo, the date, shape number 767 and the artist's initials. Height 5½ inches. $400-600

350 Iris glaze vase decorated with a band of berries by Ed Diers in 1904. Marks on the base include the Rookwood logo, the date, shape number 943 E, the artist's initials and W for white glaze. Height 6¼ inches. $400-600

351 Standard glaze vase with a band of orange leaves on the shoulder, painted by E.T. Hurley in 1896. Marks on the base include the Rookwood logo, the date, shape number 566 C, a wheel ground X and the artist's initials. Height 8¾ inches. $400-600

352 Vellum glaze scenic vase decorated by Ed Diers in 1921. Marks on the base include the Rookwood logo, the date, shape number 295 E, V for Vellum glaze body and the artist's initials. Height 7⅝ inches. $800-1000

353 Standard glaze ewer decorated with small yellow flowers by Adeliza Sehon in 1898. Marks on the base include the Rookwood logo, the date, shape number 746 D, a small star shaped esoteric mark and the artist's initials. Height 5 inches. $250-350

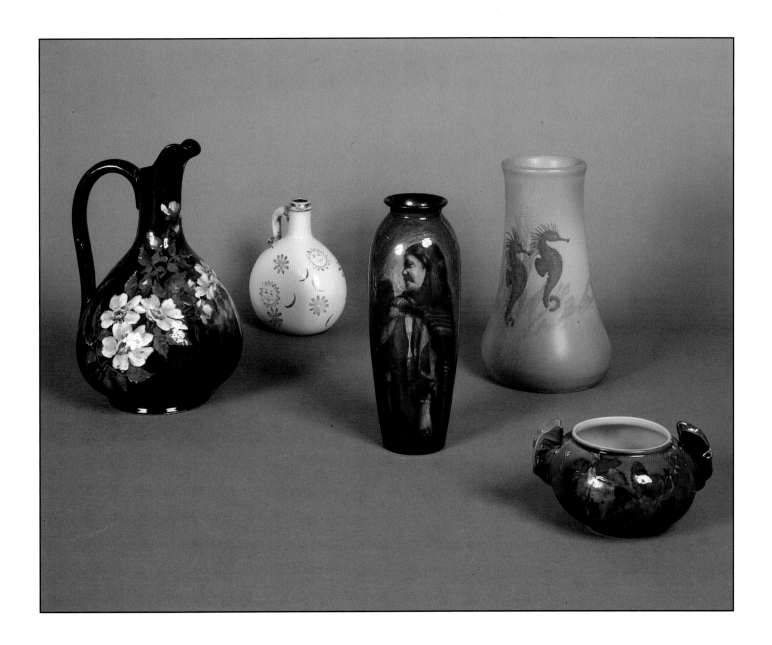

354 Limoges style glaze pitcher decorated with wild roses by Albert Valentien in 1882. Marks on the base include $500-700
Rookwood in block letters, the date, the artist's initials, and an impressed anchor mark. Height 10½ inches.

355 Limoges style glaze pilgrim flask decorated by Maria Longworth Nichols circa 1882 with small red flowers, $700-900
crescent moons and smiling suns. Marks on the base include the shape number 85, W for white clay and the
artist's initials. Height 6⅛ inches. Line at lip.

356 Standard glaze vase decorated with a Native American portrait by Grace Young in 1898. Marks on the base $700-900
include the Rookwood logo, the date, shape number 829, the inscription "Ute Maiden" and the artist's initials.
Height 9⅛ inches. There is a long crack on the back of the piece which someone has tried to polish out with a
wheel.

357 Early Vellum glaze vase decorated with three seahorses and sea grasses by E.T. Hurley in 1904. Marks on the $1500-2000
base include the Rookwood logo, the date, shape number 176 CZ, V for Vellum glaze body, the artist's full
signature and V for Vellum glaze. Height 9⅜ inches.

358 Standard glaze sugar bowl with butterfly handles and floral decoration, done in 1890 by Sallie Toohey. Marks on $200-300
the base include the Rookwood logo, the date, shape number 329, S for sage green clay, the artist's initials and L
for light Standard glaze. Height 3⅛ inches. Lid missing.

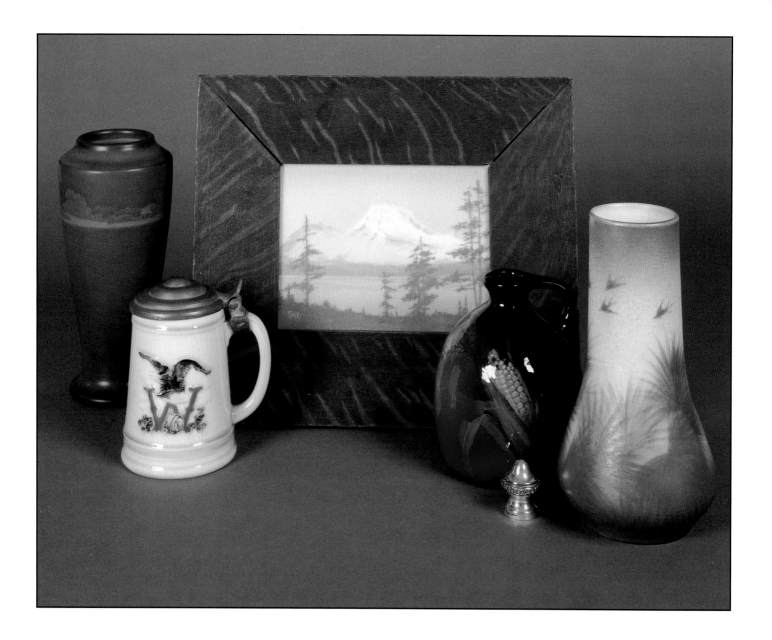

359 Unusual Green Vellum glaze banded scenic vase, decorated by Sara Sax in 1911. Marks on the base include the Rookwood logo, the date, shape number 1356 D, a small V shaped esoteric mark, the artist's monogram and GV for Green Vellum glaze. Height 8⅞ inches.　　$700-900

360 High glaze mug with pewter lid and embossed company logo on side in color. Made in 1948 for the George Wiedemann Brewing Company of Newport, Kentucky. Marks on base include the Rookwood logo, "THE GEO. WEIDEMANN BREWING CO. INC." and the date, 1948. Height, 5½ inches.　　$250-350

361 Vellum glaze scenic plaque decorated in 1912 by Sara Sax. The artist name appears in the lower left hand corner. Marks on the back include the Rookwood logo, the date and V for Vellum glaze body and the title in pencil, "Shasta". There is an original paper Rookwood logo on the frame. Size 5 ⅝ x 7⅝ inches.　　$2000-3000

362 Standard glaze whiskey jug decorated with an ear of corn and sprays of wheat by Josephine Zettel in 1897. A sterling stopper accompanies the piece. Marks on the base include the Rookwood logo, the date, shape number 747 C and the artist's initials. Height 6 inches.　　$500-700

363 Vellum glaze vase decorated with tall grasses and swallows by E.T. Hurley in 1908. Marks on the base include the Rookwood logo, the date, shape number 1278 E, V for Vellum glaze body, a wheel ground X, the artist's initials and V for Vellum glaze. Height 8 ½ inches. Glaze peppering.　　$500-700

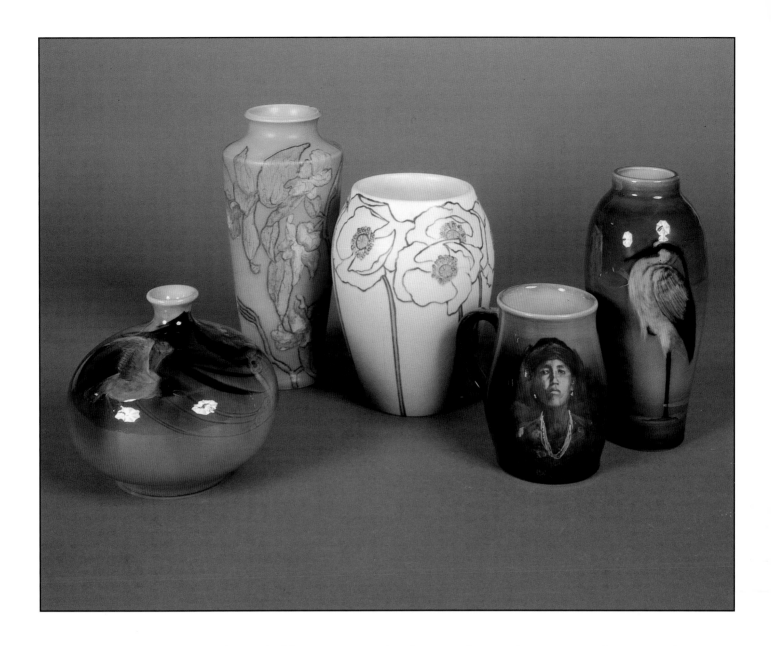

364 Standard glaze vase decorated with a bird flying over waves, done by Kataro Shirayamadani in 1898. Marks on $2000-3000
the base include the Rookwood logo, the date, shape number 762 C, a small star shaped esoteric mark and the
artist's cypher. Height 5½ inches.

365 Mat glaze vase with floral decoration, thought to be done by Jens Jensen in 1929. Marks on the base include the $800-1000
Rookwood logo, the date, shape number 1920 and an artist's monogram. Height 9⅝ inches.

366 Early Vellum glaze vase decorated with black outlined poppies by Anna Valentien in 1905. Marks on the base $1200-1500
include the Rookwood logo, the date, shape number 942 B, V for Vellum glaze body, the artist's initials and V for
Vellum glaze. Height 7½ inches.

367 Standard glaze mug decorated with a portrait of a young woman by Harriet Strafer in 1897. Marks on the base $1200-1500
include the Rookwood logo, the date, and shape number 837 and the artist's initials. Height 5¼ inches.

368 Good Sea Green vase decorated with a single egret perched on one leg, done by E.T. Hurley in 1901. Marks on $3000-4000
the base include the Rookwood logo, the date, shape number 901 C, G for Sea Green glaze and the artist's
initials. Height 8⅝ inches.

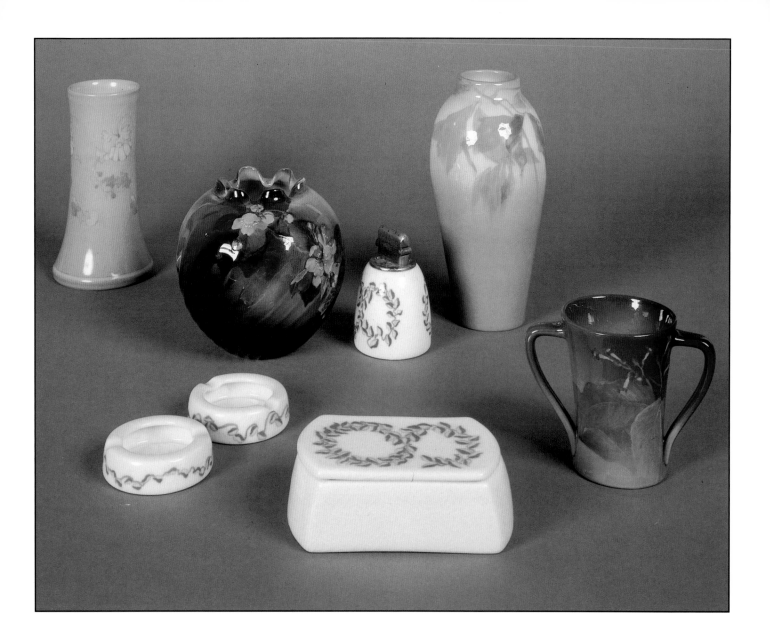

369 High glaze vase decorated with stylized flowers by Fred Rothenbusch in 1923. Marks on the base include the $400-600
 Rookwood logo, the date, shape number 1358 E, P for porcelain body, the artist's initials and Y for yellow glaze.
 Height 7⅛ inches.

370 Standard glaze swirled vase decorated with blossoms by Luella Perkins in 1893. Marks on the base include the $500-700
 Rookwood logo, the date, shape number 612 C, W for white clay, the artist's initials and L for light Standard
 glaze. Height 5½ inches.

371 Four piece high glaze smoking set consisting of two ashtrays, a lighter and a box decorated with a pattern of $300-500
 twining leaves by Jane Sacksteder in 1946. Marks on the base include the Rookwood logo, the date, shape
 number 6922 B, the number 554, the number 65 and the artist's initials. Height 1⅞ inches, length 5⅞ inches.

372 Iris glaze vase decorated with leaves by Fred Rothenbusch in 1901. Marks on the base include the Rookwood $600-800
 logo, the date, shape number 901 C, a wheel ground X and the artist's initials. Height 8¼ inches.

373 Standard glaze two-handled cup decorated with leaves and blossoms by Irene Bishop in 1902. Marks on the base $300-400
 include the Rookwood logo, the date, the artist's initials, and the inscription "S.L.T.B.T. of Cincinnati, May 7,
 1902". Height 4¼ inches.

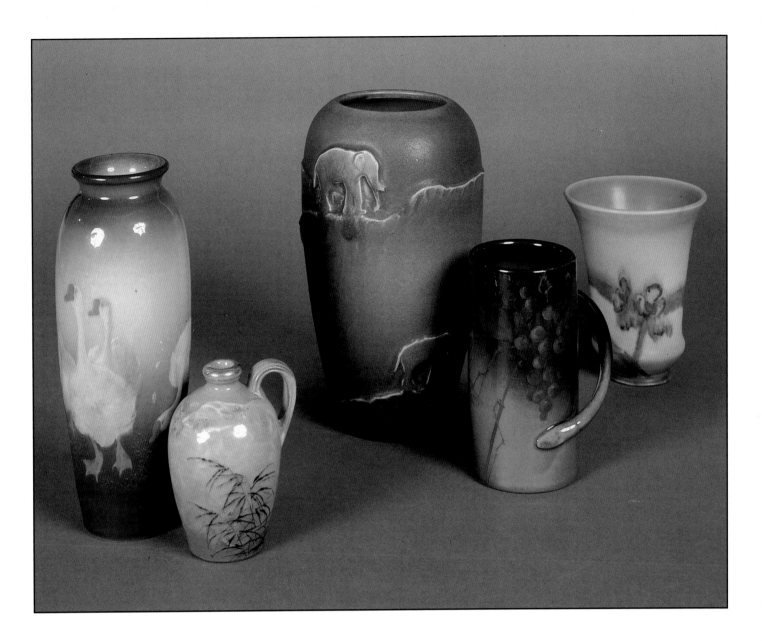

374 Iris glaze vase decorated with four geese by E. T. Hurley in 1904. Marks on the base include the Rookwood logo, the date, shape number 929, the number "261", the artist's initials and W for white glaze. Height 9¼ inches. $2500-3500

375 Limoges style glaze perfume jug decorated by an unknown artist in 1884 with grasses and clouds. Marks on the base include Rookwood in block letters, the date, shape number 61 and G for ginger clay. Height 4½ inches. $250-450

376 Mat glaze vase surrounded by four elephants in high relief done in 1913 by an unknown artist. Marks on the base include the Rookwood logo, the date, shape number 1126C and a wheel ground X. Height 9½ inches. We assume this to be a unique, carved piece, unfortunately there is no artist's signature. $400-600

377 Standard glaze mug decorated with grapes by Fred Rothenbusch in 1899. Marks on the base include the Rookwood logo, the date, shape number 328 B and the artist's initials. Height 6 inches. $300-400

378 Mat glaze vase decorated by Kataro Shirayamadani in 1935 with a floral pattern. Marks on the base include the Rookwood logo, the date, S for special shape and the artist's initials. Height 5¾ inches. $300-500

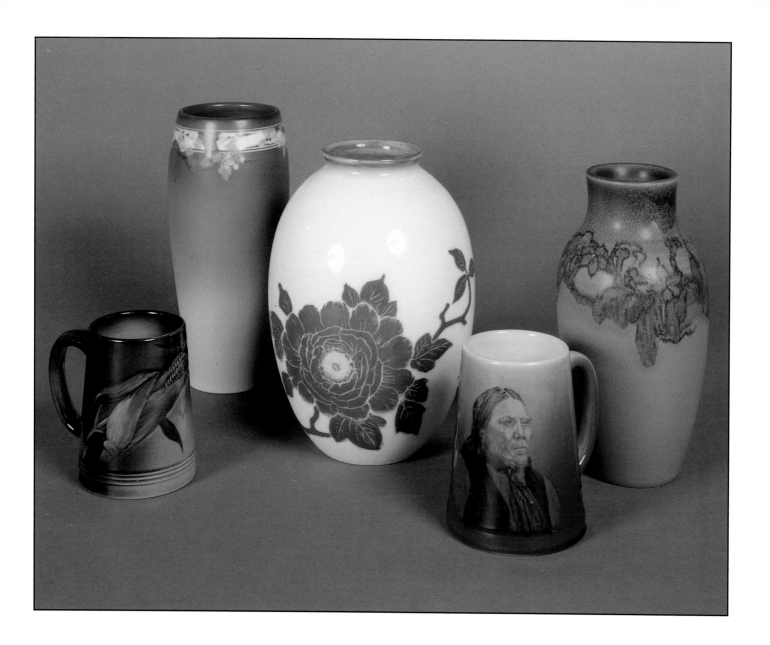

379 Standard glaze mug decorated with corn and wheat by Mary Nourse in 1895. Marks on the base include the $400-600
Rookwood logo, the date, shape number 587 C, the artist's initials and L for light Standard glaze. Height 4½
inches.

380 Vellum glaze vase with a band of cherry blossoms at the top, done by E.T. Hurley in 1926. Marks on the base $600-800
include the Rookwood logo, the date, shape number 2032 D, the artist's initials and V for Vellum glaze. Height
9⅝ inches. Minute chip off base.

381 High glaze vase decorated with large purple flowers and green leaves on a white ground by E.T. Hurley in 1944. $1250-1750
Marks on the base include the Rookwood logo, the date, shape number 6184 C and the artist's initials. Height 9½
inches.

382 High glaze mug decorated with a Native American portrait by Flora King in 1946. Marks on the base include the $600-800
Rookwood logo, the date, shape number 587 C, the inscription, "White Wolf", the number "224A" and the
artist's initials. Height 5 inches.

383 Mat glaze vase decorated with band of stylized flowers by Margaret McDonald in 1926. Marks on the base $400-600
include the Rookwood logo, the date, shape number 926 C and the artist's initials. Height 9¼ inches.

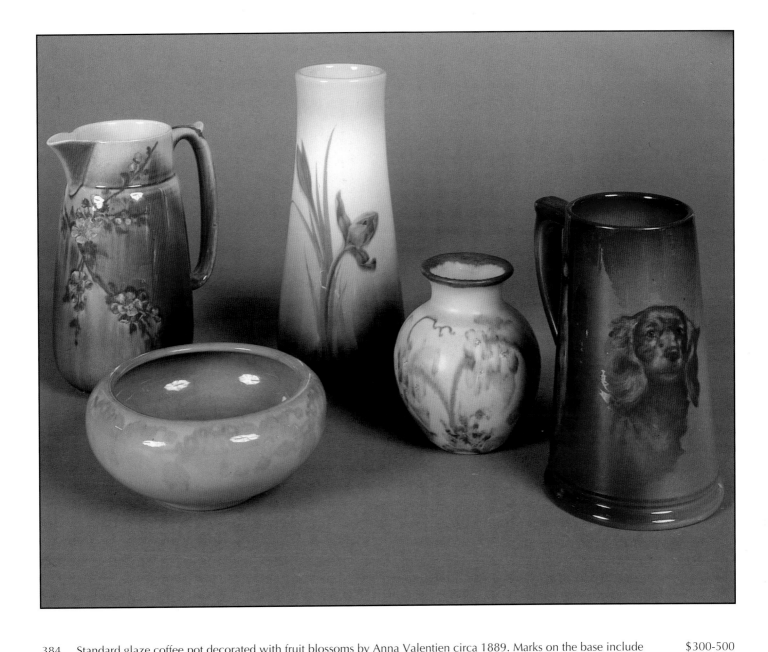

384 Standard glaze coffee pot decorated with fruit blossoms by Anna Valentien circa 1889. Marks on the base include $300-500
the Rookwood logo and the date which are partially obscured by the glaze, shape number 335, W for white clay,
the artist's initials and L for light Standard glaze. Height 8 inches. The handle has a partial crack near the top but
is very stable. Lid missing. Tiny line at rim.

385 High glaze porcelain bodied bowl decorated with a repeating band of flowers near the top by Fred Rothenbusch $300-400
in 1924. Marks on base include the Rookwood logo, the date, the shape number 957 D, P for soft porcelain, and
the artist's initials. Diameter 6½ inches.

386 Iris glaze vase decorated with crocuses by Carl Schmidt in 1908. Marks on the base include the Rookwood logo, $2500-3500
the date, shape number 950 C, a partial Rookwood label and the artist's monogram. Height 9¼ inches.

387 Mat glaze vase with stylized floral design done by Margaret McDonald in 1931. Marks on the base include the $250-350
Rookwood logo, the date, shape number 6206 F, a small fan shaped esoteric mark and the artist's initials. Height
5 inches.

388 Tall Standard glaze tankard decorated with a spaniel by E.T. Hurley in 1901. Marks on the base include the $1200-1500
Rookwood logo, the date, shape number 775 and the artist's initials. Height 7½ inches.

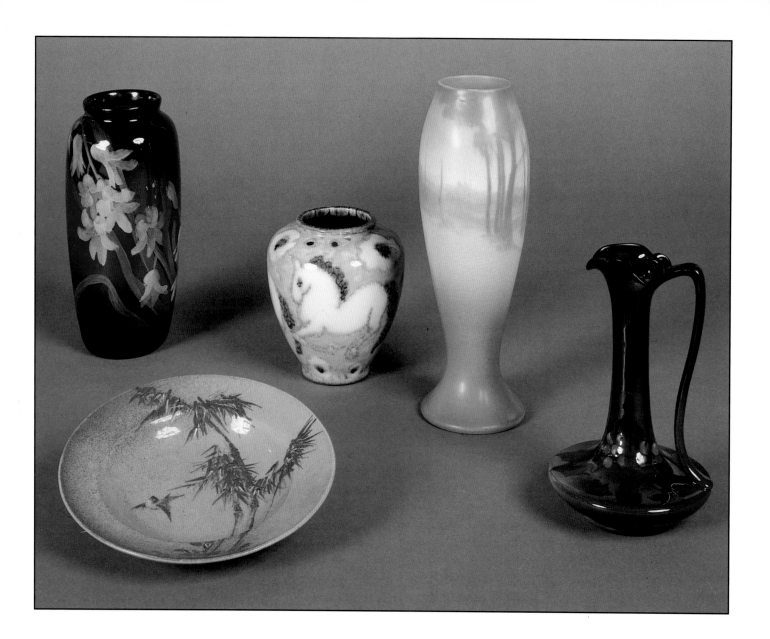

389 Standard glaze vase decorated with yellow flowers by Howard Altman in 1904. Marks on the base include the Rookwood logo, the date, shape number 904 D and the artist's initials. Height 7⅞ inches. $400-600

390 Standard glaze coupe dish decorated with bamboo and a small bird by William McDonald in 1885. Marks on the base include Rookwood in block letters, the date, S for sage green clay and the artist's initials. Diameter 6⅞ inches. $200-300

391 High glaze figural vase decorated by Jens Jensen in 1934 depicting three leaping horses and flowers. Marks on the base include the Rookwood logo, the date, S for special shape, and the artist's monogram. Height 4¾ inches. $800-1200

392 Vellum glaze vase decorated with a woodland scene by Sallie Coyne in 1919. Marks on the base include the Rookwood logo, the date, shape number 949 D, the artist's initials and V for Vellum glaze. Height 9½ inches. $900-1200

393 Standard glaze ewer with holly decoration, painted by an unknown artist in 1898. Marks on the base include the Rookwood logo, the date, shape number 566 D, a small star shaped esoteric mark and the artist's cypher. Height 6⅜ inches. $300-500

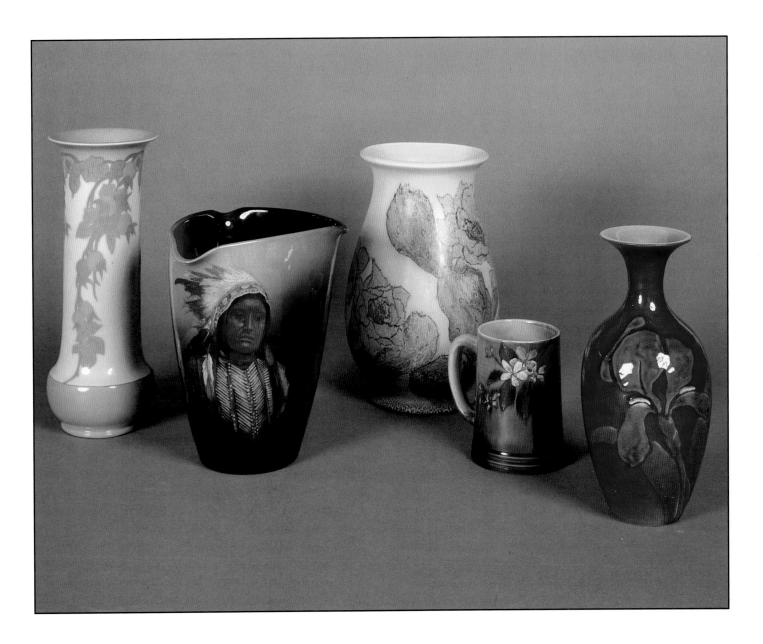

394 High glaze vase decorared with stylized berries by Sara Sax circa 1922. Marks on the base include the Rookwood logo,the partially obscured date, the partially obscured shape number, part of a Rookwood label and the artist's monogram. Height 10⅞ inches. $800-1200

395 Standard glaze crucible pitcher decorated with a Native American portrait by Bruce Horsfall in 1895. Marks on the base include the Rookwood logo, the date, shape number 259 B and the artist's monogram. Height 8 inches. Small chip on lip of spout. $2000-3000

396 Nice mat glaze vase with cactus flower decoration, done by Catherine Covalenco in 1924. Marks on the base include the Rookwood logo, the date, shape number 2782 and the artist's initials. Height 9⅝ inches. $600-800

397 Standard glaze mug decorated with a floral design by Anna Valentien in 1891. Although on white clay, this example has large areas of Tiger Eye in the glaze. Marks on the base include the Rookwood logo, the date, shape number 587, W for white clay, the artist's initials and L for light Standard glaze. Height 4½ inches. $400-600

398 High glaze vase decorated with irises by Elizabeth Barrett in 1946. Marks on the base include the Rookwood logo, the date, S for special shape, the number 3490 and the artist's monogram. Height 8¾ inches. $600-800

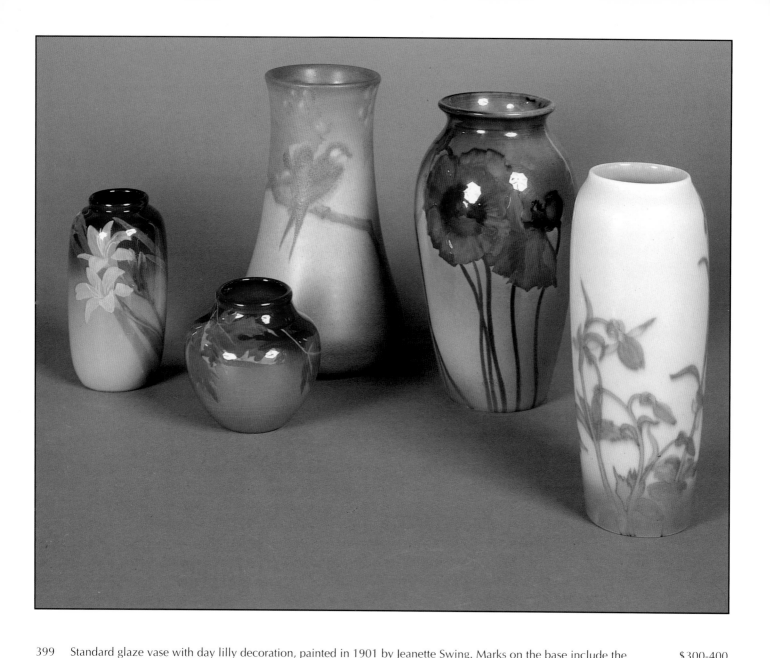

399 Standard glaze vase with day lilly decoration, painted in 1901 by Jeanette Swing. Marks on the base include the Rookwood logo, the date, shape number 924 and the artist's initials. Height 5⅞ inches. $300-400

400 Standard glaze vase decorated with oak leaves by Katherine Van Horne in 1908. Marks on the base include the Rookwood logo, the date, shape number 919 E and the artist's initials. Height 4 inches. $250-350

401 Vellum glaze vase decorated with two birds on a branch by E.T. Hurley in 1907. Marks on the base include the Rookwood logo, the date, shape number 1097 C, V for Vellum glaze, a wheel ground X and the artist's initials. Height 9¼ inches. Glaze flaw on back. $500-700

402 Standard glaze vase decorated with poppies by Sallie Toohey in 1902. Marks on the base include the Rookwood logo, the date, shape number 568 B and the artist's initials. Height 9⅛ inches. A hair line crack extends from the base vertically into the decoration on the backside. $400-600

403 High glaze, porcelain bodied vase, decorated by Charles McLaughlin in 1918 with orchids. Marks on the base include the Rookwood logo, the date, shape number 951 D, P for porcelain body and the artist's initials. Height 8⅞ inches. $800-1200

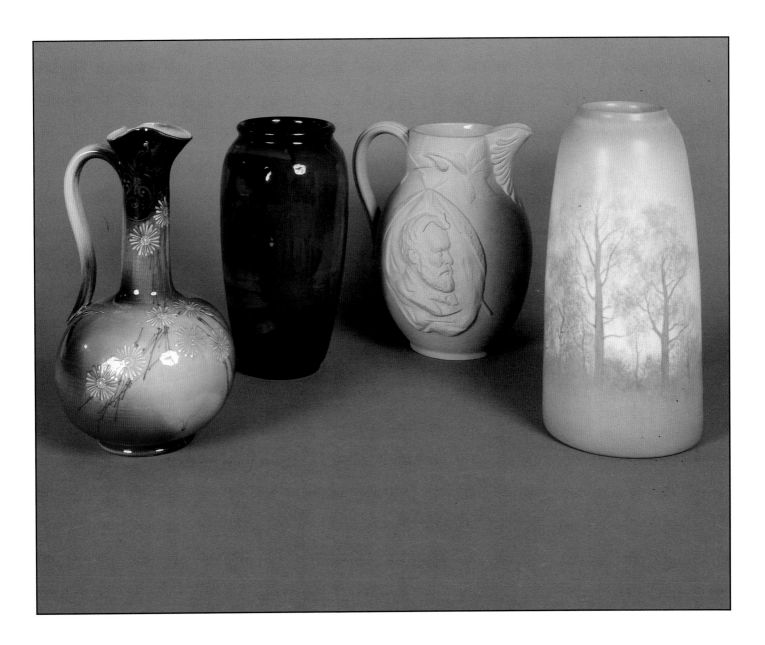

404 Standard glaze ewer decorated with stylized daisies by Albert R. Valentien in 1888. Marks on the base include the Rookwood logo, the date, shape number 101A, the artist's initials and L for light standard glaze. Height 11 inches. $1200-1400

405 Rare Sea Green glaze scenic vase, painted with a moonlit sailing ship by Sturgis Laurence in 1902. Marks on the base include the Rookwood logo, the date, shape number 892 B, a small wheel ground X, the artist's initials, and G for Sea Green glaze. Height 10 inches. Some scratches on the glaze. $3000-5000

406 Garfield memorial pitcher designed by Ferdinand Mersman and produced at Rookwood in 1881. Marks on the base include the Rookwood ribbon trademark. Height 9½ inches. $1000-1500

407 Large Vellum glaze scenic vase, decorated with trees at dawn by Kataro Shirayamadani in 1911. Marks on the base include the Rookwood logo, the date, shape number 1654 C, V for Vellum glaze body and the artist's cypher. Height 11¾ inches. $3000-4000

SATURDAY
JUNE 8th
1991
LOTS 408-804

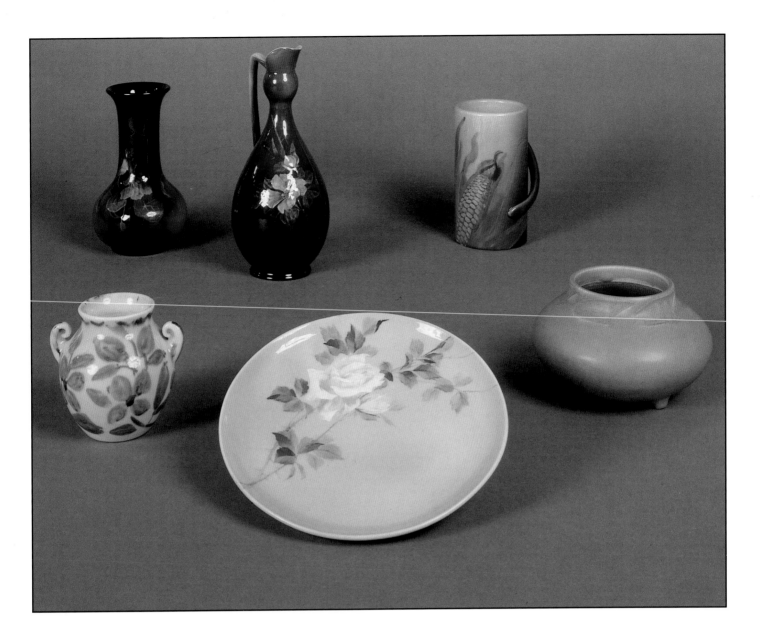

408 High glaze vase with two small curled handles and blue flowers decorated by Jens Jensen in 1946. Marks on the base include the Rookwood logo, the date, shape number 6802 and the artist's initials. Height 3⅞ inches. $300-400

409 Standard glaze vase with nasturtium decoration, painted by Sara Sax in 1897. Marks on the base include the Rookwood logo, the date, shape number 486 E, a small diamond shaped esoteric mark and the artist's monogram. Height 7 inches. $400-600

410 Standard glaze ewer decorated with flowers on a thorned stem by Luella Perkins in 1889. Marks on the base include the Rookwood logo, the date, shape number 830, S for sage clay, the artist's initials and L for light Standard glaze. Height 9¼ inches. A few small glaze bubbles under the spout. $600-800

411 Cameo glaze plate decorated with roses by Harriet Wilcox in 1890. Marks on base include the Rookwood logo, the date, shape number 224, W for white clay and the artist's initials. Diameter 8⅛ inches. $300-400

412 Standard glaze mug decorated with corn by Jeanette Swing in 1903. Marks on the base include the Rookwood logo, the date, shape number 328 B and the artist's initials. Height 6 inches. Minor glaze skip near rim. $300-500

413 Mat glaze bowl decorated by William Hentschel with a band of stylized leaves around the collar. Marks on the base include the Rookwood logo, the date, shape number 1348 and the artist's initials. Height 3¼ inches. $250-350

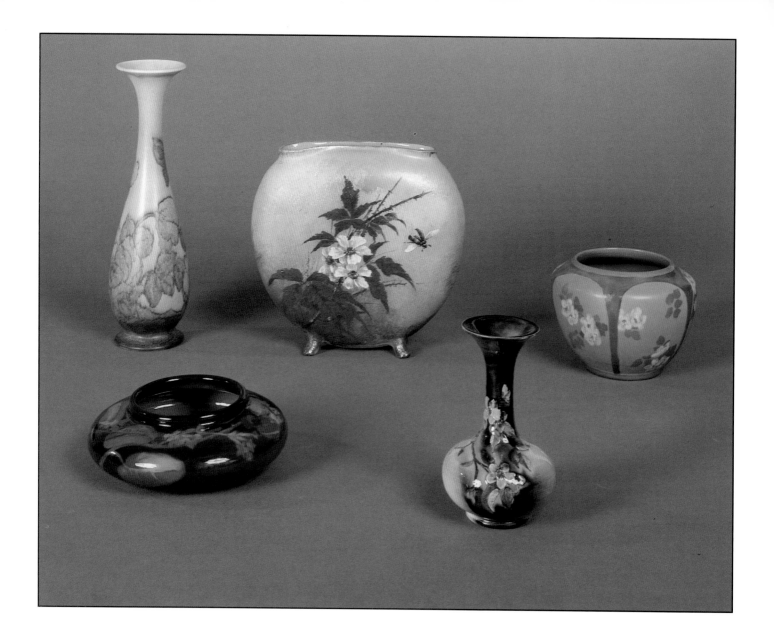

414 Mat glaze vase with floral decoration, painted by Katherine Jones in 1924. Marks on the base include the Rookwood logo, the date, shape number 2545 C and the artist's initials. Height 10¾ inches. $300-500

415 Standard glaze bowl with trumpet creepers decorated by Marianne Mitchell in 1902. Marks on the base include the Rookwood logo, the date, shape number 923, and the artist's initials. Height 2⅛ inches. $250-350

416 Bisque finish pocket vase with four feet, decorated with wild roses and a blue beetle by Albert Valentien in 1883. Marks on the base include Rookwood in block letters, the date, shape 90, G for ginger clay, and the artist's initials. Height 7⅞ inches. $700-900

417 Standard glaze vase decorated with blossoms by Kate Matchette in 1892. Marks on the base include the Rookwood logo, the date, shape number 584 C, W for white clay and the artist's initials. Height 5¼ inches. $250-350

418 Vellum glaze bowl decorated with cherry blossoms by Margaret McDonald in 1917. Marks on the base include the Rookwood logo, the date, shape number 1927, V for Vellum glaze and the artist's monogram. Height 4 inches. $400-600

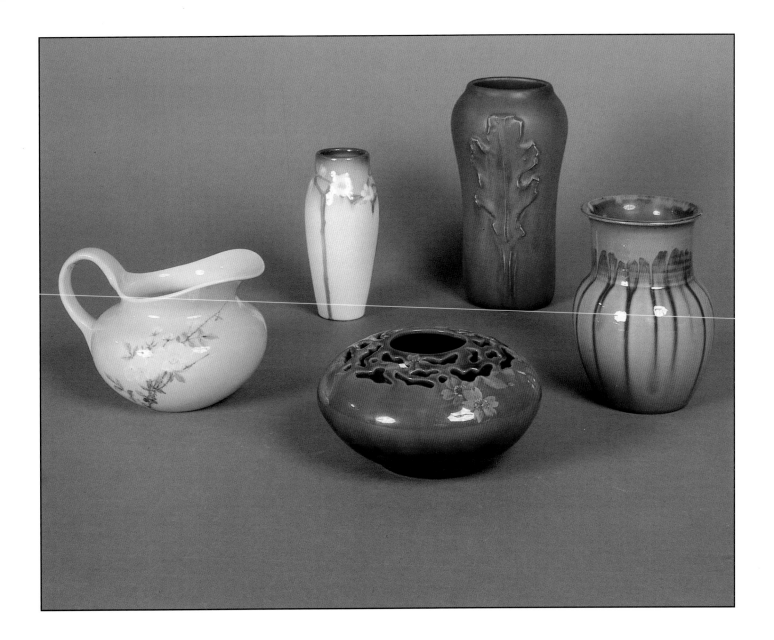

419 Cameo glaze pitcher decorated with white wild roses by Anna Valentien in 1887. Marks on the base include the Rookwood logo, the date, shape number 206, W for white clay, the artist's initials and W for white glaze. Height 4¾ inches. Cameo glaze is a forerunner of Rookwood's Iris glaze. $600-800

420 Iris glaze vase by Sallie Coyne, decorated with cherry blossoms and branches in 1906. Marks on the base include the Rookwood logo, the date, shape number 30 F and the artist's initials. Height 6½ inches. Line at rim. $200-300

421 Standard glaze reticulated bowl decorated with wild roses. Marks on the base include the Rookwood logo, the date, shape number 452, and R for red clay. Large areas of goldstone on lower portion of bowl. Height 3¼ inches. $500-700

422 Mat glaze vase with two large modeled oak leaves done by Albert Pons in 1907. Marks on the base include the Rookwood logo, the date, shape number 935 C and the artist's initials. Height 8¾ inches. $400-600

423 Vase with exotic glazes done in 1932. Marks on the base include the Rookwood logo, the date, and shape number 6315. Height 6⅛ inches. $300-500

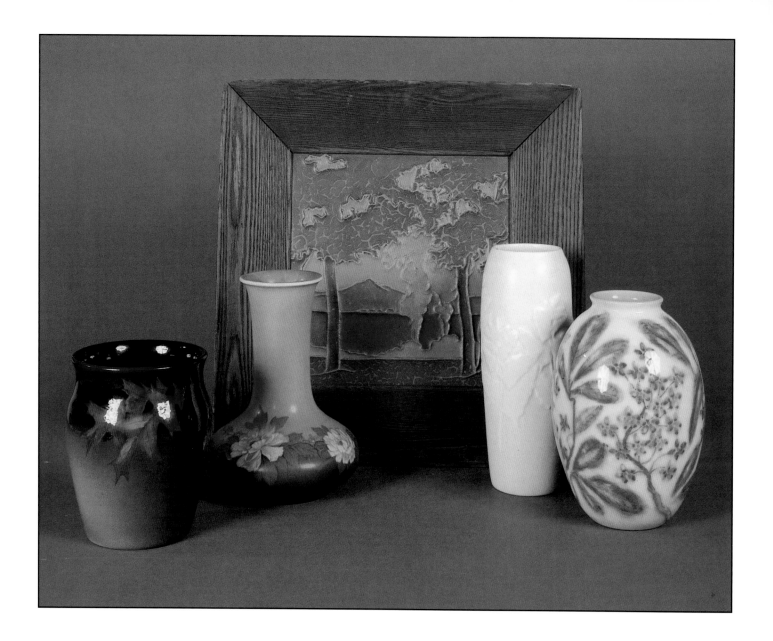

424 Standard glaze vase decorated with oak leaves and acorns by Lenore Asbury. Marks on the base include the Rookwood logo, the date, shape number S 1440 and the artist's initials. Height 7¼ inches. Drilled. $300-500

425 Vellum glaze vase decorated with pink and blue flowers by Lenore Asbury in 1925. Marks on the base include the Rookwood logo, the date, shape number 670 C, the artist's initials and V for Vellum glaze. Height 10 inches. Uncrazed. $1200-1500

426 Rookwood Architectural Faience tile in mat glaze, produced circa 1915. Impressed on the back are the words, Rookwood Faience 1226 YL. Size 12 x 12 inches. $1000-1500

427 Tall commercial ware vase with white fern leaves in high relief on a yellow ground, done in 1935. Marks on the base include the Rookwood logo, the date and shape number 2482. Height 11¼ inches. $200-300

428 High glaze vase decorated by Jens Jensen in 1948 with small blue flowers and green leaves. Marks on the base include the Rookwood logo, the date, shape number 6184 C, an inscribed circle and the artist's initials. Height 9¾ inches. $700-900

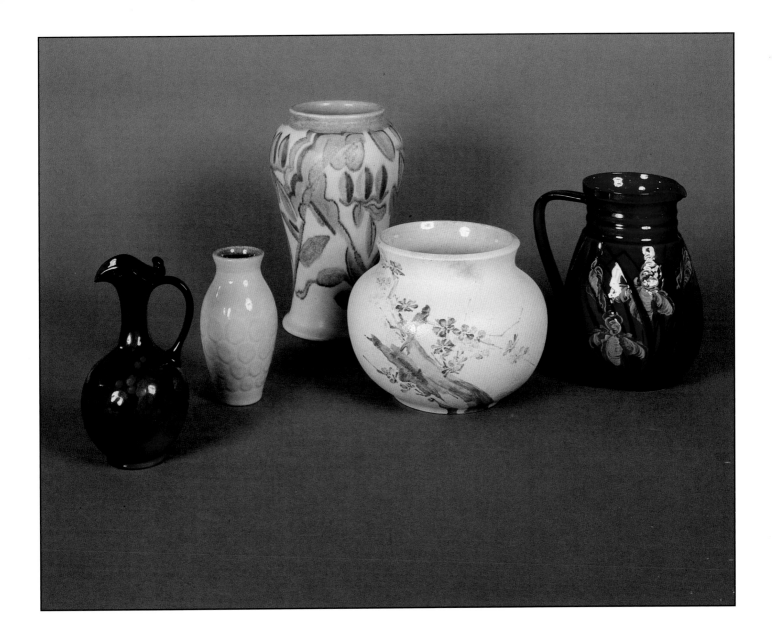

429 Standard glaze ewer with holly decoration, done in 1902 by Elizabeth Lincoln. Marks on the base include the $300-500
 Rookwood logo, the date, shape number 617 F and the artist's initials. Height 7¾ inches.

430 High glaze vase decorated with art deco design by Wilhelmine Rehm in 1929. Marks on the base include the $200-300
 Rookwood logo, the date, shape number 356 F and the artist's initials. Height 5⅜ inches.

431 Mat glaze vase decorated with stylized flowers by Wilhelmine Rehm in 1929. Marks on the base include the $600-800
 Rookwood logo, the date, shape number 945 and the artist's initials. Height 9½ inches.

432 Bisque finish vase by Laura Fry, decorated in 1886 with flowers and a twisted branch. Marks on the base include $400-600
 Rookwood in block letters, the date, shape number 268 C, Y for yellow clay and the artist's initials. Height 6 inches.

433 Standard glaze pitcher decorated with yellow irises by M.A. Daly in 1885. Marks on the base include Rookwood $700-900
 in block letters, the date, shape number 64 A, R for red clay and the artist's initials. Height 7¾ inches. Some burst
 glaze bubbles on surface.

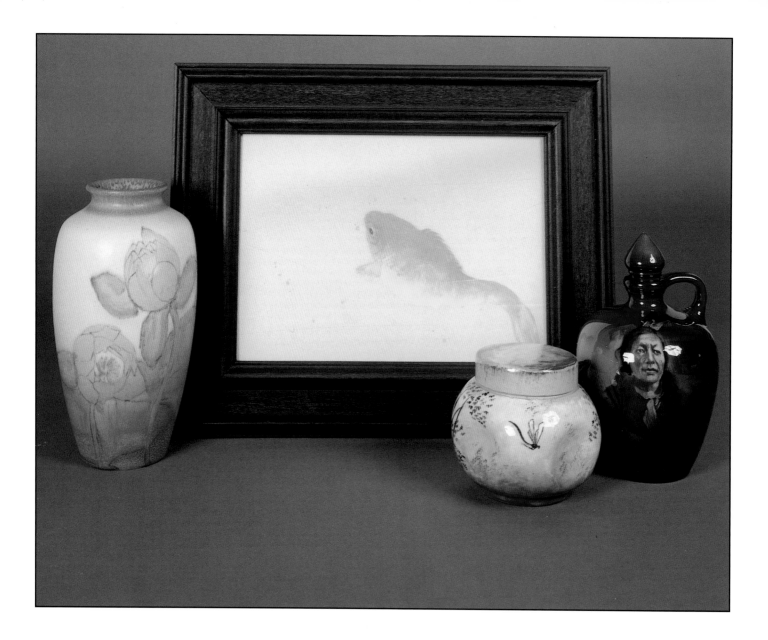

434 Mat glaze vase with floral decoration, done by Sallie Coyne in 1930. Marks on the base include the Rookwood logo, date, artist's initials, and shape number 614D. Height 10½ inches. Glaze peppering. $700-900

435 Rare and important mat glaze plaque decorated with fish by Albert Valentien in 1901. Marks on the back include the Rookwood logo, the date, shape number X 499 AX and the artist's initials. Size 9⅞ x 13⅞ inches. Some burst glaze bubbles appear on the surface. $5000-7000

436 Limoges style glaze lidded jar with bamboo and dragonflies decorated by N.J. Hirschfeld in 1883. Marks on the base include Rookwood in block letters, the date, shape 97, G for ginger clay, a small kiln mark, and the artist's initials. Height 5 inches. $500-700

437 Standard glazed stoppered jug decorated with the portrait of a Native American by Sallie Toohey in 1897. The base includes the Rookwood logo, date, artist's initials, shape number 512B, an esoteric triangle, an original Rookwood label, and an inscription "Fire Lightning". Height 9 inches. $3000-4000

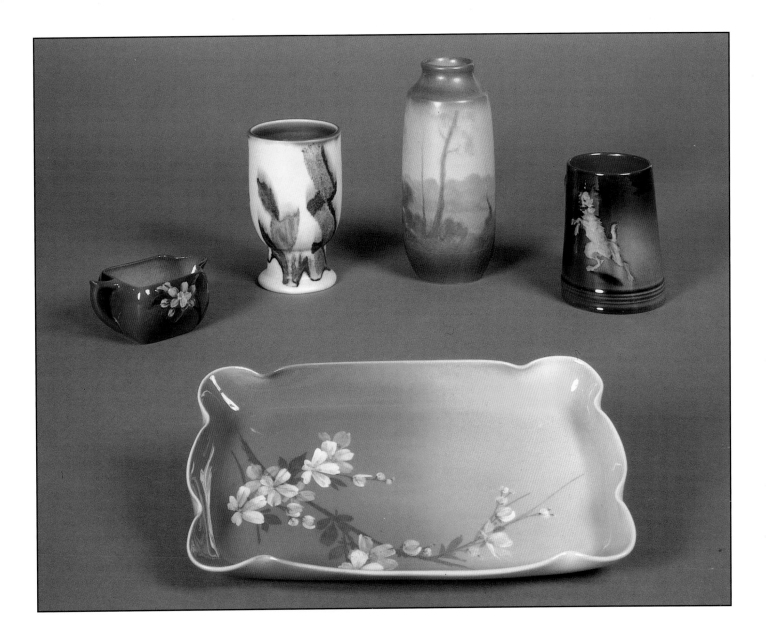

438　Standard glaze creamer decorated by Carrie Steinle in 1892 with fruit blossoms. Marks on the base include the Rookwood logo, the date, shape number 43, W for white clay and the artist's initials. Height 2 inches. $150-200

439　Mat glaze flower vase with geometric patterns, done by Janet Harris in 1930. Marks on the base include the Rookwood logo, the date, shape number 6185 F, a small wheel ground X and the artist's initials. Height 5½ inches. $200-300

440　Vellum glaze vase painted with a woodland scene by Fred Rothenbusch in 1917. Marks on the base include the Rookwood logo, the date, shape number 2061, a small V shaped esoteric mark, a small wheel ground X and the artist's initials. Height 7¼ inches. Glaze dimple. $700-900

441　Standard glaze mug decorated with a portrait of a barking dog by Harriet Wilcox in 1891. Marks on the base include the Rookwood logo, the date, shape number 587, W for white clay, the artist's initials and L for light Standard glaze. Height 4½ inches. Crack at rim in the back near the handle. $400-600

442　Cameo glaze tray decorated with apple blossoms by Sallie Toohey circa 1886. Marks on the reverse include the shape number 591 C, the artist's initials and W for white glaze. Length 11 inches, width 6¼ inches. The Rookwood logo is not visible on this piece. $300-500

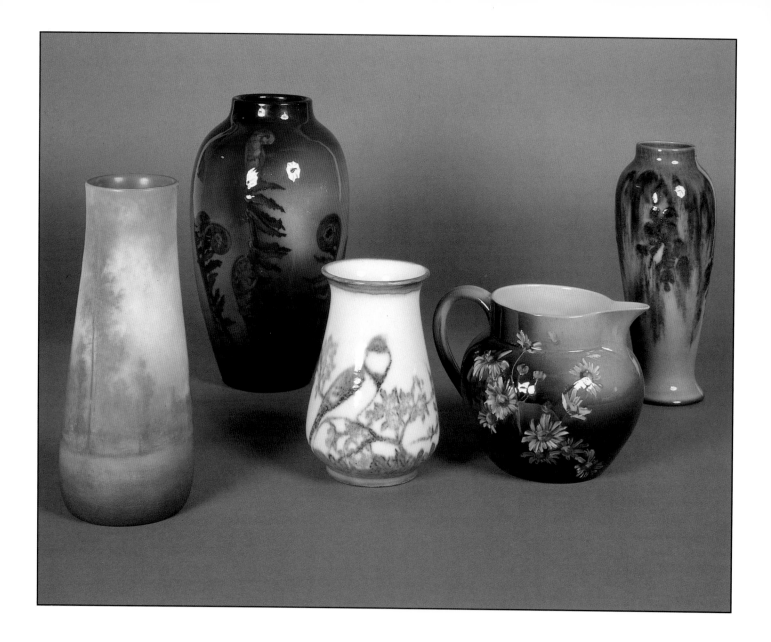

443 Tall Vellum glaze vase painted with an autumn woodland scene and high clouds by Ed Diers in 1916. Marks on the base include the Rookwood logo, the date, shape number 950 C, a small V shaped esoteric mark and the artist's initials. Height 11 inches. $1500-2500

444 Standard glazed vase decorated with ferns by John Dee Wareham in 1901. The base includes the Rookwood logo, date, artist's initials, shape number 900A, and a wheel ground X. Height 12½ inches. A tight 6 inch crack is visible from the inside, but is almost impossible to feel on the outside. $600-800

445 High glaze vase with exotic foliage and two blue birds, decorated by E.T. Hurley in 1945. Marks on the base include the Rookwood logo, the date, shape number 6359, the artist's initials and the number 5256 which appears twice. Height 7 inches. $500-700

446 Standard glaze pitcher decorated with yellow daisies by Sallie Toohey in 1891. Marks on the base include the Rookwood logo, the date, shape number 13, W for white clay, the artist's initials and L for light Standard glaze. Height 6⅛ inches. $600-800

447 Green tinted high glaze vase decorated by E.T. Hurley in 1924 with wisteria. Marks on the base include the Rookwood logo, the date, a mostly obliterated shape number and the artist's initials. Height 10⅞ inches. Drilled. $300-400

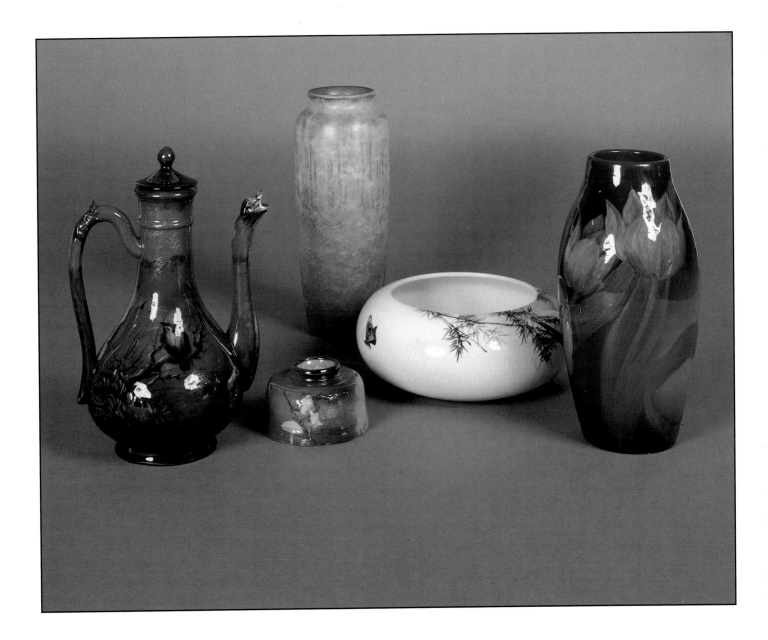

448 Limoges style glaze Turkish coffee pot decorated with several flying bats and an owl perched in a large tree. $900-1200
Marks on the base include Rookwood in block letters, the date, shape number 51, an embossed anchor mark and
the artist's initials. Height 10½ inches. Small burst glaze bubble. While a nice fit, the top is from another piece.

449 Standard glaze inkwell with a single dancing frog decorated circa 1895 by an unknown artist. Marks on the base $200-300
are completely obscured. Height 2⅛ inches. Lid missing.

450 Unusual Vellum glazed vase decorated with a fall forest scene by E.T. Hurley in 1908. The base includes the $2000-2500
Rookwood logo, date, artist's initials, shape number 904CC, and V for vellum. Height 10½ inches.

451 Early high glaze bowl decorated with bamboo and a single flying butterfly by Laura Fry in 1885. Marks on the $400-600
base include Rookwood in block letters, the date, shape number 214 A, W for white clay and the artist's initials.
Height 3½ inches. Some old spider cracks.

452 Standard glaze vase with orange tulips decorated by E.T. Hurley in 1903. Marks on the base include the $600-800
Rookwood logo, the date, shape number 939 B and the artist's initials. Height 10 inches.

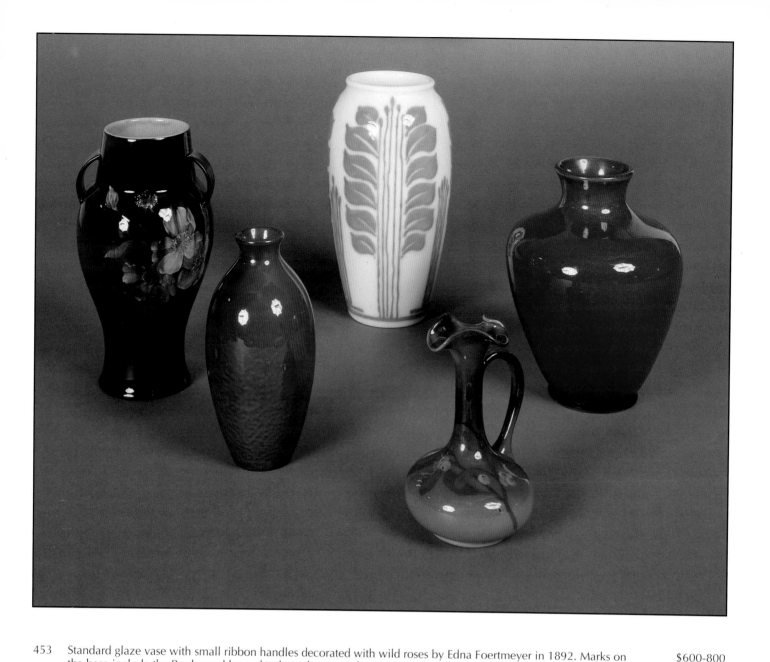

453 Standard glaze vase with small ribbon handles decorated with wild roses by Edna Foertmeyer in 1892. Marks on the base include the Rookwood logo, the date, shape number 533 C, S for sage green clay and the artist's initials. Height 8⅛ inches. $600-800

454 Standard glaze vase with much Tiger Eye effect, done circa 1895 by an unknown artist. Marks on the base include the Rookwood logo, the partially obscured date and the shape number 732 C. Height 6⅛ inches. Minor glaze flaw on side. $150-250

455 High glaze vase decorated with stylized leaf patterns by Margaret McDonald in 1936. Marks on the base include the Rookwood logo, the date, shape number 892 C and the artist's initials. Height 8¼ inches. $400-600

456 Standard glaze ewer with mistletoe decoration done by Laura Lindeman in 1900. Marks on the base include the Rookwood logo, the date, shape number 584 C, a wheel ground X and the artist's initials. Height 5⅛ inches. $250-350

457 Coromandel vase with cast hole in base, made at Rookwood in 1939. Marks on the base include the Rookwood logo, the date and shape number 6311. Height 7½ inches. Minor glaze bubbles. Cast hole. $300-400

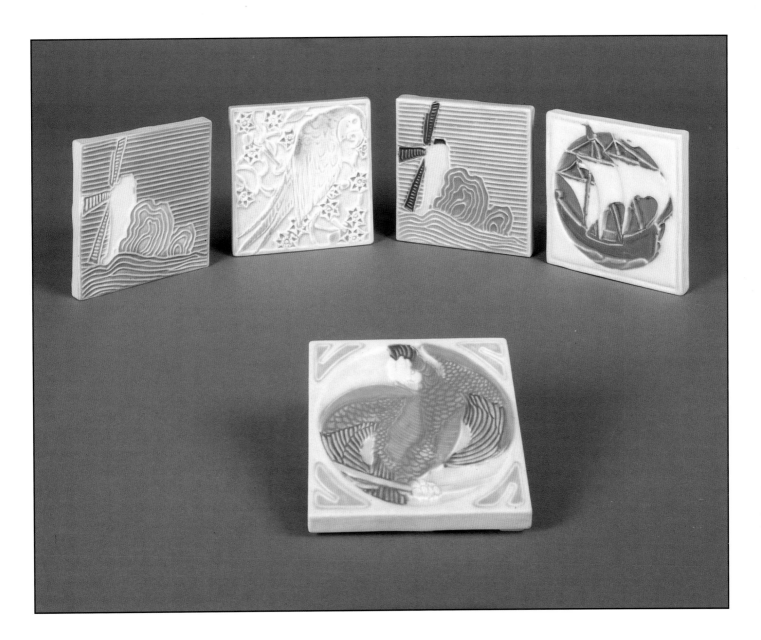

458 Rookwood trivet decorated in 1921 with a Dutch scene. Marks on the reverse include the Rookwood logo, the date and the shape number 1201. Size is 5⅝ by 5⅝ inches. $150-250

459 Rookwood trivet with a parrot in exotic foliage made in 1930. Marks on the reverse include the Rookwood logo, the date, shape number 3077, and a small esoteric mark. Size is 5⅝ by 5⅝ inches. $250-350

460 Rookwood trivet with Dutch Scene made in 1920. Marks on the reverse include the Rookwood logo, the date, a wheel ground X and the shape number 1201. Size is 5⅝ by 5⅝ inches. Crack at edge. $100-200

461 Rookwood trivet decorated with a sailing ship. Marks on reverse include the Rookwood logo, the date, and shape number 1378 E. Size 5¼ by 5¼ inches. $150-250

462 Rookwood trivet decorated with a green parrot made in 1925. Marks on the reverse include the Rookwood logo, the date, and shape number 2043. Size is 5⅝ by 5⅝ inches. $250-350

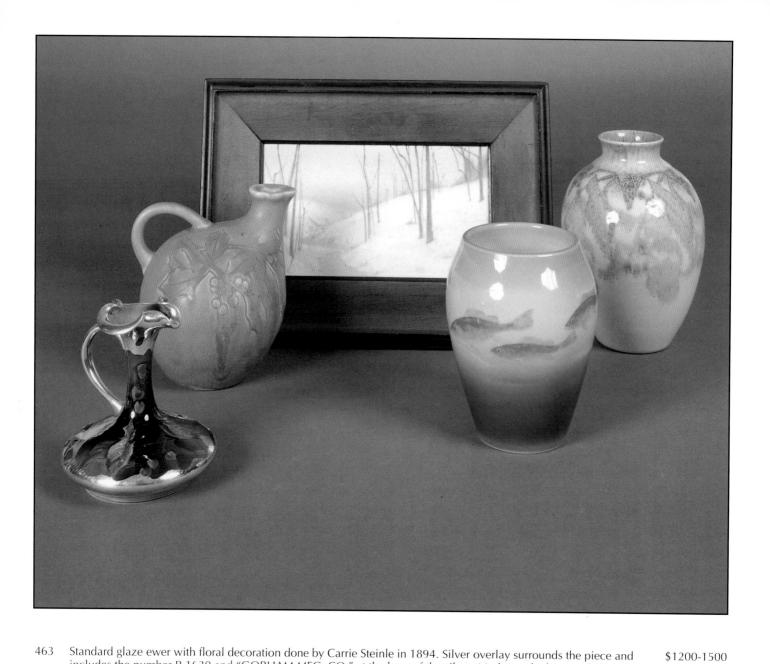

463 Standard glaze ewer with floral decoration done by Carrie Steinle in 1894. Silver overlay surrounds the piece and $1200-1500
includes the number R.1630 and "GORHAM MFG. CO." at the base of the silver. Marks on the base include the
Rookwood logo, the date, shape number 715 E and the artist's initials. Height 5⅛ inches. Cracks in the rim are
mostly covered by the silver overlay.

464 Mat glaze jug decorated with stylized holly by Albert Pons in 1907. Marks on the base include the Rookwood $300-400
logo, the date, shape number 691 and the artist's initials. Height 6⅛ inches.

465 Vellum glaze scenic plaque decorated by Sara Sax in 1914. The artist's name appears in the lower right hand $1750-2250
corner. Marks on the base include the Rookwood logo, the date, V for Vellum glaze body and a title in pencil,
"Cold Morning". Size 5 x 9⅛ inches. A small chip on the lower left corner is covered by the frame.

466 Iris glazed vase decorated with five fish by E.T. Hurley in 1904. The base includes the Rookwood logo, date, $2500-3500
artist's initials, W for white glaze, the shape number 942C, 256. Height 6¼ inches.

467 High glazed vase decorated by Sara Sax in 1931. The base includes the Rookwood logo, date, artist's monogram, $700-900
shape number 902D, and an esoteric mark. Height 7¾ inches.

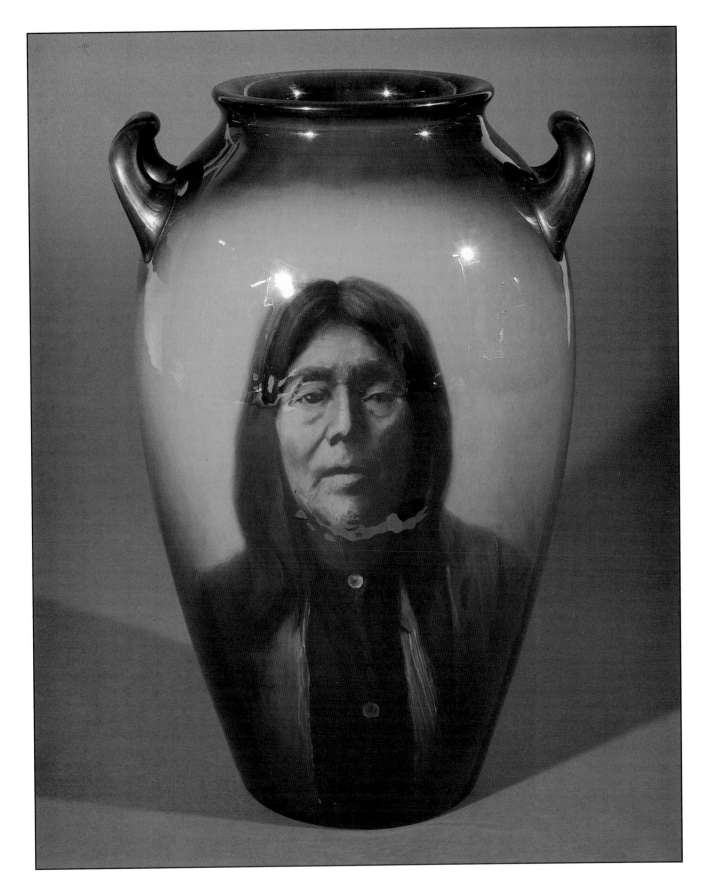

468 Large and important Standard glaze vase decorated by M.A. Daly in 1899 depicting a Native American woman. $15000-25000
The vase has two small loop handles on its shoulder which have been clad in copper. Marks on the base include
the Rookwood logo, the date, shape number 581 C, the artist's full name and the title, Ekickai Woman Wichita.
Height 13⅞ inches.

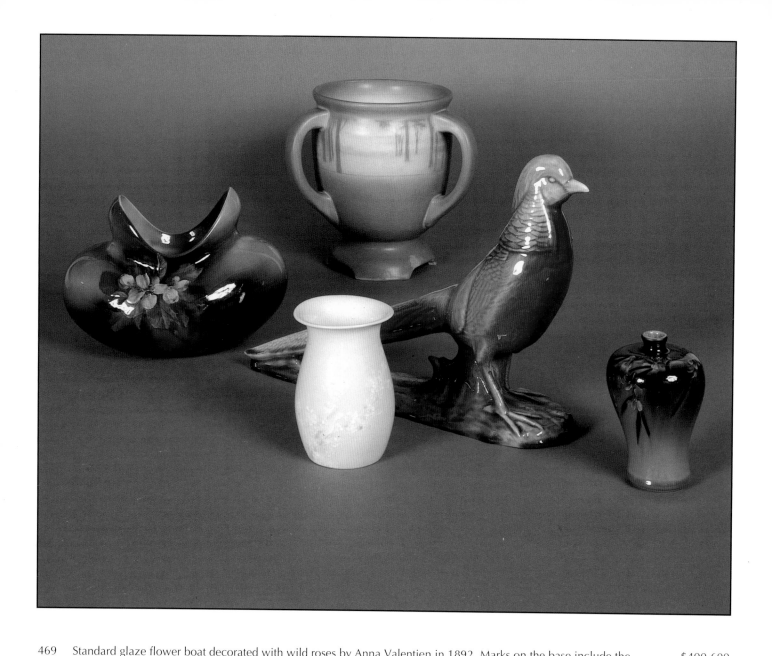

469 Standard glaze flower boat decorated with wild roses by Anna Valentien in 1892. Marks on the base include the Rookwood logo, the date, shape number 628 C, and the artist's initials. Height 6 inches. $400-600

470 Cameo glaze vase with prunus blossom decor, done by an unknown artist in 1887. Marks on the base include Rookwood in block letters, the Rookwood logo, the date, shape number 206 and an obscured mark which may be the artist's initials. Height 4½ inches. $300-400

471 Large polychromed pheasant in high glaze done in 1949. Marks on the base include the Rookwood logo, the date and shape number 2832. Height 8⅛ inches. $400-600

472 Vellum glaze three handled loving cup, decorated in 1909 by Lenore Asbury with a banded woodland scene in the arts and crafts style. Marks on the base include the Rookwood logo, the date, shape number 1818, a small V shaped esoteric mark, the artist's initials and V for vellum glaze. Height 8⅛ inches. $900-1200

473 Standard glaze vase decorated with small flowers by Helen Stuntz in 1895. Marks on the base include the Rookwood logo, the date, shape number 751 and the artist's initials. Height 4¼ inches. $200-300

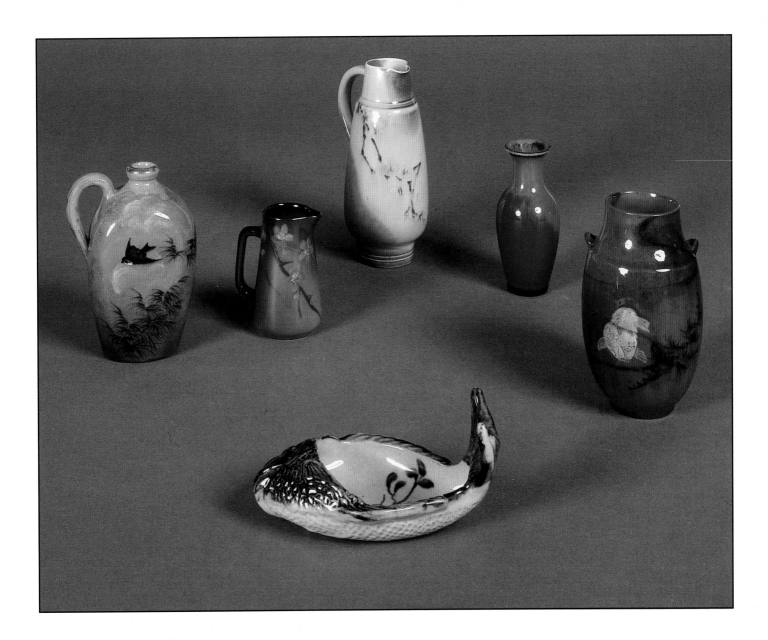

474 Limoges style glaze perfume jug decorated with bamboo and small birds by Albert Valentien in 1884. Marks on the base include Rookwood in block letters, the date, shape number 60, G for ginger clay and the artist's initials. Height 4⅝ inches. $300-500

475 Small standard glaze pitcher decorated by Sallie Toohey in 1899 with cherry blossoms. Marks on the base include the Rookwood logo, the date, shape number 769 and the artist's initials. Height 3⅛ inches. $150-200

476 Standard glaze pitcher with floral decoration done by Anna Bookprinter in 1887. Marks on the base include the Rookwood logo, the date, shape number 220, W 7 for a type of white clay and the artist's initials. Height 6 inches. $200-300

477 High glaze fish "Entree Dish" decorated by Martin Rettig in 1884. Marks on the base include Rookwood in block letters, the date, shape number 53, S for sage green clay and the artist's initials. Height 2¼ inches, length 5¼ inches. $400-600

478 Small high glaze vase decorated with coromandel type glaze in 1932. Marks on the base include the Rookwood logo, the date and a shape number which is obscured by the glaze. Height 4 inches. $100-150

479 Standard glaze vase with two tiny loop handles decorated in an oriental manner with a single swimming fish by Martin Rettig in 1885. Marks on the base include Rookwood in block letters, the date, shape number 77, R for red clay and the artist's initials. Height 4⅞ inches. One handle has been repaired. $400-500

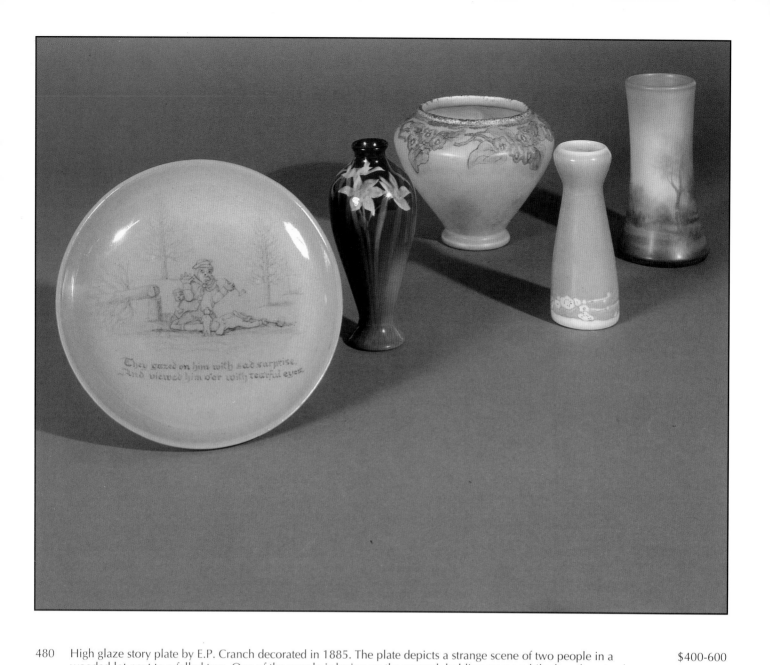

480 High glaze story plate by E.P. Cranch decorated in 1885. The plate depicts a strange scene of two people in a $400-600
 wooded lot next to a felled tree. One of the people is laying on the ground, holding an ax, while the other stands
 over the first while holding a pipe. A small boy looks from behind the standing figure and a small dog stands on
 the prone figure. The following verse is inscribed below the scene: "They gazed on him with sad surprise. And
 viewed him o'er with tearful eyes." Marks on the reverse include Rookwood in block letters, the date, shape number
 45 C, the artist's initials and the following note: "American Ballads No 1 Isaac Abbott". Diameter is 9⅛ inches.

481 Standard glazed vase decorated with daffodills by Sallie Coyne in 1898. The base includes the Rookwood logo, $300-400
 date, artist's initials, and shape number 842C. Height 7 inches.

482 Mat glaze vase decorated with red flowers and green leaves by Catherine Covalenco in 1925. Marks on the base $300-400
 include the Rookwood logo, the date, shape number 1848, and the artist's initials. Height 5¾ inches.

483 Incised floral high glazed vase decorated by Katherine Van Horne in 1911. Marks on the base include the $300-500
 Rookwood logo, the date, shape number 1656 F and the artist's initials. Height 6¼ inches.

484 Vellum glaze vase with scenic decoration, done by Rothenbusch in 1923. Marks on the base include the $900-1200
 Rookwood logo, the date, shape number 1358 E, the artist's initials and V for Vellum glaze. Height 7⅛ inches.
 One small glaze dimple but otherwise uncrazed.

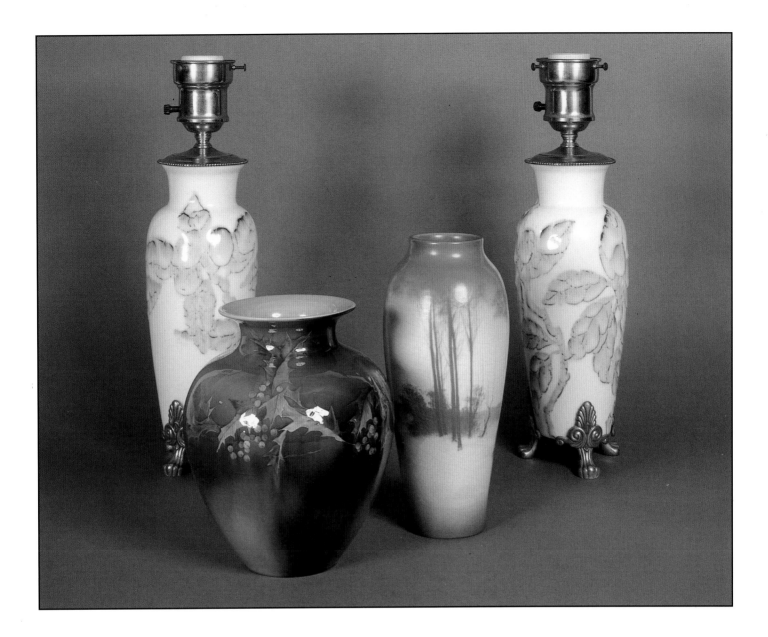

485 High glaze vase made as a lamp at Rookwood in 1948. The vase was decorated by Elizabeth Barrett with gray and redish leaves on a white ground. Marks on the base include the Rookwood logo, the date, shape number 2785 and the artist's monogram. Height of pottery portion is 13 inches. Rookwood made many lamps in the late 40's using fittings from Crest Lamp Company. Most of these lamps use an oversize, three way bulb in a "mogul" base socket and have glass diffusers on which the shade rests. — $400-600

486 Large and impressive Standard glaze vase decorated with holly by Kataro Shirayamadani in 1890. Marks on the base include the Rookwood logo, the date, shape number 488 F, W for white clay, the artist's cypher and L for light Standard glaze. Height 9¾ inches. — $2000-$2500

487 Vellum glazed scenic vase decorated with snow scene with trees and lake by E. T. Hurley in 1917. The base includes the Rookwood logo, date, artist's initials, shape number 901B, and drilled hole for lamp. Height 11¾ inches. — $1000-1500

488 Same as item number 485. — $400-600

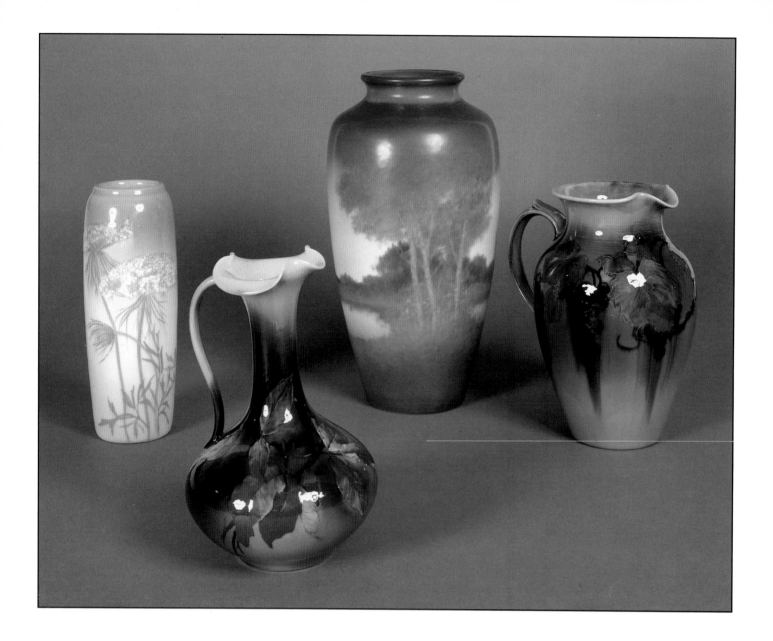

489 Iris glazed vase decorated with Queen Anne's Lace by Sallie Coyne in 1907. The base includes the Rookwood logo, date, artist's initials, and shape number 951C. Height 10½ inches. $3000-$4000

490 Standard glaze ewer decorated by Harriet Strafer in 1892 with chestnut leaves, branches and one chestnut. Marks on the base include the Rookwood logo, the date, shape number 537 D, W for white clay, the artist's initials and L for light Standard glaze. Height 10 inches. $600-800

491 Vellum glazed scenic vase decorated with trees surrounding a pond by E. T. Hurley in 1929. The base includes the Rookwood logo, date, artist's initials, and shape number 614B. Height 14½ inches. Uncrazed. $5000-7000

492 Standard glaze pitcher decorated with grape leaves, vines and fruit by Edward Abel in 1892. Marks on the base include the Rookwood logo, the date, shape number 422, W for white clay, the artist's initials and L for light Standard glaze. Height 10 inches. $800-1000

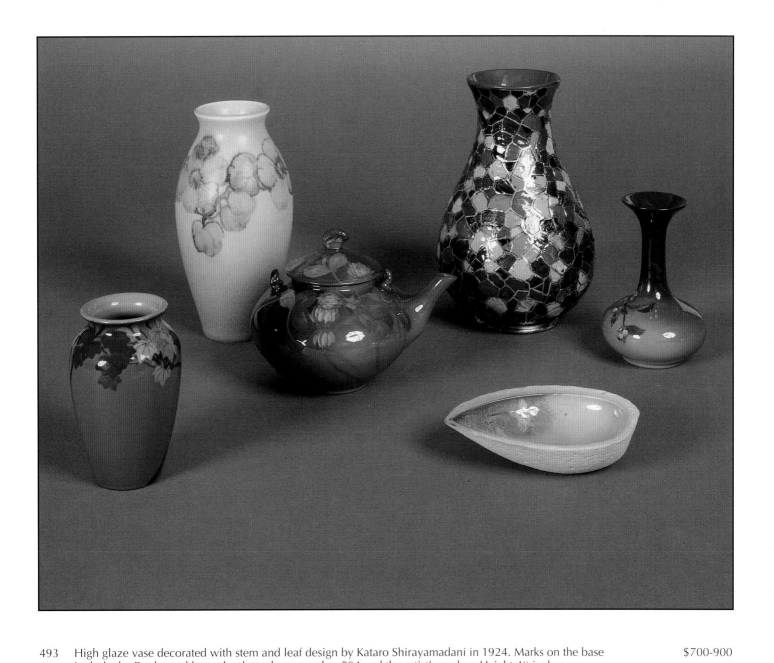

493 High glaze vase decorated with stem and leaf design by Kataro Shirayamadani in 1924. Marks on the base include the Rookwood logo, the date, shape number 594 and the artist's cypher. Height 4¾ inches. $700-900

494 Mat glaze floral vase decorated by Katherine Jones in 1926. Marks on the base include the Rookwood logo, the date, shape number 366 D and the artist's initials. Height 8⅛ inches. $300-400

495 Standard glaze lidded teapot decorated with clover by Carrie Steinle in 1904. The clover decoration appears on the top as well as the base. Marks on the base include the Rookwood logo, the date, shape number 404, a small wheel ground X and the artist's initials. Height 4⅞ inches. Would have originally come with a wicker handle. Repaired. $200-300

496 Limoges style vase decorated by Mary Louise McLaughlin in 1883 to resemble a mosaic, with a multicolored pattern divided by fired on gold lines. Marks on the base include Rookwood in block letters, the date, R for red clay and the inscription: "M.L. McLaughlin Cinti 1883 CPC". Height 8⅞ inches. $700-900

497 A bisque and Standard glazed almond dish decorated by an unknown artist with the initials G.M.Y. in 1886. Marks on the base include the Rookwood logo, the date, shape number 279, Y for yellow clay and the artist's initials. Height 1¼, width 5⅞ inches. $200-300

498 Standard glaze vase with leaves and berries, done by Elizabeth Lincoln in 1896. Marks on the base include the Rookwood logo, the date, shape number 534 C and the artist's initials. Height 5½ inches. $250-350

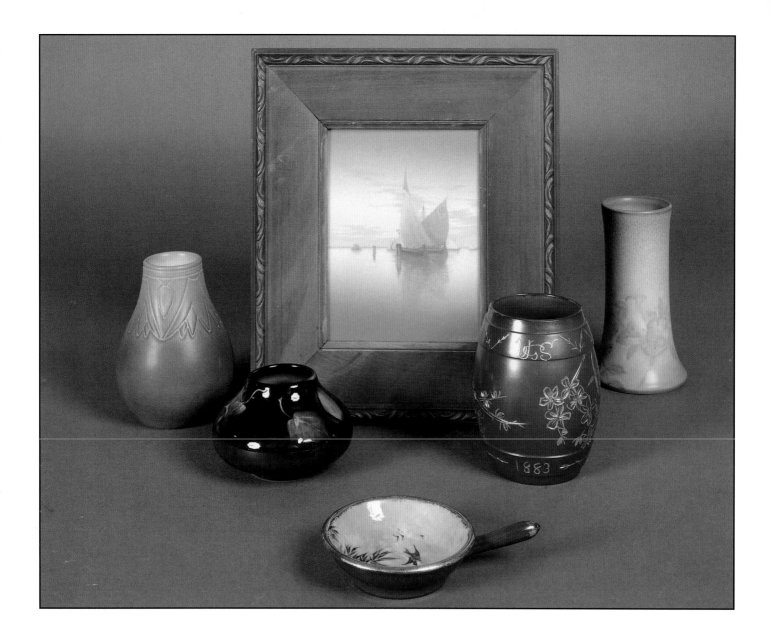

499 Vellum glaze vase with incised decoration near the top, done by Sara Sax in 1904. Marks on the base include the Rookwood logo, the date, shape number 969 C, V for Vellum glaze body, and the artist's monogram. Height 6 inches. $300-500

500 Standard glaze squat vase decorated with autumn leaves by an artist whose initials appear to be K.H.L. Marks on the base include the Rookwood logo, the date, shape number 536 E and the artist's initials. Height 3⅛ inches. $200-300

501 Limoges style glaze ramekin, decorated by Albert Valentien in 1882 with oriental grasses and a small bird. Marks on the reverse include Rookwood in block letters, the date, shape number 198, R for red clay and the artist's initials. Height 1¼ inches, length is 6½ inches. $250-450

502 Vellum glaze scenic plaque done by Carl Schmidt in 1919. The artist's name appears in the lower right hand corner. Marks on the back include the Rookwood logo and the date. Size 8 x 6⅛ inches. $3500-4500

503 A bisque finish mug incised by J.C. Meyenberg whose initials appear on the side near the base of the handle along with the incised date, 1883. The date and intertwined initials U S G are carved into bands surrounding the mug at top and bottom. Marks on the base include Rookwood in block letters, the date, R for red clay and a label in David Glover's hand. Height 5½ inches. Mr. Glover felt this mug was made for U.S. Grant. $700-900

504 Mat glaze vase decorated with trumpet vines by Kataro Shirayamadani in 1940. Marks on the base include the Rookwood logo, the date, shape number 1358 E and the artist's cipher. Height 7⅛ inches. $500-700

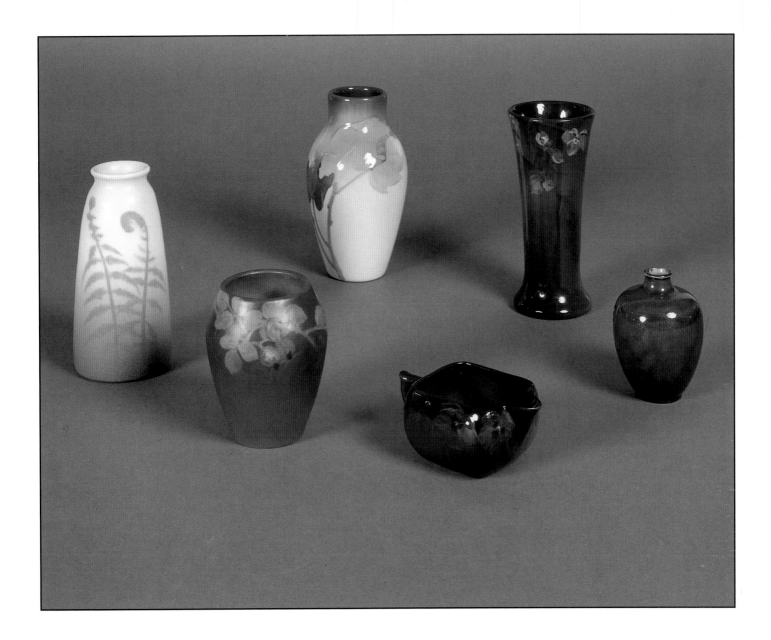

505 Vellum glaze vase with fern decoration, done by Katherine Van Horne in 1909. Marks on the base include the Rookwood logo, the date, shape number 1658 F, V for vellum glaze body, the artist's initials and V for Vellum glaze. Height 6½ inches. $300-500

506 Small painted mat glaze vase with rose hip decoration, done by Olga Geneva Reed in 1904. Marks on the base include the Rookwood logo, the date, shape number 31 EZ and the artist's initials. Height 4½ inches. $400-600

507 Iris glazed vase decorated with grape leaves by Rose Fechheimer in 1903. The base includes the Rookwood logo, date, artist's initials, W for white glaze, and the shape number 826D. Height 7 inches. $600-800

508 Standard glaze creamer with pansy decoration, done by Leona Van Briggle in 1902. Marks on the base include the Rookwood logo, the date, shape number 43 and the artist's initials. Height 2 inches, $150-200

509 Very late Standard glaze vase decorated by Katherine Van Horne with fruit blossoms in 1909. Marks on the base include the Rookwood logo, the date, shape number 1357 E, the artist's initials and the remnant of a paper sales label. Height 7 inches. $300-500

510 Small coromandel vase with much Goldstone effect done at Rookwood in 1932. Marks on the base include the Rookwood logo, the date and the shape number 637 F. Height 3¼ inches. $150-250

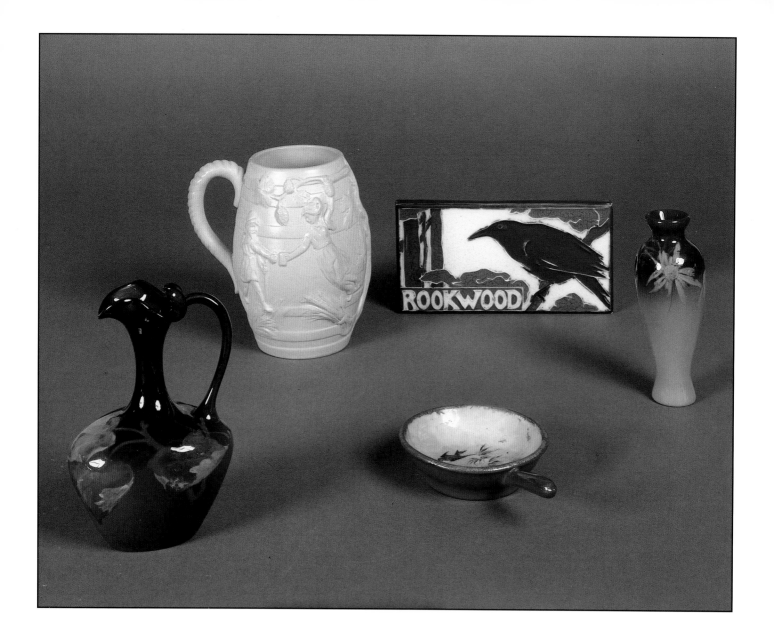

511 Standard glaze ewer decorated with maple leaves by Clara Lindeman in 1902. Marks on the base include the Rookwood logo, the date, shape number 754 and the artist's initials. Height 6¾ inches. $300-400

512 Salt glaze advertising mug made in 1882 for Cincinnati Cooperage Company whose name appears on the side. Marks on the base include the Rookwood logo ribbon mark and the date. Height 6⅞ inches. $500-700

513 Limoges style glaze ramekin decorated with bamboo and a small bird by Albert Valentien in 1882. Marks on base include Rookwood in block letters, the date, shape number 198, R for red clay, and the artist's initials. Height 1¼ inches and distance from rim to handle is 6½ inches. $250-350

514 Mat glaze Rookwood advertising sign, made with the company name in large block letters and a Rook sitting on a branch in 1922. Marks on the reverse include the Rookwood logo, the date, and shape number 1622. Height 4½ inches, width 8¾ inches. Some glaze chips at the corners. $800-1200

515 Standard glaze vase with floral decoration, done by Irene Bishop in 1901. Marks on the base include the Rookwood logo, the date, shape number 816 E and the artist's initials. Height 6⅛ inches. $200-300

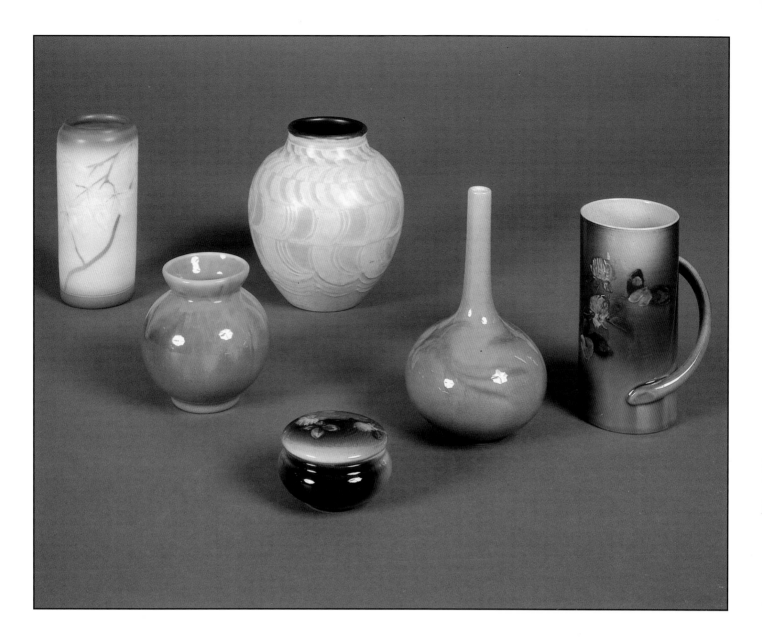

516 Vellum glaze floral vase by Carrie Steinle painted in 1910. Marks on the base include the Rookwood logo, the $400-600
 date, shape number 952 F, V for Vellum glaze body, the artist's initials and V for Vellum glaze. Height 6¼ inches.

517 Exotic glaze vase done by Rookwood in 1932. Marks on the base include the Rookwood logo, the date and shape $150-200
 number 6303. Height 4 inches.

518 Mat glaze vase done by Wilhelmine Rehm in 1931 with repeating geometric bands. Marks on the base include $300-500
 the Rookwood logo, the date, shape number 912 and the artist's initials. Height 6⅛ inches.

519 Small Standard glaze covered box, decorated with clover by Kate Matchette in 1892. Marks on the base include $200-250
 the Rookwood logo, the date, shape number 591, W for white clay and the artist's initials. Height 1⅞ inches.

520 Sea green glaze vase decorated with two Birds of Paradise by M.A. Daly in 1897. Marks on the base include the $900-1200
 Rookwood logo, the date, the artist's initials, shape number 743C, G for sea green, and a wheel ground X. Height
 6⅞ inches.

521 Standard glaze mug decorated with clover by Sallie Toohey circa 1889. Marks on the base include the Rookwood $300-500
 logo, the date, the artist's initials, shape number 328, S for sage clay, and L for light standard glaze. Height 6 inches.

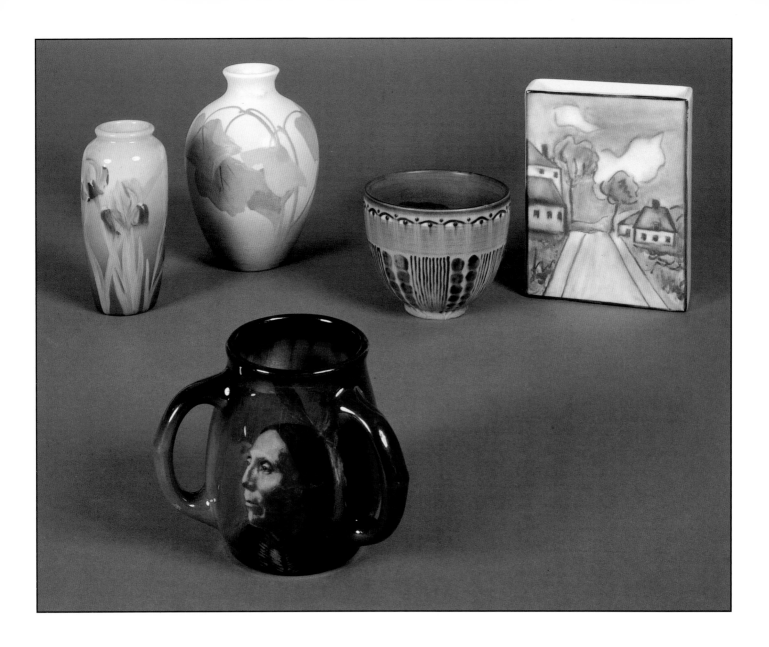

522 Iris glaze vase decorated with irises by Edith Noonan in 1906. Marks on the base include the Rookwood logo, the date, shape number 904 E, the artist's initials and W for white glaze. Height 6½ inches. $1200-1500

523 Early Vellum glaze vase with leaf decoration, done by Sara Sax in 1905. Marks on the base include the Rookwood logo, the date, shape number 902 D, V for Vellum glaze body, V for Vellum glaze and the artist's monogram. Height 7½ inches. Some discoloration under neck. $500-700

524 Standard glaze three handled loving cup decorated with a portrait of an Native American by Edith Felten in 1901. Marks on the base include the Rookwood logo, the date, shape number 859 D, the artist's initials, and the inscription, "Chief White Man. Kiowa". Height 5⅛. Glaze chip on handle. $1500-1800

525 Mat glaze vase with repeating geometric patterns done by William Hentschel in 1926. Marks on the base include the Rookwood logo, the date, shape number 2254 E and the artist's initials. Height 4⅜ inches. $400-600

526 High glaze rectangular planter decorated with a village scene in 1951 in the style of Jens Jensen. Marks on the base include the Rookwood logo, the date and the shape number 6292 C. There is no artist signature visible. Height 7½ inches. $300-500

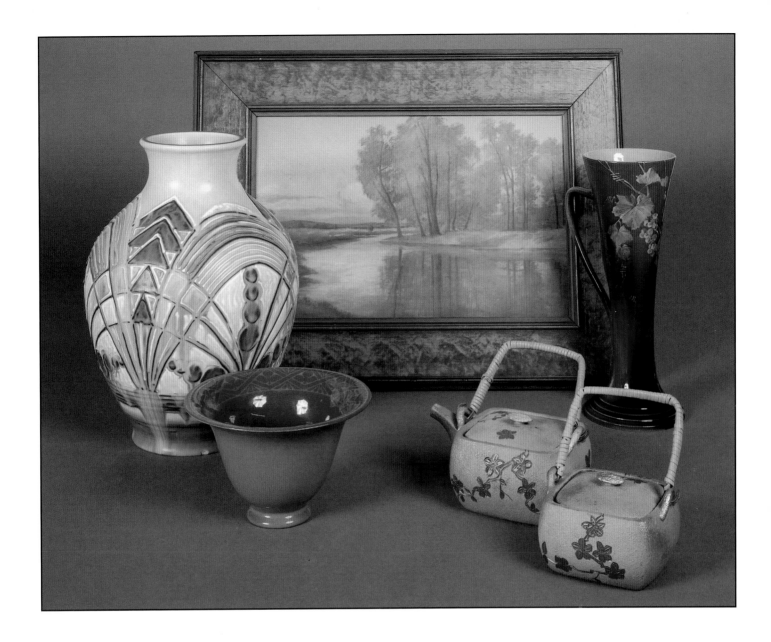

527 Mat glaze vase decorated with Art Deco patterns in very heavy slip by Elizabeth Barrett in 1928. Marks on the base include the Rookwood logo, the date, shape number 2918 B and the artist's monogram. Height 11⅜ inches. Several grinding chips on the base. $700-900

528 High glaze bowl with a contrasting geometric decoration surrounding the inner lip, done in 1916. Marks on the base include the Rookwood logo, the date, P for porcelain body and the shape number 2260E. Height 4 inches. $200-300

529 Vellum glaze scenic plaque decorated in 1922 by Ed Diers. The artist's initials appear in the lower left hand corner. Marks on the back include the Rookwood logo and the date. A large firing crack runs several inches through the center of the plaque. Size 9 x 14⅛ inches. $1500-1800

530 Bisque finish, covered Japanese teapot and sugar with wicker handles, decorated with painted and incised vines and leaves by an unknown artist in 1884. Marks on the base include Rookwood in block letters, the date, shape numbers 43 C, R for red clay and the artist's initials. Height 3 inches for the teapot and 2½ inches for the sugar. $300-500

531 Standard glaze two handled vase decorated with wild grapes by Anna Valentien in 1889. Marks on the base include the Rookwood logo, the date, shape number 292 C, S for sage green clay, the artist's initials and L for light Standard glaze. Height 10½ inches. $800-1200

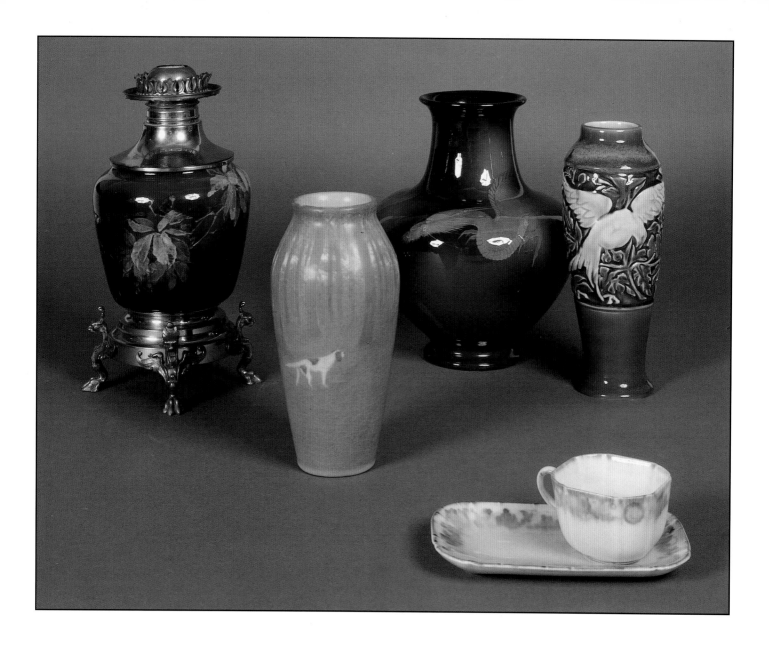

532 Standard glaze vase decorated with Virginia creeper vines and berries by Grace Young circa 1889 and subsequently converted to an oil lamp early in its life. Marks on the base include the artist's monogram and the following note: "MARK OF ROOKWOOD POTTERY CO. WITH THREE FEATHERS & 180 C & S was here". Height to the top of the burner is 13½ inches. Drilled through the base and some roughness to the rim which is covered. $600-800

533 Vellum glaze scenic vase decorated by E.T. Hurley in 1903, showing a hunting dog pointing at a flock of birds. Marks on the base include the Rookwood logo, the date, shape number 925 CC, V for Vellum glaze body, the artist's initials and V for Vellum glaze. Height 9½ inches. Hairline at rim. $400-600

534 Large Standard glaze vase decorated by Albert Valentien in 1896 with an impressive green dragon. Marks on the base include the Rookwood logo, the date, shape number 800 A, a wheel ground X, the artist's initials and L for light Standard glaze. Height 11¾ inches. Repair to lip, repair to base, several glaze pops have been repaired on the surface. $800-1200

535 High glaze cup and saucer decorated in 1924 by Lorinda Epply with stylized flowers. Marks on the base include the Rookwood logo, the date, shape numbers 2087 A & B and the artist's initials. Cup height 2⅜ inches, length of tray is 8 inches. $250-350

536 Unusual polychromed high glaze commercial ware vase with embossed parrot decoration, glazed and signed by Sallie Toohey in 1928. Marks on the base include the Rookwood logo, the date, shape number 6032, a wheel ground X and the artist's initials. Height 11 inches. $500-700

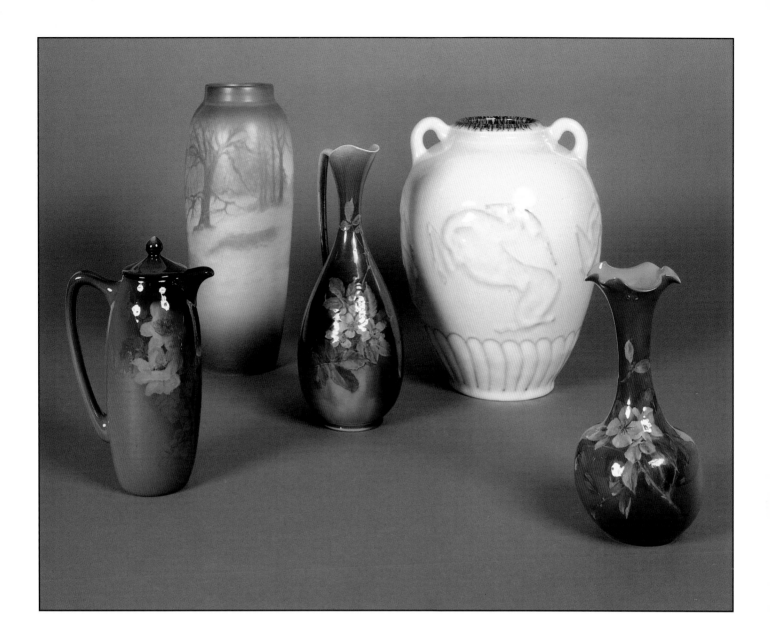

537 Standard glaze lidded chocolate pot decorated with wild roses by Sallie Coyne in 1900. Marks on the base include the Rookwood logo, the date, shape number 771 B and the artist's initials. The lid is also marked with the artist's initials. Height 10 inches. $700-900

538 Tall Vellum glaze scenic vase decorated by E.T. Hurley in 1917. Marks on the base include the Rookwood logo, the date, shape number 907 C, V for Vellum glaze body and the artist's initials. Height 14¾ inches. $3500-4500

539 Tall Standard glaze ewer with wild rose decoration, done by an unknown artist in 1889. Marks on the base include the Rookwood logo, the date, shape number 496 A, W for white clay, an unidentifiable artist's initials and possibly L for light Standard glaze. Height 12½ inches. $800-1000

540 High glaze vase decorated with four leaping gazelles by William Hentschel in 1931. Marks on the base include the Rookwood logo, the date, shape number 2640 C, a fan shaped esoteric mark and the artist's initials. Height 13¼ inches. $2500-3500

541 Standard glaze vase with fluted top, decorated with yellow flowers by Kate Matchette in 1893. Marks on the base include the Rookwood logo, the date, shape number 481, W for white clay and the artist's initials. Height 9¼ inches. $400-600

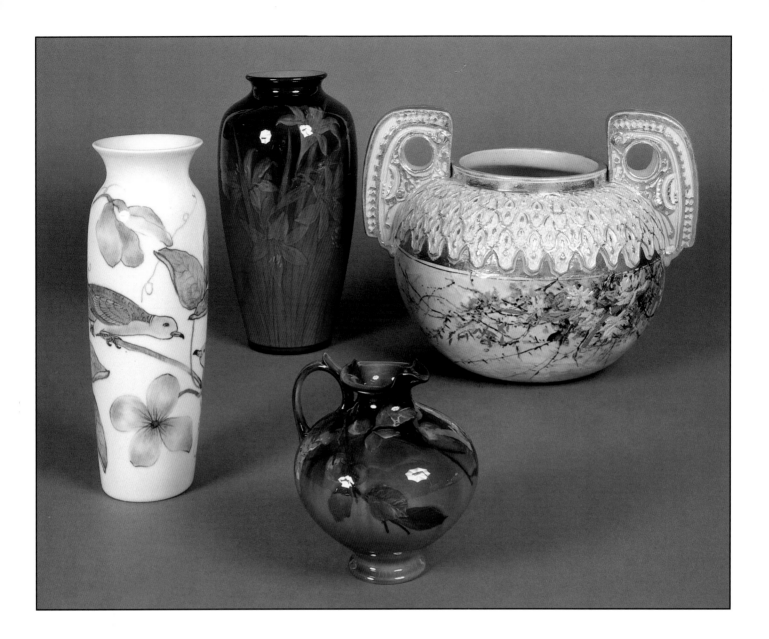

542 High glaze vase decorated with doves and flowering vines by Kay Ley in 1945. Marks on the base include the Rookwood logo, the date, shape number 6919, the artist's initials and the number 4260. Height 12 inches. $600-800

543 High glaze vase decorated with tiger lillies by Lenore Asbury in 1929. Marks on the base include the Rookwood logo, the date, shape number 614 C, the artist's initials and Y.G. for yellow glaze. Height 12⅞ inches. $1250-1750

544 Standard glaze ewer decorated by Amelia Sprague in 1891 with persimmons. Marks on the base include the Rookwood logo, the date, shape number 498 B, W for white clay, the artist's initials and L for light standard glaze. Height 6¼ inches. $300-500

545 Large and unusual Matt Morgan vase with applied handles, decorated in the Moresque style with sprays of flowers, stems and leaves on the bottom half, and with a repeating molded design on the top covered with extensive fired on gold. Marked on the base with a paper label which reads: Matt Morgan Art Pottery Cincinnati No., Height 12⅝ inches. $1000-1500

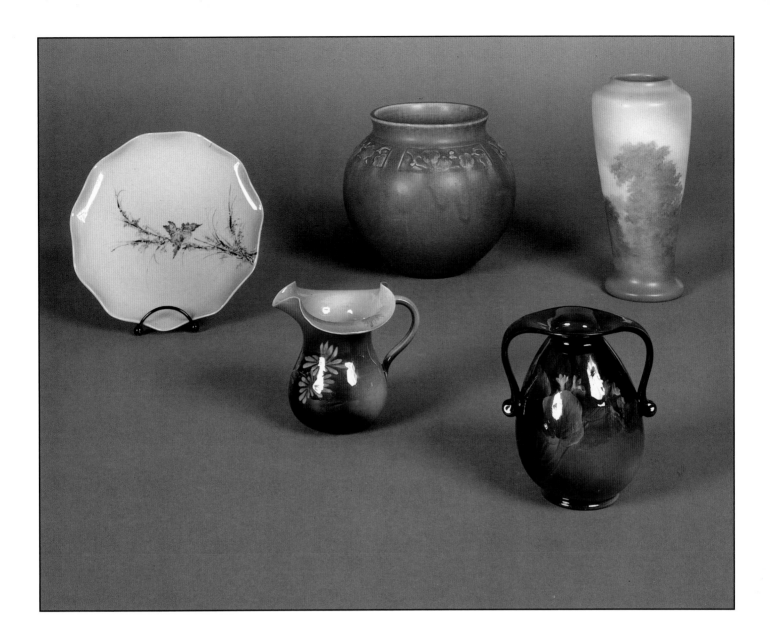

546 Cameo glaze plate decorated with grasses and a small bird by Albert Valentien in 1886. Marks on the base $250-350
 include the Rookwood logo, the date, shape number 284, the number 86 in script, S for sage clay and the artist's
 initials. Width 8 inches. Scratches on surface.

547 Standard glaze pitcher decorated with black eyed susans by Amelia Sprague in 1889. Marks on the base include $300-500
 the Rookwood logo, the date, shape number 332 C, W for white clay, the artist's initials and L for light Standard
 glaze. Height 4⅛ inches. Glaze skip.

548 Mat glaze bowl with carved and painted repeating border, done by C.S. Todd in 1915. Marks on the base include $300-500
 the Rookwood logo, the date, shape number 346 B and the artist's initials. Height 7 inches.

549 Standard glaze vase with two large handles, decorated with small yellow flowers by Sara Sax in 1898. Marks on $300-400
 the base include the Rookwood logo, the date, shape number 607 C, a small star shaped esoteric mark and the
 artist's initials. Height 5 inches.

550 Vellum glaze scenic vase decorated by Ed Diers in 1915. Marks on the base include the Rookwood logo, the $400-600
 date, shape number 1356 D, V for Vellum glaze body, a small wheel ground X and the artist's initials. Height 9⅛
 inches. Glaze flakes off the rim.

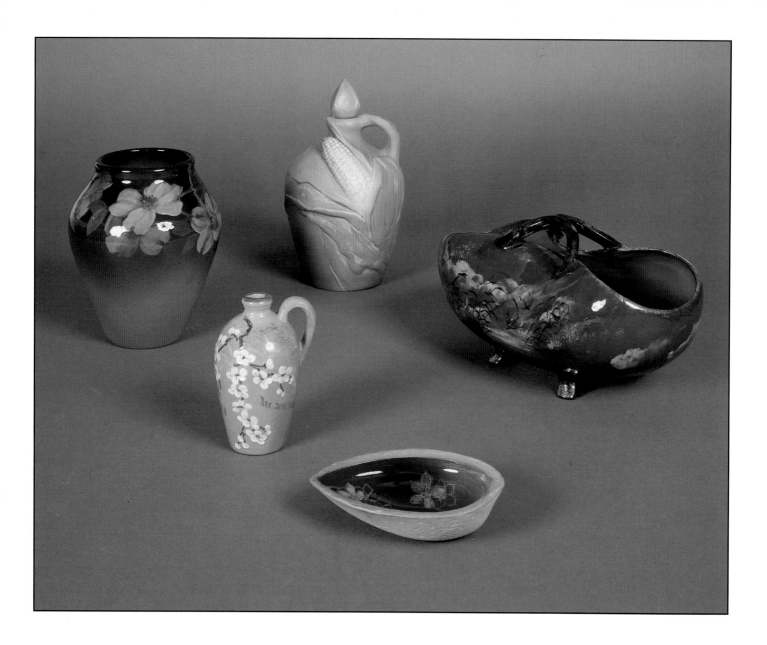

551 Standard glaze vase decorated with dogwood by Constance Baker in 1903. Marks on the base include the Rookwood logo, the date, shape number 915 C and the artist's initials. Height 7⅛ inches. — $400-600

552 Limoges style perfume jug decorated with cherry blossoms in 1883 by an unknown artist. Marks on the surface of the jug are as follows: "Myer Asch Dec. 21st. 1883.". Marks on the base include Rookwood in block letters, the date, shape number 61, G for ginger clay and a small impressed kiln mark. Height 4½ inches. — $250-350

553 Rare and unusual carved mat glaze whiskey jug decorated with corn in high relief by Kataro Shirayamadani in 1904. Marks on the base include the Rookwood logo, the date, shape number 765 BZ, a V shaped esoteric mark, a small wheel ground X and the artist's cypher. Height 9¼ inches. — $2500-3500

554 Bisque and Standard glaze almond shaped dish decorated by an unknown artist in 1891. Marks on the base include the Rookwood logo, the date, shape number 279 and Y for yellow clay. Height 1¼. width 5¼ inches. — $200-300

555 Limoges style glaze flower boat decorated by Albert Humphries circa 1881 with oriental grasses, clouds and flying birds. Marks on the base include Rookwood Pottery in script and the artist's initials. Height 5⅝ inches. One handle has been broken and glued and a two inch line appears at the rim. — $300-400

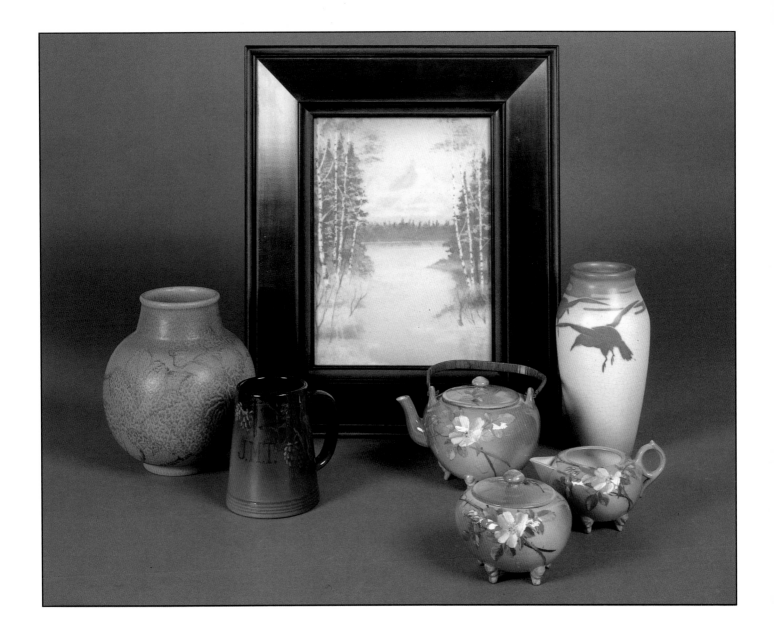

556 Mat glaze floral vase decorated by Janet Harris in 1929. Marks on the base include the Rookwood logo, the date, $250-350
 shape number 2969 and the artist's initials. Height 7½ inches.

557 Standard glaze mug decorated with hops and the initials J.M.T. by Carl Schmidt in 1900. Marks on the base $300-400
 include the Rookwood logo, the date, shape number 587 C and the artist's monogram. Height 4¼ inches. Spider
 crack in the base.

558 Vellum glaze scenic plaque decorated by E.T. Hurley in 1947. The artist's initials are in the lower left hand $3500-5500
 corner. Marks on the back include the Rookwood logo, the date and the size 9 x 12. Written in pencil on the
 back is a title, "Early Snow on Mt. Rainier". Size 11⅞ x 7⅞ inches.

559 Cameo glaze footed Japanese tea set (three pieces) decorated with pink wild roses by Anna Valentien in 1891. $1000-1500
 Marks on the base of the teapot include the Rookwood logo, the date, shape number 616, W for white clay, the
 artist's initials, and L for light glaze. The creamer and sugar bear similar markings. Height of teapot 4½ inches.

560 Vellum glaze vase decorated with two prominent flying rooks among stylized clouds, done by Lenore Asbury in $800-1000
 1910. Marks on the base include the Rookwood logo, the date, shape number 825 D, V for Vellum glaze body, a
 small wheel ground X, the artist's initials and V for Vellum glaze. Height 8½ inches. Minor firing flaw near base.

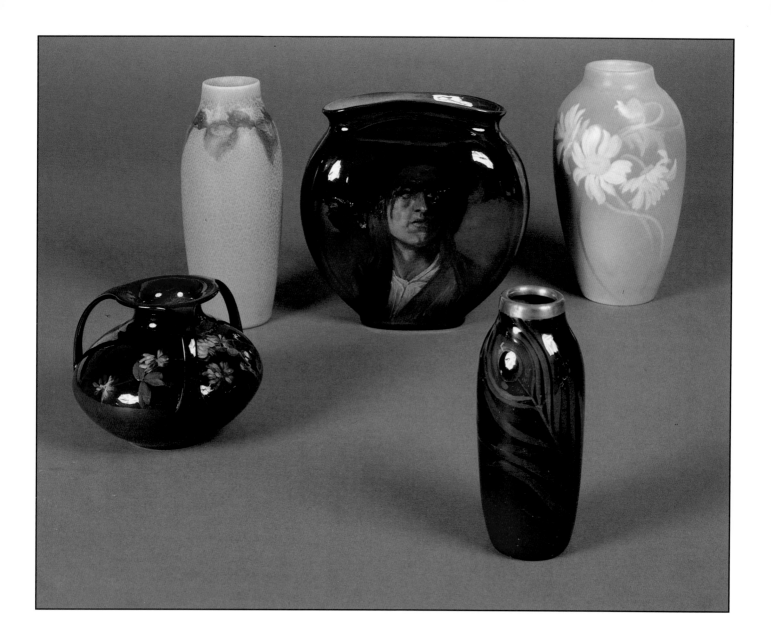

561 Standard glaze bowl with three large loop handles decorated with clover by Mattie Foglesong in 1900. Marks on the base include the Rookwood logo, the date, shape number 503 C and the artist's initials. Height 3¾ inches, diameter 5⅛ inches. Glaze problems. $250-350

562 Mat glaze vase with stylized floral border at the neck done by Charles S. Todd in 1917. Marks on the base include the Rookwood logo, the date, shape number 932 E and the artist's initials. Height 8¼ inches. $300-400

563 Standard glaze pillow vase done with a portrait of a young man wearing a hat by Anna Valentien in 1896. Marks on the base include the Rookwood logo, the date, shape number 707 A, a small wheel ground X and the artist's initials. Height 7⅞ inches, width 7⅞ inches. $800-1200

564 Standard glaze vase decorated with a single peacock feather by Elizabeth Lincoln in 1904. The vase is chased with a silver plated copper collar. Marks on the base include the Rookwood logo, the date, shape number 932 F and the artist's initials. Height 6¼ inches. Pitting in the glaze and copper collar may not be original. $500-700

565 Vellum glaze vase with daisy decoration, done by Fred Rothenbusch in 1906. Marks on the base include the Rookwood logo, the date, shape number 900 C, V for Vellum glaze body, the artist's initials and V for Vellum glaze. Height 8¼ inches. Tiny glaze flake on base. $600-800

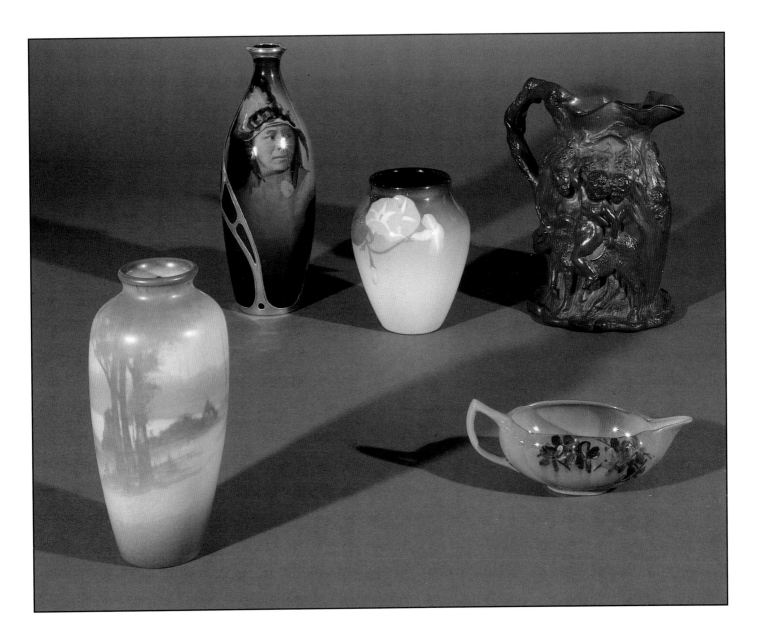

566 Vellum glaze vase with scenic decoration very much in the manner of Sallie Coyne, decorated in 1921. Marks on $600-800
the base include the Rookwood logo, the date, shape number 614 F and V for Vellum glaze. Height 7¼ inches.

567 Standard glaze vase with silver overlay decorated with a Native American portrait by Adeliza Sehon in 1901. The $6000-8000
engraved overlay has an anchor mark, a lion with a raised paw, and F, L, O. Marks on the base include the
Rookwood logo, the date, shape number 796 B, the inscription, "Spotted Jack Rabbit. - Crow" and the artist's
initials. Height 9⅞ inches.

568 Iris glaze vase decorated with petunias by Katherine Van Horne in 1907. Marks on the base include the $600-800
Rookwood logo, the date, shape number 915 E, the artist's initials and W for white glaze. Height 5½ inches.

569 Standard glaze gravy bowl decorated with small blue flowers by Charles Dibowski in 1894. Marks on the base $200-300
include the Rookwood logo, the date, shape T 857, the artist's initials and L for light Standard glaze. Height 1¼
inches, length 6¼ inches.

570 Bisque finish tankard decorated on one side with two young satyrs holding a young boy on a donkey, and on the $600-800
other side with two adult satyrs holding the arms of an adult man. Overall grape vines and fruit adorn the piece.
The initials W.A. appear on the side of the tankard. Marks on the base include Rookwood in block letters and the
date. Height 8⅛ inches. Mr. Glover felt this piece to be from the permanent Rookwood Museum and to have been
made by William Auckland. Repair to lip.

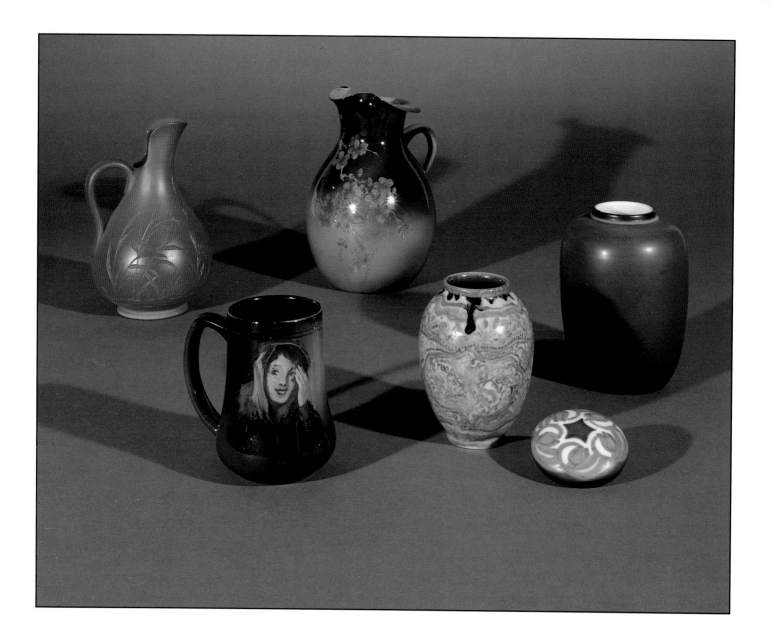

571 Bisque finish ewer decorated with carved and incised grasses and a small bird by Harriet Wenderoth in 1882. Marks on the base include Rookwood in block letters, the date and the artist's initials. Height 7¾ inches. $300-400

572 Standard glaze mug decorated with a portrait of a young woman done by Sallie Toohey in 1894. Marks on the base include the Rookwood logo, the date, shape number S 1111, W for white clay and the artist's initials. Height 4⅞ inches. Repair to lip. $400-600

573 Standard glaze ewer decorated by Anna Valentien with oriental style apple blossoms in 1888. Marks on the base include the Rookwood logo, the date, shape number 432, S for sage green clay, the artist's initials and L for light Standard glaze. Height 8¼ inches. $600-800

574 High glaze vase decorated by William Hentschel in 1922 with an overall floral pattern. Marks on the base include the Rookwood logo, the date, shape number 2191 and the artist's initials. Height 5 inches. $400-600

575 Vellum glaze lidded vase decorated with a band of stylized tulips encircling the lid, done by Sallie Coyne in 1921. Marks on the base include the Rookwood logo, the date, shape number 47 C and the artist's initials. Height 6¼ inches. $300-400

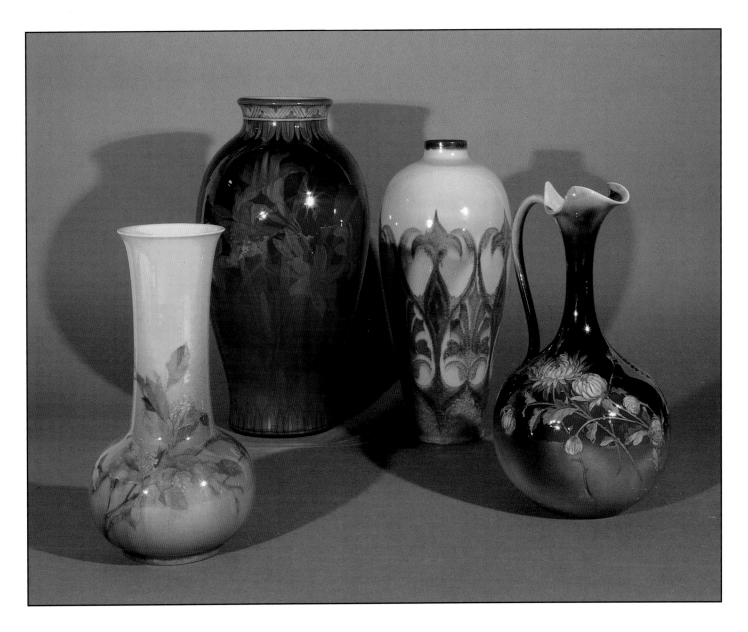

576 Standard glaze vase with small yellow flowers and green leaves decorated by Albert Valentien in 1889. Marks on $600-800
 the base include the Rookwood logo, the date, shape number 486 A, W for white clay, the artist's initials and L
 for light Standard glaze. Height 13⅛ inches. Darkened crazing in and around the decoration.

577 Large high glaze vase decorated with a repeating border top and bottom and with large sprays of day lillies by $2500-3500
 Lenore Asbury in 1930. Marks on the base include the Rookwood logo, the date, shape number 6079, a small fan
 shaped esoteric mark, Y.G. for yellow glaze and the artist's initials. Height 18¼ inches. This piece represents a
 late attempt at duplicating Rookwood's Standard glaze.

578 High glaze vase decorated with Moresque designs by Charles J. McLaughlin in 1918. Marks on the base include $400-600
 the Rookwood logo, the date, shape number 2368, P for porcelain body, a wheel ground double X and the artist's
 initials. Height 15¼ inches. Glaze problems and chips near base.

579 Good Standard glaze ewer decorated with chrysanthemums by M.A. Daly in 1892. Marks on the base include the $1800-2500
 Rookwood logo, the date, shape number 397 A, W for white clay and the artist's initials. Height 14⅛ inches.

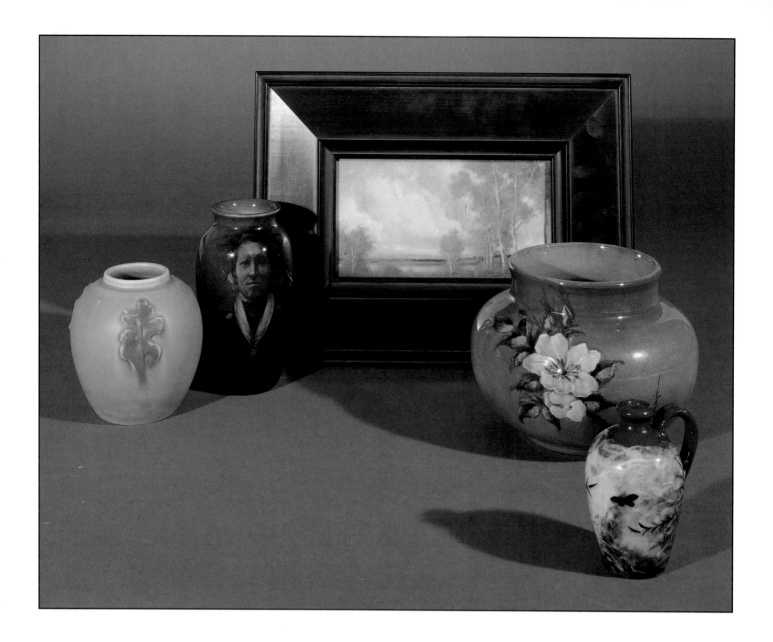

580 Carved and painted mat glaze vase by Cecil Duell in 1908, decorated with three oak leaves in very high relief. Marks on the base include the Rookwood logo, the date, shape number 834, a small wheel ground X and the artist's initials. Height 5 inches. — $200-300

581 Good Standard glaze vase decorated with a portrait of a Native American by Sturgis Laurence in 1898. Marks on the base include the Rookwood logo, the date, shape number 80 B, the title: "Bushy Tail Otoe" and the artist's initials. Height 6⅝ inches. — $1750-2250

582 Vellum glaze scenic plaque painted in 1920 by Ed Diers. The artist's initials appear in the lower right hand corner. Marks on the back include the Rookwood logo and the date. On the frame is a paper label in David Glover's hand which reads, "Ripley Through the Birches By Ed Diers 1920". Size 5⅛ x 9¼ inches. — $1500-2000

583 Standard glaze squat vase decorated by Laura Fry with wild roses in 1886. Marks on the base include Rookwood in block letters, the date, shape number 268 C, G for ginger clay and the artist's initials. Height 5¼ inches. — $500-700

584 Limoges style glaze perfume jar decorated with oriental grasses, clouds and a single butterfly by William McDonald in 1882. Marks on the base include Rookwood in block letters, the date, Shape number 61, R for red clay, a small impressed anchor mark and the artist's initials. Height 4⅛ inches. — $250-450

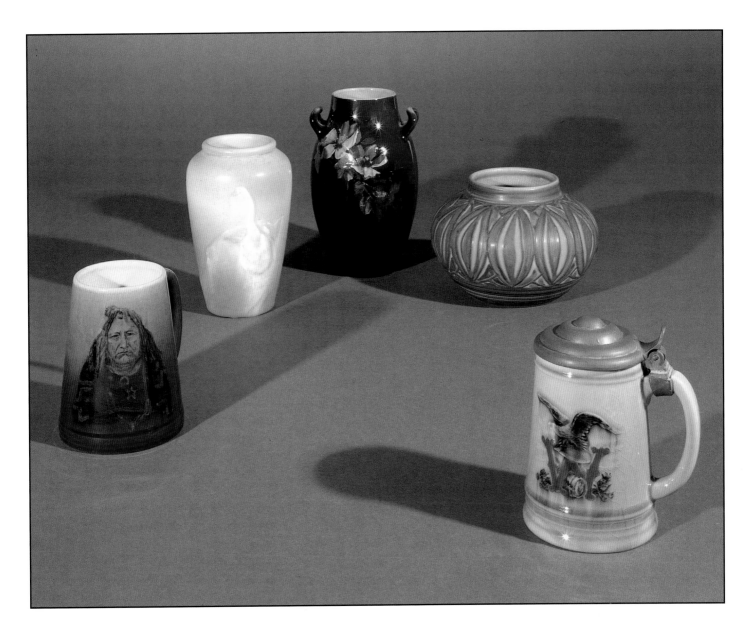

585 High glaze mug decorated with a Native American portrait by Flora King in 1946. Marks on the base include the Rookwood logo, the date, shape number 587 C, the inscription: "Ciolorow Red", the number "229A" and the artist's initials. Height 5 inches. $600-800

586 Carved Vellum glaze vase decorated with a goose on the front and a smaller painted goose on the reverse by Edith Noonan in 1907. Marks on the base include the Rookwood logo, the date, shape number 938 D, V for Vellum glaze body, the artist's initials, V for vellum glaze. Height 6¾ inches. Peppering in the glaze. $800-1200

587 Standard glaze vase with small loop handles decorated with yellow flowers by Luella Perkins in 1891. Marks on the base include the Rookwood logo, the date, shape number 77 A, W for white clay, the artist's initials and L for light Standard glaze. Height 7½ inches. Glaze loss on one flower. $300-500

588 Mat glaze vase decorated with repeating patterns by Elizabeth Barrett in 1928. Marks on the base include the Rookwood logo, the date, shape number 1923 and the artist's monogram. Height 4¾ inches. $600-800

589 High glaze mug with pewter lid and embossed company logo on side in color. Made in 1948 for the George Wiedemann Brewing Company of Newport, Kentucky. Marks on base include the Rookwood logo, "THE GEO. WEIDEMANN BREWING CO. INC." and the date. Height, 5½ inches. $250-350

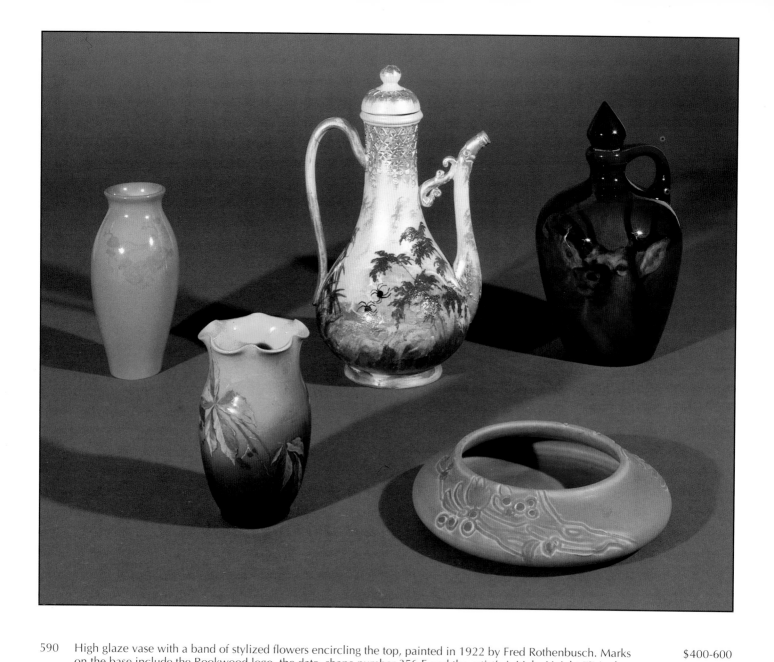

590 High glaze vase with a band of stylized flowers encircling the top, painted in 1922 by Fred Rothenbusch. Marks on the base include the Rookwood logo, the date, shape number 356 E and the artist's initials. Height 7⅝ inches. $400-600

591 Standard glaze vase with fluted rim, painted with floral decoration by Sallie Toohey in 1890. Marks on the base include the Rookwood logo, the date, shape number 513, S for sage green clay, the artist's initials and L for light Standard glaze. Height 5¼ inches. $300-500

592 Bisque finish Turkish coffee pot in the manner of Maria Longworth Nichols decorated in 1883 with spiders, oriental grasses and trees. Marks on the base include Rookwood in block letters, the date and Y for yellow clay. Height 11 inches. $700-900

593 Mat glaze incised and painted mat glaze bowl decorated by Cecil Duell in 1907 with leaves and berries. Marks on the base include the Rookwood logo, the date, shape number 1185, a small wheel ground X, a small V shaped esoteric mark and the artist's initials. Height 1½ inches, diameter 7½ inches. $300-400

594 Standard glaze whiskey jug decorated with a male deer by E.T. Hurley in 1898. Marks on the base include the Rookwood logo, the date, shape number 512 B, a small wheel ground X and the artist's initials. Height 9¼ inches. $1400-1800

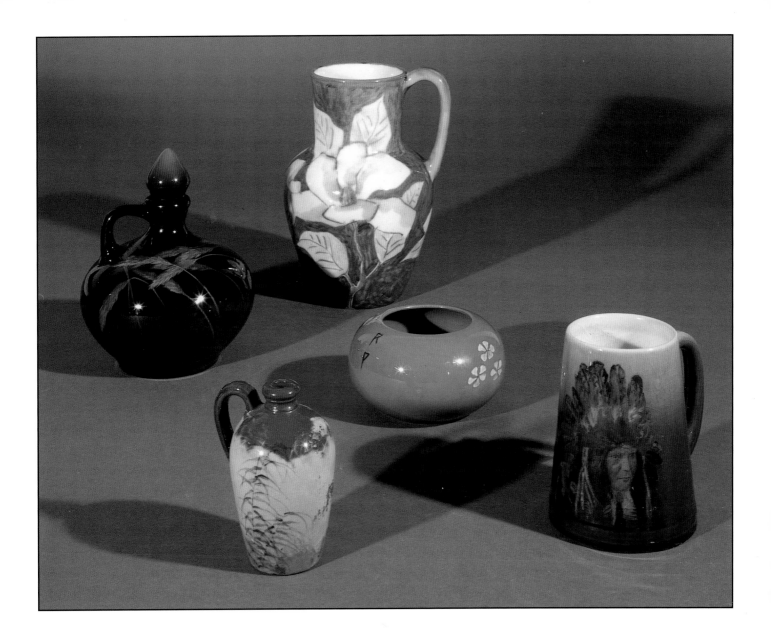

595 Standard glaze whiskey jug decorated with sprays of wheat by Sallie Toohey in 1896. Marks on the base include the Rookwood logo, the date, shape number 675 and the artist's initials. Height 7¼ inches. Glaze scuff. $600-800

596 Limoges style glaze perfume jug decorated with oriental grasses and bats by Martin Rettig in 1883. Marks on the base include Rookwood in block letters, the date, shape number 61, R for red clay, a small impressed kiln mark and the artist's initials. Height 4½ inches. $300-500

597 High glaze pitcher decorated by Jens Jensen in 1943 with magnolia. Marks on the base include the Rookwood logo, the date, shape number 6320 and the artist's cypher. Height 9 inches. $700-900

598 Standard glaze bowl decorated with four small yellow blossoms and the initials R P by Mary Taylor in 1886. Marks on the base include the Rookwood logo, the date, shape number 214 C, G for ginger clay and the artist's initials. Height 2⅞ inches. $250-350

599 High glaze mug decorated with a Native American portrait by Flora King in 1946. Marks on the base include the Rookwood logo, the date, shape number 587 C, the inscription "Quick Bear", the number "222A" and the artist's initials. Height 5 inches. $600-800

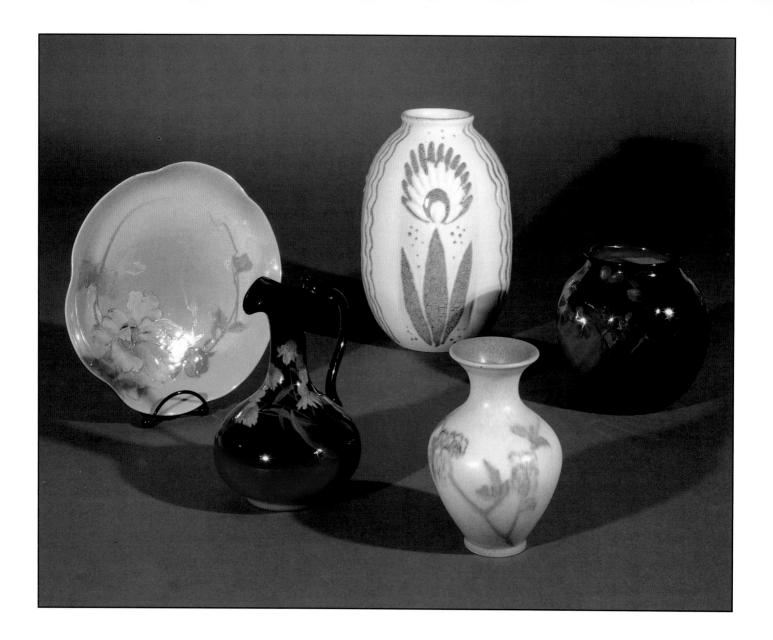

600 Standard glaze plate decorated with yellow poppies by an unidentified artist. Marks on the base include the Rookwood logo, the date, shape number 205, a wheel ground X and the artist's initials. Diameter 8¼ inches. Roughness on rim. $150-250

601 Standard glaze ewer decorated with black eyed susans by Marianne Mitchell in 1901. Marks on the base include the Rookwood logo, the date, shape number 462 D and the artist's initials. Height 6⅝ inches. $300-500

602 Butterfat glaze ribbed vase decorated by Elizabeth Barrett with a Southwest American motif in 1944. Marks on the base include the Rookwood logo, the date, S for special shape, the artist's monogram and the swirl "signature" of potter Reuben Earl Menzel. Height 9¼ inches. $1200-1500

603 Mat glaze floral vase, decorated by Kataro Shirayamadani in 1937. Marks on the base include the Rookwood logo, the date, shape number 6148 and the artist's cypher. Height 5½ inches. $400-600

604 Standard glaze vase decorated with rose hips by Anna Valentien in 1895. Marks on the base include the Rookwood logo, the date, shape number 612 C and the artist's initials. Height 5½ inches. $400-600

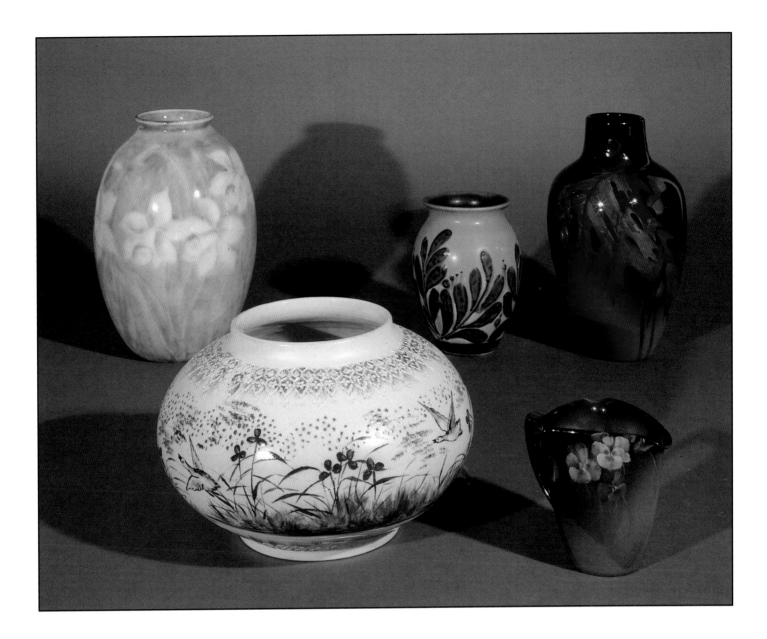

605 High glaze vase decorated with jonquils by Jens Jensen in 1948. Marks on the base include the Rookwood logo, the date, shape number 6184 C, an inscribed circle and the artist's initials. Height 9¾ inches.

$700-900

606 Limoges style glaze oval vase decorated by William McDonald in 1882 with ducks overflying a marsh. There is a border of die impressed marks around the top and bottom of the piece, highlighted with fired on gold. Marks on the base include Rookwood in block letters, the date, shape number 95, C possibly for cream colored clay, a small impressed anchor mark and the artist's initials. Height 6⅜ inches, diameter 9½ inches.

$800-1200

607 Mat glaze floral vase decorated by Elizabeth Barrett in 1929. Marks on the base include the Rookwood logo, the date, shape number 363 and the artist's monogram. Height 6¼ inches.

$400-600

608 Standard glaze tri-cornered pitcher decorated with pansies by Constance Baker in 1897. Marks on the base include the Rookwood logo, the date, shape number 259 E and the artist's initials. Height 4 inches.

$250-350

609 Standard glaze vase decorated with oak leaves and acorns by Lenore Asbury in 1901. Marks on the base include the Rookwood logo, the date, shape number 905 C and the artist's initials. Height 9½ inches.

$500-700

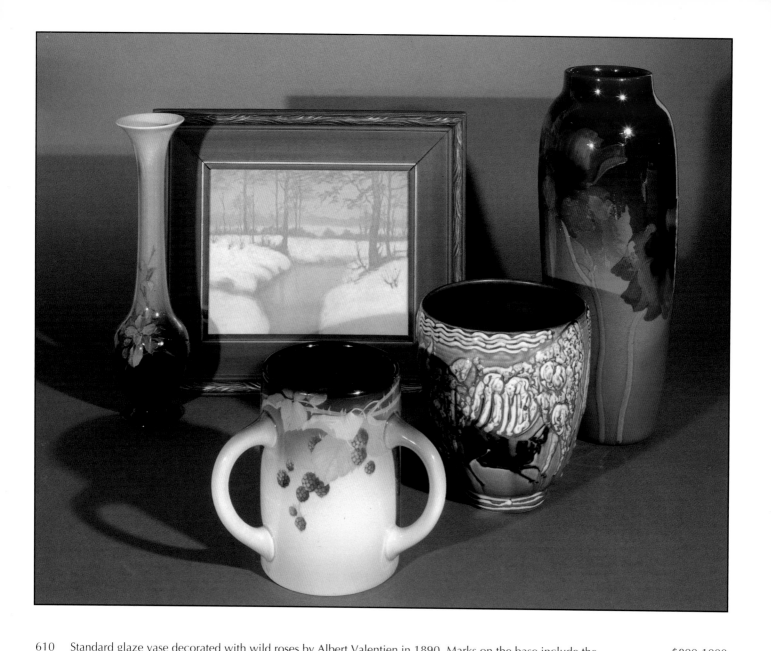

610 Standard glaze vase decorated with wild roses by Albert Valentien in 1890. Marks on the base include the
 Rookwood logo, the date, shape number 559 B, W for white clay, the artist's initials and L for light Standard
 glaze. Height 14⅛ inches. $800-1000

611 Vellum glaze scenic plaque by E.T. Hurley, done in 1918. The artist's initials appear in the lower left hand corner.
 Marks on the back include the Rookwood logo and the date. On the frame are an original paper Rookwood logo
 and an original paper label with the title, "The Brook in Winter E.T. Hurley". Size 8½ x 10⅞ inches. $4000-5000

612 Iris glaze three handled loving cup, decorated with blackberry leaves, stems and fruit by Lenore Asbury in 1907.
 Marks on the base include the Rookwood logo, the date, shape number 880 B, a small wheel ground X, the
 artist's initials and W for white glaze. Height 7½ inches. Horizontal crack of about five inches between two of the
 handles. Lip bruise. $300-500

613 Mat glaze bowl decorated with heavy slip by William Hentschel in 1929. The vase shows several cattle with one
 black nursing calf. Marks on the base include the Rookwood logo, the date, shape number 6112 and the artist's
 initials. Height 8 inches. Horizontal crack. $900-1200

614 Large and impressive Standard glaze vase decorated with large red poppies by Sturgis Laurence in 1904. Marks
 on the base include the Rookwood logo, the date, shape number 907 B, a small wheel ground X and the artist's
 initials. Height 17 inches. A ¼ inch glaze flake appears near the base but is barely noticeable. $2500-3500

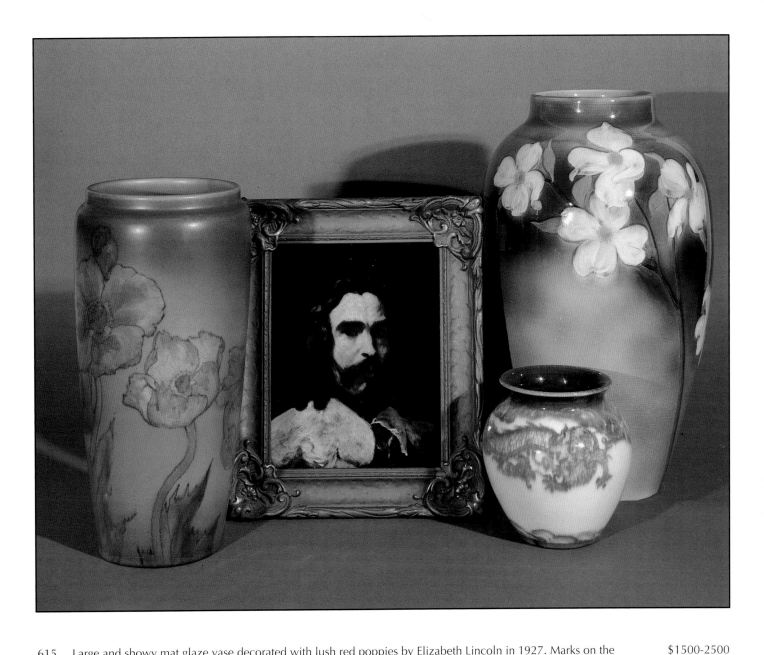

615 Large and showy mat glaze vase decorated with lush red poppies by Elizabeth Lincoln in 1927. Marks on the $1500-2500
base include the Rookwood logo, the date, shape number 1369 B and the artist's initials. Height 14¼ inches.

616 Rare and important Standard glaze plaque decorated with a portrait of a Spanish gentleman, after Valasquez, $4000-6000
done by William McDonald in 1895. Marks on the back include the Rookwood logo and date impressed four
times, the inscription, "After Valasquez by W.P. McDonald 1895". Size 10 x 8 inches. A few small glaze bubbles
appear on the surface.

617 Unusual high glaze blue and white vase decorated with an encircling dragon by Lorinda Epply in 1924. Marks on $600-800
the base include the Rookwood logo, the date, shape number 130 and the artist's initials. Height 6⅜ inches.

618 Large and important Iris glaze vase, decorated in 1902 by Sturgis Laurence with dogwood. The artist's full $4000-6000
signature appears on the side of the vase, near the base. Marks on the base include the Rookwood logo, the date
and shape number 900 AA. Height 18 inches. A very tight horizontal line runs approximately half way around the
rim. It can be felt and barely seen from the outside, but is visible inside upon close inspection.

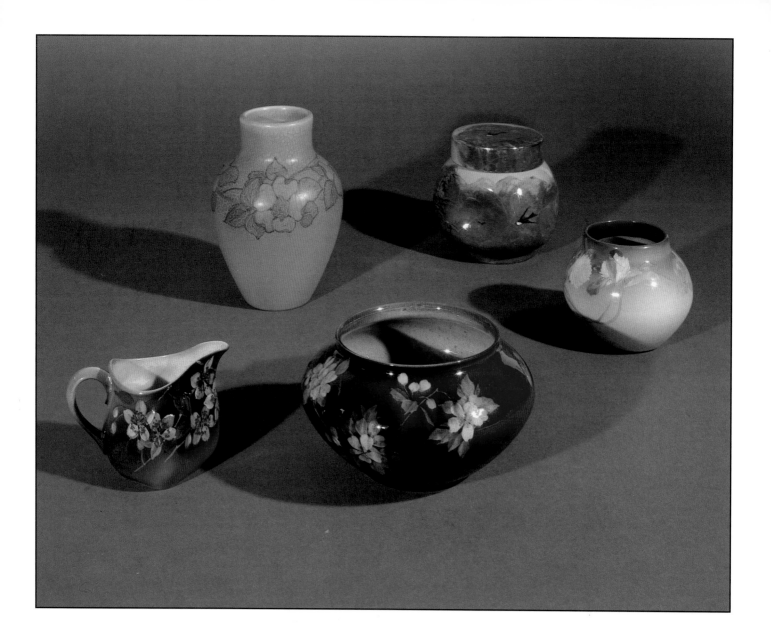

619 Standard glaze creamer decorated with wild roses by Charles Dibowski in 1893. Marks on the base include the Rookwood logo, the date, shape number 692, W for white clay and the artist's initials. Height 3½ inches. $200-300

620 Mat glaze vase decorated by Margaret McDonald in 1928 with a band of intertwined floral blossoms. Marks on the base include the Rookwood logo the date, shape number 927 E and the artist's initials. Height 7⅛ inches. $300-500

621 Standard glaze bowl decorated with wild roses by Harriet Wilcox in 1889. Marks on the base include the Rookwood logo, the date, shape number 494 B, S for sage green clay, the artist's initials and LY for light yellow (Standard) glaze. Height 3⅛ inches, diameter 7⅛ inches. $300-500

622 Limoges style glaze tea jar decorated by Martin Rettig in 1882 with oriental grasses and several flying birds. Marks on the base include Rookwood in block letters, the date, shape number 97, G for ginger clay and the artist's initials. Height 5⅛ inches. $600-800

623 Iris glaze vase decorated with pink carnations by Ed Diers in 1903. Marks on the base include the Rookwood logo, the date, shape number 911 E and the artist's initials. Height 4 inches. $600-800

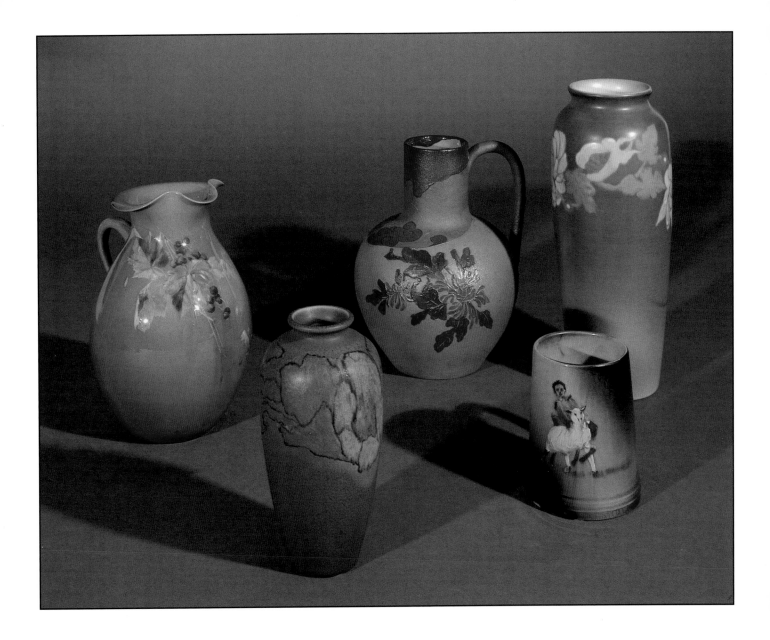

624 Standard glaze ewer decorated with wild grapes by Artus Van Briggle in 1888. Marks on the base include the Rookwood logo, the date, shape number 412, G for ginger clay, the artist's initials and L for light Standard glaze. Height 8½ inches. $800-1000

625 Mat glaze vase decorated by Charles Klinger in 1925 with a band of stylized flowers surrounding the shoulder. Marks on the base include the Rookwood logo, the date, shape number 614 F and the artist's initials. Height 7 inches. $300-400

626 Bisque finish ewer in the style of Chaplet decorated with chrysanthemums by Albert Valentien in 1884. Marks on the base include Rookwood in block letters, the date, shape number 62, G for ginger clay, and the artist's initials. Height 8¼ inches. $600-800

627 Standard glaze mug depicting a shepherd and one sheep, done in 1891 by Artus Van Briggle. Marks on the base include the Rookwood logo, the date, shape number 587, W for white clay, the artist's initials and L for light Standard glaze. Height 4½ inches. $700-900

628 Vellum glaze vase decorated by an unknown artist in 1920 with raspberries and flowers. Marks on the base include the Rookwood logo, the date, shape number 904 CC, V for Vellum glaze body and the artist's cypher. Height 11 inches. $600-800

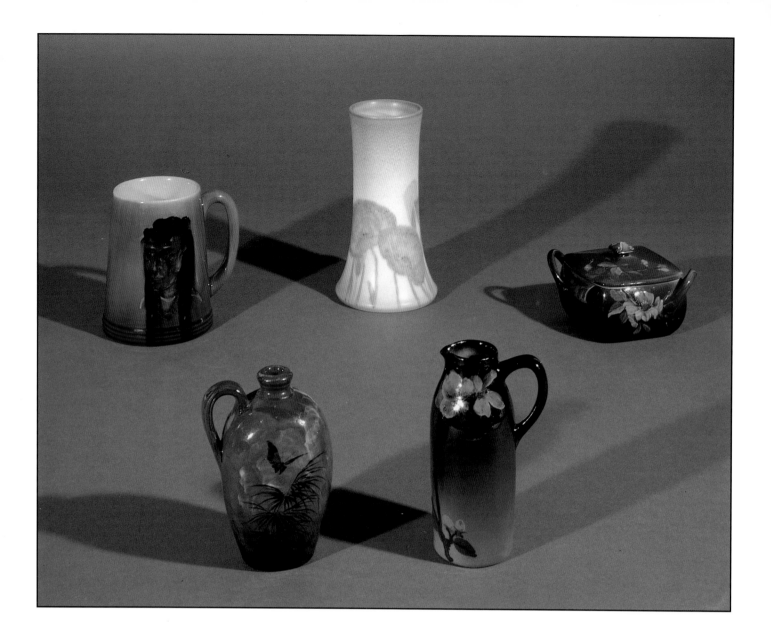

629 High glaze portrait mug done by Jane Sacksteder in 1946. Marks on the base include the Rookwood logo, the date, shape number 587 C, the number 522 A and the artist's initials. Height 5 inches. $400-600

630 Limoges style glaze perfume jug decorated with oriental grasses and a butterfly in 1884 by an unknown artist. Marks on the base include Rookwood in block letters, the date, shape number 60 and R for red clay. Height 4½ inches. $250-350

631 Mat glaze vase decorated with poppies by Kataro Shirayamadani in 1940. Marks on the base include the Rookwood logo, the date, shape number 1358 E and the artist's initials. Height 7 inches. $600-800

632 Standard glaze pitcher decorated with fruit blossoms by an unknown decorator in 1899. Marks on the base include the Rookwood logo, the date, shape number 819, a small star shaped esoteric mark and the artist's cypher. Height 5⅛ inches. $250-350

633 Standard glaze lidded sugar bowl, decorated with small orange flowers on both lid and base by an unknown artist in 1889. Marks on the base include the Rookwood logo, the date, shape number 21 D and W for white clay. Height 2⅞ inches. $200-300

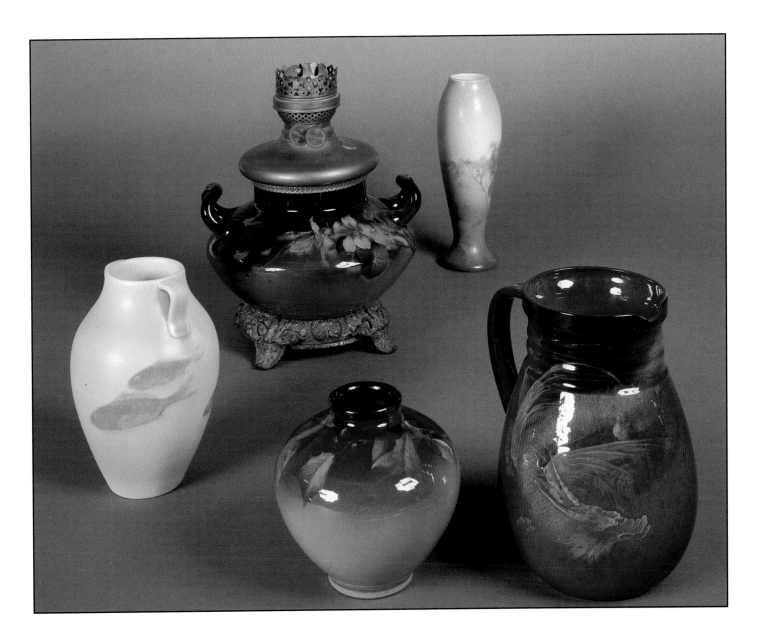

634 Vellum glaze vase with two ribbon handles, decorated by E.T. Hurley in 1906 with five swimming fish. Marks on $1000-1500
the base include the Rookwood logo, the date, shape number 604 D, V for Vellum glaze body, the artist's initials
and V for Vellum glaze. Height 7 inches. Some peppering in the glaze.

635 Standard glaze two handled vase decorated with nasturtium leaves and flowers by William McDonald in 1892. $700-900
Converted to use as an oil lamp with font and Duplex burner. Marks on the base include the Rookwood logo, the
date, shape number 158, the artist's initials and an original Rookwood sales label. Height of pottery only, 5¼ inches.

636 Standard glaze vase painted with holly by Josephine Zettel in 1899. Marks on the base include the Rookwood $300-500
logo, the date, shape number 764 C and the artist's initials. Height 5¼ inches.

637 Vellum glaze scenic vase done by Fred Rothebusch in 1914. Marks on the base include the Rookwood logo, the $600-800
date, shape number 949 D, V for Vellum glaze body, the artist's initials and V for Vellum glaze. Height 9¼ inches.

638 Good Standard glaze pitcher done in 1885 by M.A. Daly, depicting a large horned dragon. Marks on the base $1000-1500
include Rookwood in block letters, the date, shape number 54 A, R for red clay, the artist's full signature and the
date in script, 6/11/85. Height 8 inches. Small chip at lip.

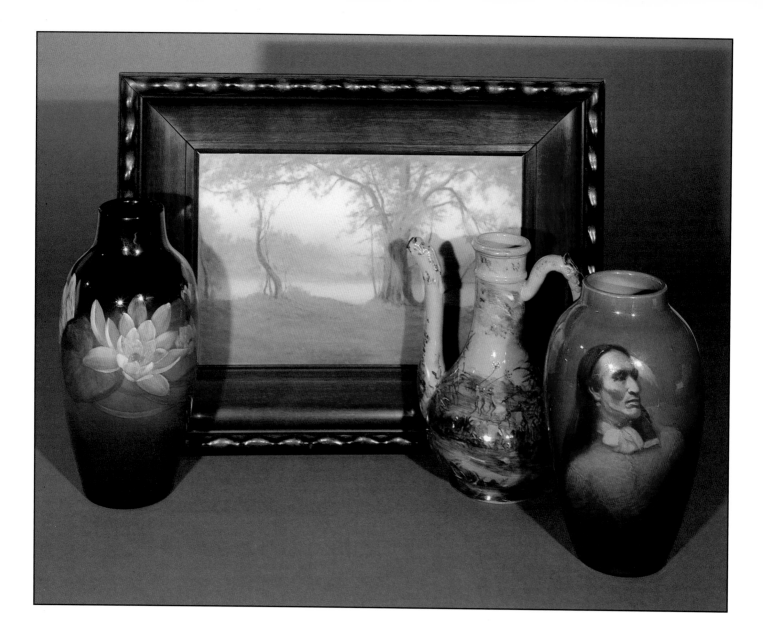

639 Important Sea Green Glaze vase decorated with lotus blossoms by Constance Baker in 1903. Marks on the base include the Rookwood logo, the date, shape number 940 C, a small wheel ground X, G for Sea Green glaze and the artist's initials. Height 11⅛ inches. $4000-6000

640 Vellum glaze scenic plaque done in 1912 by Ed Diers. The artist's initials appear in the lower right hand corner. Marks on the back include the Rookwood logo, the date and V for Vellum glaze body. A title appears on the inside of the paper backing and reads, "Tranquil Waters Little Miami River". Size 9½ x 14½ inches. $3000-4000

641 Rare Limoges style glaze Turkish coffee pot decorated by Maria Longworth Nichols in 1882 with frolicking frogs and marching grasshoppers. The pot is signed under the handle, M.L.N. in fired on gold. Marks on the base include Rookwood in block letters and the date. Height 9½ inches. The handle has been broken and glued and the lid is missing. $700-900

642 Standard glaze vase decorated with a portrait of a Native American by Sturgis Laurence in 1900. Marks on the base include the Rookwood logo, the date, a wheel ground X, shape number 900 B, the inscription "White Man Bear, Sioux" and the artist's initials. Height 9⅞ inches. $3000-4000

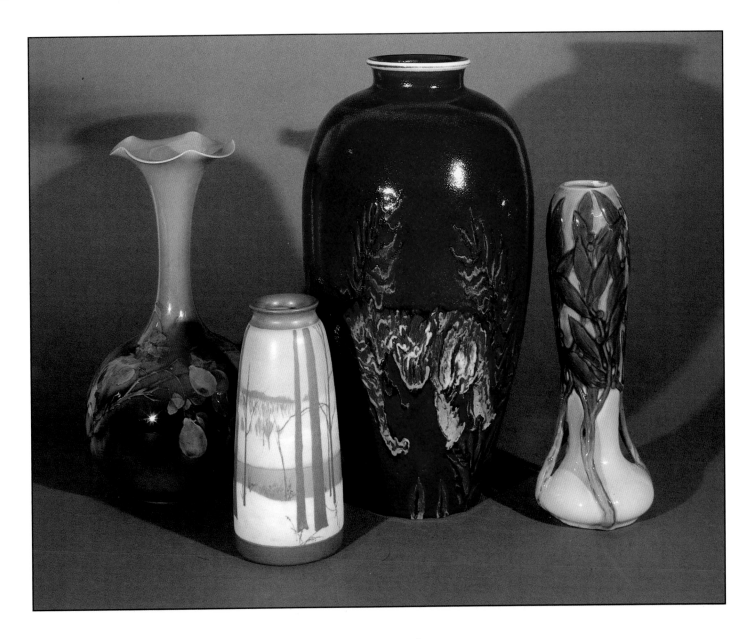

643 Large Standard glaze vase with fluted top, decorated by Kataro Shirayamadani in 1889 with lemons. Marks on the base include the Rookwood logo, the date, shape number 380 A, S for sage green clay, the artist's cypher and L for light Standard glaze. Height 15¼ inches. $2500-3500

644 Vellum glaze vase with a snowy woodland scene done in an arts and crafts style by Sara Sax in 1910. Marks on the base include the Rookwood logo, the date, shape number 1658 D, V for Vellum glaze body, the artist's monogram and V for Vellum glaze. Height 9⅞ inches. $2000-3000

645 Large and unusual high glaze vase decorated with tigers in 1937 by John Dee Wareham. Marks on the base include the Rookwood logo, the date, shape number S 2152 and the artist's initials. Height 19 inches. $4000-6000

646 Rare and unusual carved Iris glaze vase by M.A. Daly, executed in 1900. The vase has four vines which ascend from the base and stand clear of the piece for several inches, then rejoin the sides to form three dimensional leaves and berries. Marks on the base include the Rookwood logo, the date, shape number 373, the artist's full signature and W for white glaze. Height 13⅞ inches. One vine has a crack where it attaches to the base. $1500-2000

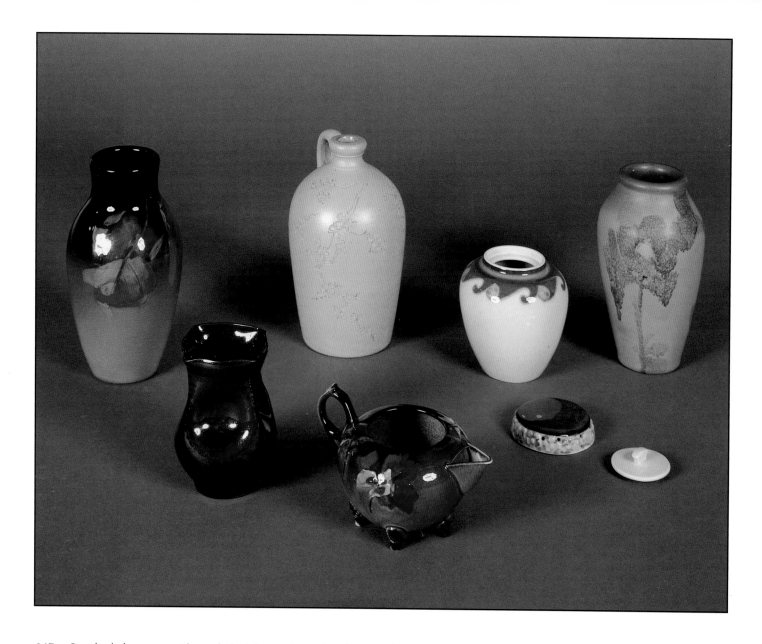

647 Standard glaze vase with maple leaf decoration, painted in 1904 by Carrie Steinle. Marks on the base include the Rookwood logo, the date, shape number 926 D, a small wheel ground X and the artist's initials. Height 7 inches. $250-350

648 Standard glaze vase covered with goldstone done circa 1887. Marks on the base include the Rookwood logo, the date which is partially obscured, shape number 312 C and R for red clay. Height 4 inches. Small glaze chip at rim. Was George Ohr ever in Cincinnati? $300-500

649 Bisque finish jug decorated with incised cherry blossoms by Laura Fry in 1882. Marks on the base include Rookwood in block letters, the date, a small star, the artist's initials and the inscription, "Cincinnati Pottery Club 1882" Height 6⅝ inches. $400-600

650 Standard glaze five footed creamer decorated by Laura Fry in 1892 with pansies. Marks on the base include the Rookwood logo, the date, shape number 616, W for white clay, the artist's initials and L for light Standard glaze. Height 3⅛ inches. $300-400

651 High glaze potpourri jar with lid and cover, decorated by C.S. Todd in 1920. Marks on the base include the Rookwood logo, the date, shape number 1321 E and the artist's initials. Height 3⅜ inches. Small flake off lower edge of cover. $300-500

652 Painted Mat glaze vase by Sallie Toohey with floral decoration done in 1901. Marks on the base include the Rookwood logo, the date, shape number 4 EZ and the artist's initials. Height 6¼ inches. $300-500

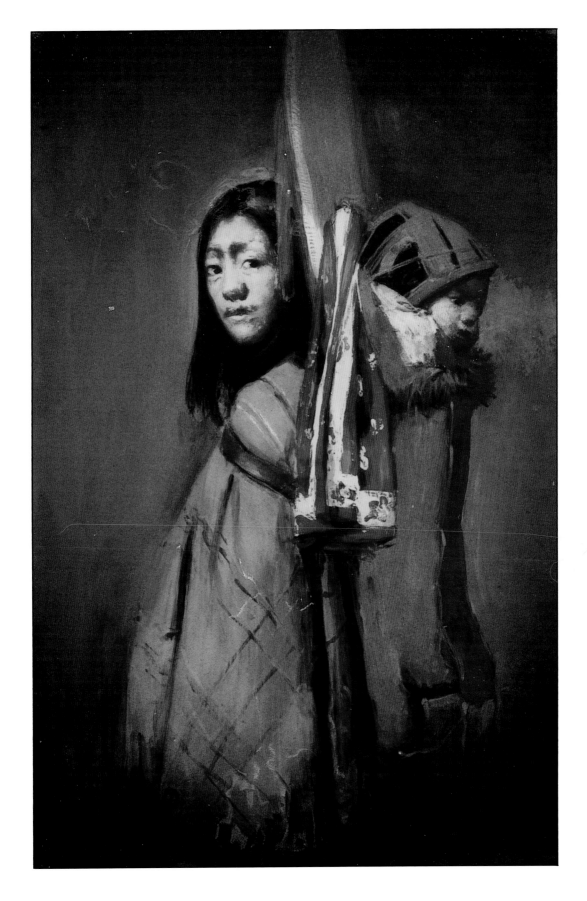

653 Extremely rare and important Standard glaze plaque painted with a Native American squaw and papoose by $20000-30000
 Grace Young in 1903. Marks on the back include a very large Rookwood logo, the date, shape number X 499
 AX, the inscription, "Ra-de-da Rio Pimas" and the artist's monogram. Also on the back is a paper label which
 reads, "A.B. Closson Jr. & Co. Art Dealer 110 W. 4th St. Cincinnati. O." and a paper label which reads,
 "Rookwood Pottery Cincinnati, U.S.A. 1904 Louisiana Purchase Exposition, St. Louis.". Size 12¼ x 8¾ inches.
 This plaque appears to be uncrazed but does have two very tiny glaze bubbles.

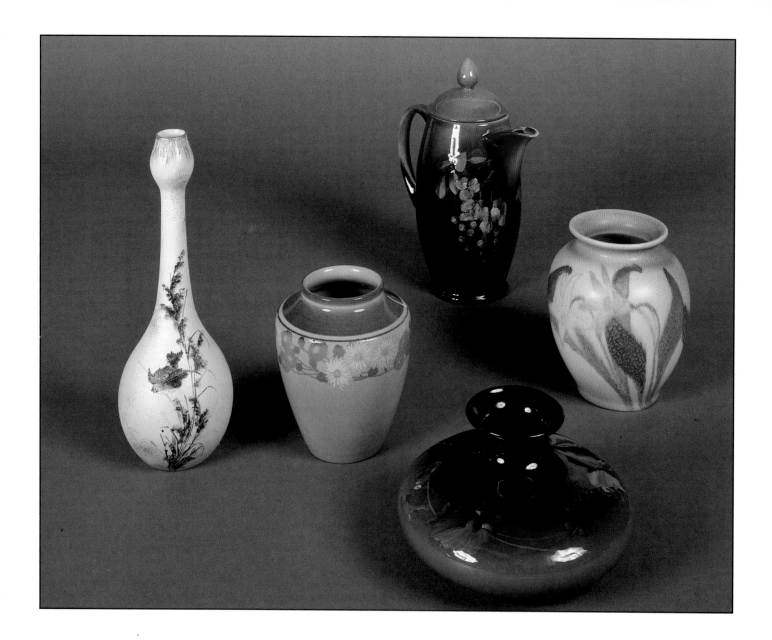

654 Bisque finish vase decorated with oriental grasses and a small bird by Anna Bookprinter in 1886. Marks on the base include Rookwood in block letters, the date, shape number 288 C, Y for yellow clay and the artist' initials. Height 10½ inches. $600-800

655 High glaze vase decorated by Kataro Shirayamadani with stylized flowers in a band near the top of the piece, done in 1922. Marks on the base include the Rookwood logo, the date, shape number 1925 and the artist's cypher. Height 5½ inches. $800-1000

656 Standard glaze bowl decorated with violets by Lenore Asbury in 1897. Marks on the base include the Rookwood logo, the date, shape number 671 B and the artist's initials. Height 4¼ inches. $300-500

657 Standard glaze lidded chocolate pot with wild rose decoration, done in 1892 by Anna Valentien. Marks on the base include the Rookwood logo, the date, shape number 621, W for white clay, the artist's initials and L for light Standard glaze. Height 9½ inches $700-900

658 Mat glaze vase decorated with dogstooth violets by Kataro Shirayamadani in 1932. Marks on the base include the Rookwood logo, the date, S for special shape number and the artist's cypher. Height 6 inches. $600-800

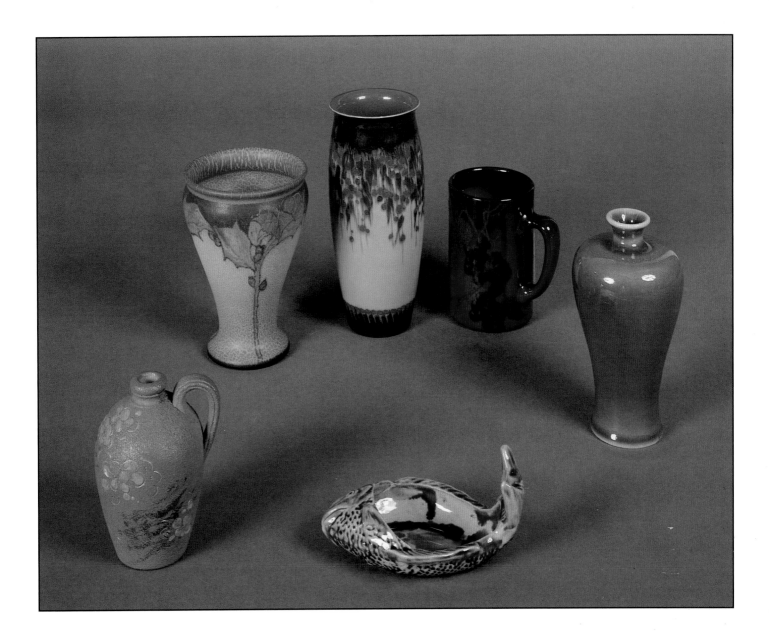

659 Bisque finish perfume jug decorated with small blue flowers in 1884 by Laura Fry. Marks on the base include the $300-500
 date, shape number 61, G for ginger clay and the artist's initials. Height 4⅝ inches.

660 Mat glaze vase with holly decoration, painted by Elizabeth Lincoln in 1922. Marks on the base include the $300-400
 Rookwood logo, the date, shape number 2238 and the artist's initials. Height 6½ inches.

661 Blue tinted high glaze vase decorated with hanging flowers by Lorinda Epply in 1920. Marks on the base include $300-400
 the Rookwood logo, the date, shape number 808 and the artist's initials. Height 7¼ inches. Tiny flake off rim and
 burst glaze bubble.

662 High glaze fish "Entree Dish" decorated by Martin Rettig in 1884. Marks on the base include Rookwood in block $400-600
 letters, the date, shape number 53, Y for yellow clay and the artist's initials. Height 2¼ inches, length 5¼ inches.

663 Standard glaze mug decorated by E.T. Hurley in 1900 with grapes, grape leaves and vines. Marks on the base $400-600
 include the Rookwood logo, the date, shape number S 1671 and the artist's initials. Height 4⅝ inches.

664 High glaze porcelain bodied vase made at Rookwood in 1915. Marks on the base include the Rookwood logo, $150-250
 the date, shape number S 1944 and P for porcelain body. Height 6⅛ inches.

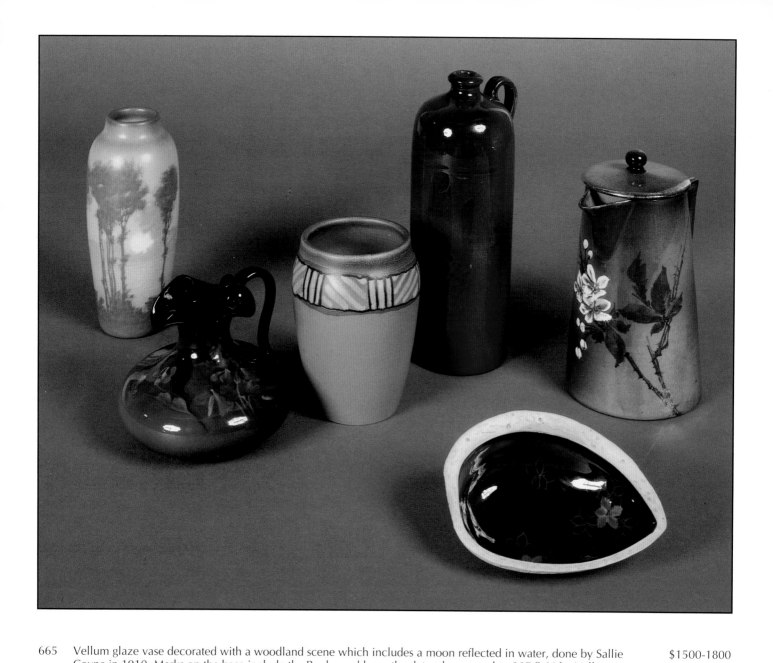

665 Vellum glaze vase decorated with a woodland scene which includes a moon reflected in water, done by Sallie $1500-1800
Coyne in 1910. Marks on the base include the Rookwood logo, the date, shape number 907 F, V for Vellum
glaze body, the artist's initials and V for vellum glaze. Height 7¾ inches.

666 Standard glaze ewer decorated by an unknown artist in 1897 with violets. Marks on the base include the $300-500
Rookwood logo, the date, shape number 495 C, a small triangular esoteric mark and the artist's cypher. Height
4½ inches.

667 Early mat glaze vase with geometric patterns near the top, done by an unknown artist in 1900. Marks on the base $200-300
include the Rookwood logo, the date and the shape number 25 Z. Height 5½ inches.

668 Standard glaze bottle with single loop handle, decorated with incised vines and leaves by an unknown artist in $400-600
1886. The piece shows several areas of Tiger Eye and the inscription, "Whisky" on the side. Marks on the base
include the Rookwood logo, the date, shape number 122 and R for red clay. Height 9¾ inches.

669 Bisque and standard glaze almond shaped dish decorated by Anna Valentien in 1896. Marks on the base include $200-300
the Rookwood logo, the date, Shape number 279, the number 99 and the artist's initials. Height 1¼ width 6⅛
inches.

670 Cameo glaze lidded chocolate pot decorated with wild roses by Laura Fry in 1887. Marks on the base include the $700-900
Rookwood logo, the date, shape number 251, G for ginger clay, the artist's initials and W for white glaze. Height
7⅞ inches.

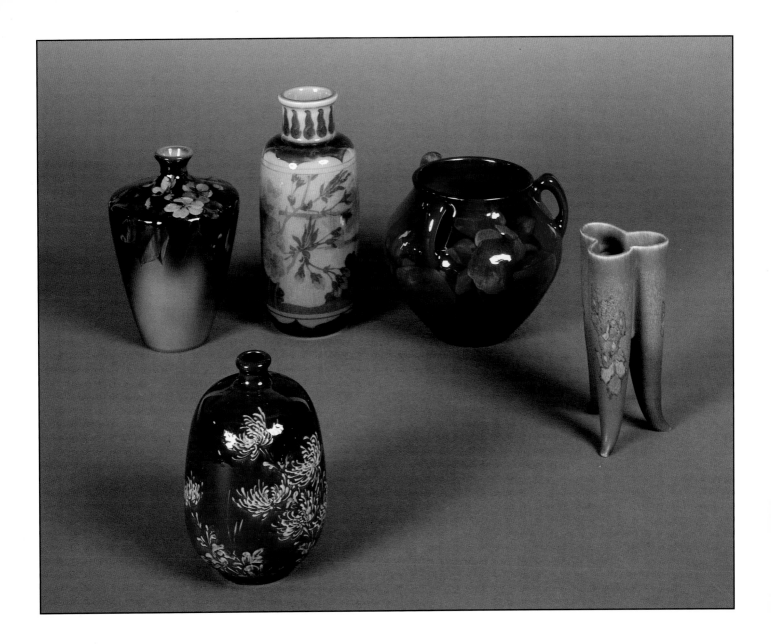

671 Standard glaze vase decorated with wild roses by Emma Foertmeyer in 1894. Marks on the base include the Rookwood logo, the date, the code 7 - W - N bracketed by crescent moon esoteric marks and the artist's initials. Height 6¾ inches. Glaze problems. $200-400

672 Standard glaze vase decorated in an oriental manner by Laura Fry in 1885 with mums. Marks on the base include Rookwood in block letters, the date, shape number 215, G for ginger clay and the artist's initials. Height 5½ inches. $300-500

673 High glaze scenic vase decorated with stylized pink roses by Arthur Conant in 1921. Marks on the base include the Rookwood logo, the date, shape number 2528, and the artist's monogram. Height 8½ inches. $2000-2500

674 Standard glaze bowl with three handles decorated with nasturtiums by E.T. Hurley in 1900. Marks on the base include the Rookwood logo, the date, shape number 906 C, a small wheel ground X and the artist's initials. Height 5⅝ inches. Spider web crack on base. $200-300

675 Mat glaze three lobed flower vase, decorated by Katherine Jones in 1925. Marks on the piece include the Rookwood logo, the date, shape number 2764 and the artist's initials. Height 6 inches. $250-350

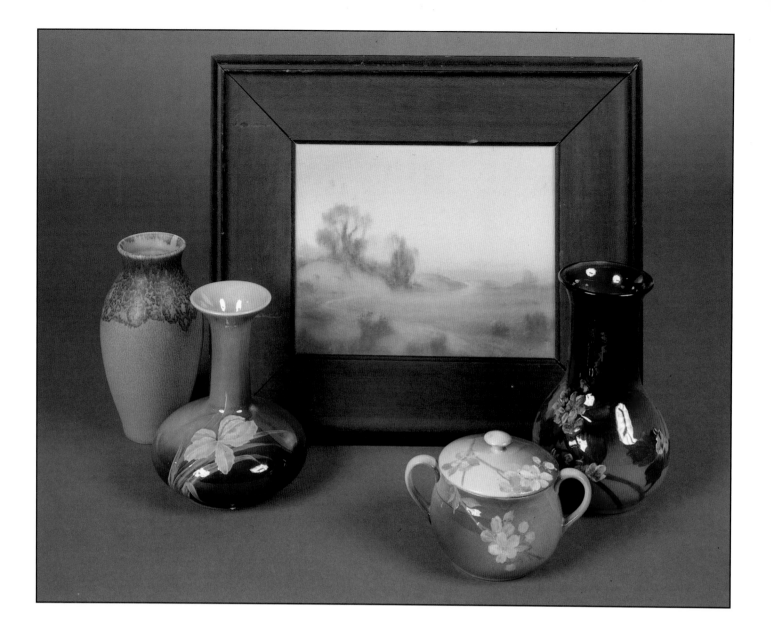

676 Mat glaze floral vase by Katherine Jones, done in 1923. Marks on the base include the Rookwood logo, the date, shape number 356 E and the artist's initials. Height 6⅜ inches. $250-350

677 Standard glaze vase decorated with a single yellow iris blossom by Olga Geneva Reed in 1890. Marks on the base include the Rookwood logo, the date, shape number 415, W for white clay, the artist's initials and L for light Standard glaze. Height 6⅝ inches. $300-500

678 Vellum glaze scenic plaque done in 1915 by Fred Rothenbusch. The artist's initials appear in the lower right hand corner. Marks on the back include the Rookwood logo, the date, V for Vellum glaze body and a title in pencil, "Winding Brook". Size 7⅛ x 9⅜ inches. Glaze bubbles. $1200-1500

679 Cameo glaze covered sugar bowl decorated with wild roses by Emma Foertmeyer in 1890. Marks on the base include the Rookwood logo, the date, shape number 554, W for white clay, the artist's initials and L for light standard glaze. This piece, for unknown reasons, was glazed with the "white" or Cameo glaze instead of a light standard glaze which the artist had indicated on the base. Height 3¼ inches. Tight one inch line from the rim. $300-400

680 Standard glaze vase with leaves and flowers, decorated by Carrie Steinle in 1898. Marks on the base include the Rookwood logo, the date, shape number 486 E and the artist's initials. Height 7 inches. $400-600

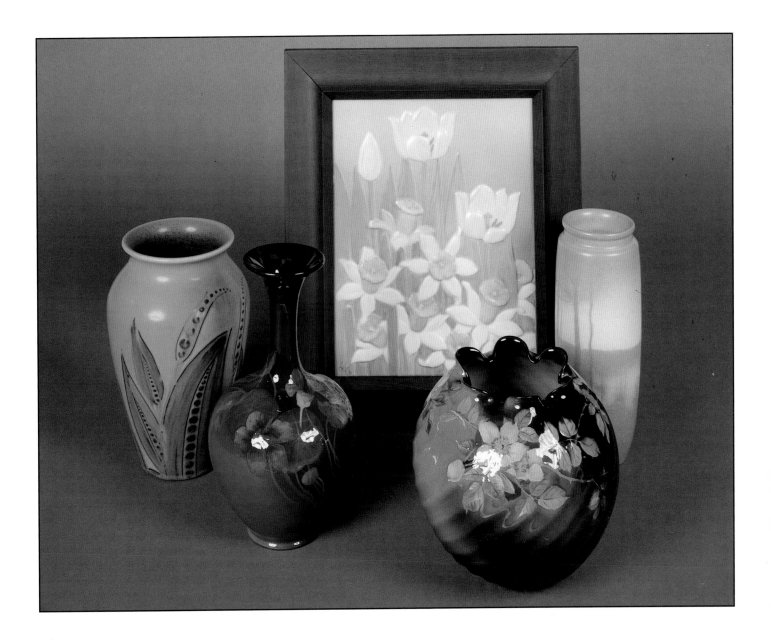

681 Mat glaze vase with Art Deco leaf and berry decoration, done by William Hentschel in 1927. Marks on the base $500-700
include the Rookwood logo, the date, shape number 2996 and the artist's initials. Height 8¼ inches.

682 Standard glaze vase decorated with nasturtiums by Clara Lindeman in 1900. Marks on the base include the $500-700
Rookwood logo, the date, shape number 578 D and the artist's initials. Height 9¾ inches.

683 Rare commercial plaque designed by Kataro Shirayamadani, cast with tulips and jonquils in high relief, and $1500-2000
apparently hand colored by Lenore Asbury in 1931. The plaque is initialled L.A. in the lower left hand corner.
Marks on the back include the Rookwood logo, the date, and shape number 6291. Size 11½ X 9 inches.

684 Standard glaze ribbed and swirled vase with fluted top, decorated with wild roses by Sallie Toohey in 1895. $300-400
Marks on the base include the Rookwood logo, the date, shape number 612 B and the artist's initials. Height
7 inches. Restoration on lip.

685 Vellum glaze woodland scenic vase, decorated by E.T. Hurley in 1913 in unusual shades of brown. Marks on the $1200-1500
base include the Rookwood logo, the date, shape number 589 E, V for Vellum glaze body and the artist's initials.
Height 9¼ inches.

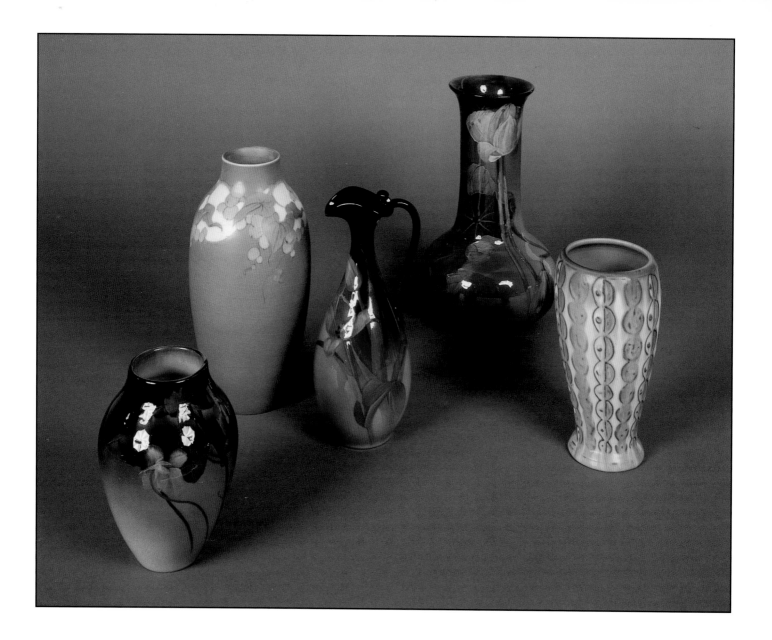

686 Standard glaze vase with nasturtium decoration by Mary Nourse in 1898. Marks on the base include the $400-600
Rookwood logo, the date, shape number 604 D, a small star shaped esoteric mark, the artist's initials, and L for
light Standard glaze. Height 6⅛ inches.

687 Vellum glaze vase with a repeating border of exotic flowers, vines and fruit encircling the top, decorated by $800-1200
Lenore Asbury in 1917. Marks on the base include the Rookwood logo, the date, shape number 940 D, V for
Vellum glaze body and the artist's initials. Height 10⅛ inches.

688 Standard glaze ewer decorated with orange tulips by Josephine Zettel in 1901. Marks on the base include the $500-700
Rookwood logo, the date, shape number 496 C and the artist's initials. Height 9⅝ inches.

689 Standard glaze vase decorated with lotus blossoms and leaves by Grace Young in 1897. Marks on the base $1000-1200
include the Rookwood logo, the date, shape number 486 B, a small diamond shape esoteric mark, a small wheel
ground X and the artist's initials. Height 11⅛ inches. Several glaze bubbles.

690 Mat glaze vase with Art Deco styling by Elizabeth Barrett, done in 1928. Marks on the base include the $400-600
Rookwood logo, the date, shape number 1779 and the artist's monogram. Height 8 inches.

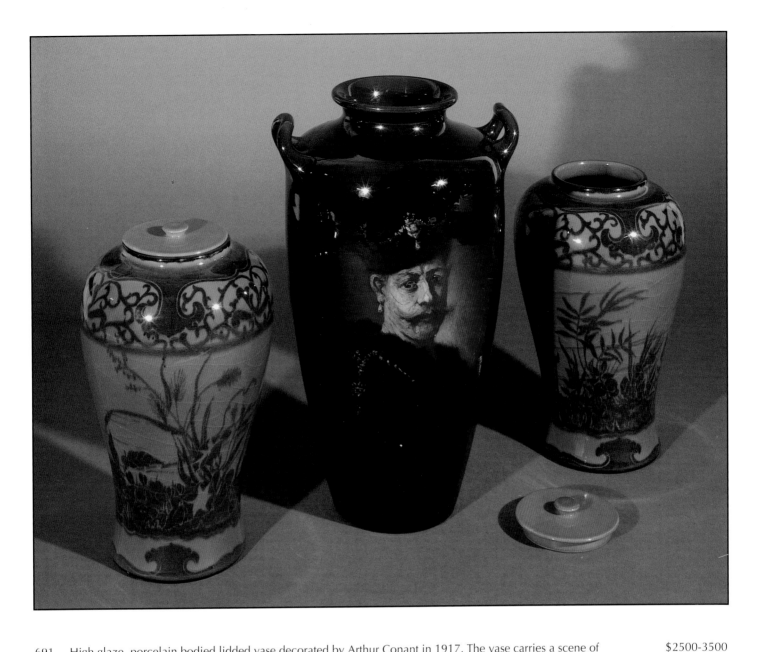

691　High glaze, porcelain bodied lidded vase decorated by Arthur Conant in 1917. The vase carries a scene of　　　$2500-3500
　　　flowers and shrubs by a body of water with an occasional sea creature in the foliage, and is banded, top and
　　　bottom with moresque borders and covered with a blue tinted glaze. The top is original and signed with Conant's
　　　monogram. Marks on the base include the Rookwood logo, the date, shape number 2443, P for porcelain body
　　　and the artist's monogram. Height 10¼ inches.

692　Large Standard glaze two handled vase decorated with a portrait of a gentleman, possibly after Rembrandt, by　　　$1500-2500
　　　M.A. Daly in 1899. Marks on the base include the Rookwood logo, the date, shape number 614 B, a wheel
　　　ground X, an arrowhead shaped esoteric mark and the partially obliterated artist's initials. Height 13⅞ inches.
　　　Crude hole in bottom. Some surface scratches.

693　High glaze, porcelain bodied lidded vase decorated by Arthur Conant in 1917. The vase carries a scene of　　　$2500-3500
　　　flowers and shrubs by a body of water with an occasional sea creature in the foliage, and is banded, top and
　　　bottom with moresque borders and covered with a blue tinted glaze. The top is original and signed with Conant's
　　　monogram. Marks on the base include the Rookwood logo, the date, shape number 2443, P for porcelain body
　　　and the artist's monogram. Height 10¼ inches.

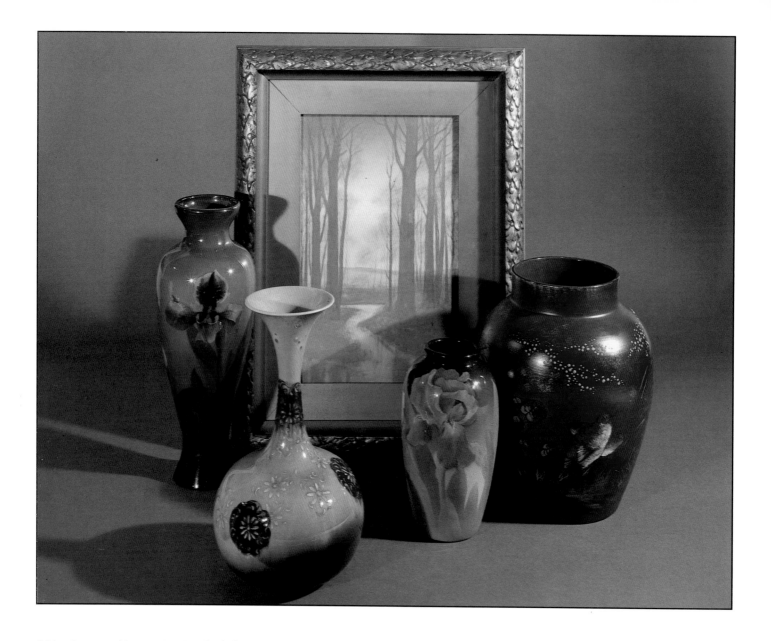

694 Large and impressive Standard glaze vase decorated with two orchids by Albert Valentien in 1898. The piece carries the artist's full signature on its side. Marks on the base include the Rookwood logo, the date and shape number 816 D. Height 13¾ inches. — $2500-3500

695 Standard glaze vase decorated with stylized blossoms by M.A. Daly in 1887. Marks on the base include the Rookwood logo, the date, shape number 380, W7 for white clay, the artist's initials and L for light standard glaze. Height 11¾ inches. Several glaze bubbles under the flared top. — $600-800

696 Vellum glaze scenic plaque decorated in 1912 by Kataro Shirayamadani. The artist's cypher appears in the lower right hand corner. Marks on the back include the Rookwood logo, the date, V for Vellum glaze body and the title, "Evening Reflections". Size 14¼ x 9 inches. — $4000-6000

697 Iris glaze vase decorated with purple irises by Ed Diers in 1902. Marks on the base include the Rookwood logo, the date, shape number 922 C, W for white glaze, a small unknown esoteric mark and the artist's initials. Height 8¼ inches. — $1750-2250

698 Large bisque finish vase decorated by Albert Valentien in 1882 with a pair of quail in low foliage. Marks on the base include Rookwood in block letters, the date, shape number 103, R for red clay, a small impressed anchor mark and the artist's initials. Height 11 inches. Repair to lip. — $900-1200

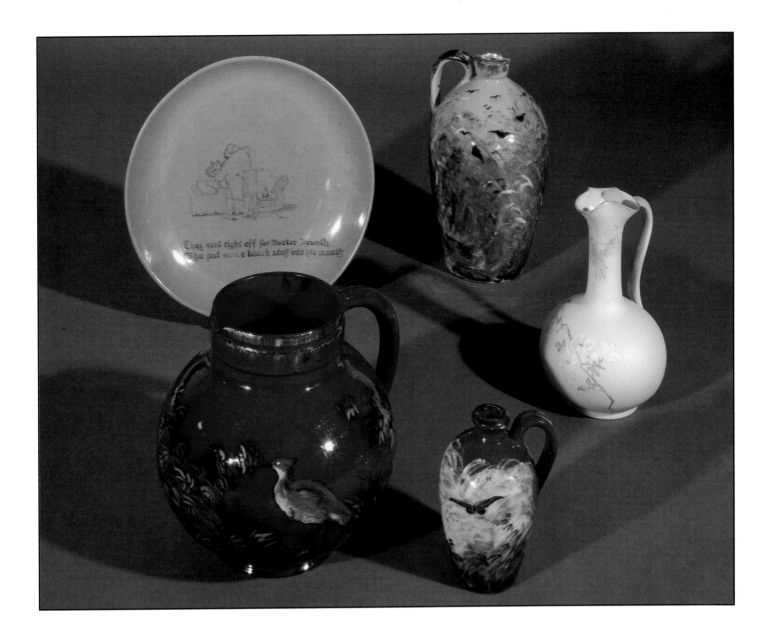

699 High glaze story plate done by E.P. Cranch in 1885. The plate shows a man in a frock coat, administering $400-600
medicine to another person who is in bed. Below the scene is the following verse: "They sent right off for Doctor
Drowth, Who put some black stuff into his mouth". Marks on the reverse include Rookwood in block letters, the
date, shape number 45 C, the artist's initials and the following note: "American Ballads. Isaac Abbott". Diameter
is 9⅛ inches.

700 Limoges style glaze pitcher decorated with green foliage and two birds by Albert Valentien in 1882. Marks on the $900-1200
base include Rookwood in block letters, the date, shape number 36, an impressed anchor, R for red clay and the
artist's initials. Height 6¾ inches.

701 Limoges style glaze perfume jug decorated with oriental grasses, clouds and two butterflies by Albert Valentien in $300-500
1882. Marks on the base include Rookwood in block letters, the date, shape number 61, R for red clay, a small
impressed anchor mark and the artist's initials. Height 4⅜ inches.

702 Limoges style glaze jug decorated in 1882 by N.J. Hirschfeld with bats flying through clouds and trees. Marks on $500-700
the base include Rookwood in block letters, the date and the artist's initials. Height 8¼ inches.

703 Bisque finish ewer decorated with apple blossoms by Grace Young in 1889. Marks on the base include the $500-700
Rookwood logo, the date, W for white clay, shape number 101 D, the artist's initials and S for an unknown glaze
designation. Height 6⅞ inches.

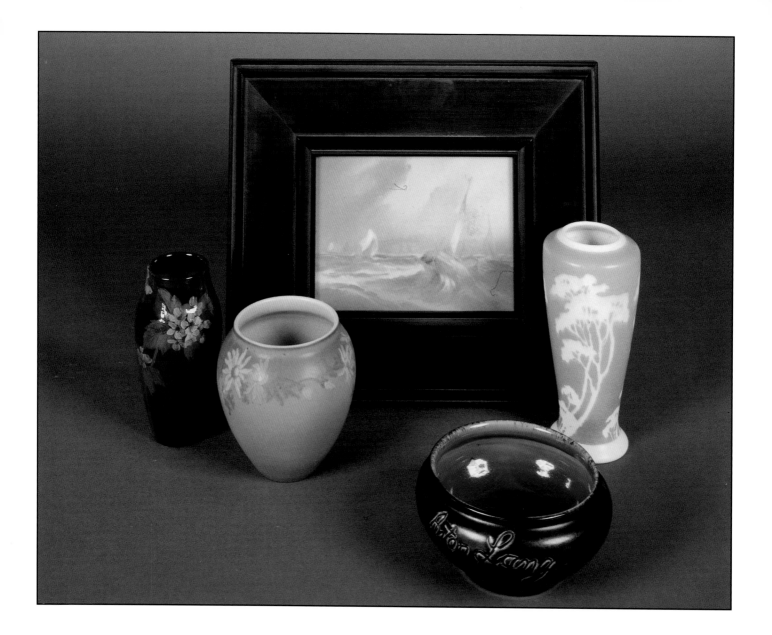

704　Standard glaze vase decorated with fruit blossoms and leaves by Rose Fechheimer in 1899. Marks on the base include the Rookwood logo, the date, shape number 30 F, a small wheel ground X and the artist's initials. Height 6 inches.　　　$250-350

705　Vellum glaze vase decorated with chrysanthemums by Katherine Jones in 1923. Marks on the base include the Rookwood logo, the date, shape number 1343, V for vellum glaze, P for porcelain body and the artist's initials. Height 5 inches.　　　$500-700

706　Vellum glaze scenic plaque decorated in 1928 by Fred Rothenbusch. The artist's initials appear in the lower left hand corner. Marks on the back include the Rookwood logo, the date and the title in pencil, "Squall Coming". Size 6 x 7⅞. This plaque is uncrazed but has an area of discoloration and pitting near the largest boat.　　　$1500-2000

707　Rookwood gunmetal glaze bowl thrown and signed on the side by Anton Lang. Lang was an actor in the Oberammergau Passion Plays in his native Bavaria as well as a potter, and on a visit to Rookwood in 1924, threw and signed a number of pieces. Marks on the base include the Rookwood logo and the date. Height 2⅞ inches.　　　$300-400

708　Unusual Vellum glaze vase with a repeating woodland scene in silhouette painted by Mary Grace Denzler in 1915. Marks on the base include the Rookwood logo, the date, shape number 1356 E, V for Vellum glaze body and the artist's monogram. Height 7⅛ inches.　　　$700-900

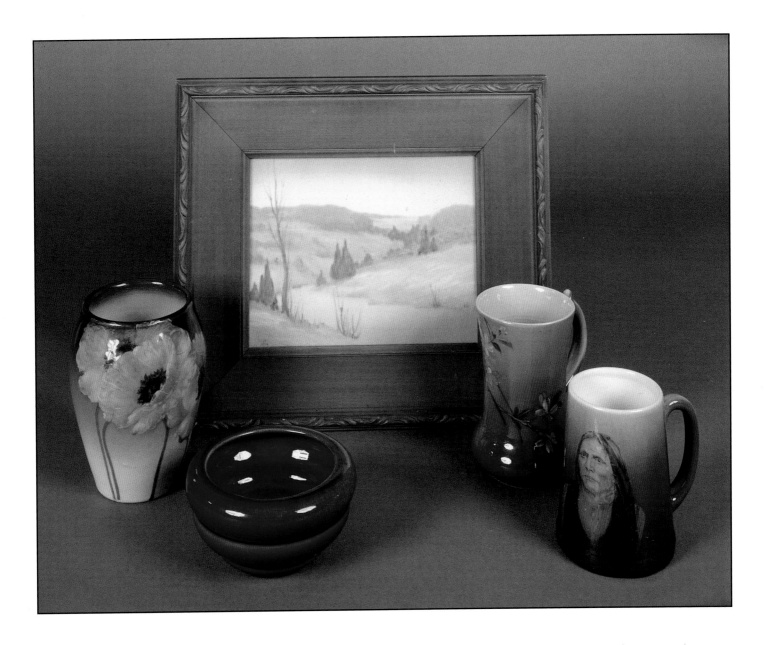

709 Iris glaze vase with white poppies decorated by E.T. Hurley in 1904. Marks on the base include the Rookwood logo, the date, shape number 942 C, a wheel ground X, the artist's initials and W for white glaze. A small glaze bruise appears on the upper lip. Height 6½ inches. $600-800

710 Coromandel style glaze bowl from 1932. Marks on the base include the Rookwood logo, the date, shape number 6286 and monogram of Louise Abel, the artist who designed the shape. Height 2⅞ inches. Lid missing. $200-300

711 Vellum glaze plaque decorated in 1917 by Lorinda Epply. The artist's initials appear in the lower left hand corner. Marks on the back include the Rookwood logo, the date and V for Vellum glaze body. Size 7¼ x 9⅝ inches. $2500-3500

712 Standard glaze mug decorated with orange flowers and green leaves by Sallie Toohey in 1890. Marks on the base include the Rookwood logo, the date, shape number 561, W for white clay, the artist's initials and L for light Standard glaze. Height 5⅞ inches. Some discoloration in crazing. $300-400

713 High glaze mug decorated with a Native American portrait by Flora King in 1946. Marks on the base include the Rookwood logo, the date, shape number 587 C, the inscription, "Big Bow", the number "221A" and the artist's initials. Height 5 inches. $600-800

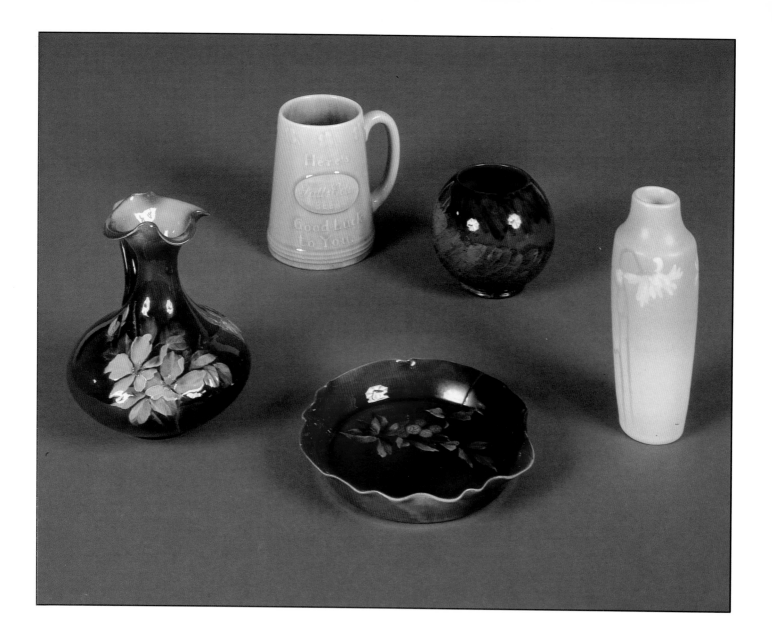

714 Standard glaze ewer decorated with yellow wild roses by an unknown artist in 1891. Marks on the base include $300-500
the Rookwood logo, the date, shape number T 549, W for white clay, the artist's initials and L for light Standard
glaze. Height 6¼ inches.

715 High glaze advertising mug, made for Falls City Brewing Company in Louisville by Rookwood in 1948. Marks on $200-300
the base include the Rookwood logo and the date. Height 5 inches.

716 Standard glaze plate decorated with berries by Harriet Wilcox in 1889. Marks on the base include the Rookwood $200-300
logo, the date, the artist's initials and L.Y. for light yellow (Standard) glaze. Height 1⅛, width 6¼ inches.

717 Limoges style glaze bowl decorated with abstract designs by Mary Virginia Keenan in 1883. Marks on the base $200-300
include Rookwood in block letters, the date and R for red clay. The artist's initials appear on the side of the bowl.
Height 3⅝ inches.

718 Vellum glaze vase painted with daisies by Lorinda Epply in 1907. Marks on the base include the Rookwood logo, $200-300
the date, shape number 941 E, V for Vellum glaze body, the artist's initials and V for Vellum glaze. Height 6⅞
inches. Some peppering in glaze.

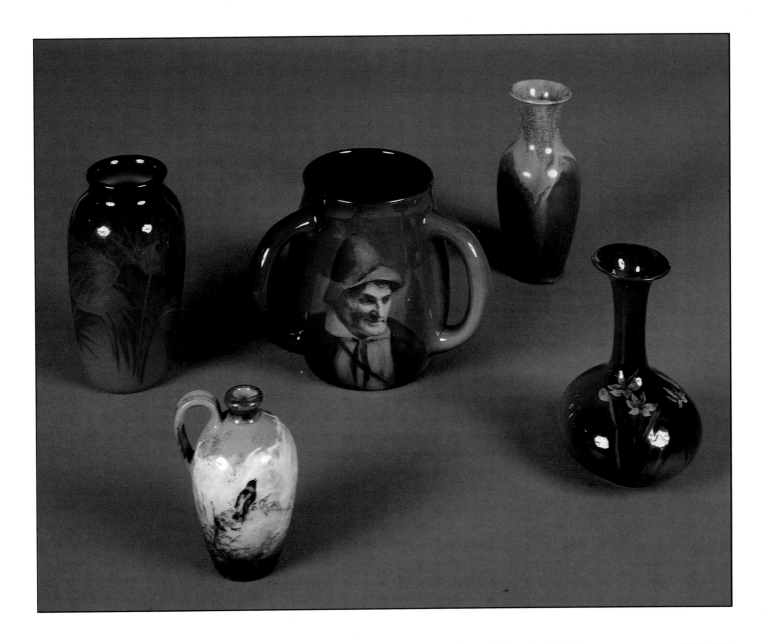

719 Standard glaze vase decorated with palm fronds by E.T. Hurley in 1902. Marks on the base include the Rookwood logo, the date, shape number 80 B and the artist's initials. Height 6¾ inches. $300-500

720 Limoges style glaze perfume jar decorated with oriental grasses, clouds and birds by N.J. Hirschfeld in 1882. Marks on the base include Rookwood in block letters, the date, shape number 61, G for ginger clay, a small impressed anchor mark and the artist's initials. Height 4½ inches. $350-550

721 Standard glaze three handled loving cup decorated by Edith Felton and featuring a portrait of the American actor, Joe Jefferson in his most famous role of Rip Van Winkle. Jefferson, a frequent visitor to Cincinnati and to Rookwood was the subject of many portrait pieces over the years and did decorate several large circular plaques himself. Marks on the base include the Rookwood logo, the date, shape number 659 C, the artist's initials and the title: "Joseph Jefferson - as - Rip - Van - Winkle." Height 6¼ inches. $2000-3000

722 Drip glaze vase with some crystals, done in 1932. Marks on the base include the Rookwood logo, the date, shape number 6038 D and a small cross shaped esoteric mark. Height 6⅞ inches. $200-300

723 Standard glaze vase with Star of Bethlehem flowers, possibly decorated by Carl Schmidt in 1895. Marks on the base include the Rookwood logo, the date, shape number 527 F and an artist's cypher which is somewhat different from Schmidt's usual mark. Height 6 inches. $300-500

724 Monumental vase by Kataro Shirayamadani made in 1900 with electroplated copper fish swimming under a Sea Green glaze. Two large carp move among art nouveau currents and sea grasses, with carved grasses in the upper half of the vase. An extraordinary and important example, its marks on the base include the Rookwood logo, the date, shape number 804 A and the artist's cypher. Two older paper labels are taped to the base. Height 18⅜ inches. There is a small ½ inch by⅛ inch kiln kiss on the back side of the rim. $40000-60000

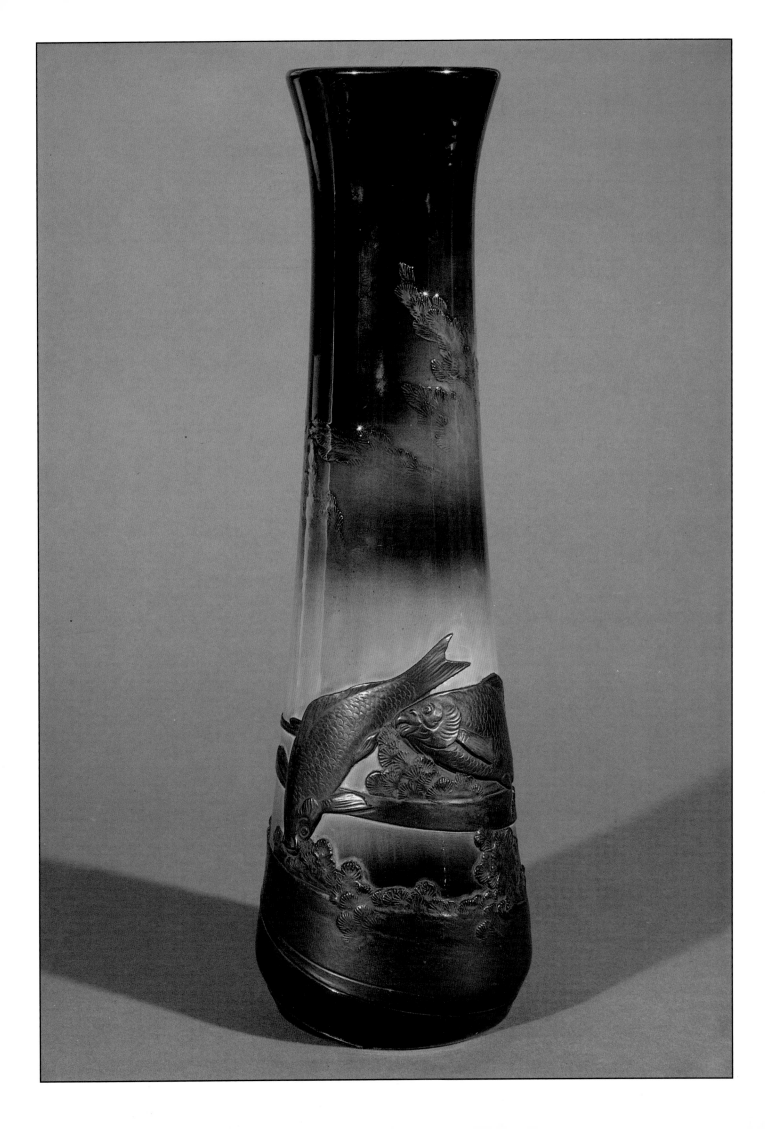

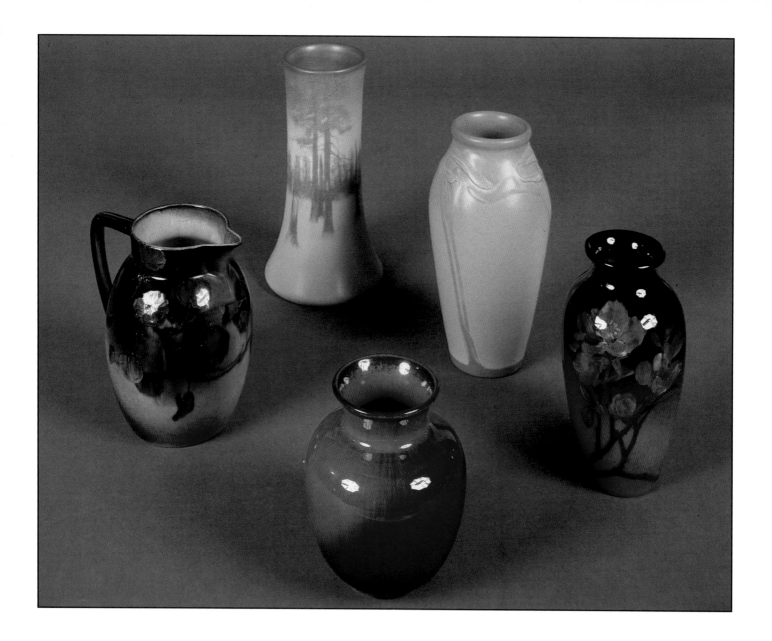

725 Standard glaze pitcher with leaves and tiny blue flowers, decorated by William McDonald in 1892. Marks on the base include the Rookwood logo, the date, shape number 18, W for white clay and the artist's initials. Height 5⅛ inches. Repair to lip. $200-300

726 Vellum glaze vase with woodland snow scene, decorated by E.T. Hurley in 1910. Marks on the base include the Rookwood logo, the date, shape number 1358 D, V for Vellum glaze body and the artist's initials. Height 8⅞ inches. Three dark lines can be seen on the inside which do not appear on the surface. $1200-1500

727 High glaze vase with coromandel type glaze, made in 1932. Marks on the base include the Rookwood logo, the date, S for a special shape and the date. Height 5¼ inches. $200-300

728 Nice carved and painted vellum glaze vase decorated by Lorinda Epply with three somewhat stylized jacks-in-the-pulpit in 1909. Marks on the base include the Rookwood logo, the date, shape number 925 D, V for Vellum glaze body, the artist's initials and V for Vellum glaze. Height 8⅛ inches. $1500-2500

729 Standard glaze vase decorated with orange flowers by E.T. Hurley in 1902. Marks on the base include the Rookwood logo, the date, shape number 534 C, a small wheel ground X and the artist's initials. Height 7 inches. $400-600

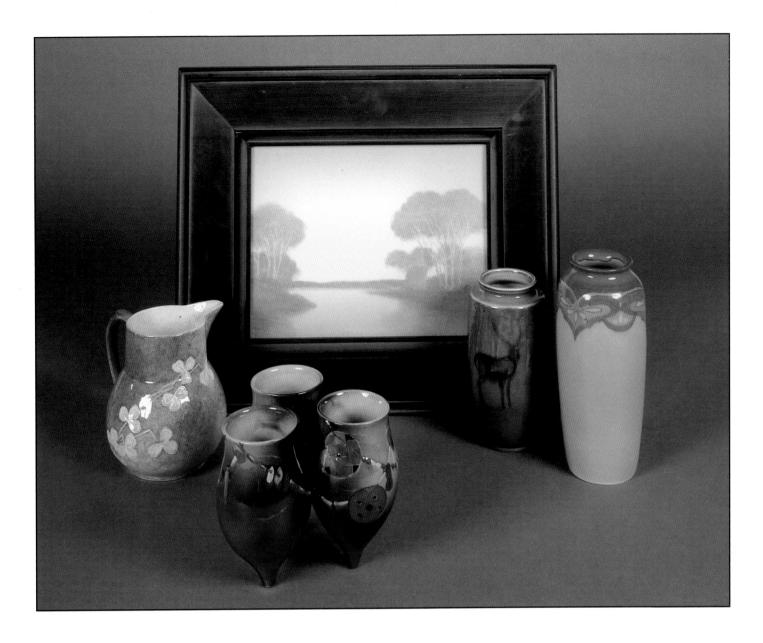

730 High glaze pitcher with carved and incised leaves and vines, done by Anna Bookprinter in 1885. Marks on the base include Rookwood in block letters, the date, shape number 88, W for white clay, the artist's initials and the following note incised in the base: "Anna Marie Bookprinter Winton Place". Winton Place is a suburb of Cincinnati where the Bookprinter family lived. Height 5¼ inches. $300-500

731 Unusual three compartmented flower bowl decorated with Native American designs by Mary Nourse in 1893. Marks on the piece include the Rookwood logo, the date, shape number 83, the artist's initials and L for light Standard glaze. Height 5½ inches. $1500-2000

732 Vellum glaze scenic plaque decorated by E.T. Hurley in 1918. The artist's initials appear in the lower left hand corner. Marks on the back include the Rookwood logo and the date. Size 8⅝ x 10⅞ inches. $2000-2500

733 Rare and early Sea Green vase decorated with an elk in a woodland setting by M.A. Daly in 1894, the first year for Sea Green. Marks on the base include the Rookwood logo, the date, shape number 734 DD, W for white clay, G for Sea Green glaze, the artist's initials and the number 138. Height 6⅞ inches. $2500-3500

734 Blue tinted high glaze, porcelain bodied vase, decorated by Charles McLaughlin in 1918 with a repeating border near the top. Marks on the base include the Rookwood logo, the date, shape number 904 D, P for porcelain body and the artist's initials. Height 8⅛ inches. $400-600

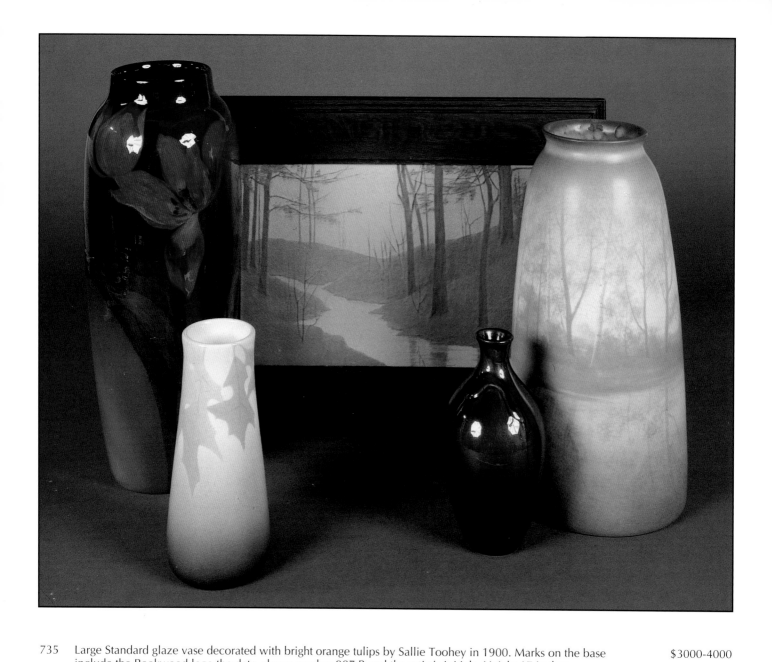

735 Large Standard glaze vase decorated with bright orange tulips by Sallie Toohey in 1900. Marks on the base $3000-4000
 include the Rookwood logo the date, shape number 907 B and the artist's initials. Height 17 inches.

736 Iris glaze vase decorated with oak leaves by Sara Sax in 1907. Marks on the base include the Rookwood logo, the $500-700
 date, shape number 950 D, W for white glaze and the artist's monogram. Height 8½ inches.

737 Vellum glaze scenic plaque painted in 1914 by Sara Sax. The artist's name appears in the lower right hand $5000-7000
 corner. Marks on the back include the Rookwood logo, the date and an incised V for Vellum glaze. On the frame
 is an original paper label with the title, "Autumn Evening Afterglow". Size 9¼ x 14⅛ inches.

738 Standard glaze vase decorated with a snakelike dragon encircling the piece. The vase is a wonderful example of $2500-3500
 Rookwood's Tiger Eye effect. Pooling of the glaze obscures the artist's initials and we can only approximate the
 date at circa 1898. Marks visible on the base include the Rookwood logo, the shape number 745 B, a small
 triangular shaped esoteric mark and R for red clay. Height 7¾ inches.

739 Large and impressive Vellum glaze scenic vase painted by Kataro Shirayamadani in 1912, depicting birch woods $3000-5000
 reflected in water. Marks on the base include the Rookwood logo, the date, shape number 1658 B, V for Vellum
 glaze body and the artist's cypher. Height 14¾ inches.

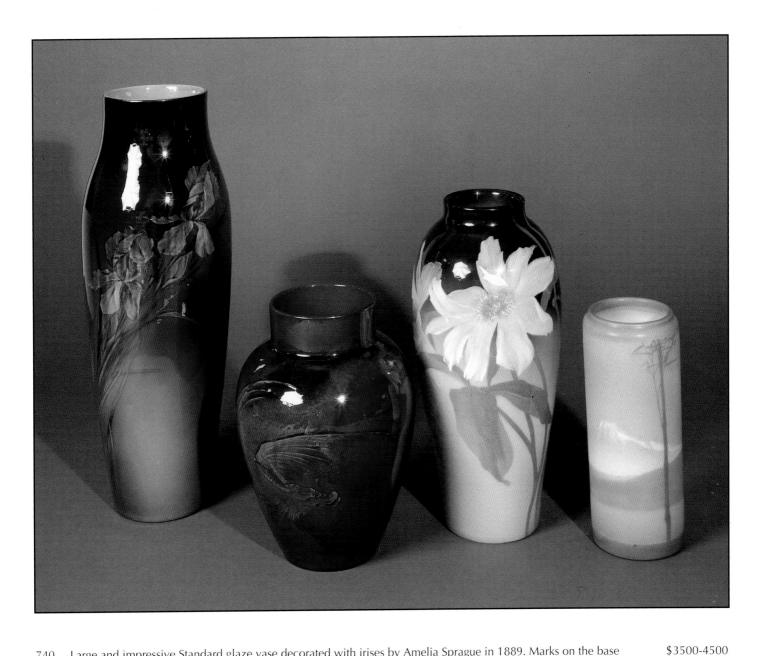

740 Large and impressive Standard glaze vase decorated with irises by Amelia Sprague in 1889. Marks on the base $3500-4500
include the partially obscured Rookwood logo, the date, S for sage green clay, the artist's initials, L for light
Standard glaze and the date in script, Sept. 25/'89. Height 18 inches.

741 Standard glaze vase with a large encircling winged dragon done by M.A. Daly in 1885. There is much Tiger Eye $3000-3500
effect evident in the piece. Marks on the base include Rookwood in block letters. the date, shape number 162 B,
R for red clay and the artist's initials. Height 10¼ inches. Several small glaze bubbles.

742 Large and impressive Iris glaze vase with several peonies in various stages of blooming, decorated in 1903 by $5000-7000
Sara Sax. Marks on the base include the Rookwood logo, the date, shape number 901 A, W for white glaze, a
small wheel ground X and the artist's monogram. Height 13½ inches.

743 Unusual scenic Vellum glaze vase, decorated by Sara Sax in 1919. This piece shows Mount Fuji through a grove $1250-1500
of bamboo. Marks on the base include the Rookwood logo, the date, shape number 952 D, V for Vellum glaze
body, the artist's monogram and V for Vellum glaze. Height 9⅜ inches.

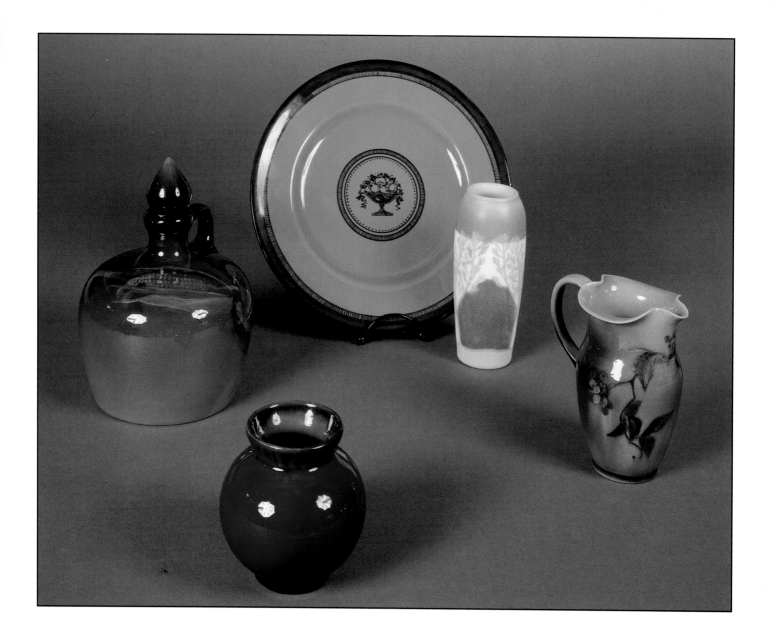

744 Standard glaze whiskey jug, decorated with corn by Lenore Asbury in 1899. Marks on the base include the Rookwood logo, the date, shape number 676 and the artist's initials. Height 7⅞ inches. $700-900

745 Coromandel glaze vase done circa 1932. Marks on the base are almost completely obscured with the exception of the Rookwood logo which is quite visible. Height 4 inches. $150-250

746 Green tinted high glaze plate with formal fruit compote decoration done by Arthur Conant circa 1920. Marks on the base include the Rookwood logo (reversed R and P with no flames), and artist's monogram. Most diner ware made at Rookwood in the 1920's does not have flames around the trademark or Roman numerals for the date. Because of Conant's tenure at Rookwood, we can assume the plate to have been made circa 1920. Diameter 10 inches. $300-500

747 Vellum glaze vase with floral decoration, done by Elizabeth N. Lincoln in 1907. Marks on the base include the Rookwood logo, the date, shape number 915 F, V for Vellum glaze body, a fan shaped esoteric mark, the artist's initials and V for Vellum glaze. Height 6 inches. $300-400

748 Standard glaze pitcher decorated by Grace Young in 1889 with small red berries and green leaves. Marks on the base include the Rookwood logo, the date, shape number 513, S for sage green clay, the artist's monogram and L for light Standard glaze. Height 5½ inches. $300-400

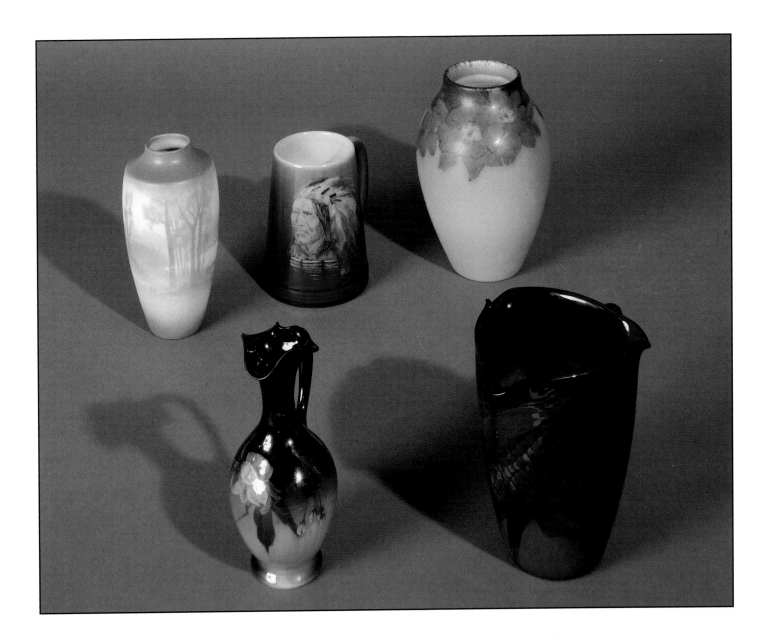

749 Vellum glaze vase painted with a woodland scene by Sallie Coyne in 1922. Marks on the base include the $1000-1200
 Rookwood logo, the date, shape number 1926, V for Vellum glaze body and the artist's initials. Height 6½ inches.

750 Standard glaze ewer with floral decoration, done by Mattie Foglesong in 1898. Marks on the base include the $250-350
 Rookwood logo, the date, shape number 639 D, a small star shaped esoteric mark and the artist's initials. Height
 6 inches.

751 High glaze mug decorated with a Native American portrait by Flora King in 1946. Marks on the base include the $600-800
 Rookwood logo, the date, shape number 587 C, the inscription, "Little Bald Eagle", the number "213" and the
 artist's initials. Height 5 inches.

752 Mat glaze vase with floral decoration, painted in 1926 by Elizabeth Lincoln. Marks on the base include the $300-500
 Rookwood logo, the date, shape number 604 DD and the artist's initials. Height 7¼ inches.

753 Standard glaze tri-cornered pitcher decorated in 1907 by Clara Lindeman, depicting an ear of corn. Marks on the $300-500
 base inlcude the Rookwood logo, the date, shape number 259 C, a small wheel ground X and the artist's initials.
 Height 5¾ inches.

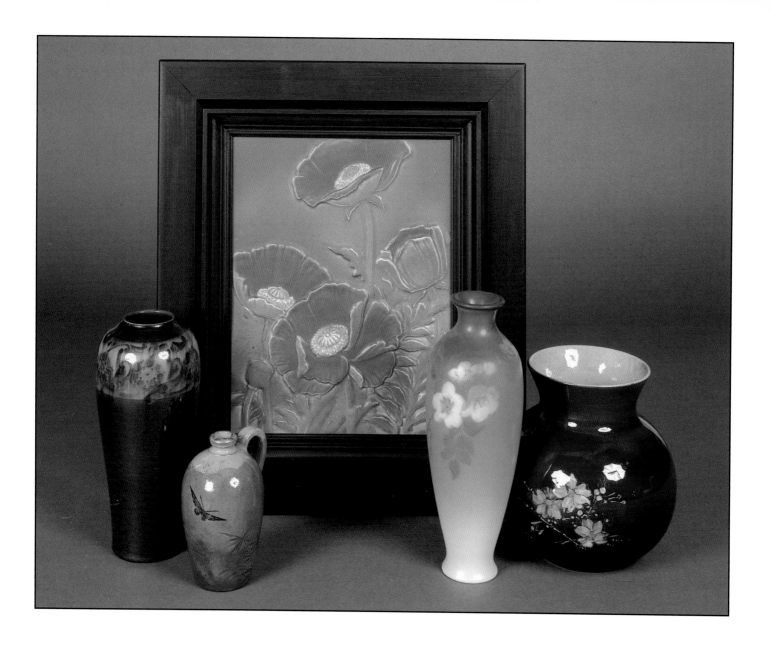

754 Rare decorated aventurine glaze vase, done by Lorinda Epply circa 1920, showing a band of abstract flowers near the top. Marks on the base include the partially obscured Rookwood logo, the partially obscured date and the artist's initials. Height 8⅛ inches. Grinding flake on base. $900-1200

755 Limoges style glaze perfume jar with oriental grasses, clouds and a large butterfly, decorated in 1883 by an unknown artist. Marks on the base include Rookwood in block letters, the date, shape number 61, G for ginger clay and a small impressed kiln mark. Height 4½ inches. $300-500

756 Rare commercial plaque designed by Kataro Shirayamadani and cast and polychromed in 1931. Marks on the back include the Rookwood logo, the date and the shape number 6300. Size 11¼ x 8¾ inches. $1500-2000

757 Vellum glaze vase decorated with wild roses by Margaret Helen McDonald in 1923. Marks on the base include the Rookwood logo, the date, shape number 839 B, V for Vellum glaze body and the artist's initials. Height 9⅜ inches. Repair to lip. $300-500

758 Standard glaze vase decorated with wild roses by Luella Perkins circa 1895. Marks on the base include the artist's full name in block print, M. Luella Perkins, W for white clay and L for light Standard glaze. This piece may have been made in the artist's spare time since it lacks the Rookwood logo, but it is Rookwood none the less. We also may have uncovered the correct spelling of the artist's middle name! Height 6¼ inches. $400-600

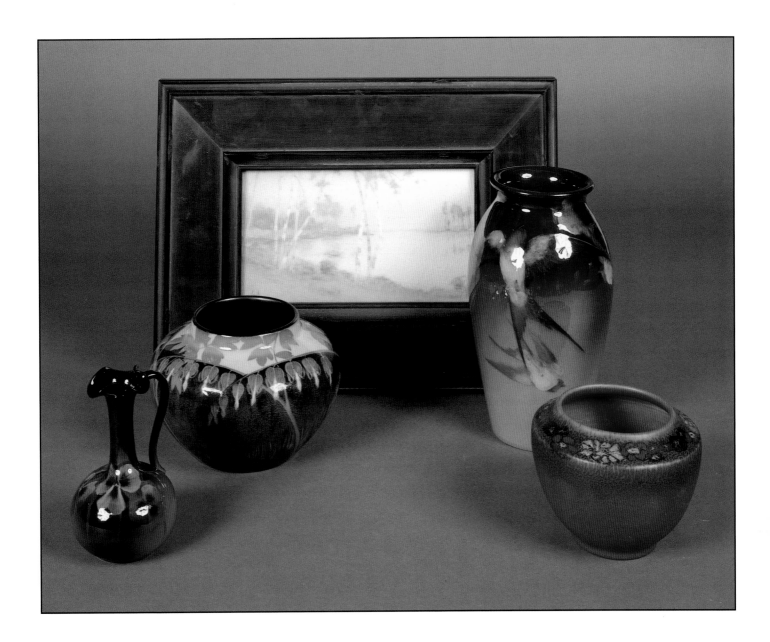

759 Standard glaze ewer decorated by Leona Van Briggle in 1900 with orange pansies. Marks on the base include the Rookwood logo the date, shape number 844 and the artist's initials. Height 5½ inches. $300-400

760 High glaze vase decorated with bleeding hearts in a four paneled design by Shirayamadani in 1924. Marks on the base include the Rookwood logo, the date, shape number 1929 and the artist's cipher. Height 4⅛ inches. $900-1200

761 Vellum glaze scenic plaque decorated in 1914 by Lenore Asbury. The artist's initials appear in the lower left hand corner. Marks on the back include the Rookwood logo, the date, V for Vellum glaze body and the title in pencil, "Birches". Size 5⅛ x 9¼ inches. $1500-2500

762 Good Standard glaze vase by Josephine Zettel decorated with five barn swallows in the midst of some aerial acrobatics. Marks on the base include the Rookwood logo, the date, shape number 568 B and the artist's initials. Height 9 inches. $2000-2500

763 Mat glaze bowl painted by Elizabath Lincoln in 1922 with a band of multicolored flowers near the top. Marks on the base include the Rookwood logo, the date, shape number 1927 and the artist's initials. Height 4 inches. $300-400

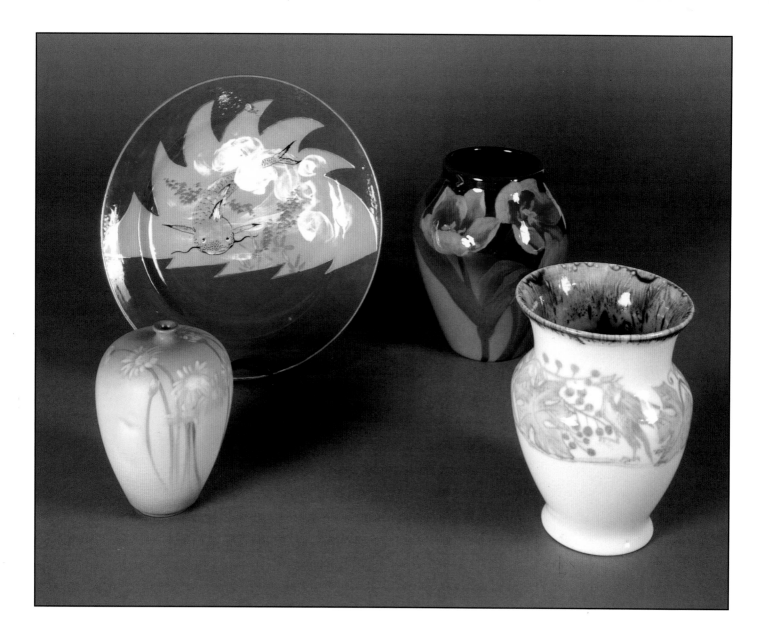

764　Vellum glaze bud vase with daisy decoration done by Caroline Steinle in 1910. Marks on the base include the　$400-600
　　　Rookwood logo, the date, shape number 750 C, V for Vellum glaze body, a small wheel ground X and the artist's
　　　initials. Height 5½ inches.

765　Limoges style glaze plate with fish decoration done by Maria Longworth Nichols circa 1880. The only marks on　$1500-2000
　　　the base are the gold overglaze initials, MLN. Diameter 10¼ inches. This plate may have been from Rookwood's
　　　first year. See Peck, The Book of Rookwood Pottery, colorplate # 1.

766　Standard glaze vase decorated with large yellow tulips by Jeanette Swing in 1903. Marks on the base include the　$500-700
　　　Rookwood logo, the date, shape number 915 C and the artist's initials. Height 7⅜ inches.

767　High glaze vase decorated with berries, leaves and colorful birds by Lorinda Epply in 1943. Marks on the base　$500-700
　　　include the Rookwood logo, the date, a shape number obscured by the glaze and the artist's initials. Height
　　　7 inches

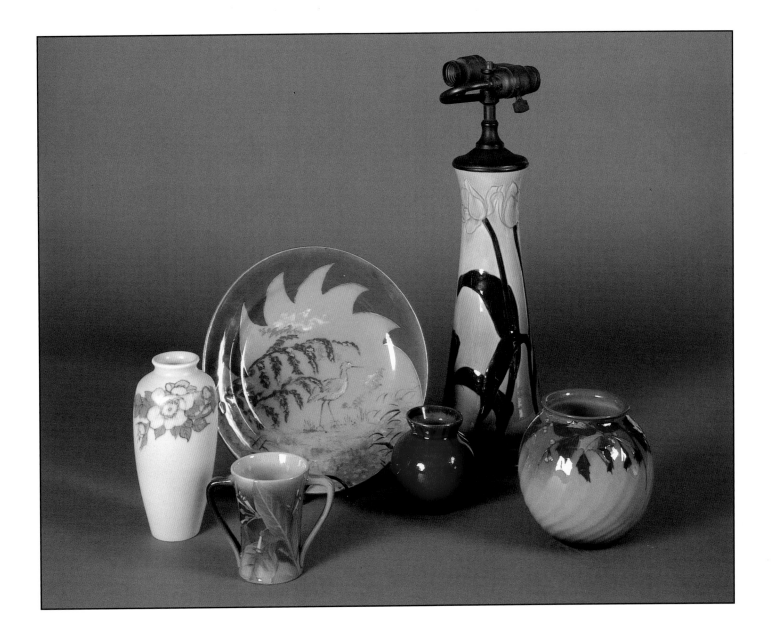

768 Vellum glaze vase decorated with a band of wild roses by Ed Diers in 1918. Marks on the base include the Rookwood logo, the date, shape number 614 F and the artist's initials. Height 7¼ inches. $400-600

769 Standard glaze two handled mug decorated with small yellow flowers by Lenore Asbury in 1902. Marks on the base include the Rookwood logo, the date, the artist's initials and the following inscription: "S.L.T.B.T. of Cincinnati May - 7 — 1902". Height 4 inches. $300-400

770 Limoges style glaze plate with bird decoration done by Maria Longworth Nichols circa 1880. The only marks on the base are the gold overglaze initials, MLN. Diameter 10¾ inches. This plate may have been from Rookwood's first year. See Peck, The Book of Rookwood Pottery, colorplate # 1. $1500-2000

771 Coromandel glaze vase done circa 1932. Marks on the base are almost completely obscured with the exception of the Rookwood logo which is quite visible. Height 4 inches. $150-250

772 Sea Green glaze vase with incised and painted tulip decoration by John Dee Wareham done in 1899. Marks on the base include the Rookwood logo, the date, shape number 804C, G for Sea Green glaze and the artist's initials which are mostly obscured by a large hole drilled in the base. Height of pottery portion only, 12¾ inches. Fittings are older but not original. $1800-2200

773 Standard glaze vase with ribbed and swirled body, decorated in 1893 by Edward Abel with holly. Marks on the base include the Rookwood logo, the date, shape number 612 C, W for white clay, a small wheel ground X, the artist's initials and L for light Standard glaze. Height 6¾ inches. $300-500

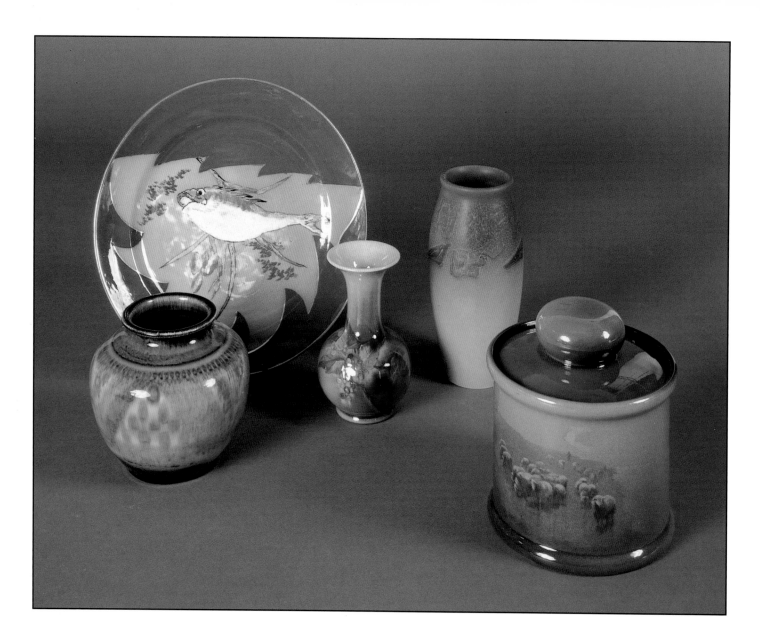

774 High glaze vase decorated with geometric patterns by Lorinda Epply in 1932. Marks on the base include the Rookwood logo, the date, shape number 5360 and the artist's initials. Height 5 inches. $300-500

775 Limoges style glaze plate with fish decoration done by Maria Longworth Nichols circa 1880. There are no marks on the plate. Diameter 10¾ inches. This plate may have been from Rookwood's first year. See Peck, The Book of Rookwood Pottery, colorplate # 1. $1000-1500

776 Standard glaze floral vase decorated by Elizabeth Lincoln in 1893. Marks on the base include the Rookwood logo, the date, shape number 40, W for white clay and the artist's initials. Height 5⅝ inches. $250-350

777 Mat glaze vase decorated by Elizabeth N. Lincoln in 1919. Marks on the base include the Rookwood logo, the date, shape number 917 D, V for Vellum glaze body and the artist's initials. Height 7½ inches. $200-300

778 Good Standard glaze humidor, decorated with a pastoral scene of several shepherds and a flock of sheep, done by Sturgis Laurence in 1897. Marks on the base include the Rookwood logo, the date, shape number 801, the artist's initials and a paper label which reads: "To Johnstone Allen Esquire of Cambridge - Mass. from his Uncle William Christmas 1898". The lid is marked with the monogram of Sallie Toohey and has a line on one side. Height 6¾ inches. A wheel ground X appears on the side of the piece. $1000-1500

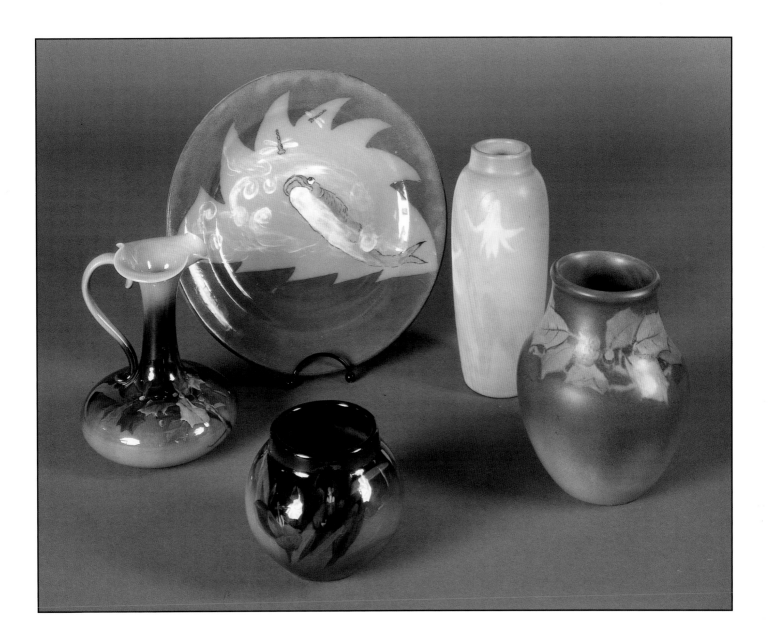

779 Standard glaze ewer painted with holly by Amelia Sprague in 1891. Marks on the base include the Rookwood logo, the date, shape number 433, W for white clay, the artist's initials and L for light Standard glaze. Height 6¼ inches. $300-500

780 Limoges style glaze plate with fish decoration done by Maria Longworth Nichols circa 1880. There are no marks on the plate. Diameter 10¾ inches. This plate may have been from Rookwood's first year. See Peck, The Book of Rookwood Pottery, colorplate # 1. $1000-1500

781 Standard glaze vase with dark blue crocus decoration, done by Alice Willitts in 1906. Marks on the base include the Rookwood logo, the date, shape number 911 E and the artist's initials. Height 4 inches. $300-400

782 Painted Mat glaze vase done by Olga Geneva Reed in 1905 with dogstooth violets. Marks on the base include the Rookwood logo, the date, shape number 907 E and the artist's initials. Height 8⅝ inches. $600-800

783 Painted Mat glaze vase with holly decoration, done by Olga Geneva Reed in 1902. Marks on the base include the Rookwood logo, the date, shape number 33 DZ and the artist's initials. Height 6¼ inches. $700-900

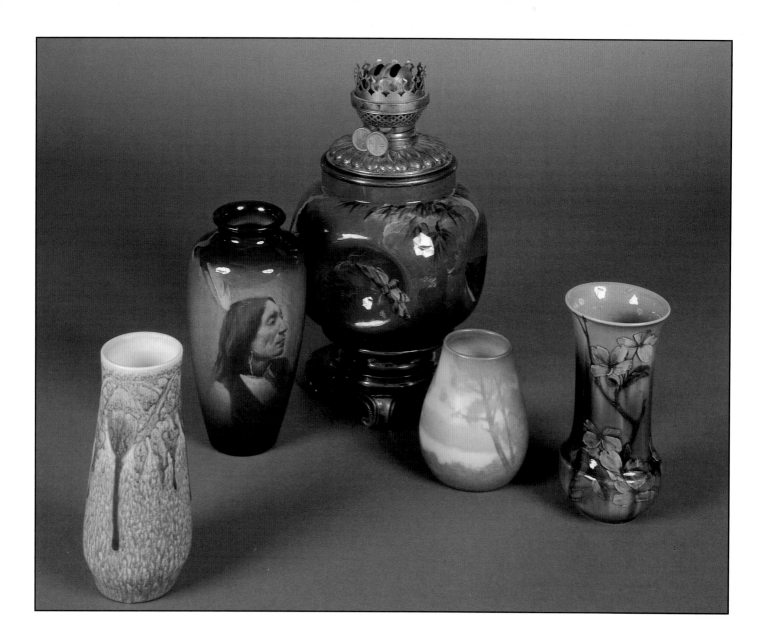

784 Incised and painted mat glaze vase, decorated by William Hentschel with stylized flowers in 1915. Marks on the base include the Rookwood logo, the date, shape number 1930 and the artist's initials. Height 6⅞ inches. $300-500

785 Standard glaze vase decorated with a Native American portrait by Grace Young in 1901. Marks on the base include the Rookwood logo, the date, shape number 614 F, the inscription "Lone Wolf Kiowa" and the artist's monogram. Height 8 inches. $2500-3500

786 Original Rookwood limoges style glaze lamp with brass fittings, decorated with oriental grasses and two large moths in 1882 by Albert Valentien. The ceramic part has a cast hole for attaching the fittings which include a brass font and a Duplex burner that appears to be functional. Marks on the base include Rookwood in block letters, the date, shape number 97, R for red clay and the artist's initials. Height to the top of the burner is 12 inches. $1200-1500

787 Vellum glaze vase with scenic decoration done by Sallie Coyne in 1921. Marks on the base include the Rookwood logo, the date, shape number 2104, the artist's initials and V for Vellum glaze. Height 4½ inches. $500-700

788 Standard glaze vase by M.A. Daly with dogwood decoration, done in 1889. Marks on the base include the Rookwood logo, the date, shape number 535 E, Y for yellow clay, the artist's initials and L for light Standard glaze. Height 6¼ inches. Pitting and small bubbles in glaze. $400-600

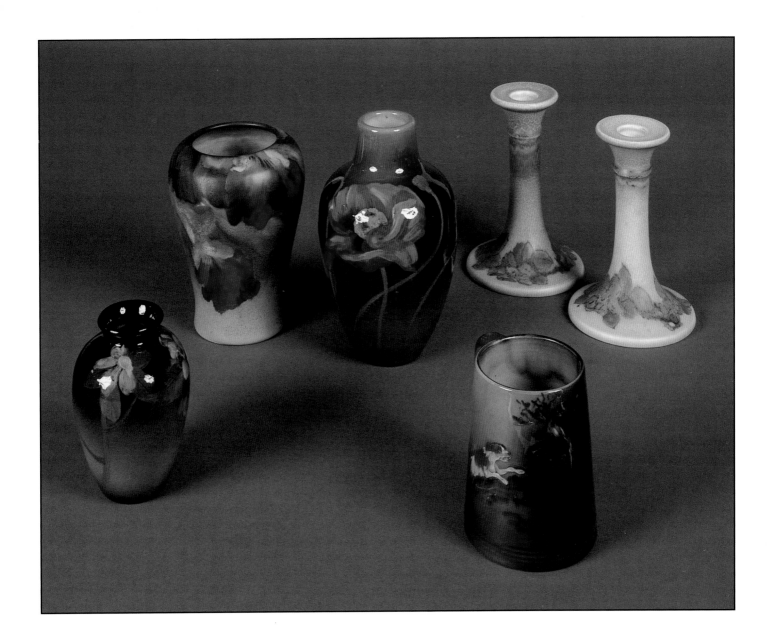

789 Standard glaze vase with fruit blossom decoration, done by Carrie Steinle in 1905. Marks on the base include the Rookwood logo, the date, shape number 605 E and the artist's initials. Height 4¼ inches. $300-400

790 Painted Mat glaze vase decorated with orchids by Albert Valentien in 1899. Marks on the base include the Rookwood logo, the date, shape number 59 Z and the artist's full signature. Height 6½ inches. $1200-1500

791 Standard glaze vase with red poppies, done by Edith Noonan in 1904. Marks on the base include the Rookwood logo, the date, shape number 905 D and the artist's initials. Height 7¾ inches. $500-700

792 Standard glaze mug with a dog chasing a fox into a den, decorated by an unknown artist in 1891. Marks on the base include the Rookwood logo, the date, shape nunber 587 and W for white clay. Height 4½ inches. $600-800

793 Pair of mat glaze candlesticks decorated with wild roses by Margaret McDonald in 1926. Marks on the base include the Rookwood logo, a small triangular esoteric mark, the date, shape number 822 D, and the artist's initials. Height 6½ inches. $400-600

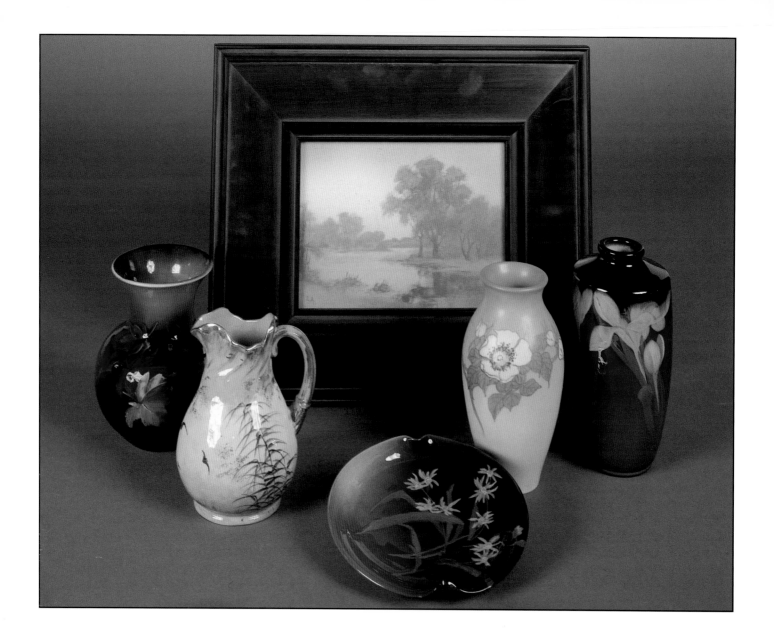

794 Standard glaze vase by Sallie Toohey, deocrated with autumn leaves in 1891. Marks on the base include the Rookwood logo, the date, shape number 402, W for white clay, the artist's initials and L for light Standard glaze. Height 6 inches. $300-400

795 Limoges style glaze pitcher decorated with oriental grasses and several soaring birds by Martin Rettig in 1883. Marks on the base include Rookwood in block letters, the date, shape number 87, G for ginger clay and the artist's initials. Height 5¼ inches. Tiny glaze nick on rim. $300-500

796 Vellum glaze plaque with woodland scene, decorated by Lenore Asbury in 1922. The artist's initials appear in the lower left hand corner. Marks on the back include the Rookwood logo, the date and P for porcelain body. Size 6⅛ x 8¼ inches. Uncrazed. $2500-3500

797 Standard glaze plate decorated with small orange flowers by Edith Noonan in 1903. Marks on the base include the Rookwood logo, the date, shape number 205 D, and the artist's initials. Diameter 6 inches. $200-250

798 Vellum glaze vase decorated with wild roses by Ed Diers in 1923. Marks on the base include the Rookwood logo, the date, shape number 356 E and the artist's initials. Height 6⅝ inches. Uncrazed. $600-800

799 Standard glaze vase decorated with crocus by Sallie Coyne in 1902. Marks on the base include the Rookwood logo, the date, shape number 735 DD and the artist's initials. Height 7⅛ inches. $300-400

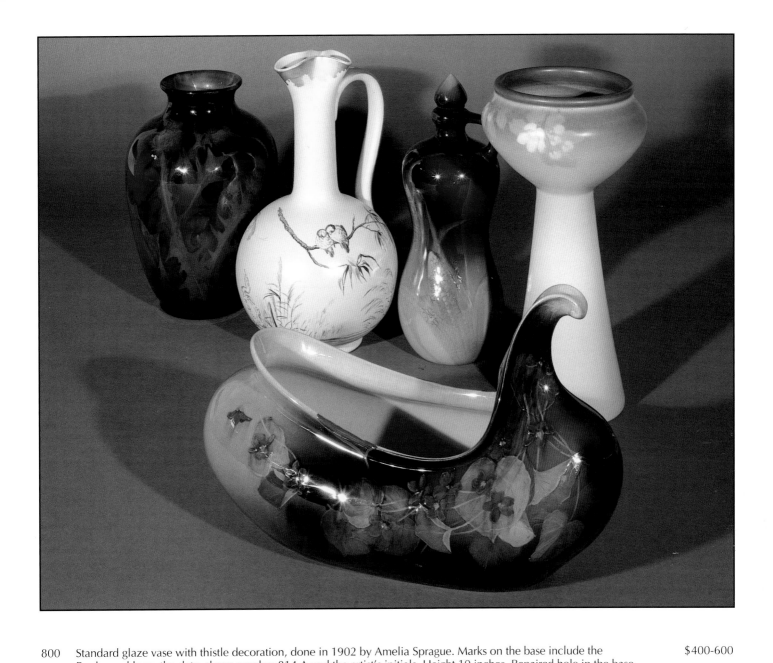

800 Standard glaze vase with thistle decoration, done in 1902 by Amelia Sprague. Marks on the base include the $400-600
Rookwood logo, the date, shape number 814 A and the artist's initials. Height 10 inches. Repaired hole in the base.

801 Bisque finish ewer with carved and incised flowers by Harriet Wenderoth and Marie Eggers, decorated in 1882 $500-700
with ducks in a swamp and two birds nestling on a branch. Marks on the base include Rookwood in block letters,
the date, the number 25 and the artists' initials. Height 12 inches.

802 Standard glaze Victorian flower boat decorated with blue violets by William McDonald in 1893. Marks on the $700-900
base include the Rookwood logo, the date, shape number 407, W for white clay and the artist's initials. Height 8⅞
inches, length 13 1/2 inches. Three very tight and minor ½ inch lines.

803 Standard glaze stoppered whiskey jug with corn decoration, done by Sallie Coyne in 1899. Marks on the base $200-300
include the Rookwood logo, the date, shape number 677, a wheel ground X and the artist's initials. Height 11¼
inches. Glaze losses in some places.

804 Vellum glaze vase with cherry blossom decoration, done by E.T. Hurley in 1911. Marks on the base include the $500-700
Rookwood logo, the date, shape number 1665, V for Vellum glaze body and the artist's initials. Height 12⅛ inches.

**SUNDAY
JUNE 9th
1991
LOTS 805-1210**

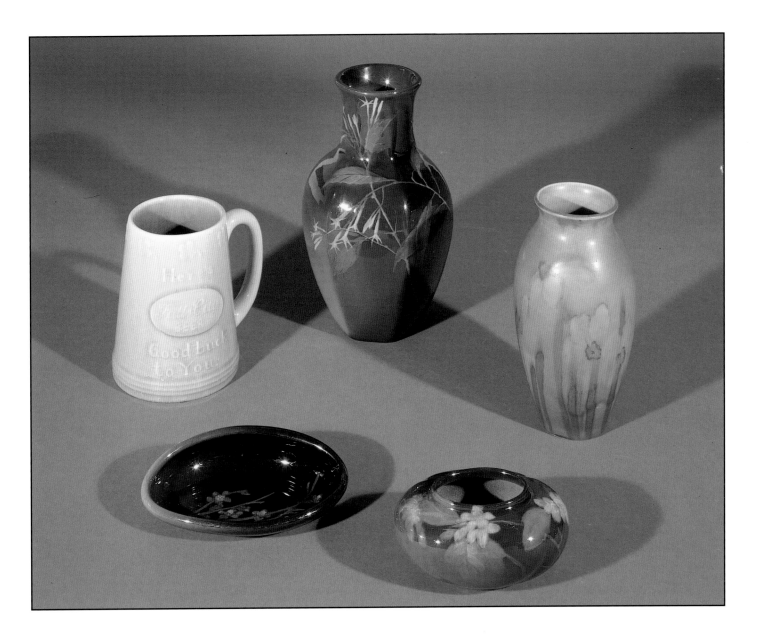

805 High glaze advertising mug, made for Falls City Brewing Company in Louisville by Rookwood in 1948. Marks on the base include the Rookwood logo and the date. Height 5 inches. $200-300

806 Standard glaze tray decorated with apple blossoms by Edith Noonan in 1903. Marks on the base include the Rookwood logo, the date, shape number 930 D, and the artist's initials. Height 1½ inches. $200-300

807 Standard glaze vase decorated by E.T. Hurley with small yellow flowers in 1898. Marks on the base include the Rookwood logo, the date, shape number 850 and the artist's initials. Height 8½ inches. $500-700

808 Standard glaze bowl with small yellow flowers decorated by Adeliza D. Sehon in 1900. Marks on base include the Rookwood logo, the date, shape number 708C, and the artist's initials. Height 2¼ inches. $200-300

809 Mat glaze vase by Kataro Shirayamadani decorated with daffodils in 1931. Marks on the base include the Rookwood logo, the date, shape number 356 E and the artist's cypher. Height 6¾ inches. $600-800

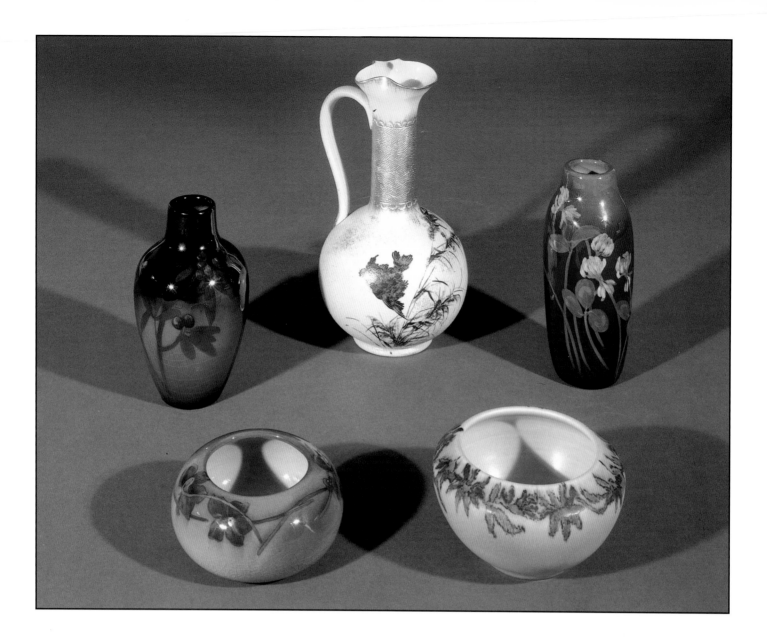

810 Standard glaze vase decorated with leaves and berries by Carrie Steinle in 1907. Marks on the base include the Rookwood logo, the date, shape number 905 F and the artist's initials. Height 5⅜ inches. $250-350

811 Iris glaze bowl decorated with violets by Caroline Bonsall in 1902. Marks on base include the Rookwood logo, the date, shape number 214 E and the artist's initials. Height 2 inches. $300-400

812 Bisque finish ewer decorated oriental grasses, a flying bird, and die impressed decorations around the neck by Anna Bookprinter in 1886. Marks on the base include Rookwood in block letters, the date, shape number 101 C, Y for yellow clay and the artist's initials. Height 8¼ inches. $700-900

813 Small mat glaze bowl with blue flowers on a yellow ground, decorated by Elizabeth Barrett in 1924. Marks on the base include the Rookwood logo, the date, shape number 955 and the artist's monogram. Height 2⅝ inches. $200-300

814 Standard glaze vase with clover decoration, done by Edith Noonan in 1904. Marks on the base include the Rookwood logo, the date, shape number 932 F and the artist's initials. Height 6 inches. $250-350

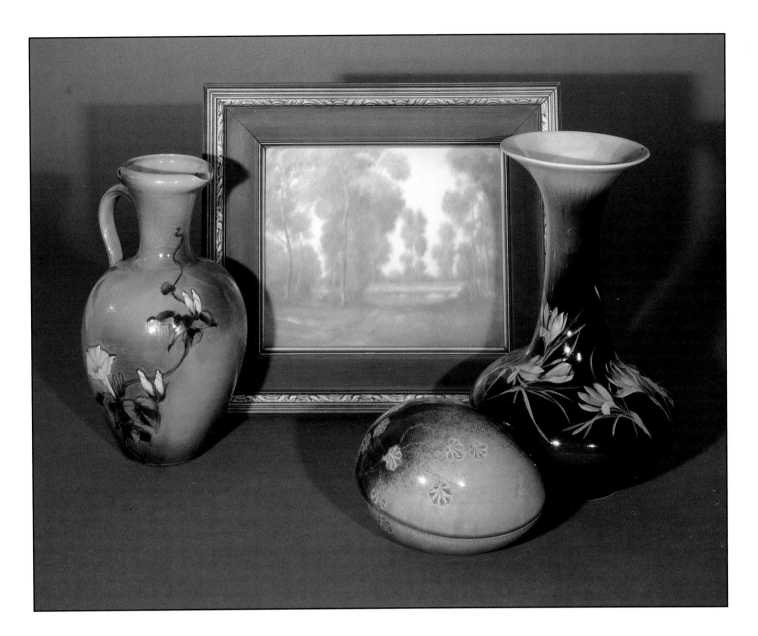

815 Standard glaze ewer decorated with yellow morning glories by Albert Valentien in 1886. Marks on the base include Rookwood in block letters, the date, shape number 267, S for sage green clay and the artist's initials. Height 10¼ inches. $900-1200

816 Vellum glaze scenic plaque by Ed Diers, done in 1925. The artist's initials appear in the lower right hand corner. Marks on the back include the Rookwood logo, the date and an original Rookwood label with the title, "October Day Diers". Size 7⅞ x 9⅞. Uncrazed. $3000-4000

817 Standard glaze egg shaped box decorated with incised leaves and vines by Anna Bookprinter in 1885. Marks on the base include Rookwood in block letters, the date, shape number 44 A, W for white clay and the artist's initials. Height 4¼ inches. Four small chips on the inside rim which are completely covered by the lid. $400-600

818 Standard glaze vase decorated with yellow crocuses by Albert Valentien in 1892. Marks on the base include the Rookwood logo, the date, shape number 469 E, W for white clay, the artist's initials and L for light Standard glaze. Height 11½ inches. $900-1200

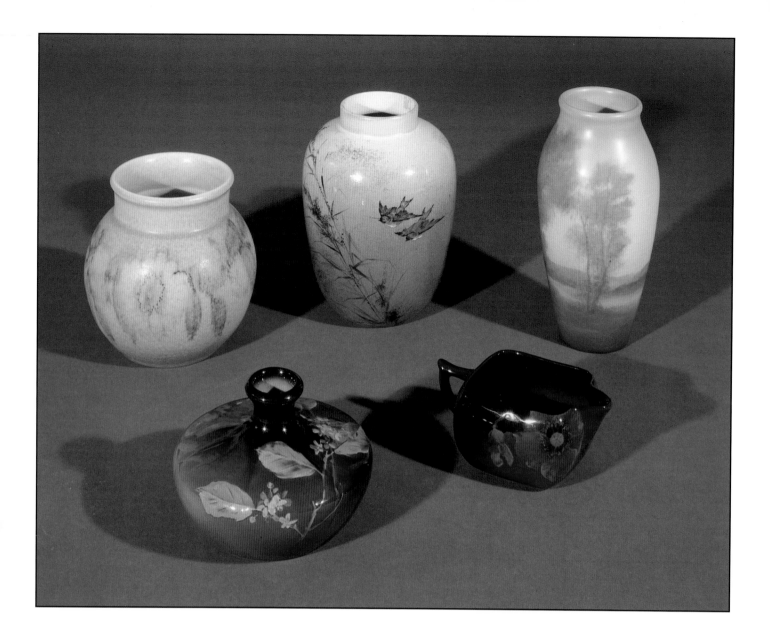

819 Mat glaze vase with floral decoration, done by Katherine Jones in 1928. Marks on the base include the $300-400
Rookwood logo, the date, shape number 2078 and the artist's initials. Height 5 inches.

820 Standard glaze vase with floral decoration by Amelia B. Sprague dated 1893. Marks on base include the $300-400
Rookwood logo, the date, shape number, 686 and the artist's initials. Height 3⅛ inches.

821 Limoges style glaze jar decorated with oriental grasses and two swallows in flight by M.A. Daly in 1885. Marks $200-250
on the base include Rookwood in block letters, the date, shape number 47 B, W for white clay and the artist's
initials. Height 6⅛ inches. Lid missing.

822 Standard glaze creamer decorated with poppies by Jeanette Swing in 1902. Marks on the base include the $200-300
Rookwood logo, the date, shape number 43 and the artist's initials. Height 2 inches.

823 Vellum glaze vase with scenic decoration done by Ed Diers in 1921. Marks on the base include the Rookwood $900-1200
logo, the date, shape number 925 E, V for Vellum glaze and the artist's initials. Height 7¼ inches.

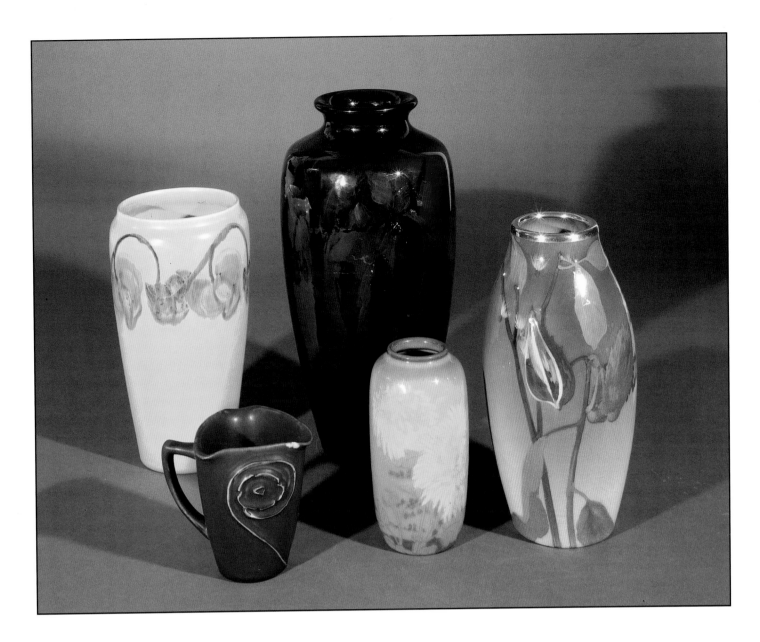

824 Mat glaze floral vase by C.S. Todd, done in 1920. Marks on the base include the Rookwood logo, the date, shape number 1369 D and the artist's initials. Height 9¼ inches. $200-400

825 Mat glaze tri-cornered pitcher with a swirling pattern on one side, decorated by Sallie Toohey in 1905. Marks on the base include the Rookwood logo, the date, shape number 259 E, and the artist's initials. Height 4¼ inches. Glaze skip at lip. $200-300

826 Large and showy Standard glaze vase decorated with dark blue irises by Amelia Sprague in 1899. Marks on the base include the Rookwood logo, the date, shape number 614 C and the artist's initials. Height 12½ inches. Some glaze scratches. $1000-1500

827 High glaze oriental style scenic vase, decorated by Arthur Conant in 1921. Marks on the base include the Rookwood logo, the date, shape number 924 and the artist's monogram. Height 6 inches. $1500-2000

828 Iris glaze vase decorated with milkweed pods by Josephine Zettel in 1903. A silver band surrounds the upper lip. Marks on the base include the Rookwood logo, the date, shape number 939 E, a wheel ground X, the artist's initials, and W for white glaze. Height 9¾ inches. $3000-4000

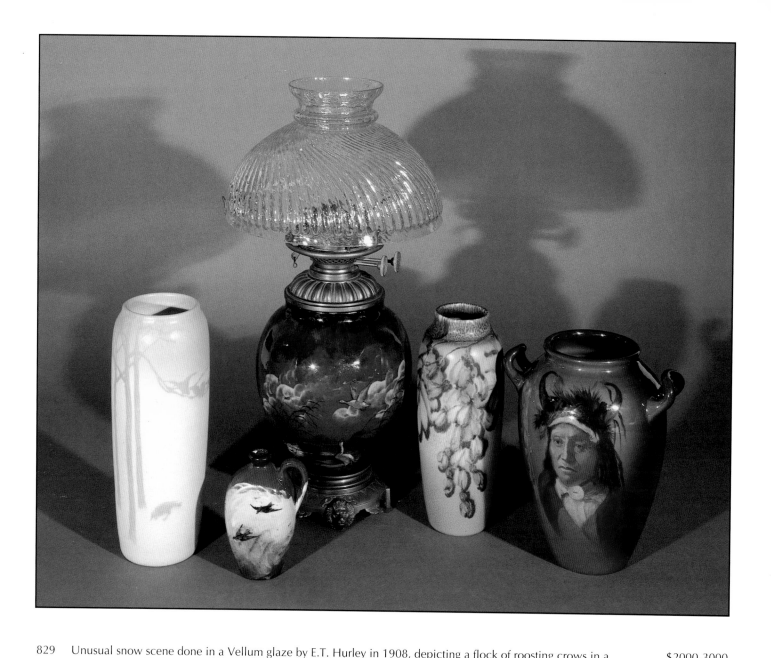

829 Unusual snow scene done in a Vellum glaze by E.T. Hurley in 1908, depicting a flock of roosting crows in a wooded area. Marks on the base include the Rookwood logo, the date, shape number 951 C, V for Vellum glaze body, the artist's full name and V for Vellum glaze. Height 10⅛ inches. $2000-3000

830 Limoges style glaze perfume jug decorated with oriental grasses and flying birds by Hattie Horton in 1883. Marks on the base include Rookwood in block letters, the date, shape number 60, R for red clay, a small impressed kiln mark and the artist's initials. Height 4½ inches. $300-500

831 Limoges style glaze lamp base with brass fittings and a brass burner, decorated with oriental grasses, clouds and geese by Albert Humphreys in 1882. Marks on the base include Rookwood in block letters, the date, an impressed anchor mark and the artist's initials. Height to the top of the Duplex burner is 13¼ inches. $1200-1500

832 Mat glaze vase, decorated by Margaret McDonald in 1930 with exotic leaves and vines. Marks on the base include the Rookwood logo, the date, shape number 907 E, a small fan shaped esoteric mark and the artist's initials. Height 9¼ inches. $400-600

833 Standard glaze two-handled vase decorated with the portrait of a Native American by Sturgis Laurence in 1900. Marks on the base include the Rookwood logo, the date, shape number 581 E, a wheel ground X, the inscription "Chief Wet Sit -Assiniboine" and the artist's initials. Height 9 inches. $4000-6000

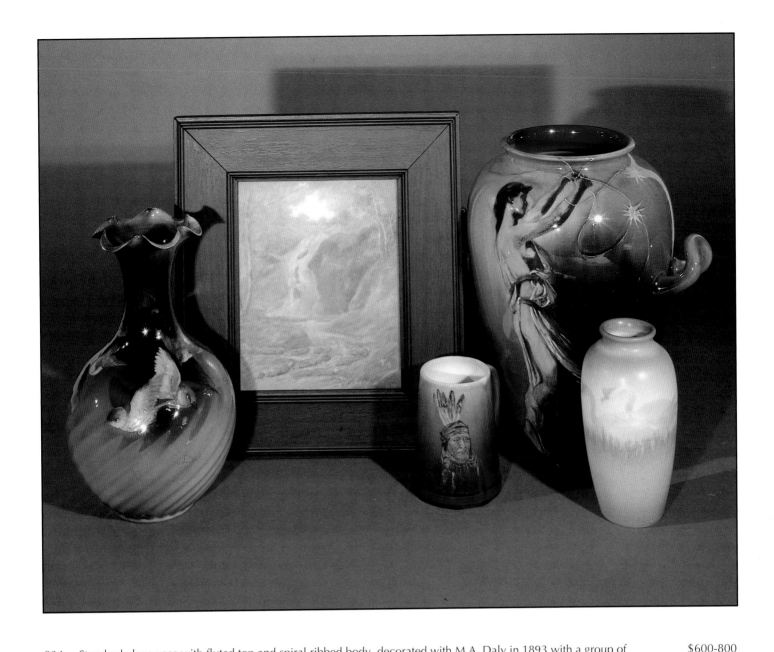

834 Standard glaze vase with fluted top and spiral ribbed body, decorated with M.A. Daly in 1893 with a group of sparrows in flight. Marks on the base include the Rookwood logo, the date, shape number 653, W for white clay and the artist's initials. Height 12 inches. Repaired at rim. $600-800

835 Vellum glaze scenic plaque done in 1924 by Ed Diers. The artist's initials appear in the lower right hand corner. Marks on the back include the Rookwood logo, the date and an original Rookwood paper label with the title, "Waterfalls E. Diers". Size 9¾ x 7¾ inches. Uncrazed. $3500-4500

836 High glaze mug decorated with a Native American portrait by Flora King in 1946. Marks on the base include the Rookwood logo, the date, shape number 587 C, the inscription "Blue Bird", the number "215A" and the artist's initials. Height 5 inches. $600-800

837 Large two handled Standard glaze portrait vase depicting a partially clad young woman, possibly from mythology, who appears to be hanging stars in the sky. Marks on the base include the partially obscured Rookwood logo, the partially obscured date, shape number 531 C, W for white clay and the artist's initials. The artist's initials may also appear on the side of the vase where some refiring seems to have occurred. Height 13¾ inches. A ½ inch glaze flake appears near the base. $2000-2500

838 Vellum glaze scenic vase with three geese in a swampy setting, decorated by E.T. Hurley in 1908. Marks on the base include the Rookwood logo, the date, shape number 922 D, V for vellum glaze and the artist's initials. Height 7⅜ inches. $600-800

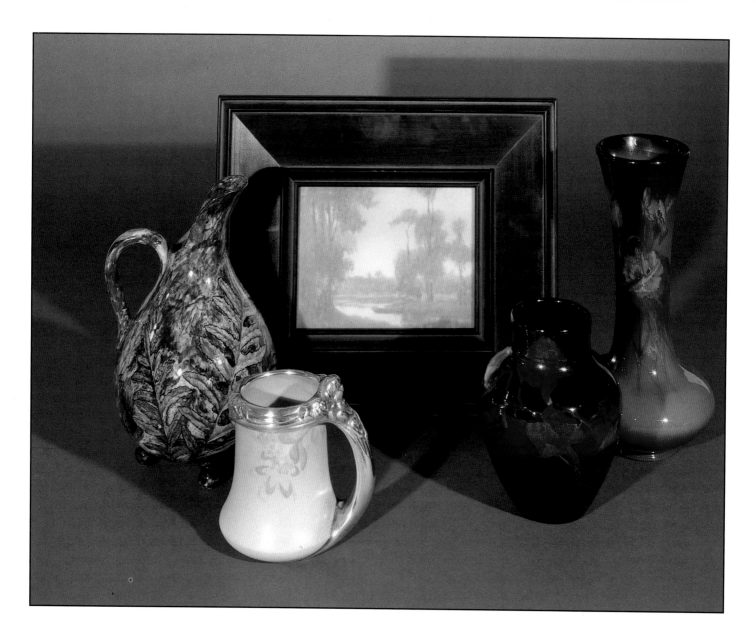

839　Unusual early high glaze pitcher with overall floral decoration done by M.E. Hattersley, in 1882. Marks on the base are as follows: M.E. Hattersley Rooockwood (sic) Pottery Cinti, O. Feb 7' 1882. Height 10 inches.　$400-600

840　Vellum glaze mug with electro-deposited silver handle decorated by Mary Nourse in 1905. Marks on the base include the Rookwood logo, the date, the artist's initials, V for vellum body, V for vellum glaze, and "Commercial Club of Cincinnati 1880- 1905". "MR. FIELD" is engraved in the silver at the front of the mug. Height 5½ inches.　$600-800

841　Vellum glaze scenic plaque done in 1912 by Ed Diers. The artist's initials appear in the lower left hand corner. Marks on the back include the Rookwood logo, the date, V for Vellum glaze body and the title in pencil, "Pirogue and Spanish Moss". Size 5¾ x 7⅝ inches.　$1500-2000

842　Standard glaze vase with decoration of grape leaves, done by Howard Altman in 1904. Marks on the base include the Rookwood logo, the date, shape number 927 E and the artist's initials. Height 6⅝ inches.　$300-400

843　Standard glaze vase with carnation decoration, done by Josephine Zettel in 1900. Marks on the base include the Rookwood logo, the date, shape number 556 C and the artist's initials. Height 11 inches.　$700-900

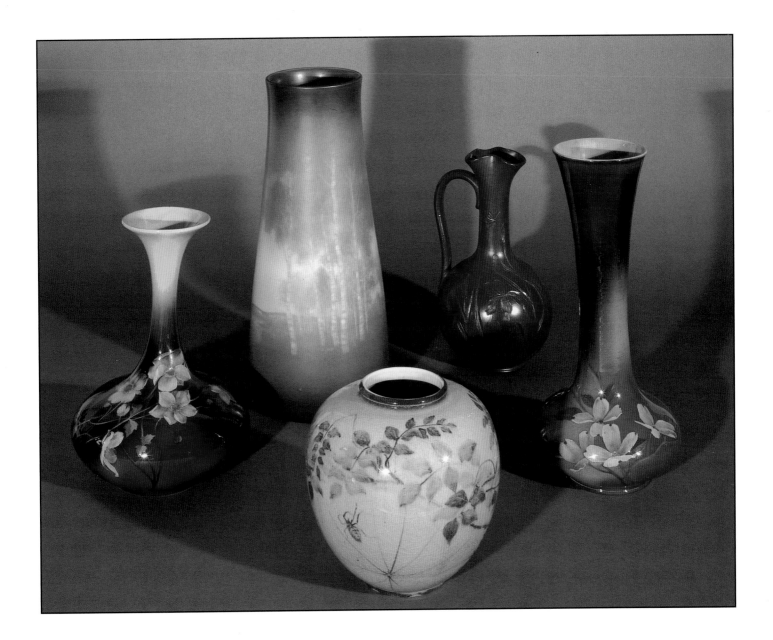

844 Standard glaze vase painted with jonquils by William McDonald in 1895. Marks on the base include the Rookwood logo, the date, shape number 611 A and the artist's initials. Height 10¼ inches. $800-1000

845 Large Vellum glaze scenic vase with a grove of birch trees, accented with a pink sky, decorated by E.T. Hurley in 1920. Marks on the base include the Rookwood logo, the date, shape number 950 A, V for Vellum glaze body, a wheel ground double X and the artist's initials. Height 15⅛ inches. There are three ½ to 1 inch glaze skips on the back side of the piece near the base which would account for the "second" mark. $1750-2250

846 High glaze vase decorated with wisteria vines and a spider and its web by Kay Ley. Marks on the base include the Rookwood logo, the date, shape number 6204 C, and the artist last name. Height 6¾ inches. $400-600

847 Bisque finish ewer with incised cattail, iris and butterfly decoration by W.H. Ryden in 1883. Marks on the base include Rookwood in block letters, the date, shape number 101, R for red clay and the artist's name, W.H. Ryden April '83 Cinn. Height 10¼ inches. $400-600

848 Standard glaze tall vase decorated by Amelia Sprague in 1894 with dogwood. Marks on the base include the Rookwood logo, the date, shape number 556 B, W for white clay and the artist's initials. Height 13¼ inches. $700-900

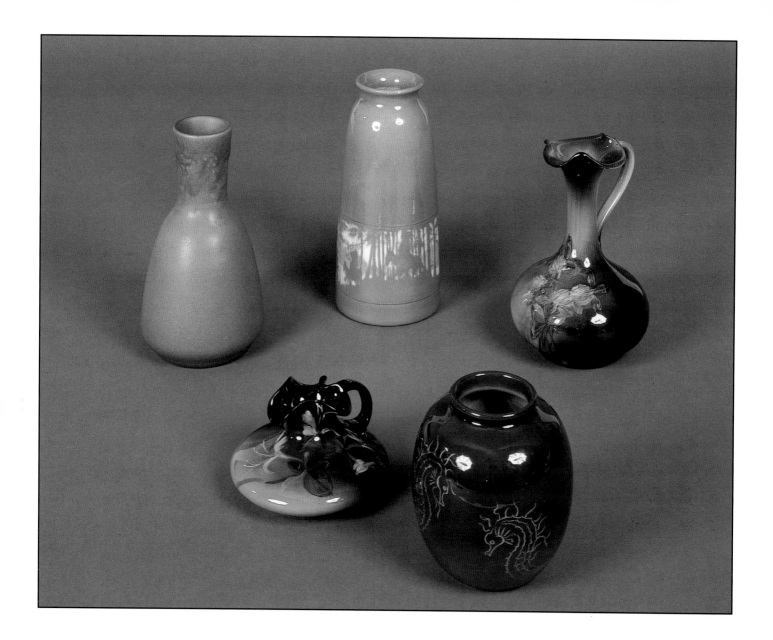

849 Mat glaze bottle shaped vase done in 1912 by C.S. Todd, with carved and painted flowers near the top. Marks on the base include the Rookwood logo, the date, shape number 2042 E and the artist's initials. Height 7¼ inches. $200-300

850 Standard glaze low ewer decorated with honeysuckle flowers and vines by Caroline Steinle in 1898. Marks on the base include the Rookwood logo, the date, shape number 720 E, a small star shaped esoteric mark and the artist's initials. Height 2⅞ inches. $250-350

851 Rare Iris glaze vase with a banded scene depicting several Native Americans on horseback in a wooded area. Marks on the base include the Rookwood logo, the date, shape number 1658 E, W for white clay and the artist's initials. Height 7¾ inches. Repair to rim. $1000-1500

852 High glaze squat vase decorated with two outlined seahorses by Caroline Stegner in 1946. Marks on the base include the Rookwood logo, the date, shape number 6183 F, the artist's initials and the number 361 A. Height 4⅝ inches. $300-500

853 Standard glaze ewer decorated with clover by Anna Valentien in 1891. Marks on the base include the Rookwood logo, the date, shape number 462 D, W for white clay, the artist's initials and L for light Standard glaze. Height 6⅞ inches. $350-500

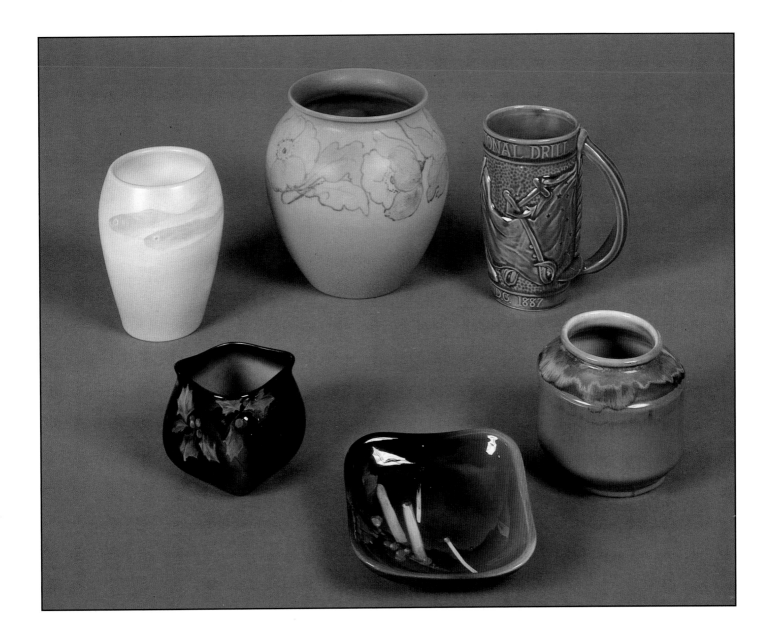

854 Vellum glaze vase decorated with three fish swimming in murky water by E.T. Hurley in 1905. Marks on the base include the Rookwood logo, the date, shape number 942 D, the artist's full signature and V for vellum glaze. Height 5 inches. $700-900

855 Standard glaze bowl with holly decoration done by Elizabeth Lincoln in 1896. Marks on the base include the Rookwood logo, the date, shape number 692 and the artist's initials. Height 3 inches. $250-350

856 Mat glaze vase decorated with large red flowers by Katherine Jones in 1930. Marks on the base include the Rookwood logo, the date, shape number 130, a small esoteric fan shaped mark and the artist's initials. Height 6½ inches. $500-700

857 Standard glaze ash tray with holly, matches and cigarettes, decorated in 1899 by Edith R. Felton. Marks on the base include the Rookwood logo, the date, shape number 835 and the artist's initials. Height 1⅛ inches. $200-300

858 Early high glaze mug made by Rookwood in 1887. The exterior of the mug bears the following information: Souvenir National Drill Washington D.C. 1887. Marks on the base include a W for white clay and in script, Rookwood Pottery Cincinnati. Height 5⅞ inches. $400-600

859 Multicolored drip glaze bowl made in 1932. Marks on the base include the Rookwood logo, the date and shape number 6316. Height 3¼ inches. $200-300

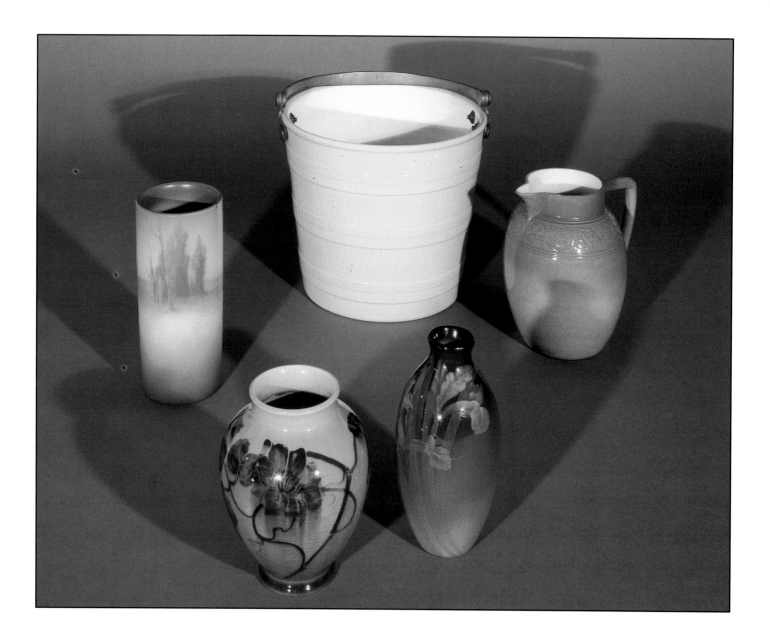

860 Vellum glaze vase with a snow covered woodland scene, decorated by Lenore Asbury in 1914. Marks on the base include the Rookwood logo, the date, shape number 1124 E, V for Vellum glaze body and the artist's initials. Height 7⅛ inches. Glaze pitting. $700-900

861 High glaze vase with floral decoration, done in 1942 by Margaret Helen McDonald. Marks on the base include the Rookwood logo, the date, S for special shape and the artist's monogram. The vase is covered with a reddish tinted high glaze which Rookwood called Wine Madder. Height 5⅜ inches. $300-400

862 Rookwood high glaze water bucket with attached brass handle, made in 1884. Marks on the base include Rookwood in block letters, the date, shape number 185 and Y for yellow clay. Height 7¾ inches. Tight line at rim. $200-400

863 Standard glaze vase decorated with Japanese iris by Leona Van Briggle in 1903. Marks on the base include the Rookwood logo, the date, shape number 732 C and the artist's initials. Height 6½ inches. $300-500

864 Early high glaze pitcher with a border of vines and leaves near the top. Marks on the base include Rookwood in block letters, the date, S for sage green clay, and an obscured shape number with a B suffix. Height 6½ inches. $200-300

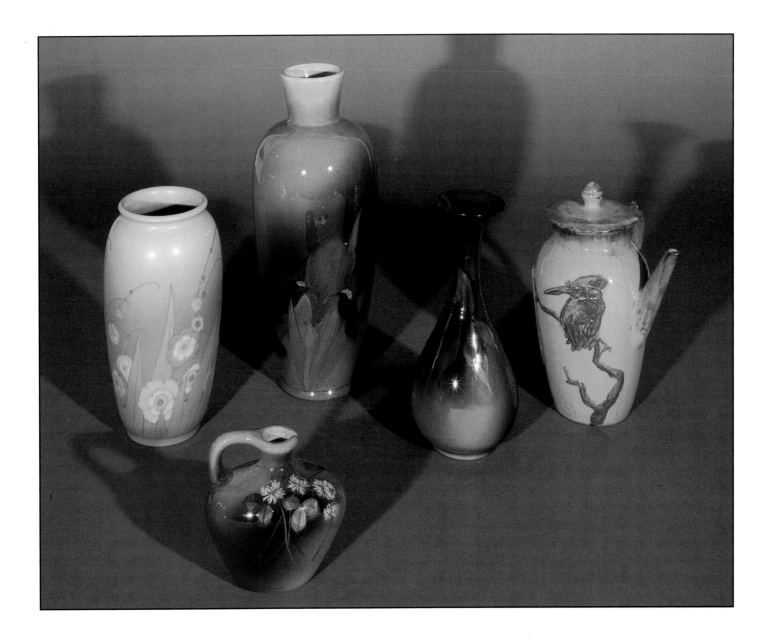

865 Unusually clean Vellum glaze vase by Lenore Asbury, decorated with colorful stylized flowers and leaves in 1931. Marks on the base include the Rookwood logo, the date, shape number 892 C, the artist's initials and V for Vellum glaze. Height 9 inches. $1000-1500

866 Standard glaze handled jug, decorated with clover by Josphine Zettel in 1895. Marks on the base include the Rookwood logo, the date, shape number 706 and the artist's initials. Height 4½ inches. $300-400

867 Standard glaze vase decorated with irises by Sturgis Laurence in 1902. Marks on the base include the Rookwood logo, the date, shape number 856 C, a wheel ground X and the artist's initials. Height 13 inches. Small flake at base. $1000-1200

868 Standard glaze vase decorated by Sallie Coyne with Virginia creepers in 1898. Marks on the base include the Rookwood logo, the date, shape number 381 B, the number X 405 X, a small wheel ground X and the artist's initials. Height 9¼ inches. $300-400

869 Early high glaze chocolate pot with lid, molded with kingfisher and oriental plaque on surface. Marks on the base include Rookwood in block letters, the date, shape number 100, G for ginger clay and an impressed anchor mark. Height 9⅛ inches. Very tight one inch hairline from rim. $400-600

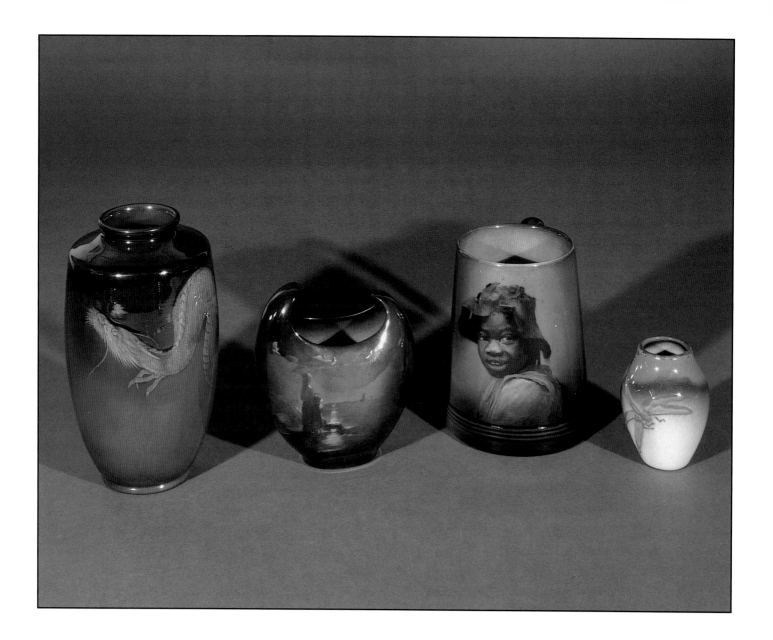

870 Good Standard glaze vase decorated with two encircling dragons by M.A. Daly in 1894. Marks on the base $3000-3500
include the Rookwood logo, the date, shape number 735 D, R for red clay and the artist's initials. Height 7 inches.

871 Rare Standard glaze vase with moonlit scene of woman and child watching ships passing, decorated by Tom Lunt $2000-3000
in 1896. Marks on the base include the Rookwood logo, the date, shape number 712 and the artist's first name,
TOM. Height 5 inches.

872 Standard glaze mug decorated with portrait of a young African- American boy by Harriet Strafer in 1895. Marks $700-900
include the Rookwood logo, the date, the artist's initials, and L for light Standard glaze on the base. Incised on the
side are the initials C.N. and the date Aug 10, 95. Height 5 inches. Two loose hairlines extend several inches
from the rim.

873 Unusual Iris glaze vase decorated with a single dragonfly in 1898. The glaze obscures the artist's initials. Marks $300-500
on the base include the Rookwood logo, the date, and a slightly obscured shape number. Height 3⅛ inches. Tight
line at lip.

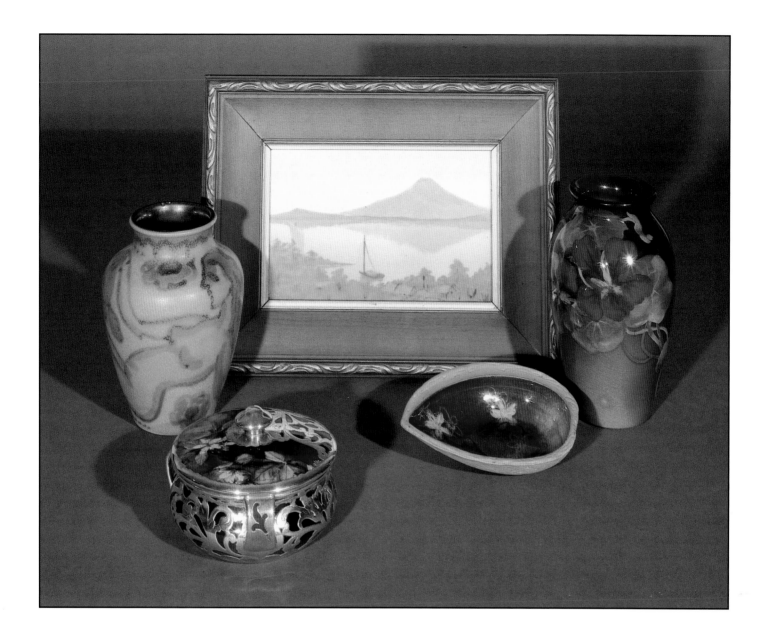

874 Mat glaze vase decorated with a single nude reclining among large abstract flowers, decorated by Jens Jensen in 1933. Marks on the base include the Rookwood logo, the date, S for special shape, a wheel ground X, and the artist's monogram. Height 6½ inches. $1200-1500

875 Standard glaze candy box with extensive silver overlay on both the bowl portion and the lid. The box was decorated with apple blossoms by Mary Nourse in 1892. Marks on the silver are as follows: R 1208 Gorham Mfg. Co. Licensed. Marks on the pottery base include the Rookwood logo, the date, shape number 232 B, W for white clay, the artist's initials and L for light standard glaze. Height 3½ inches. Chip at rim covered by the applied silver. Crack across the lid. $1200-1500

876 Vellum glaze scenic plaque done in 1917 by Sara Sax. The artist's name appears in the lower left hand corner. Marks on the back include the Rookwood logo, the date and V for Vellum glaze body. An original Rookwood paper label with the title, "Fujiyama S. Sax" and an original paper Rookwood logo on the frame. Size 5¼ x 8¼. $2500-3500

877 Bisque and standard glazed almond dish decorated with small flowers. Marks on the base include the Rookwood logo, the date, shape number 279 and Y for yellow clay. Height 1¼ width 5¾ inches. $200-300

878 Standard glaze vase with nasturtium decoration, done in 1902 by an unidentified decorator. Marks on the base include the Rookwood logo, the date, shape number 568 C, and the artist's cypher. Height 7⅛ inches. $400-600

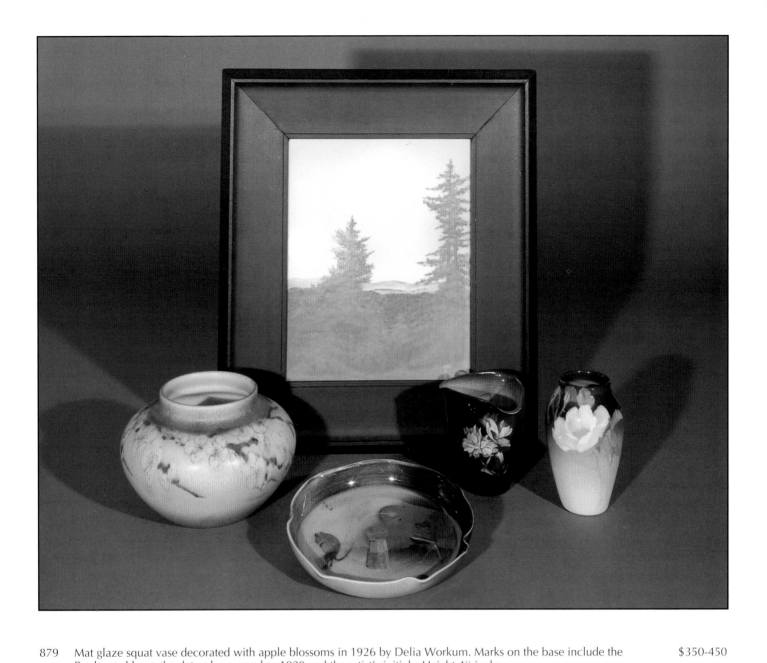

879 Mat glaze squat vase decorated with apple blossoms in 1926 by Delia Workum. Marks on the base include the Rookwood logo, the date, shape number 1929 and the artist's initials. Height 4½ inches. $350-450

880 Standard glaze plate decorated with mice on a springboard by William McDonald in 1891. Marks on the base include the Rookwood logo, the date, shape number 59 F, W for white clay, a wheel ground X and the artist's initials. Diameter 7¼ inches. Two chips on the rim. $200-300

881 Vellum glaze scenic plaque decorated by Katherine Van Horne in 1912. The artist's initials appear in the lower right hand corner. Marks on the back include the Rookwood logo, the date and V for Vellum glaze body. Size 10½ x 8⅜ inches. $3000-4000

882 Standard glaze pitcher decorated with carnations by Grace Young in 1892. Marks on the base include the Rookwood logo, the date, shape number 533 D, S for sage green clay and the artist's initials. Height 4 inches. Two inch line descending from lip. $150-250

883 Iris glaze vase decorated with wild roses by Fred Rothenbusch in 1907. Marks on the base include the Rookwood logo, the date, shape number 913 F, W for white glaze, and the artist's initials. Height 5 inches. $500-700

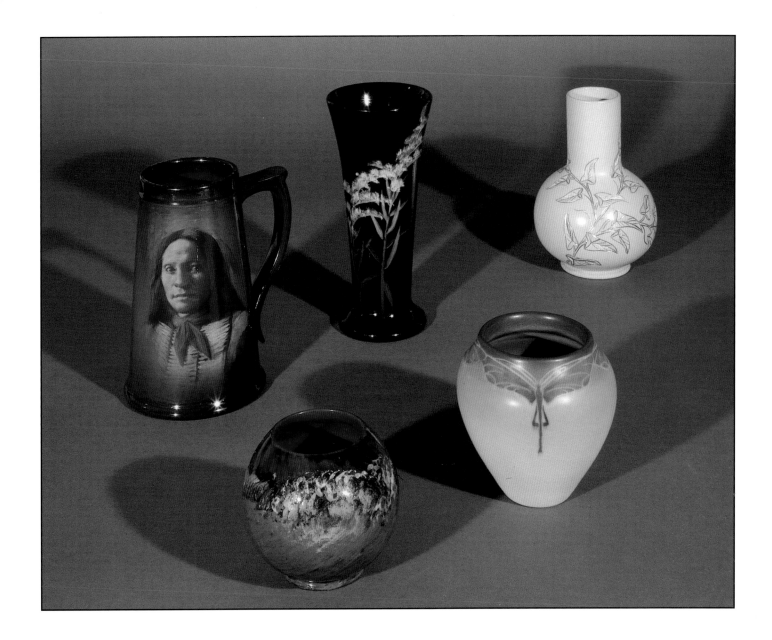

884 Standard glaze tankard decorated with the portrait of a Native American by Grace Young in 1900. Marks on the $3000-4000
 base include the Rookwood logo, the date, shape number 775, the inscription "Chief Goes To War-Sioux-" and
 the artist's initials. Height 7½ inches.

885 Limoges style glaze bowl decorated with abstract designs by Mary Virginia Keenan in 1883. Marks on the base $200-300
 include Rookwood in block letters, the date, and R for red clay. The artist's initials appear on the side of the bowl.
 Height 3⅝ inches.

886 Dark Iris glaze vase with goldenrod decoration by Lenore Asbury, done in 1910. Marks on the base include the $2000-3000
 Rookwood logo, the date, shape number 1357 D, the artist's initials, and W for white glaze. Height 8½ inches.

887 Vellum glaze vase decorated with stylized butterflies by Lorinda Epply in 1909. Marks on the base include the $400-600
 Rookwood logo, the date, shape number 1343, V for Vellum glaze body, the artist's initials and V for Vellum
 glaze. Height 4⅝ inches.

888 Bisque finish vase decorated with incised and gilded leaves by Nettie Wilson circa 1881. Marks on the base $300-500
 include Rookwood Pottery incised, the artist's initials, and the name Collins in fired on gold. Height 7 inches.

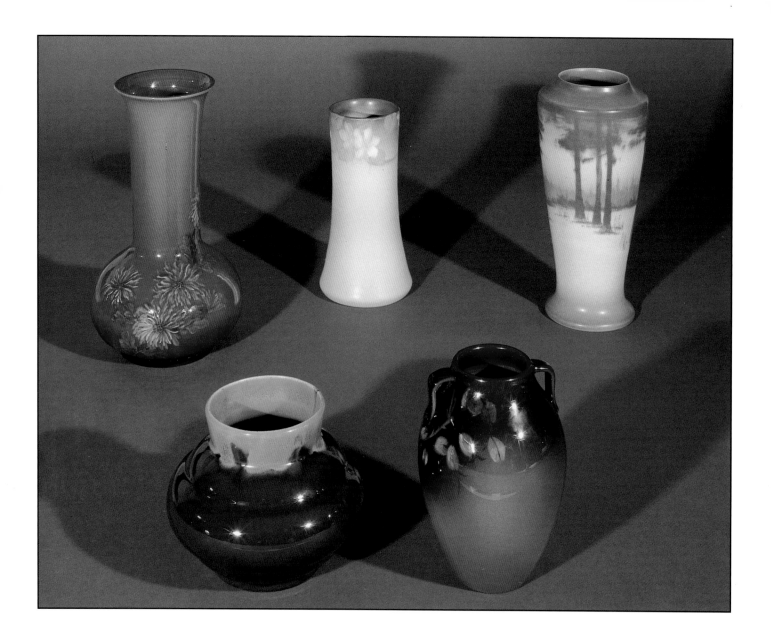

889 Standard glaze vase decorated with chrysanthemums by Anna Valentien in 1889. Marks on the base include the $800-1000
Rookwood logo, the date, shape number 486 C, R for red clay, the artist's initials and D for dark Standard glaze.
Height 9⅝ inches.

890 High glaze bowl with crystaline blue over dark gray, done in 1933. Marks on the base include the Rookwood $250-300
logo, the date and shape number 6373. Height 4⅛ inches.

891 Vellum glaze vase decorated with wild roses by Caroline Steinle in 1911. Marks on the base include the $600-800
Rookwood logo, the date, shape number 1358 E, V for Vellum glaze body, the artist's initials and V for Vellum
glaze. Height 7¼ inches. Uncrazed.

892 Standard glaze vase with small ribbon handles, decorated with rose hips by Leona Van Briggle in 1899. Marks on $300-400
the base include the Rookwood logo, the date, shape number 604 E and the artist's initials. Height 5⅞ inches.

893 Vellum glaze vase with encircling scene of pine trees in the snow, decorated by Sallie Coyne in 1918. Marks on $1400-1800
the base include the Rookwood logo, the date, shape number 1356 D and the artist's initials. Height 9⅛ inches.

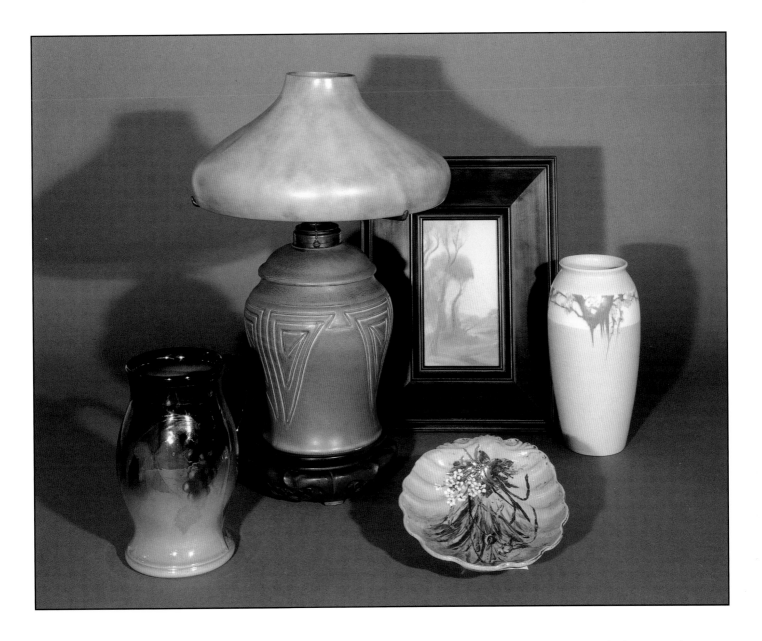

894 Standard glaze tankard decorated with grapes and leaves by Mary Nourse in 1898. Marks on the base include the Rookwood logo, the date, shape number 820, a small triangular esoteric mark, the artist's initials and L for light Standard glaze. Height 8¼ inches. Tight one inch line at rim and small glaze flake near base. $250-350

895 Mat glaze arts and crafts lamp with geometric decoration and brass fittings, made at Rookwood in 1905. The lamp was originally an oil burner which has been converted to electricity. The burner formerly sat on a ceramic cap with a brass font underneath. Only the burner has been removed and replaced many years ago with electrical fittings. Marks on the base include the Rookwood logo, the date and shape number 1078. Height to the top of the fittings is 17¾ inches. $3000-4000

896 Vellum glaze scenic plaque, attributed to Lenore Asbury and done in 1922. Possibly signed in the lower left hand corner. Marks on the back include the Rookwood logo, the date and the title in pencil, "Sunset". Size 7⅞ x 4¼ inches. $800-1200

897 Limoges style glaze shell dish decorated with flowers and grasses and two small birds in 1882 by an unknown artist whose initials are M.H.P. Marks on the base include Rookwood in block letters, the date, shape number 222, G for ginger clay, a small kiln mark, a small cross and the artist's initials. Height 2⅛ inches, length 8½ inches. $250-350

898 Vellum glaze vase decorated with a band of cherry blossoms by E.T. Hurley in 1916. Marks on the base include the Rookwood logo, the date, shape number 892 C, the artist's initials and V for Vellum glaze. Height 9⅜ inches. $500-700

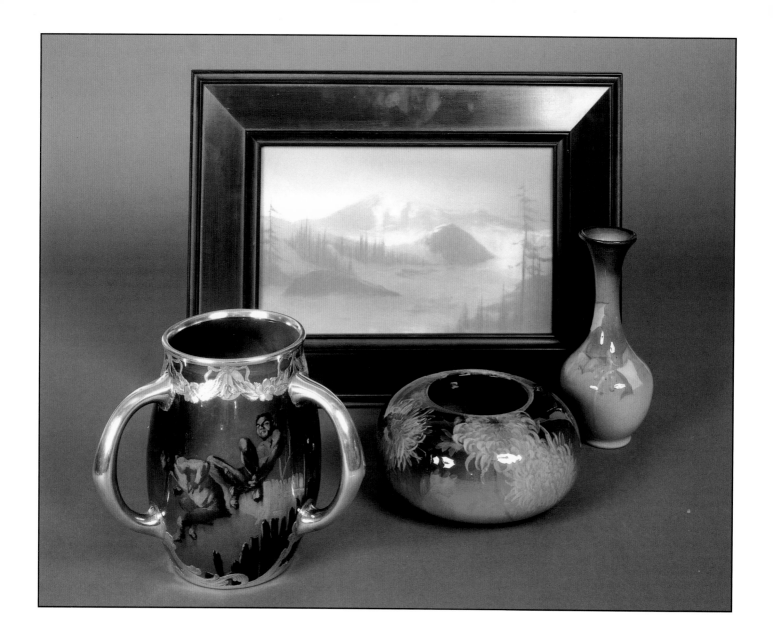

899 Standard glaze three-handled mug with silver overlay, decorated by Bruce Horsfall with five satyrs fleeing in the moonlight with a stolen goose. The engraved silver overlay bands the top and bottom and covers the three handles and is inscribed "Gorham Mfg Co", "R190S", and "999/1000". Marks on the base include the Rookwood logo, the date, shape number 659, W for white clay and the artist's monogram. A tight spider crack appears on the base. Height 8 inches. $8000-10000

900 Vellum glaze scenic plaque decorated by Lenore Asbury in 1913. The artist's initials appear in the lower left hand corner. Marks on the back include the Rookwood logo, the date and a V for Vellum glaze body. Size 9 x 14¼ inches. Repairs to edges of plaque. $1400-1800

901 Rimless Standard glaze bowl decorated by Olga Geneva Reed in 1898 with chrysanthemums. Marks on the base include the Rookwood logo, the date, shape number 214 A, a small star shaped esoteric mark and the artist's initials. Height 4⅛ inches. $600-800

902 Iris glaze vase decorated with holly by Fred Rothenbusch in 1901. Marks on the base include the Rookwood logo, the date, shape number 557 and the artist's initials. Height 9 inches. $700-900

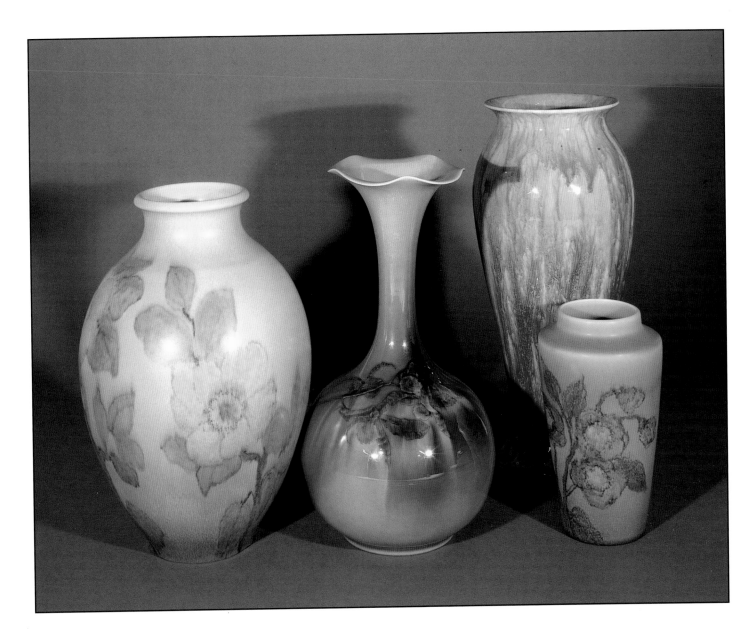

903 Large mat glaze vase decorated with red flowers and green leaves by Katherine Jones in 1928. Marks on the base include the Rookwood logo, the date, shape number 2246 C, and the artist's initials. Height 14⅛ inches. Drilled. $600-800

904 Large Standard glaze vase with fluted top, decorated with orchids by Kataro Shirayamadani in 1889. Marks on the base include the Rookwood logo, the date, shape number 330 A, W for white clay, the artist's cypher and L for light Standard glaze. Height 15 inches. $2500-3000

905 Large lamp base in unusual mottled high glaze, decorated by Sallie Toohey in 1920. Marks on the base include the Rookwood logo, the date, shape number S2013, the artist's initials, and the figure 2K. Height 16⅝ inches. $300-400

906 Mat glaze vase decorated by Charles Klinger in 1925 with large blue flowers. Marks on the base include the Rookwood logo, the date, shape number 1918 and the artist's initials. Height 8⅞ inches. Two lines from rim. $200-300

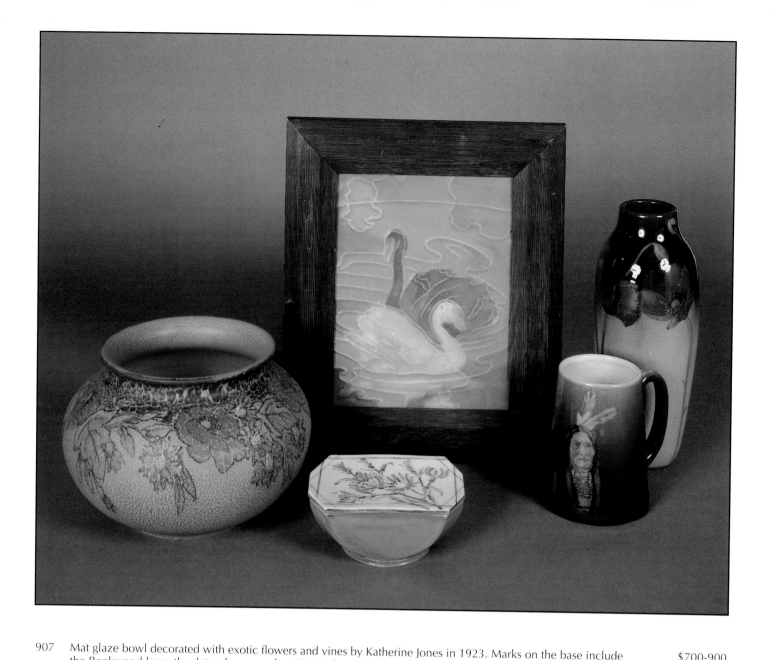

907 Mat glaze bowl decorated with exotic flowers and vines by Katherine Jones in 1923. Marks on the base include $700-900
the Rookwood logo, the date, shape number 494 A, the number 9850 and the artist's initials. Height 6 inches.

908 High glaze lidded cigarette box decorated with blue flowers by Margaret McDonald in 1946. Marks on the base $300-400
include the Rookwood logo, the date, shape number 6923 B, the number 623, the number 6W and the artist's
initials. Height 2⅛ inches, length 5⅜ inches.

909 Rookwood Architectural Faience mat glaze tile with swan decoration, done circa 1915. Impressed in the back are $800-1200
the words, Rookwood Faience 1165 3Y. Size 9 x 7⅛ inches.

910 High glaze mug decorated with a Native American portrait by Flora King in 1946. Marks on the base include the $600-800
Rookwood logo, the date, shape number 587 C, the inscription "Dirty Face", the number, "228A" and the artist's
initials. Height 5 inches.

911 Standard glaze vase decorated with red poppies by Mary Nourse in 1903. Marks on the base include the $800-1200
Rookwood logo, the date, shape number 932 CC, a partial Rookwood salesroom label and the artist's initials.
Height 10 inches.

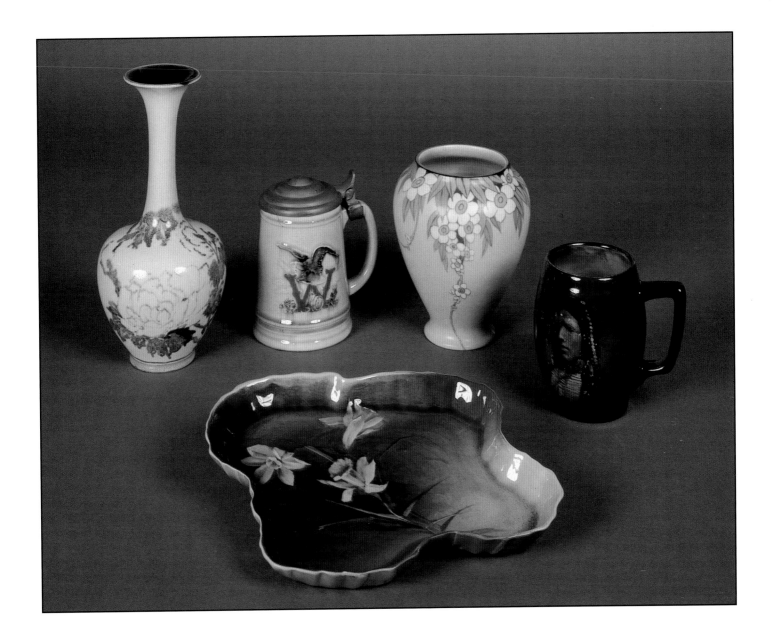

912 Blue tinted high glaze vase decorated with chrysanthemums by William Hentschel in 1922. Marks on the base include the Rookwood logo, the date, shape number 778 and the artist's initials. Height 10 inches. $300-400

913 High glaze mug with a pewter lid and the polychromed company logo of the Weidemann Brewing Company embossed on side. Made for the George Wiedemann Brewing Company of Newport, Kentucky in 1948. Marks on base include the Rookwood logo, the date, and the inscription, "THE GEO. WEIDEMANN BREWING CO. INC.". Height, 5½ inches. $250-350

914 Standard glaze tray decorated with jonquils in 1889. Marks on the base include the Rookwood logo, the date, shape number 421, and S for sage green clay. Width is 10½ inches. $200-300

915 Unusually clean Vellum glaze vase with exotic floral decoration, done by Lenore Asbury in 1931. Marks on the base include the Rookwood logo, the date, shape number 1781, V for Vellum glaze body, the artist's initials and V for Vellum glaze. Height 6⅜ inches. $800-1200

916 Standard glaze mug with a portrait of a Native American, decorated by an unidentified artist in 1896. Marks on the base include the Rookwood logo, the date, shape number 645, a small wheel ground X and the artist's initials which are obscured by the glaze. Numerous blotches partially obscure the portrait. $300-500

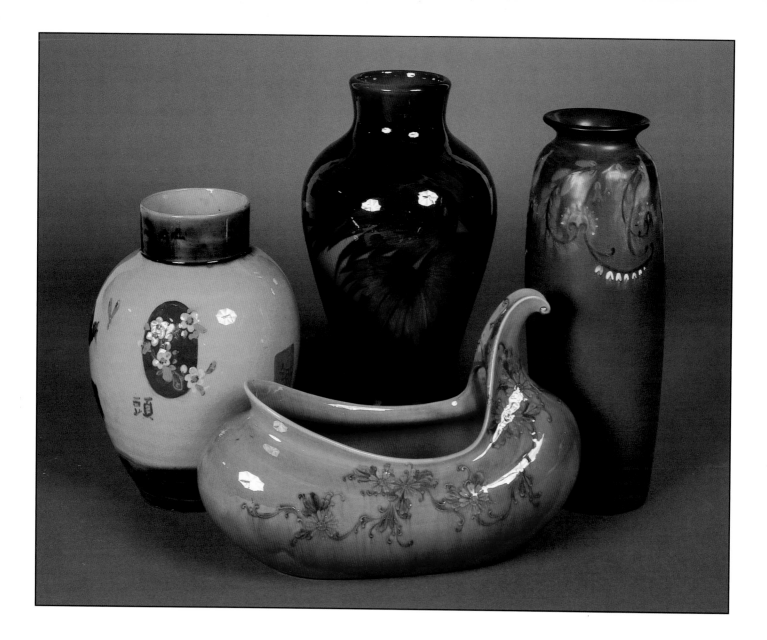

917 Early high glaze vase done in 1882 by an unknown decorator, with oriental symbols and designs and a small bird chasing a moth. Marks on the base include Rookwood in block letters and the date. Height 11 inches. $400-600

918 Standard glaze flower boat decorated with stylized daisies by Kataro Shirayamadani in 1888. Marks on the base include the Rookwood logo, the date, shape number 407, W for white clay, the artist's cypher and D for dark Standard glaze. Height 8½ inches, length 13¾ inches. $2000-2500

919 Good Standard glaze vase decorated with palm fronds by M.A. Daly in 1902. Marks on the base include the Rookwood logo, the date, shape number S1713, a small wheel ground X, the artist's initials and Y for Yellow (Standard) glaze. Height 14½ inches. $1500-2000

920 Vellum glaze vase decorated with stylized birds and blossoms by Lorinda Epply in 1915. Marks on the base include the Rookwood logo, the date, shape number 271 A, V for Vellum glaze body, the artist's initials and V for vellum glaze. Height 14¼ inches. $1200-1500

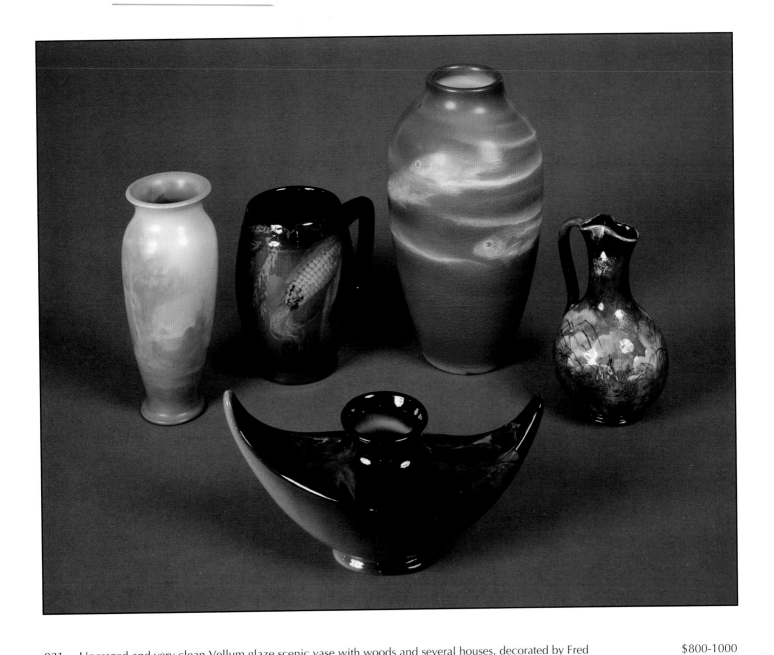

921 Uncrazed and very clean Vellum glaze scenic vase with woods and several houses, decorated by Fred Rothenbusch in 1935. Marks on the base include the Rookwood logo, the date, shape number 2721, the artist's initials and V for Vellum glaze. Height 6½ inches. $800-1000

922 Standard glaze mug decorated with corn and barley by Josephine Zettel in 1898. Marks on the base include the Rookwood logo, the date, shape number 645, and the artist's initials. Height 4¾ inches. $300-500

923 Standard glaze vase with upturned ends decorated with oak leaves by Katherine Hickman in 1897. Marks on the base include the Rookwood logo, the date, shape number 678 E, a small triangular esoteric mark, and the artist's initials. Height 3¾ inches. $300-400

924 Good Vellum glaze vase decorated with four swimming fish by E.T. Hurley in 1907. Marks on the base include the Rookwood logo, the date, shape number 900 C, V for Vellum glaze body, the number 407 marked twice in tiny script, the artist's initials and V for Vellum glaze. Height 8⅜ inches. $1200-1500

925 Limoges style glaze ewer decorated with oriental grasses, clouds, and a small bunny by Albert Humphreys in 1882. Marks on the base include Rookwood in block letters, the date, an impressed anchor mark, and the artist's initials. Height 5 inches. $400-600

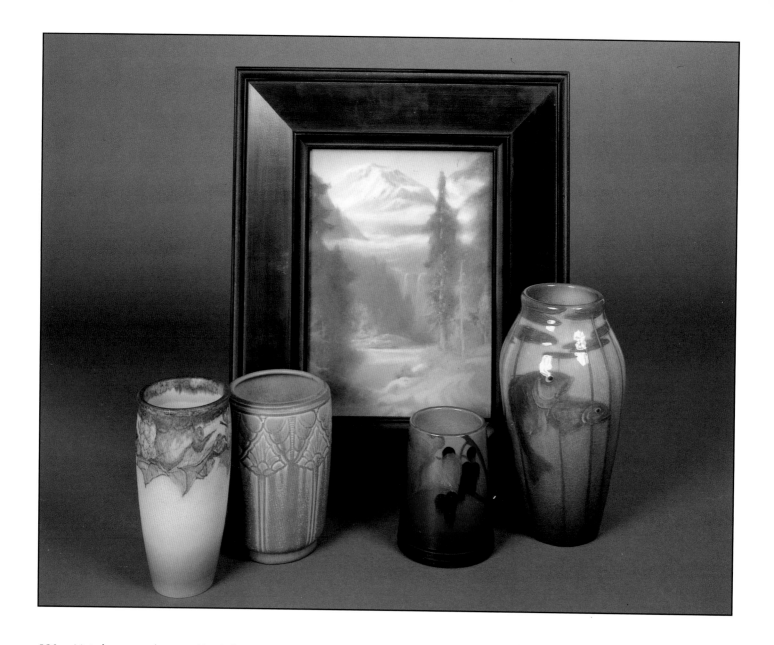

926 Mat glaze vase decorated by Sallie Coyne in 1926 with holly berries and leaves. Marks on the base include the $300-400
 Rookwood logo, the date, shape number 2062 and the artist's initials. Height 7 inches.

927 Mat and crystalline glaze vase with repeating incised decoration, done by Ruben Earl Menzel in 1937. Marks on $250-350
 the base include the Rookwood logo, the date, shape number 6647 D and the artist's initials. Height 6 inches. Pin
 head size chip at base.

928 Good Vellum glaze scenic plaque, decorated by Fred Rothenbusch in 1937. The artist's initials appear in the $4000-6000
 lower right hand corner. Marks on the back include the Rookwood logo, the date and the size 9 x 12. Actual size
 is 11⅝ x 8½ inches. Uncrazed.

929 Standard glaze mug decorated with grapes and grape leaves by Leona Van Briggle in 1903. Marks on base $150-250
 include the Rookwood logo, the date, shape number 587 C, a wheel ground X, and the artist's initials. Height 4¾
 inches. Glaze skips at rim have been repaired.

930 Iris glaze vase decorated in an oriental style with three fish and lilly pads, done by M.A. Daly in 1901. Marks on $3000-4000
 the base include the Rookwood logo, the date, shape number 925 C, the artist's initials and W for white glaze.
 Height 9⅜ inches. Minor glaze blister.

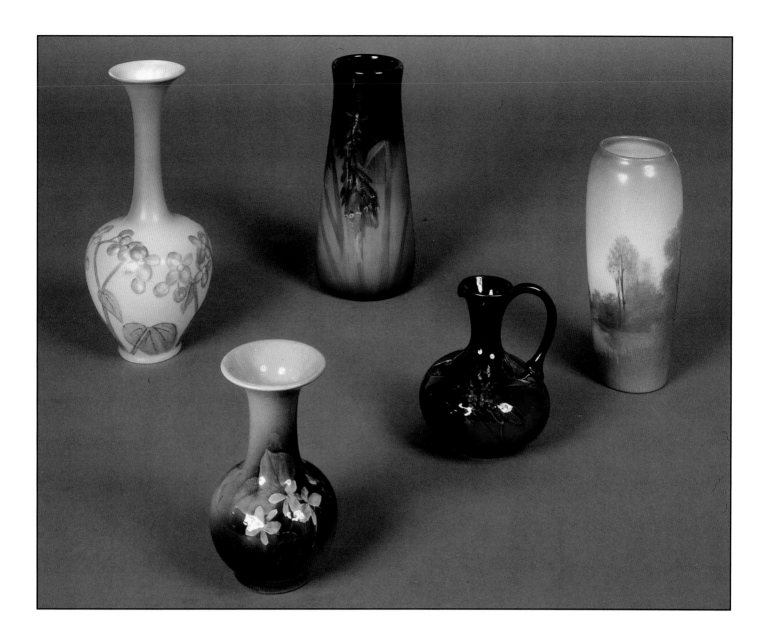

931 Mat glaze vase with floral decoration, done by Kataro Shirayamadani in 1944. Marks on the base include the **$700-900**
Rookwood logo, the date, shape number 778 and the artist's initials. Height 9⅝ inches.

932 Standard glaze vase decorated with violets by Elizabeth Lincoln in 1893. Marks on the base include the **$150-250**
Rookwood logo, the date, shape number 40, W for white clay and the artist's initials. Height 5½ inches. Tight one
inch hairline from rim.

933 Standard glaze vase decorated with red flowers and green stems by Carrie Steinle in 1907. Marks on the base **$500-700**
include the Rookwood logo, the date, shape number 950 D and the artist's initials. Height 8½ inches.

934 Standard glaze ewer decorated with forget-me-nots by Edith Felton in 1898. Marks on the base include the **$300-400**
Rookwood logo, the date, shape number 509 and the artist's initials. Height 4¾ inches.

935 Vellum glaze vase with woodland scene decorated by Carl Schmidt in 1916. Marks on the base include the **$1200-1400**
Rookwood logo, the date, shape number 951 E, V for Vellum glaze body, the artist's monogram and V for Vellum
glaze. Height 7⅞ inches.

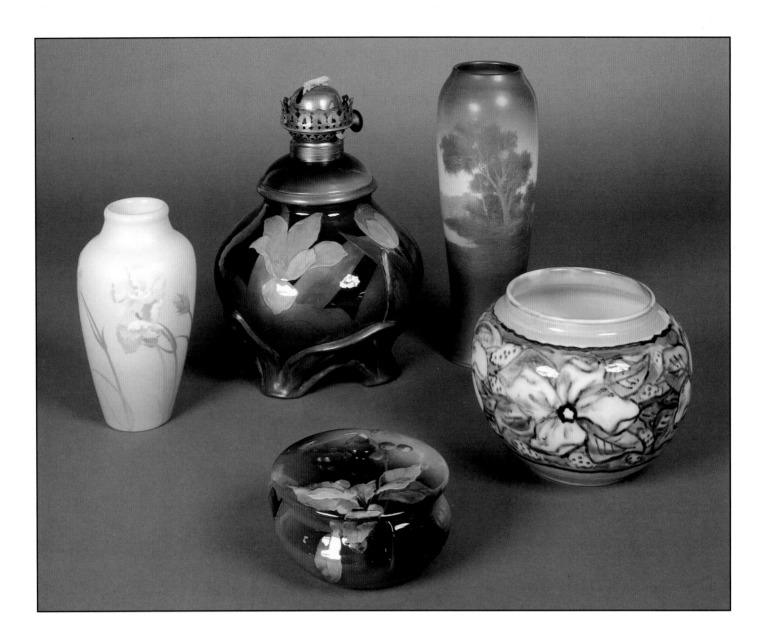

936 Early Vellum glaze floral vase decorated by Fred Rothenbusch in 1905 with carnations. Marks on the base $800-1000
include the Rookwood logo, the date, shape number 943 D, V for Vellum glaze body, the artist's initials and W
which means the artist possibly wanted an Iris glaze but got Vellum anyway. Height 8 inches.

937 Important metal mounted Standard glaze lamp base with applied, carved, and electroplated feet and leaves, $4000-6000
decorated with tulips by Kataro Shirayamadani in 1901. Marks on the base include the Rookwood logo, the date,
shape number T 1250 and the artist's cypher. The base has a cast hole in it and the cap for the burner is also
Rookwood, although it has a repaired crack. Height to the top of the burner is 11½ inches.

938 Standard glaze candy box with three small ribbon handles, decorated with cherries and leaves by Harriet Strafer $250-350
in 1891. Marks on the base include the Rookwood logo, the date, shape number 232 A, W for white clay, the
artist's initials and L for light Standard glaze. Height 3½ inches. Repair at bottom edge of lid.

939 Vellum glaze scenic vase decorated with trees and a pond by E.T.Hurley in 1921. Marks on the base include the $700-900
Rookwood logo, the date, shape number 2040 C, V for Vellum glaze body, and the artist's initials. Height 11⅞
inches. Tight two inch line descends from the rim.

940 High glaze vase with a prominent band of magnolia blossoms encircling, executed by Jens Jensen in 1948. Marks $700-900
on the base include the Rookwood logo, the date, S for special shape and the artist's monogram. Height 6 inches.

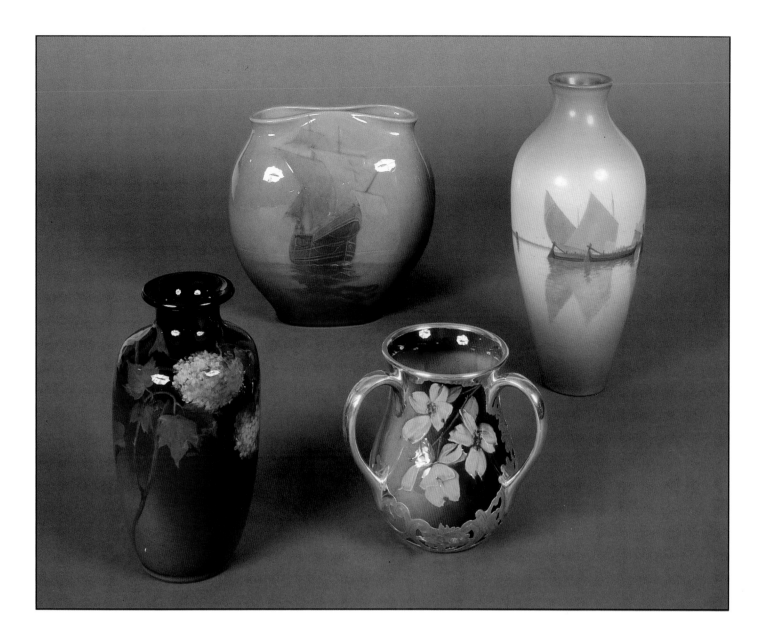

941 Standard glaze vase with hydrangea decoration, executed by Irene Bishop in 1902. Marks on the base include the $500-700
Rookwood logo, the date, shape number 903 C, and the artist's initials. Height 8¼ inches.

942 Important Standard glaze pillow vase decorated by Sturgis Laurence with a scene of the Pinta at sail. Marks on the $2000-3000
base include the Rookwood logo, the date, shape number 707 AA, the artist's full name and the title, "The "Pinta"
1492." Height 9¼ inches.

943 Standard glaze three handled loving cup with extensive silver overlay, decorated with dogwood by John Dee $2500-3500
Wareham in 1894. Marks on the silver include S/822 and Gorham Mfg. Co. Marks on the base include the
Rookwood logo, the date, shape number 729, W for white clay and the artist's initials. Height 5⅞ inches. Minor
break in silver.

944 Fine Vellum glaze vase decorated with a Venetian ship at sail by Carl Schmidt in 1922. Marks on the base $3000-4000
include the Rookwood logo, the date, shape number 170, V for Vellum glaze body and the artist's monogram.
Height 12 inches.

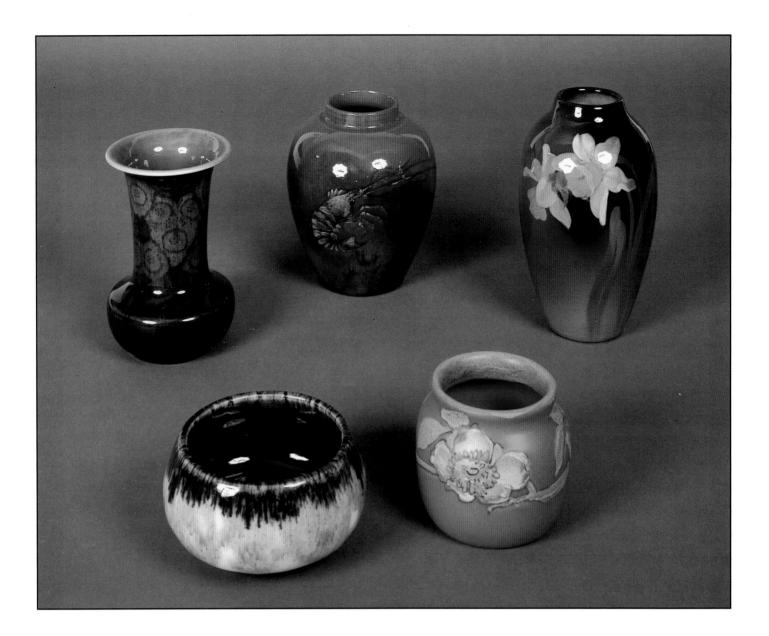

945 High glaze vase with stylized floral decoration done by Ed Diers in 1924. Marks on the base include the $300-500
 Rookwood logo, the date, shape number 3719 and the artist's initials. Height 6½ inches.

946 High glaze bowl decorated with abstract flowers by Lorinda Epply in 1928. Marks on the base include the $250-350
 Rookwood logo, the date, shape number 1842 and the artist's initials. Height 3 inches.

947 Early high glaze vase decorated with crabs and a lobster by Albert Valentien in 1884. Marks on the base include $300-500
 Rookwood in block letters, the date, shape number 142 B, R for red clay and the artist's initials. Height 6¼ inches.
 Possibly missing a lid.

948 Painted Mat glaze bowl decorated with three large blossoms encircling the piece, done in 1904 by Sallie Toohey. $500-700
 Marks on the base include the Rookwood logo, the date, shape number 95 Z, V for Vellum glaze body and the
 artist's monogram. Height 3⅝ inches.

949 Standard glaze vase decorated with jonquils in 1904 by Grace Hall. Marks on the base include the Rookwood $200-300
 logo, the date, shape number 900 C and the artist's initials. Height 8⅝ inches. Line at lip.

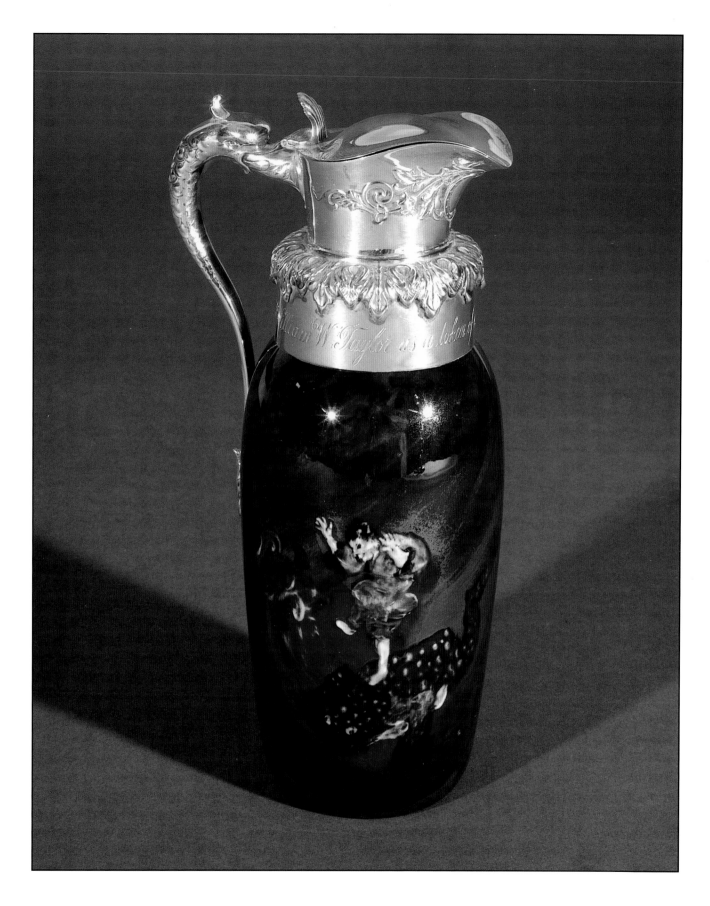

950 Rare and important presentation pitcher decorated by Maria Longworth Nichols with a Japanese character riding $15,000-20,000
on a frog's back. The vase is mounted with a silver collar, spout and a dolphin handle and is inscribed, "To
William W. Taylor as a Token of Esteem from Maria L. Nichols". Marks on the base include Rookwood in block
letters, the date, shape number 80 B, R for red clay and the artist's initials. Tiger Eye effect is noticable especially
on the decorated side of the vase. Height 8 inches.

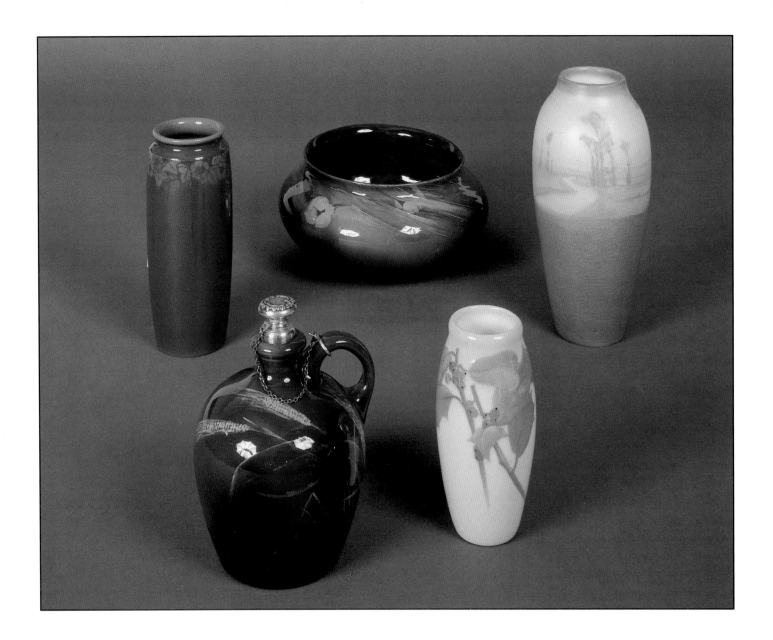

951 High glaze vase decorated with small stylized flowers near the top by Patti Conant in 1917. Marks on the base $500-700
include the Rookwood logo, the date, shape number 589 F, P for porcelain body and the artist's monogram.
Height 7½ inches.

952 Standard glaze silver stoppered ewer with wheat decoration, done by Edward Abel in 1894. Marks on the base $500-700
include the Rookwood logo, the date, shape number 512 C, W for white clay, the artist's initials and L for light
Standard glaze. Height 6 inches.

953 Standard glaze bowl with lotus blossoms and leaves in a swirling pattern, done by Sallie Toohey in 1896. Marks $400-600
on base include the Rookwood logo, the date, shape 494 A, a wheel ground X and the artist's initials. Height
4⅛ inches.

954 Iris glaze vase decorated by Sara Sax with holly in 1902. Marks on the base include the Rookwood logo, the date, $400-600
shape number 917 E, W for white glaze and the artist's monogram. Height 5¾ inches.

955 Vellum glaze banded vase with road winding through a wooded field. Decorated in 1912 by Sallie Coyne. Marks $400-600
on the base include the Rookwood logo, the date, shape number 295 D, V for Vellum glaze body, the artist's
initials and V for Vellum glaze. Height 9 inches. Possible tight line at rim.

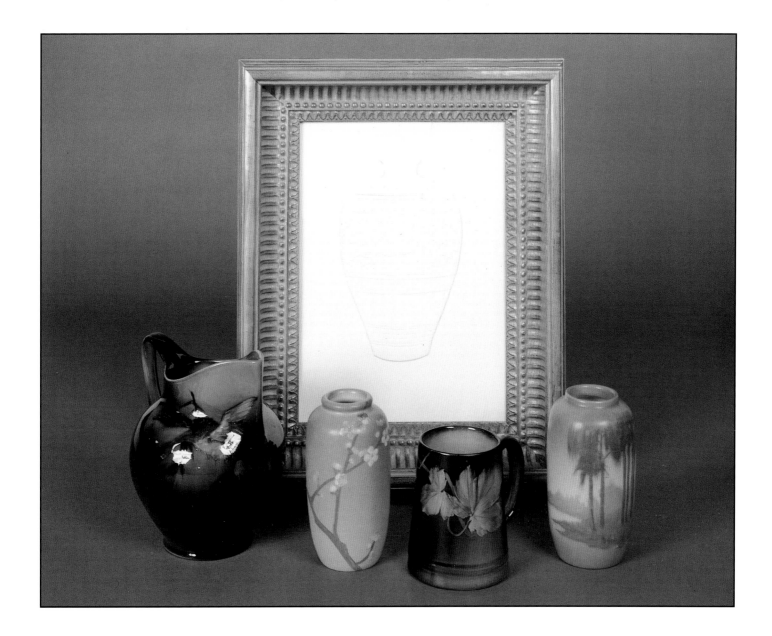

956 Standard glaze pitcher decorated by Sallie Toohey in 1893 with three prominent ducks preparing to land in a $1200-1500
marsh. Marks on the base include the Rookwood logo, the date, shape number 525, W for white clay and the
artist's initials. Height 7¼ inches.

957 Early Vellum glaze vase with cherry blossom decoration done by Constance Baker in 1904. Marks on the base $500-700
include the Rookwood logo, the date, shape number 56 Z, V for Vellum glaze body and the artist's initials.
Height 5⅞ inches.

958 Bisque finish, cast plaque showing a Rookwood vase design in high relief, done in 1952. Marks on the back $300-500
include the Rookwood logo and the date. There are two paper labels, one reading M 44 and the other reading
1407. Size 10 x 8 inches. Firing crack.

959 Standard glaze mug decorated with hops by Olga Geneva Reed in 1894. Marks on the base include the $250-350
Rookwood logo, the date, shape number 587, W for white clay, and the artist's initials. Height 4⅝ inches.

960 Vellum glaze scenic vase decorated with palm trees on a beach by Elizabeth McDermott in 1915. Marks on the $700-900
base include the Rookwood logo, the date, shape number 924, V for Vellum glaze body and the artist's initials.
Height 6 inches.

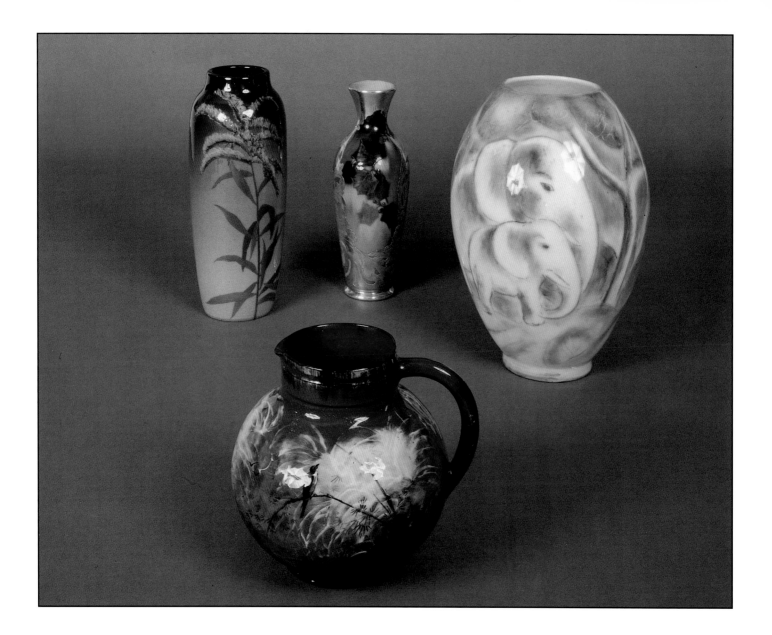

961 Tall Standard glaze vase decorated by Mary Nourse in 1901 with goldenrod. Marks on the base include the $1000-1500
 Rookwood logo, the date, shape number 907 D, the artist's initials and L for light Standard glaze. Height 10⅞ inches.

962 Limoges style glaze pitcher decorated by Albert Valentien in 1882 showing oriental grasses, several birds in flight $800-1200
 and a single bird perched on a branch. Marks on the base include Rookwood in block letters, the date, shape
 number 36, R for red clay, an impressed anchor and the artist's initials. Height 6¾ inches.

963 Standard glaze vase with silver overlay by Gorham, decorated by Artus Van Briggle in 1892 with holly. Marks on $1000-1500
 the base of the silver include R 1366 and Gorham Mfg. Co.. Marks on the base include the Rookwood logo, the
 date, shape number 562, W for white clay, the artist's initials and L for light Standard glaze. Height 9¾ inches.
 Two minor breaks in the silver overlay. Long crack on one side of the vase.

964 Good high glaze figural vase, decorated by Jens Jensen in 1948, showing a mother and baby elephant. This vase $3000-4000
 is said to have been in Rookwood's own Museum during its latter years. Marks on the base include the
 Rookwood logo, the date, shape number 6918 and the artist's monogram. Height 11⅝ inches. Very tight one inch
 line descending from rim.

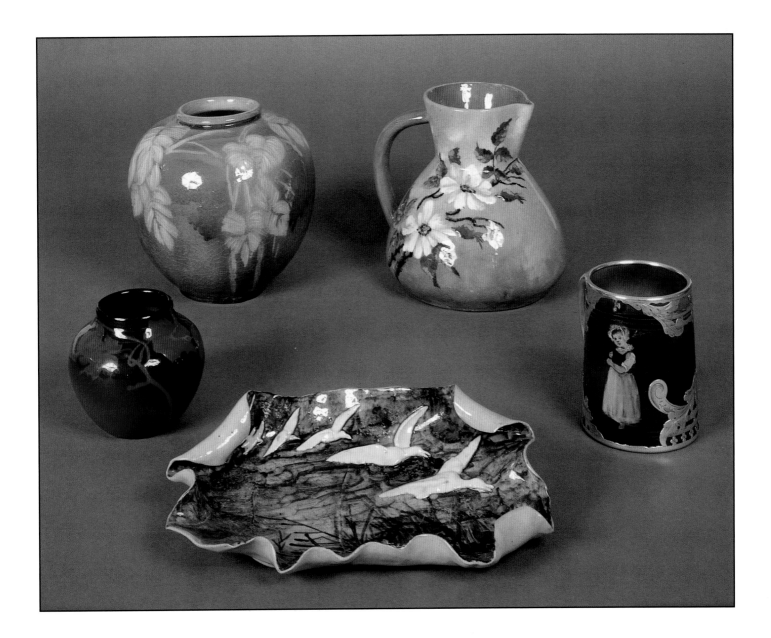

965 Standard glaze vase with grape leaf decoration by Irene Bishop, dated 1903. Marks on base include the $300-400
Rookwood logo, the date, shape number 919E and the artist's initials. Height 5½ inches.

966 High glaze vase decorated with stylized palm fronds by Lois Furukawa in 1946. Marks on the base include the $400-600
Rookwood logo, the date, shape number 6204 C, and the artist's initials. Height 7¼ inches.

967 Early, possibly important tray decorated with five carved and applied ducks flying over a marsh. A note on the $500-700
tray, written by David Glover reads as follows: "From great grand niece of Jane P. Dodd. Said piece was in 1st
kiln at RP, and made by Maria Longworth Nichols. Clay from Mat Morgan Pottery & rolled like pie dough, then
shaped. Ducks applied." Width of tray is 10¼ inches.

968 Limoge style glaze ewer decorated with daisies by Albert Valentien in 1882. Marks on the base include Rookwood's $600-800
rare Eastern Avenue mark, the artist's initials, and an impressed anchor. Height 7⅜ inches.

969 Standard glaze mug with silver overlay decorated by an unknown artist in 1892 with a portrait of a young girl. $700-900
Marks on the silver include R 753 and Gorham Mfg. Co. Marks on the base include the Rookwood logo, the date,
shape number 587, W for white clay and the unknown artist's cypher. Height 4⅞ inches. Several cracks in the
pottery body and some missing silver.

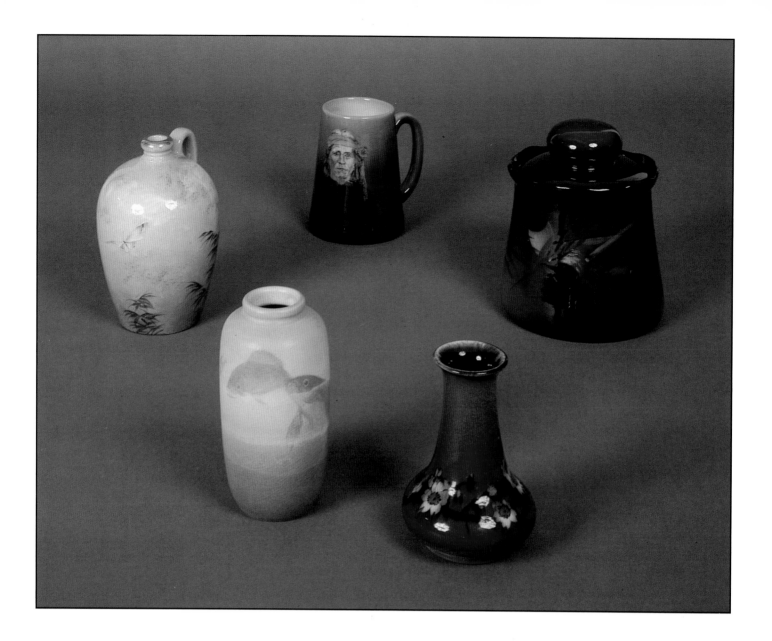

970 Limoges style glaze jug decorated by Albert Valentien in 1883 with oriental grasses and a single blue butterfly. $800-1000
Marks on the base include Rookwood in block letters, the date, shape number 12 C, a G for ginger clay and the
artist's initials. Height 6½ inches.

971 Early Vellum glaze vase decorated by E.T. Hurley in 1904, depicting three fish swimming in murky water. Marks $900-1100
on the base include the Rookwood logo, the date, shape number 56Z, V for Vellum glaze body, the artist's initials
and W, possibly for white (Iris) glaze, even though this piece is obviously covered with Vellum glaze. Height 5¼
inches.

972 High glaze mug decorated with a Native American portrait by Flora King in 1946. Marks on the base include the $600-800
Rookwood logo, the date, shape number 587 C, the inscription, "Kis-i-ti-wa", the number "226A" and the artist's
initials. Height 5 inches.

973 Black Opal glaze vase decorated with cherry blossoms by Harriet Wilcox in 1926. Marks on the base include the $400-600
Rookwood logo, the date, shape number 2718 and the artist's initials. Height 5 inches.

974 Standard glaze humidor decorated with leaves, cigars and pipes by Lenore Asbury in 1900. Marks on the base $600-800
include the Rookwood logo, the date, shape number 672 and the artist's initials. The lid also carries the artist's
initials. Height 6¼ inches. Tiny glaze nick.

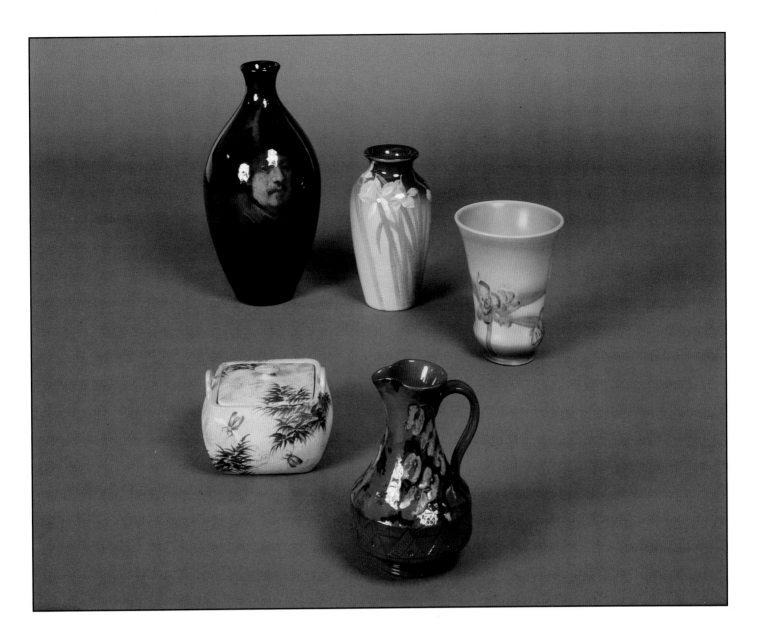

975 Standard glaze vase with portrait of a man, decorated by Artus Van Briggle in 1898. Marks on the base include $1500-2000
 the Rookwood logo, the date, shape number 745 A, a small star shaped esoteric mark, a wheel ground X, the
 artist's initials, and L for light standard glaze.

976 Bisque glaze candy box with scarab finial and two small loop handles, decorated with bamboo leaves and flying $200-300
 beetles by Albert Valentien in 1882. Marks on base include Rookwood in block letters, the date, shape number
 21, and Y for yellow clay. The artist's initials are painted in black slip on base. Tight line in lid and one handle
 broken and glued. Height 3 inches.

977 Iris glaze vase decorated with jonquils by Josephine Zettel in 1902. Marks on the base include the Rookwood $700-900
 logo, the date, the artist's initials and a W for white clay. The shape number is covered by an original Davis
 Collamore retail label. Height 7 inches.

978 Limoges style glaze ewer decorated by Rhoda L. Cairns in 1882 with maple catkins. An incised and repeating $250-350
 border encircles the widest part of the piece. Marks on the base include Rookwood in block letters, the date, the
 artist's full name, and the word, may. Height 5¾ inches.

979 Mat glaze vase decorated by Kataro Shirayamadani in 1935 with a floral pattern. Marks on the base include the $300-500
 Rookwood logo, the date, S for special shape and the artist's cypher. Height 5¾ inches.

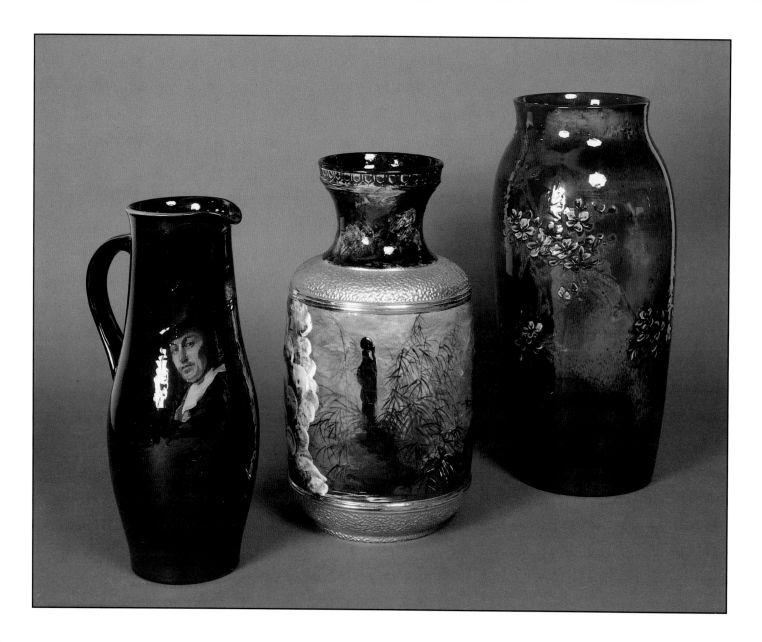

980 Large Standard glaze tankard decorated with a portrait of young Flemish gentleman by Sturgis Laurence in 1896. $1750-2250
Marks on the base include the Rookwood logo, the date, shape number 838 A, the artist's full name and the title,
"After Jan de Bray." Height 14½ inches.

981 Large and unusual Limoges style glaze vase decorated in 1883 with an encircling scene which includes several $1000-1500
perched owls, birds in flight, large trees, and a woman with a water jug on her head. The vase is not signed but
could be the work of Maria Longworth Nichols. Marks on the base include Rookwood in block letters, the date,
G for ginger clay and a small kiln mark. Height 15½ inches. Glaze flake off lip.

982 Large Standard glaze vase decorated by Albert Valentien in 1884 with large sprays of fruit blossoms and stems $4000-6000
and large passages of Tiger Eye evident. Marks on the base include Rookwood in block letters, the date, shape
number 139 A, R for red clay and the artist's initials. Height 17¾ inches. Several glaze bubbles.

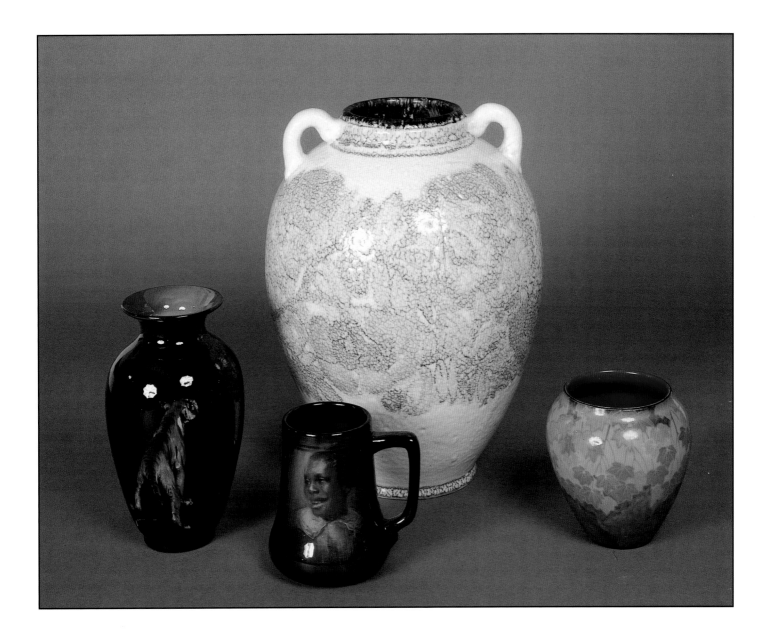

983 Fine Standard glaze vase decorated with a stalking tiger by Bruce Horsfall in 1895. Marks on the base include the $2500-3500
Rookwood logo, the date, shape number 704 and the artist's monogram. Height 8¼ inches.

984 Good Standard glaze vase decorated by Sadie Markland in 1898, featuring a portrait of an African-American $1400-1800
youth. Marks on the base include the Rookwood logo, the date, shape number 656, a small star shaped esoteric
mark, the artist's initials and L for light Standard glaze. Height 4⅞ inches.

985 Unusual decorated Butterfat glaze vase with two small loop handles and extensive floral designs, done by Lorinda $1500-2500
Epply in 1928. Marks on the base include the Rookwood logo, the date, shape number 2640 C and the artist's
initials. Height 13⅜ inches.

986 High glaze vase decorated by Kataro Shirayamadani in 1924 with multicolored English ivy. Marks on the base $800-1200
include the Rookwood logo, the date, shape number 1343 and the artist's cypher. Height 5 inches.

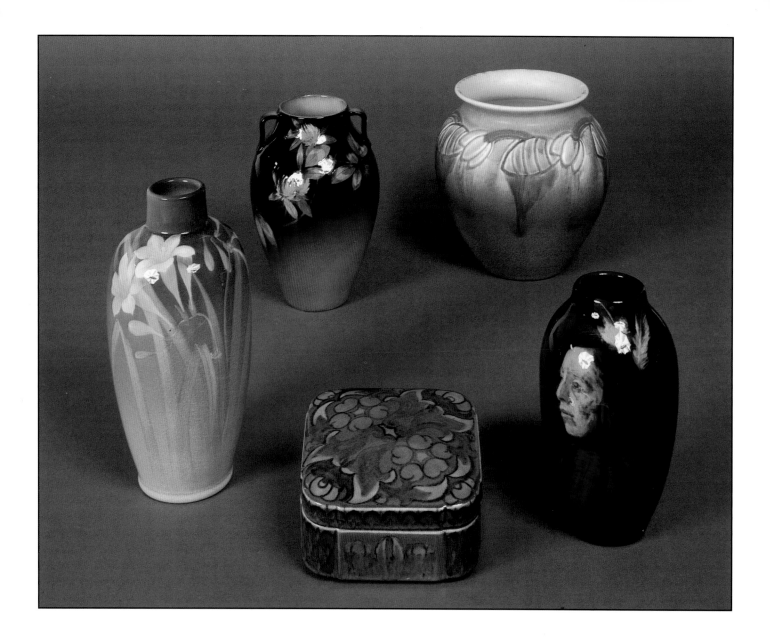

987 Iris glaze vase decorated with white lillies by Carl Schmidt in 1901. Marks on the base include the Rookwood logo, the date, shape number ...6 D which is partially obscured by a neat drill hole, W for white glaze and the artist monogram. Height 8⅛ inches. $1200-1500

988 Standard glaze vase with two small ribbon handles decorated with clover by Harriet Wilcox in 1894. Marks on the base include the Rookwood logo, the date, shape number 604 D, W for white clay and the artist's initials. Height 7 inches. $300-500

989 Unusual Black Opal glaze box decorated with lush foliage by Sara Sax in 1926. Marks on the base include the Rookwood logo, the date, shape number 2839 and the artist's monogram. Height 2½ inches, width 4½ inches. $500-700

990 Mat glaze vase by C.S. Todd, decorated with incised and painted flowers near the top. Marks on the base include the Rookwood logo, the date, shape number 130, a wheel ground X and the artist's initials. Height 6¾ inches. $300-500

991 Good Standard glaze vase decorated with the portrait of a Native American by Edith Noonan in 1904. Marks on the base include the Rookwood logo, the date, shape number 900 D and the artist's initials. Height 6½ inches. $1000-1200

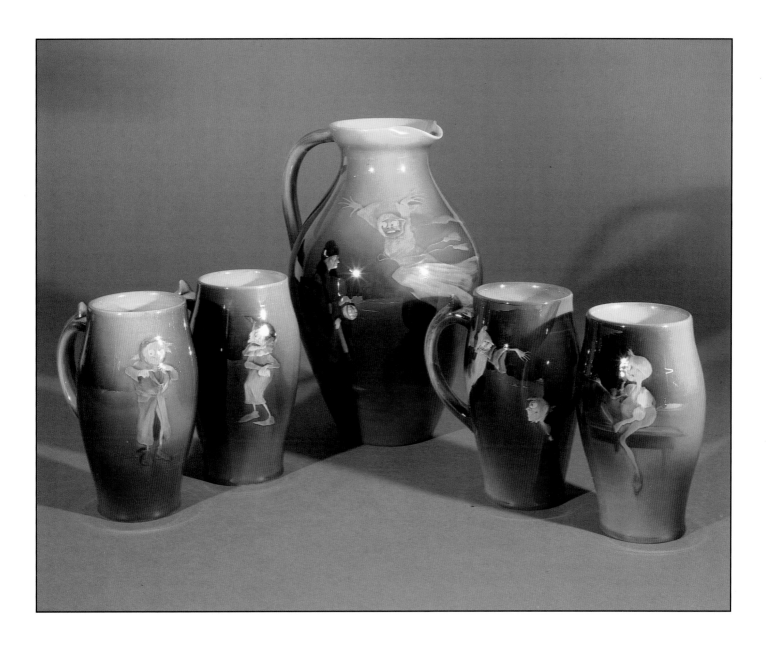

992 Important Standard glaze pitcher and four mugs, decorated in 1889 and 1890 by Harriet Wilcox. The pitcher has $7000-9000
an older person with a lantern being frightened by a ghost while the four mugs each have a "portrait" of a single
ghost or goblin. Marks on the base include the Rookwood logo, the dates 1889 or 1890, shape numbers 423 for
the pitcher and 422 for the mugs, W for white clay, the artist's initials and LY for light yellow (Standard) glaze.
Height for the pitcher is 10½ inches, height for the mugs is 6 inches. One of the mugs has a tight line at the rim
and another mug has a crack in the handle.

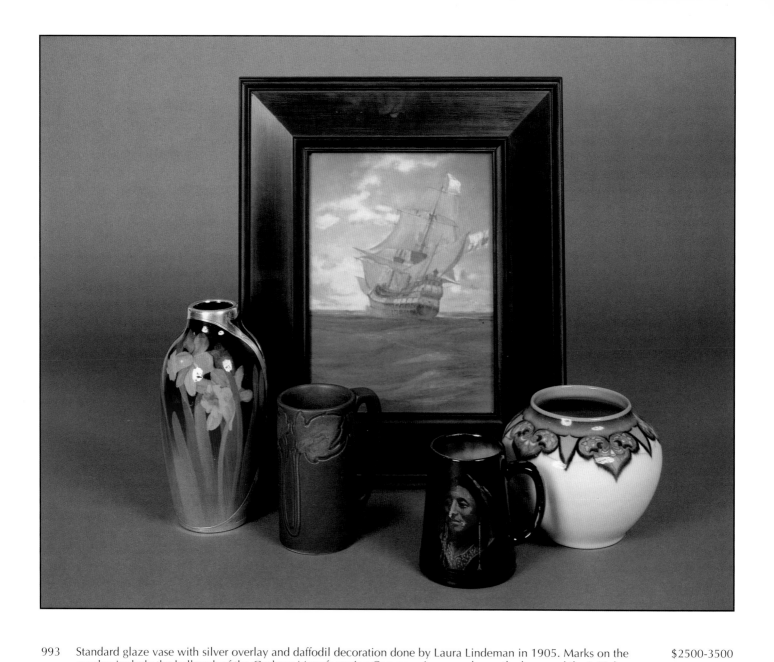

993 Standard glaze vase with silver overlay and daffodil decoration done by Laura Lindeman in 1905. Marks on the overlay include the hallmark of the Gorham Manufacturing Company impressed near the base and the initials F.L.U. in the same area. Marks on the pottery base include the Rookwood logo, the date, shape number 940 D, and the artist's initials. Height 9 inches. $2500-3500

994 Mat glaze mug decorated with stylized incised leaves by Rose Fechheimer in 1904. Marks on the base include the Rookwood logo, the date, shape number 1071, V for Vellum glaze body and the artist's initials. Height 5¾ inches. $400-600

995 Good Vellum glaze scenic plaque, decorated by Ed Diers in 1926. The artist's initials appear in the lower right hand corner. Marks on the back include the Rookwood logo, the date and an original Rookwood paper label with the title, "Rift in the Clouds F. Rothenbusch". Sometimes even Rookwood made mistakes. Size 11⅞ x 8⅞ inches. This plaque is uncrazed but has a few tiny pits in the glaze. $6000-8000

996 Standard glaze mug with a portrait of a Native American done by M.A. Daly in 1897. Marks on the base include the Rookwood logo, the date, shape number 537 C and the artist's initials. Height 4¼ inches. Cracks in bottom, burst glaze bubbles on the decorated surface and roughness on the rim. $400-600

997 High glaze vase decorated with repeating border of Moorish design, done by Charles McLaughlin in 1919. Marks on the base include the Rookwood logo, the date, shape number 890 C and the artist's initials. Height 5½ inches. $800-1200

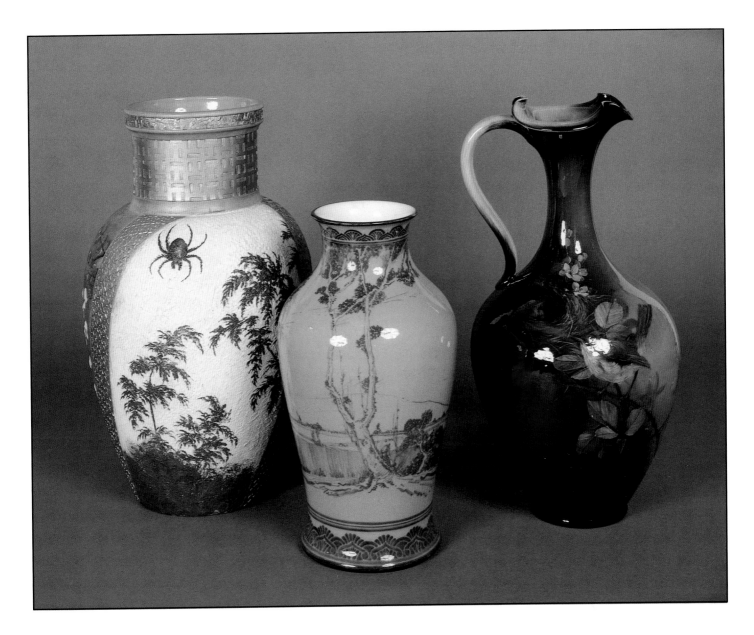

998 Important and large bisque finish vase decorated by three historically significant Rookwood artists. The vase is $2500-3500
divided into three panels, decorated respectively by Albert Valentien (trees and a large garden spider), Clara
Chipman Newton (apple blossoms) and Fanny Auckland (more apple blossoms and probably the intircate
patterning on the collar and between the panels). Marks on the vase itself include the respective artist's initials.
Marks on the base include Rookwood in block letters, the date, a small impressed kiln mark and G for ginger
clay. Height 16⅜ inches. Roughness on the base.

999 High glaze vase decorated with a woodland scene by Arthur Conant in 1917. Marks on the base include the $4000-6000
Rookwood logo, the date, shape number 2301, P for porcelain body and the artist's monogram. Possibly missing
lid. Height 12¾ inches.

1000 Important and large Standard glaze ewer depicting a prominent bird's nest on an apple branch with a parent bird $3000-5000
looking in on its young. Decorated by Albert Valentien in 1892. Marks on the base include the Rookwood logo, the
date, shape number 578 B, W for white clay, the artist's initials and L for light Standard glaze. Height 16⅝ inches.

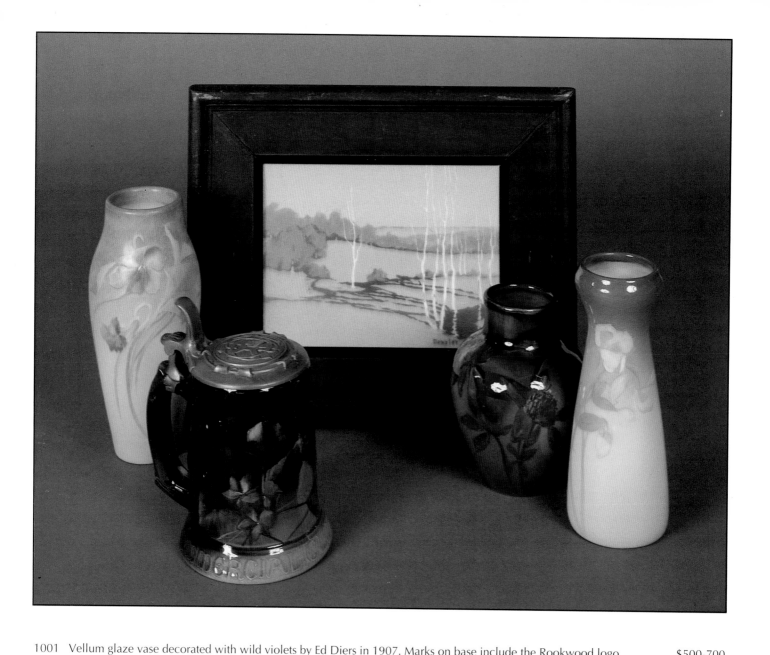

1001 Vellum glaze vase decorated with wild violets by Ed Diers in 1907. Marks on base include the Rookwood logo, the date, the shape number 80 E, V for Vellum glaze body, the artist's initials, V for Vellum glaze and what appears to be the letter C. Height 7⅞ inches. $500-700

1002 Standard glaze mug decorated with violets by Mary Nourse in 1895. Embossed around the top of the piece are the Roman numerals, MDCCCXCIV. Embossed along the bottom is the title, "Commercial Club of Cincinnati". The pewter lid carries the club's logo. Inside the lid is the following inscription: "To J.E. Mooney of the Commercial Club of Cincinnati from W.W. Taylor President 1894". Marks on the base include the Rookwood logo, the date, shape number 783 and the artist's initials. Height 6½ inches. $700-900

1003 Vellum glaze scenic plaque decorated in 1915 by Mary Grace Denzler. The artist's name appears in the lower right hand corner. Marks on the back include the Rookwood logo, the date, the artist's monogram and V for Vellum glaze body. Marks on the paper backing include a Rookwood paper logo and an original Rookwood paper label with the title, "The Robe of Snow M.G. Denzler". Size 6¼ x 8¼ inches. $3000-3500

1004 Standard glaze vase decorated by Grace Hall in 1902 with clover. Marks on the base include the Rookwood logo, the date, shape number 927 F, a small wheel ground X and the artist's initials. Height 5½ inches. $300-400

1005 Iris glaze vase decorated by Caroline Steinle with pink flowers in 1910. Marks on the base include the Rookwood logo, the date, shape number 1656 E, W for white glaze and the artist's initials. Height 7½ inches. $600-800

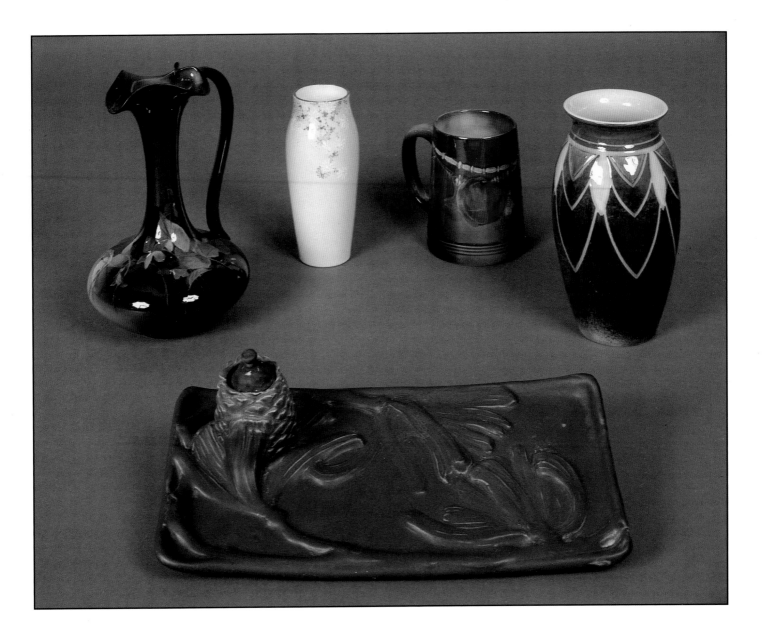

1006 Standard glaze ewer decorated with wild violets by Tom Lunt in 1895. Marks on the base include the Rookwood logo, the date, shape number 611 D, and the artist's first name, TOM. Height 8¼ inches. $400-600

1007 Cameo glaze vase decorated with small white flowers and victorian patterns in 1887, possibly by Kataro Shirayamadani. Marks on the base include the Rookwood logo, the date, shape number 30 C, W 7 for a type of white clay, W for white glaze and an oriental sytle "chop" which Mr. Glover attributes to Shirayamadani. Glover says he was told by Ruben Earl Menzel that he had seen one other piece with this chop and that it was the earliest mark used by Shirayamadani after coming to Rookwood. Height 6 inches. Two inch line from the rim. $300-500

1008 Mat glaze modeled and carved inkwell and attached tray done by John Dee Wareham in 1902. Marks on the base include the Rookwood logo, the date, shape number 403 Z, and the artist full name. Height 2⅝ inches, length 11¼ inches, width 5¾ inches. Well has original ink cup, but the lid appears to be a replacement. $400-600

1009 Standard glaze mug decorated with Native American necklace of beads and medalions, done by Edward Abel in 1892. Marks on the base include the Rookwood logo, the date, shape number 587, W for white clay, the artist's initials and L for light Standard glaze. Height 4½ inches. $800-1200

1010 High glaze vase decorated with a repeating stylized border by Rubin Earl Menzel in 1952. Marks on the base include the Rookwood logo, the date, S for special shape, the artist's initials and the swirl mark that Menzel also used as a monogram. Height 7½ inches. $300-400

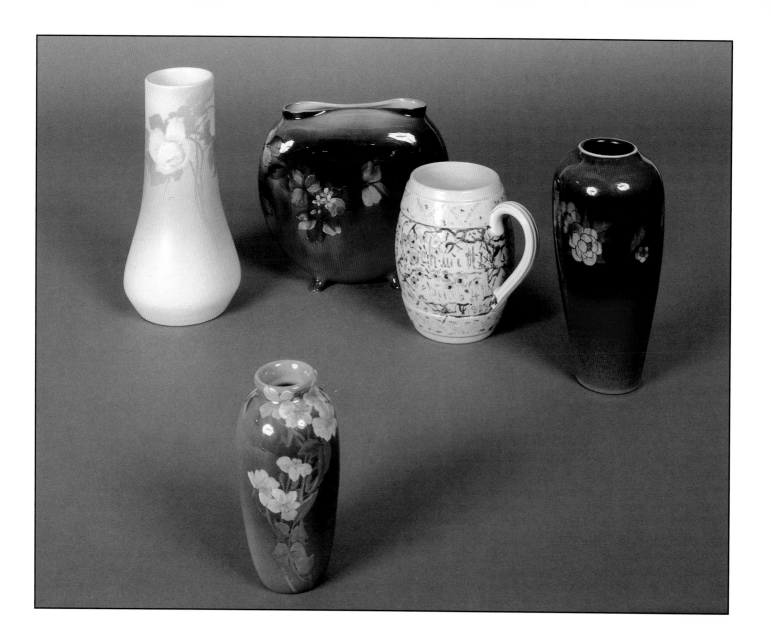

1011 Vellum glaze vase decorated by Ed Diers in 1916 with pink roses. Marks on the base include the Rookwood logo, the date, shape number 1278 E and the artist's initials. Height 9¼ inches. Drilled. $200-300

1012 Standard glaze vase decorated with tea roses in 1905 by an artist whose cypher we cannot read. Marks on the base include the Rookwood logo, the date, shape number 922 E, and the artist initials. Height 5½ inches. $250-350

1013 Standard glaze pillow vase decorated with flowers and leaves by Sallie Toohey in 1891. Marks on the base include the Rookwood logo, the date, shape number 90 A, W for white clay, the artist's initials, and L for light Standard glaze. Height 7¼ inches. $400-600

1014 Early high glaze mug decorated with fruit blossoms by Mary Virginia Keenan in 1883 as a birthday present for G.A. Schmitt. Marks on the base include Rookwood in block letters, the date, and an S for sage green clay. Marks on the side include G.A. Schmitt, March 4, 1883 and the initials of the artist, MVK. Height 5¾ inches. $300-400

1015 Black Opal glaze vase with an encircling band of white flowers and leaves decorated by Harriet Wilcox in 1927. Marks on the base include the Rookwood logo, the date, shape number 2033 E and the artist's initials. Height 8¼ inches. $600-800

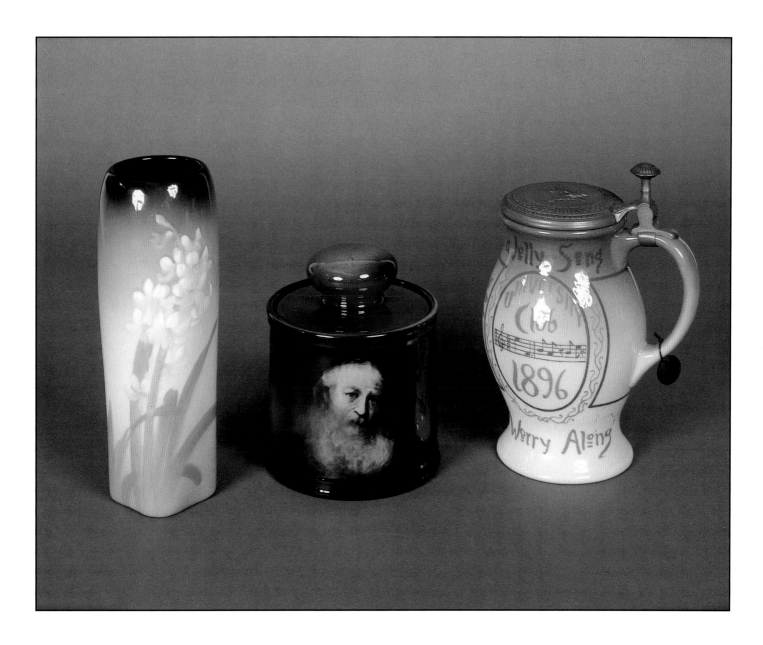

1016 Iris glaze vase decorated with long stemmed white flowers by Lenore Asbury in 1906. Marks on the base include the Rookwood logo, the date, shape number 821 C, the artist's initials and W for white glaze. Height 9⅞ inches. $2500-3500

1017 Standard glaze humidor with portrait of an old man, done by Sallie Toohey in 1895. Marks on the base include the Rookwood logo, the date, shape number 801, and the artist's initials. Height 7 inches. $2000-3000

1018 Rare and important Iris glaze 1½ liter stein designed by Edwin Atlee Barber and decorated by William McDonald in 1896. The stein carries the Rookwood logo on its surface, flanked by an oval enclosing a display of hops on one side and an oval with "University Club 1896" and a musical scale with notes on the other. A two line rhyme, "A Pot of Beer With a Jolly Song", "Helps a King to Worry Along" wraps respectively around the top and bottom of the piece. The pewter lid is decorated with chrysanthemums and carries the marks "1½ L" near the hinge. Marks on the bottom include the Rookwood logo, the date, shape number S1266, W for white glaze and the artist's initials. The Rookwood logo and the artist's initials are encircled with a line and the imprint: "Designed by Edwin A. Barber". A brass tag attached to the handle is marked: "E.A. Barber 5". Height 9½ inches. Edwin A. Barber of the Pennsylvania Museum and School of Industrial Art in Philadelphia was considered the foremost authority on pottery in America in the late 19th century. William Watts Taylor gave many early examples of Rookwood to Barber for the Museum's collection and maintained a close relationship with him for many years. Many of the pieces in the Museum collection were sold in the 1940's and 1950's and this stein may well have been part of that group or in Barber's personal collection. $3000-5000

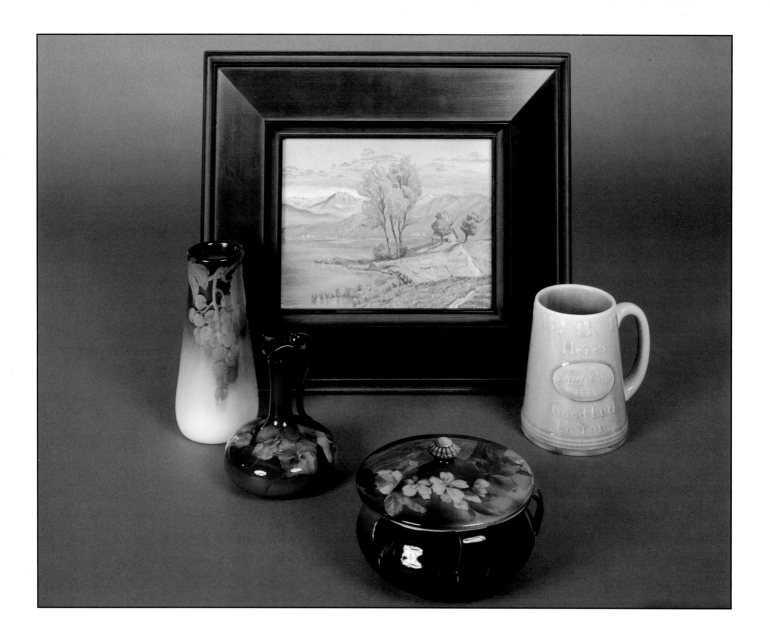

1019　Iris glaze vase decorated with grapes by Irene Bishop in 1906. Marks on the base include the Rookwood logo, the date, shape number 950 E, a wheel ground X, the artist's initials and W for white glaze. Height 6¼ inches. Glaze bubbles.　$700-900

1020　Standard glaze ewer decorated with pansies by E.T. Hurley in 1899. Marks on the base include the Rookwood logo, the date, shape number 852 E, and the artist's initials. Height 4⅞ inches.　$300-500

1021　Vellum glaze scenic plaque decorated by Flora King in 1946. The artist's initials appear in the lower left hand corner. Marks on the back include the Rookwood logo and the date. Size 8 x 10 inches. Uncrazed.　$2500-3500

1022　Standard glaze lidded candy box with five ribbon handles, decorated with wild roses by Sallie Toohey in 1890. Marks on the base include the Rookwood logo, the date, shape number 232, the artist's initials and L for light Standard glaze. Height 4 inches. Tight line in bowl.　$200-400

1023　High glaze advertising mug, made for Falls City Brewing Company in Louisville by Rookwood in 1948. Marks on the base include the Rookwood logo and the date. Height 5 inches.　$200-300

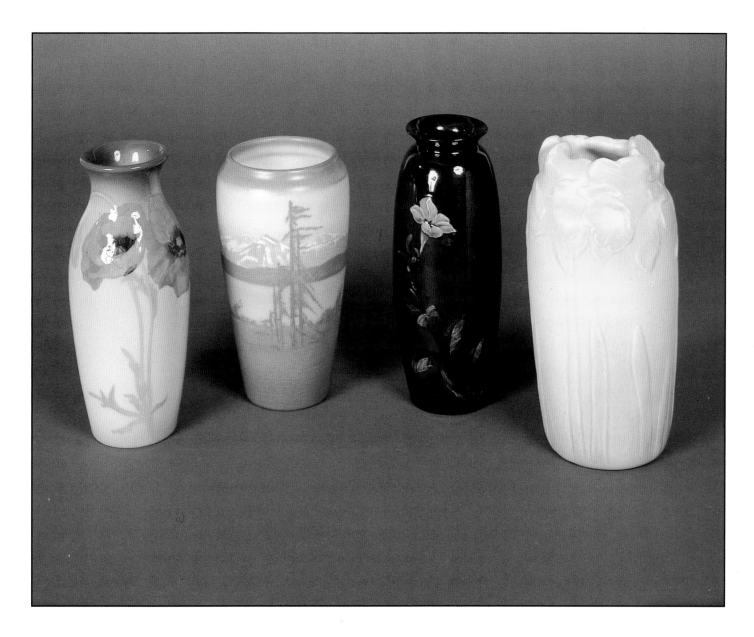

1024 Iris glaze vase with bright red poppies, decorated by Rose Fechheimer in 1903. Marks on the base include the Rookwood logo, the date, shape number 117 C, the artist's initials and W for white glaze. Height 8 inches. $1200-1800

1025 Vellum glaze vase decorated with an arts and crafts style scene of pine trees, mountains and a lake by Sallie Coyne in 1912. Marks on the base include the Rookwood logo, the date, shape number 1369 E, V for Vellum glaze body, the artist's initials and V for Vellum glaze. Height 7⅜ inches. $1000-1500

1026 Standard glaze vase painted with heavy slip decorated flowers and leaves by M.A. Daly in 1886. Nearly the entire surface of the vase has evidence of goldstone in the glaze. Marks on the base include Rookwood in block letters, the date, shape number 271, R for red clay, and the artist's initials. Height 8¼ inches. $2000-3000

1027 Mat glaze vase with high relief jonquils, decorated by Harriet Wilcox in 1903. Marks on the base include the Rookwood logo, the date, shape number 386 Z and the artist's initials. Height 9¼ inches. $800-1200

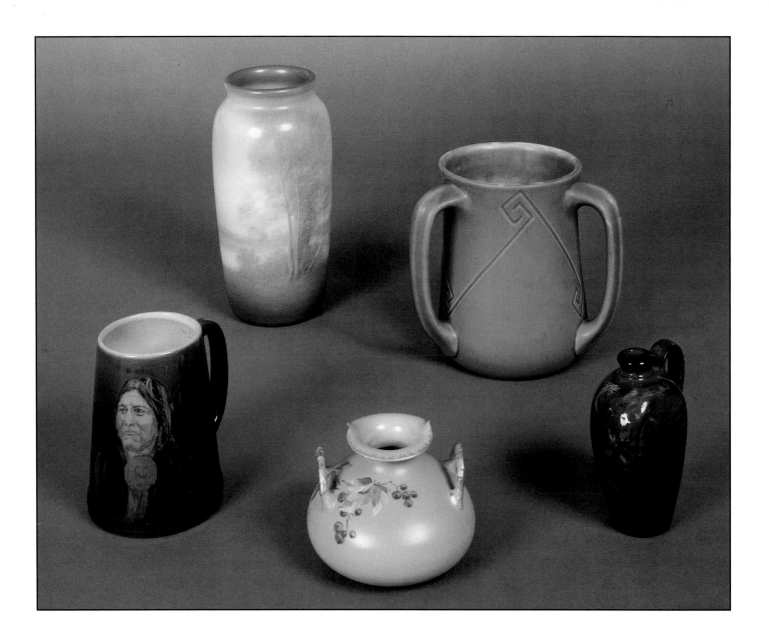

1028 High glaze mug decorated with a Native American portrait by Flora King in 1946. Marks on the base include the Rookwood logo, the date, shape number 587 C, the inscription, "Mow Way", the number "227A" and the artist's initials. Height 5 inches. $600-800

1029 Vellum glaze vase decorated with a woodland scene by Ed Diers in 1920. Marks on the base include the Rookwood logo, the date, shape number 1065 C, V for Vellum glaze body and the artist's initials. Height 8⅞ inches. $1200-1500

1030 Bisque finish vase with small loop handles decorated with leaves and berries by Amelia Sprague in 1888. Marks on the base include the Rookwood logo, the date, shape number 461, W for white clay and the artist's initials. Height 3⅝ inches. $400-600

1031 Mat glaze three handled loving cup with incised geometric design in the arts and crafts manner, made in 1902. Marks on the base include the Rookwood logo, the date and the shape number 258 Z. Height 6⅞ inches. $250-350

1032 Limoges style glaze perfume jug with handle, decorated with oriental grasses and a single butterfly by Hattie Horton in 1882. Marks on the base include Rookwood in block letters, the date, shape number 60, R for red clay, a small kiln mark and the artist's initials. Height 4¼ inches. Slight abrasion at rim. $300-400

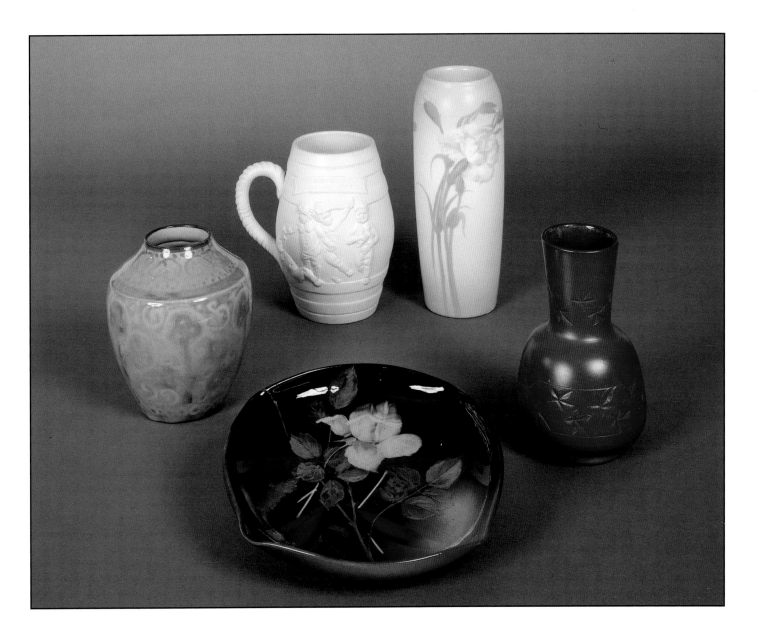

1033 High glaze vase decorated with repeating patterns by William Hentschel in 1920. Marks on the base include the Rookwood logo, the date, shape number 1091 D and the artist's initials. Height 6½ inches. $300-500

1034 Early salt glaze advertising mug made for Cincinnati Cooperage Company circa 1882. Marks on the piece include the name, Cincinnati Cooperage Company on the surface of the mug and the Rookwood ribbon mark on the base. Height 7½ inches. $500-700

1035 Standard glaze ashtray decorated with cigars, matches, and a yellow rose by Ed Diers in 1898. Marks on the base include the Rookwood logo, the date, shape number 205 B, and the artist's initials. Diameter 9⅛ inches. $400-600

1036 Vellum glaze vase done by Ed Diers in 1906 with carnations. Marks on the base include the Rookwood logo, the date, shape number 951 C, V for Vellum glaze body, a small wheel ground X, the artist's initials and V for Vellum glaze. Height 10⅜ inches. Glaze skip on base. $600-800

1037 Bisque finish vase with incised leaves by Nettie Wilson, done in 1881. Marks on the base include Rookwood Pottery incised, and the artist's initials. Height 7½ inches. $300-500

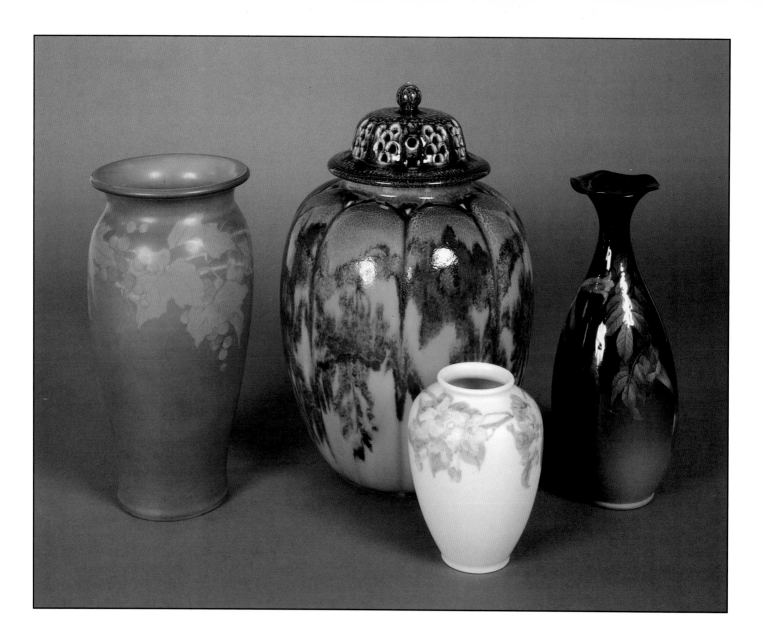

1038 Tall Vellum glaze vase decorated with grape leaves, vines and fruit by Lenore Asbury in 1926. Marks on the base include the Rookwood logo, the date, shape number 2786 and V for Vellum glaze. The artist's initials are partially obscured by a neatly drilled hole. Height 11⅞ inches. $800-1000

1039 High glaze lidded potpourri jar decorated with exotic foliage by E.T. Hurley in 1927. This piece includes the inner lid as well as the pierced outer lid. Marks on the base include the Rookwood logo, the date, shape number 2582 and the artist's initials. Height 14⅜ inches. $3000-5000

1040 Mat glaze vase decorated with pink blossoms in 1940 by Margaret McDonald. Marks on the base include the Rookwood logo, the date, shape number 6771 and the artist's initials. Height 6 inches. $400-600

1041 Standard glaze vase with fluted rim, decorated by Josephine Zettel in 1899 with trumpet creeper flowers and vines. Marks on the base include the Rookwood logo, the date, shape number 496 B and the artist's initials. Height 11½ inches. $700-900

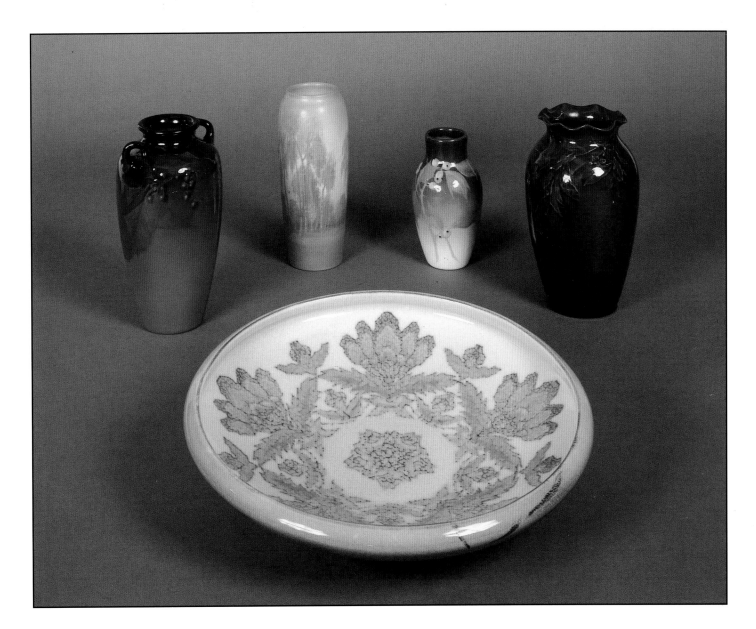

1042 Standard glaze vase with small loop handles decorated with holly by E.T. Hurley in 1900. Marks on the base include the Rookwood logo, the date, shape number 614 E and the artist's initials. Height 8¼ inches. $400-600

1043 Vellum glaze vase with woodland decoration by Ed Diers, done in 1920. Marks on the base include the Rookwood logo, the date, shape number 951 E, V for Vellum glaze body and the artist's initials. Height 7¾ inches. $700-900

1044 High glaze low bowl decorated with flowering artichokes by Sara Sax in 1929. Marks on the base include the Rookwood logo, the date, shape number 2574 C and the artist's monogram. Height 3 inches, diameter 12¾ inches. $800-1000

1045 Iris glaze vase with holly decoration by Irene Bishop, done in 1903. Marks on the base include the Rookwood logo, the date, shape number 926 E, the artist's initials, and W for white glaze. Height 5¼ inches. $400-600

1046 Standard glaze vase with fluted rim decorated by Kataro Shirayamadani in 1889. The decoration of leaves and berries is covered with sparkling passages of Tiger Eye, but is still quite visible. Marks on the base include the Rookwood logo, the date, shape number 464, R for red clay, the artist's cypher and D for dark Standard glaze. Height 7⅞ inches. Rim repair. $500-700

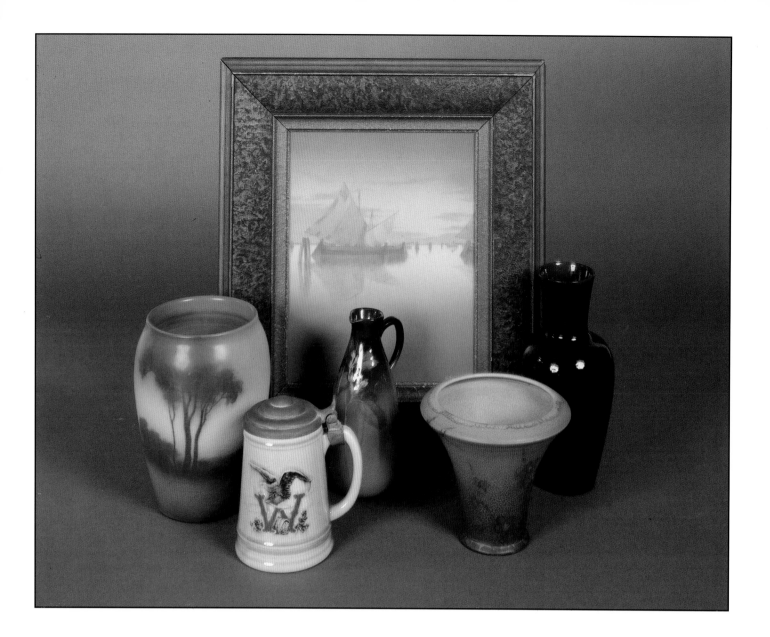

1047 Vellum glaze vase decorated with a nocturnal woodland scene by Lenore Asbury in 1916. Marks on the base include the Rookwood logo, the date, shape number 942 C, V for Vellum glaze body and the artist's initials. Height 7⅜ inches. Few glaze bubbles. — $900-1100

1048 High glaze mug with pewter lid and embossed company logo on side in color. Made in 1948 for the George Wiedemann Brewing Company of Newport, Kentucky. Marks on base include the Rookwood logo, "THE GEO. WEIDEMANN BREWING CO. INC." and the date. Height, 5½ inches. — $250-350

1049 Standard glaze cruet with trumpet honeysuckle decoration, done by Edith Felten in 1900. Marks on the base include the Rookwood logo, the date, shape number 818 and the artist's initials. Height 7 inches. Some roughness at rim. — $200-250

1050 Vellum glaze scenic plaque painted by Carl Schmidt in 1918. The artist's name appears in the lower right hand corner. Marks on the back include the Rookwood logo and the date. On the frame are an original paper Rookwood logo and an original paper label with the title, "Venetian Boats C. Schmidt". Size 10⅞ x 8⅝ inches. — $5000-7000

1051 Mat glaze flared vase with floral decoration, done by Vera Tischler in 1922. Marks on the base include the Rookwood logo, the date, shape number 2268 E and the artist's initials. Height 5¼ inches. — $300-400

1052 Standard glaze vase with some goldstone evident. Marks on the base include Rookwood in block letters, the date, shape number S 513, R for red clay and the numbers 323:00 in red paint which are probably Cincinnati Art Museum accession numbers. Height 8⅝ inches. — $150-250

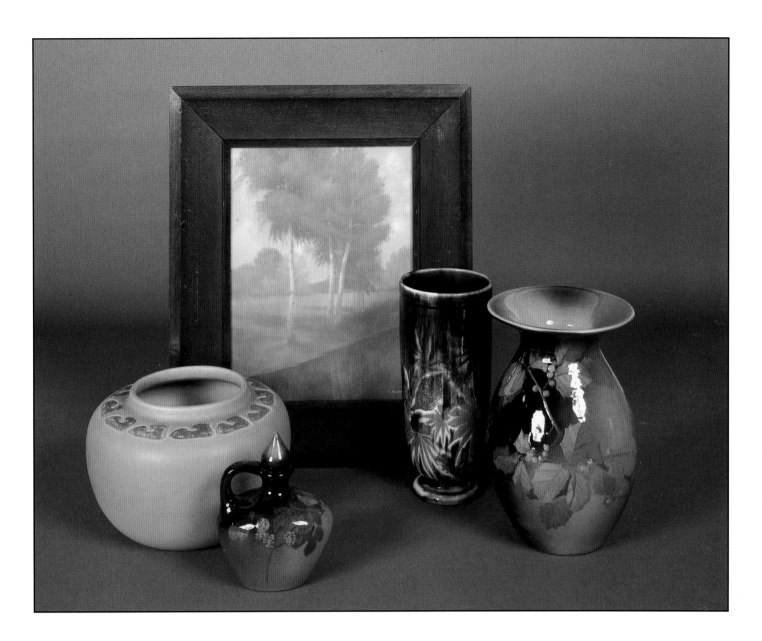

1053 Large mat glaze bowl decorated with painted and incised designs on the shoulder by William Hentschel in 1913. $400-600
Marks on the base include the Rookwood logo, the date, shape number 131, and the artist's initials. Height 5⅞ inches.

1054 Standard glaze stoppered jug decorated with hops by Caroline Steinle in 1896. Marks on the base include the $350-450
Rookwood logo, the date, shape number 706 and the artist's initials. Height 5⅞ inches.

1055 Vellum glaze scenic plaque decorated by Carl Schmidt in 1915. The artist's name appears in the lower right hand $4000-6000
corner. Marks on the back include the Rookwood logo, the date, V for Vellum glaze body and the title in pencil,
"Birches along the Creek". Size 12½ x 9⅜ inches.

1056 High glaze vase decorated with exotic red and green flowers on a black ground by E.T. Hurley in 1944. Marks on $400-600
the base include the Rookwood logo, the date, shape number 2194 and the artist's initials. Height 9½ inches.

1057 Standard glaze vase decorated by Albert Valentien with holly berries, leaves and stems in 1892. Marks on the $800-1000
base include the Rookwood logo, the date, shape number 665, W for white clay, the artist's initials and L for light
Standard glaze. Height 9¾ inches.

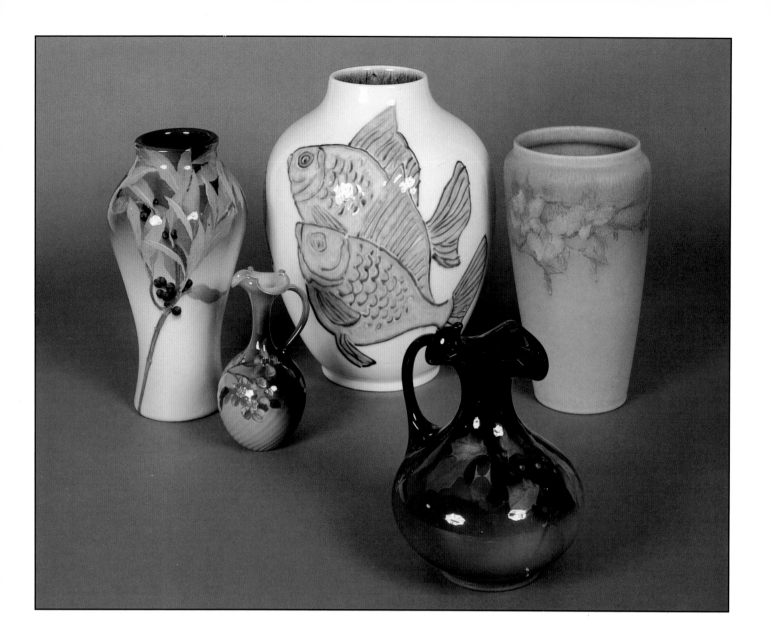

1058 Iris glaze vase decorated with wild grapes by John Dee Wareham in 1902. Marks on the base include the Rookwood logo, the date, shape number 909 B, a small wheel ground X and the artist's initials. Height 11½ inches. A small ¼ inch underglaze skip is apparent. $1400-1800

1059 Standard glaze swirled ewer decorated with wild roses by John Dee Wareham in 1894. Marks on base include the Rookwood logo, the date, shape number 617 F, W for white clay, and the artist's initials. Height 6 inches. $400-600

1060 Large and unusual high glaze vase, decorated with five imposing fish by Elizabeth Barrett in 1944. Marks on the base include the Rookwood logo, the date, shape number 6080 and the artist's monogram. Height 13⅛ inches. $3000-4000

1061 Standard glaze ewer decorated with holly leaves and berries by Olga Geneva Reed in 1897. Marks on the base include the Rookwood logo, the date, shape number 718, a small diamond shaped esoteric mark, and the artist's initials. Height 7¾ inches. $500-700

1062 Mat glaze vase with wild rose decoration, done by Herman Moos in 1924. Marks on the base include the Rookwood logo, the date, shape number 1369 C and the artist's initials. Height 11 inches. $500-700

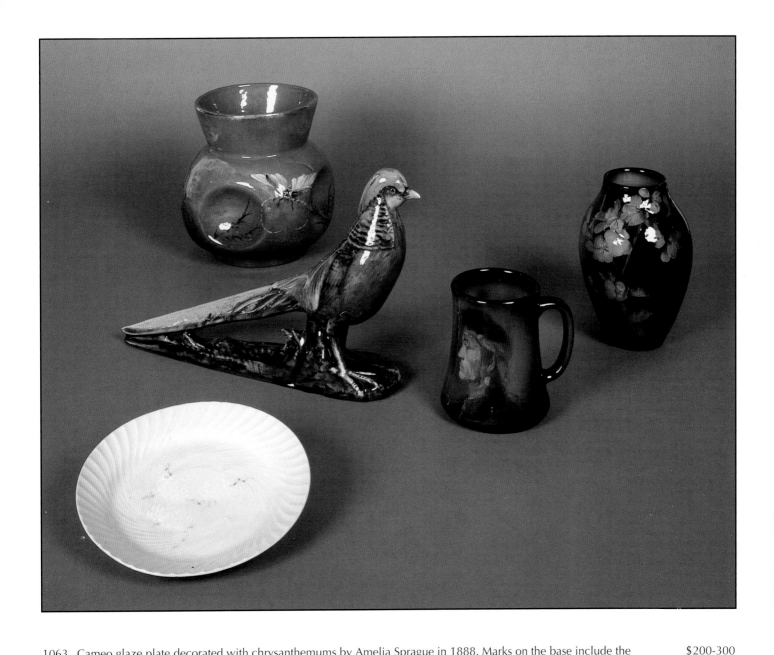

1063 Cameo glaze plate decorated with chrysanthemums by Amelia Sprague in 1888. Marks on the base include the Rookwood logo, the date, shape number 386 B, W for white clay, the artist's initials, and W for white glaze. Diameter 8 inches. — $200-300

1064 Large polychromed pheasant in high glaze made in 1948. Marks on the base include the Rookwood logo, the date and shape number 2832. Height 8⅝ inches. — $400-600

1065 Limoges style glaze vase decorated with bamboo and a large pincered flying beetle by M.A. Daly in 1885. Marks on the base include Rookwood in block letters, the date, shape number 197 B, R for red clay, and the artist's initials. Height 7½ inches. — $1000-1200

1066 Good Standard glaze portrait mug decorated by Elizabeth Brain in 1899 with the profile of a Native American. Marks on the base include the Rookwood logo, the date, shape number 853, the title, "The Man Assinniboine", and the artist's initials. Height 5 inches. Some minor glaze abrasions. — $1000-1500

1067 Standard glaze vase decorated with wild roses by Adeliza D. Sehon in 1899. Marks on the base include the Rookwood logo, the date, shape number 604 D, and the artist's initials. Height 7 inches. — $400-600

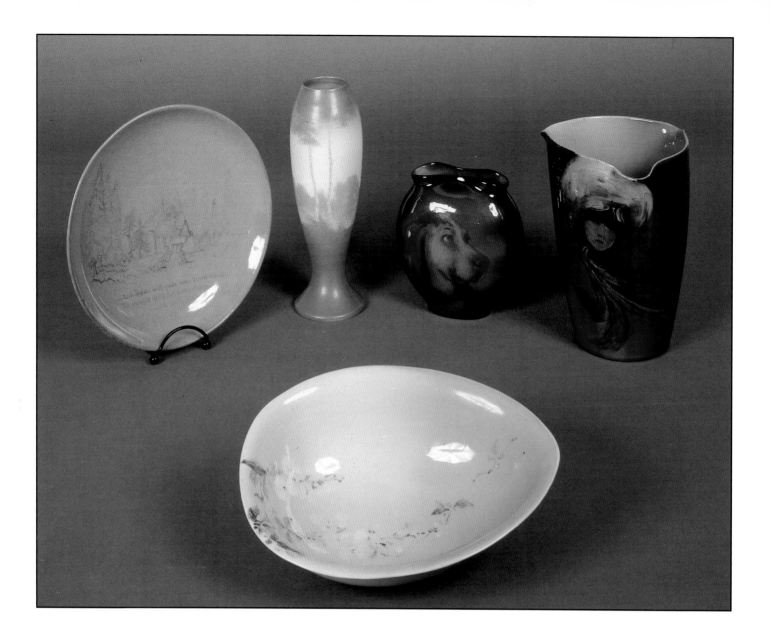

1068 Early high glaze story plate by E.P. Cranch, done in 1885. The plate shows a man digging in a wooded cemetery. $400-600
Below that scene is found the following verse: "And Isaac with care was borne away To mingle with his native
clay -gle with his native clay". Marks on the reverse include Rookwood in block letters, the date, shape number
45 C, O possibly for orange clay, the artist's initials and the following note: "American Ballads. Isaac Abbott".
Diameter 9⅛ inches.

1069 Vellum glaze vase with woodland scene done by E.T. Hurley in 1917. Marks on the base include the Rookwood $700-900
logo, the date, shape number 949 D, V for Vellum glaze body and the artist's initials. Height 9½ inches.

1070 Cameo glaze vegetable bowl decorated with wild roses by Artus Van Briggle in 1887. Marks on base include the $400-600
Rookwood logo, the date, the shape number 316 F, 7 W for white clay, the artist's initials, and W for white glaze.
Height 2¼ inches.

1071 Standard glaze pillow vase decorated with a golden retreiver by E.T. Hurley in 1899. Marks on the base include $700-900
the Rookwood logo, the date, shape number 707 B, a wheel ground X and the artist's initials. Height 5¾ inches.

1072 Standard glaze tri-cornered pitcher decorated with head of a young woman wearing a large yellow hat, done by $2000-3000
Artus Van Briggle in 1889. Marks on base include the Rookwood logo, the date, shape number 259, S for sage
green clay, the artist's initials, and L for light Standard glaze. Height 8 inches.

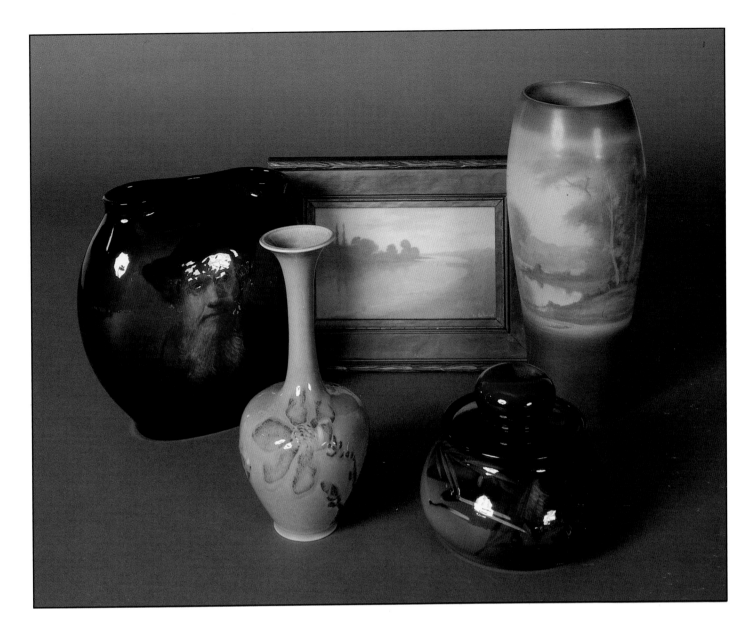

1073 Standard glaze pillow vase decorated with the portrait after Rembrandt of a Flemish gentleman by Sturgis Laurence in 1899. Marks on the base include the Rookwood logo, the date, shape number 707 AA, a wheel ground X, the artist's initials, and the title, "After Rembrandt". Height 9⅛ inches. Small line descends from rim. $700-900

1074 High glaze vase with magnolia flowers and stems, decorated by Loretta Holtkamp in 1946. Marks on the base include the Rookwood logo, the date, shape number 778 and the artist's initials. Height 9¼ inches. $500-700

1075 Vellum glaze scenic plaque decorated by Carl Schmidt in 1915. The artist's name appears in the lower right hand corner. Marks on the back include the Rookwood logo, the date and V for Vellum glaze body. On the frame are an original paper Rookwood logo and an original label with the title, "A Quiet Stream". Size 5¼ x 8¼ inches. $2000-2500

1076 Standard glaze humidor decorated with cigars, pipes, matches and palm fronds by Lenore Asbury in 1898. Marks on base include the Rookwood logo, the date, shape number 805 and the artist's initials. Height 5 inches. $700-900

1077 Large Vellum glaze banded scenic vase with trees, hills and a lake, done by Fred Rothenbusch in 1920. Marks on the base include the Rookwood logo, the date, shape number 2032 C, V for Vellum glaze body and the artist's initials. Height 12⅛ inches. $2000-2500

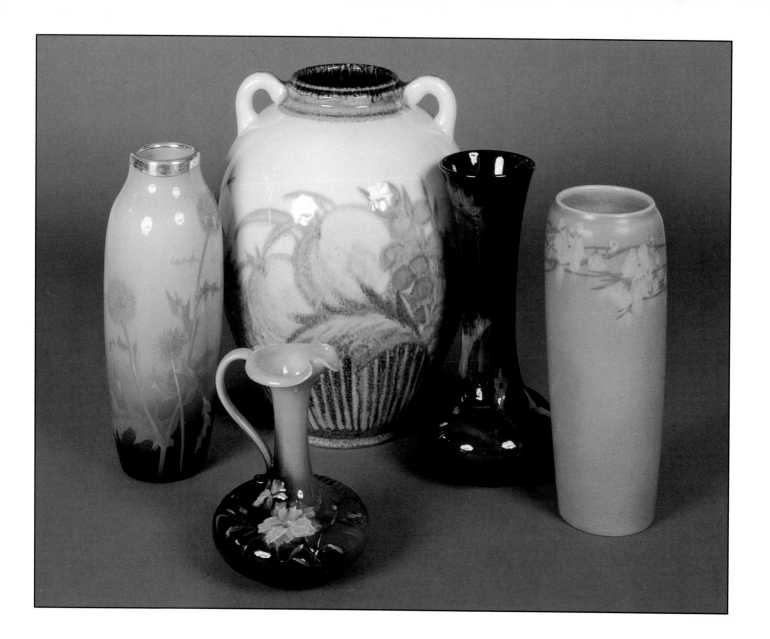

1078 Iris glaze vase decorated with globe thistles by Albert R. Valentien in 1903. An engraved silver collar surrounds $5000-7000
the vase's rim. Marks on the base include the Rookwood logo, the date, the shape number 932 C and the artist's
full signature. Height 11⅛ inches. Uncrazed.

1079 Standard glaze ewer decorated by an unknown artist with leaves and flowers in 1891. Marks on the base include $300-500
the Rookwood logo, the date, shape number 433 C, and W for white clay. Height 6¾ inches.

1080 Large and exotic high glaze vase with small ring handles, decorated with grapes, pineapples and pomegranates $3000-4000
by Lorinda Epply in 1928. Possibly owned or worn by Carmen Miranda. Marks on the base include the
Rookwood logo, the date, shape number 2640 C and the artist's initials. Height 13¼ inches.

1081 Standard glaze vase painted by Anna Valentien with milkweed pods and seeds in 1897. Marks on the base $600-800
include the Rookwood logo, the date, shape number 556 C, a small diamond shaped esoteric mark and the
artist's initials. Height 11 inches.

1082 Vellum glaze vase with floral decoration by Sallie Coyne, done in 1916. Marks on the base include the $500-700
Rookwood logo, the date, shape number 951 C, V for Vellum glaze body and the artist's initials. Height 10⅝
inches.

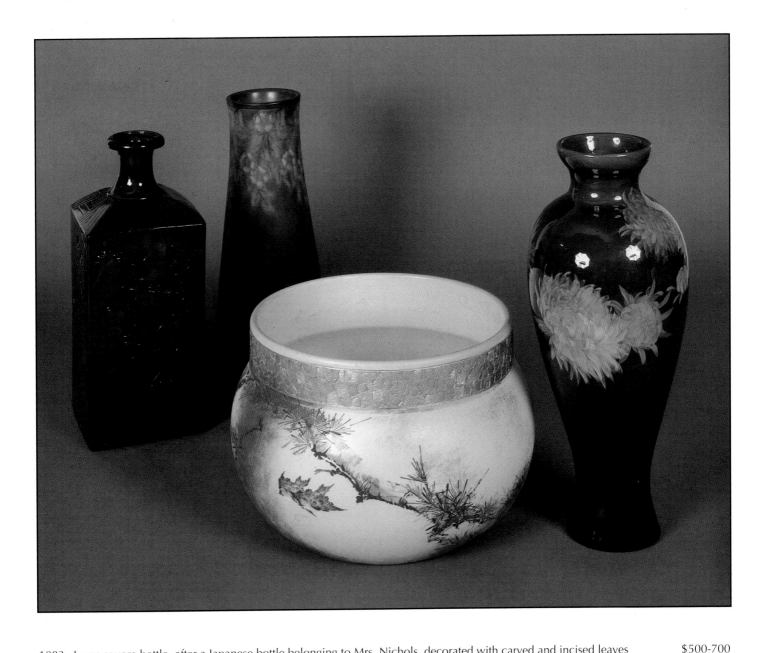

1083 Large square bottle, after a Japanese bottle belonging to Mrs. Nichols, decorated with carved and incised leaves and flowers in a dark high glaze by an unknown artist in 1884. Marks on the base include Rookwood in block letters, the date, R for red clay and the shape number 192. Height 12½ inches. $500-700

1084 Large Vellum glaze vase decorated with sprays of hanging flowers by Sara Sax in 1915. Marks on the base include the Rookwood logo, the date, shape number 950 B, V for Vellum glaze body, a wheel ground X, the artist's monogram and V for Vellum glaze. Height 12¾ inches. $400-600

1085 Large bisque finish jardiniere decorated with oriental pine boughs and two sparrows in flight by M.A. Daly in 1883. The rim of the piece has a repeating border of die impressed lined blocks, covered with fired on gold. Marks on the base include Rookwood in block letters, the date, shape number 253, Y for yellow clay and the artist's initials. Height 7¾ inches, diameter 12 inches. $1400-1800

1086 Large Sea Green vase decorated with chrysanthemums by Albert Valentien in 1895. The piece carries the artist's full signature on the side near the base. Marks on the base include the Rookwood logo, the date, shape number 792 B and G for Sea Green glaze. Several cracks in the lower half of the vase have been repaired. Height 14½ inches. $1200-1500

1087 Monumental Standard glaze vase with two large loop handles, decorated in an oriental manner with several $30000-50000
 cranes flying through high clouds. This most important work was created by Albert Valentien in 1893. Marks on
 the base include the Rookwood logo, the date, shape number 581 A, R for red clay, the artist's initials and D for
 dark Standard glaze. Height 19⅝ inches.

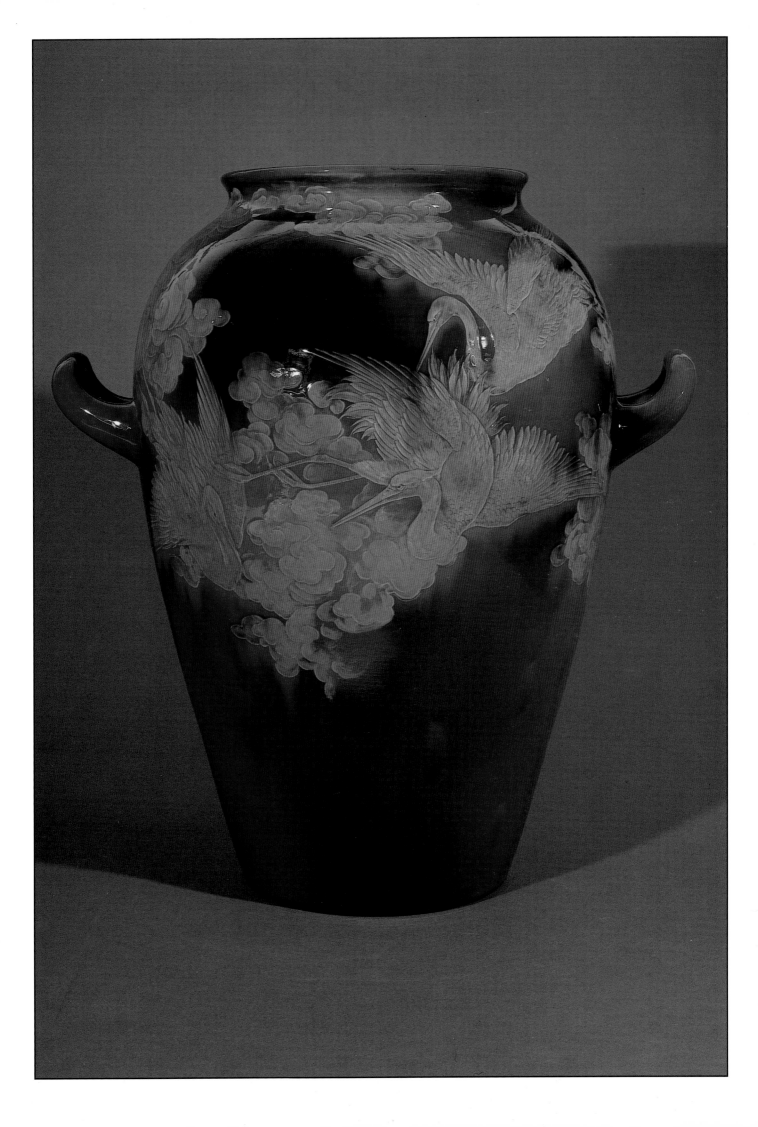

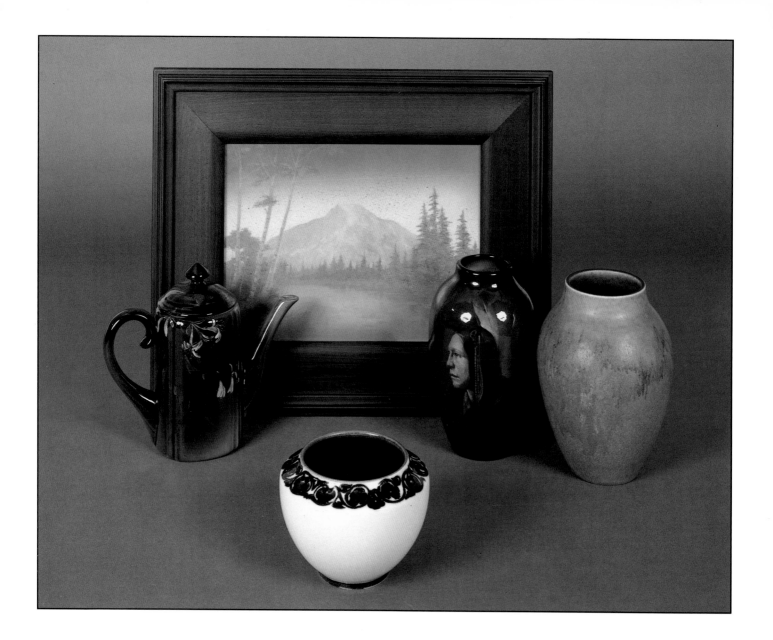

1088 Standard glaze coffee pot with honeysuckle decoration done in 1893 by an unknown artist. Marks on the base include the Rookwood logo, the date, shape number 552, and W for white clay. Height 7½ inches. Line at rim. $250-400

1089 High glaze bowl decorated with repeating border near the top by Lorinda Epply in 1922. Marks on the base include the Rookwood logo, the date, shape number 1927, and the artist's initials. Height 4 inches. $200-300

1090 Vellum glaze scenic plaque decorated by E.T. Hurley in 1942. The artist's initials appear in the lower left hand corner. Marks on the back include the Rookwood logo, the date and the numbers, 9 x 12. Size 8⅜ x 11⅝ inches. $2500-3500

1091 Good Standard glaze portrait of a Native American, decorated by Grace Young in 1901. Marks on the base include the Rookwood logo, the date, shape number 900 C, the title, "Stars Come Out Sioux", a small wheel ground X and the artist's initials. Height 7¾ inches $2500-3500

1092 Mat glaze vase with abstract floral design in subtle colors, decorated by Margaret Helen McDonald in 1929. Marks on the base include the Rookwood logo, the date, shape number 604 D, and the artist's initials. Height 7⅜ inches. $300-500

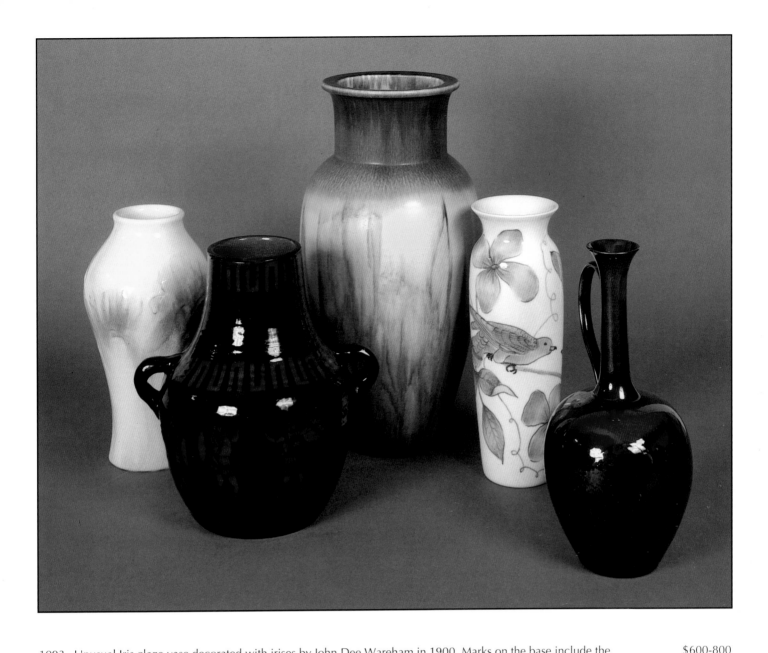

1093 Unusual Iris glaze vase decorated with irises by John Dee Wareham in 1900. Marks on the base include the Rookwood logo, the date, shape number 909 B, a wheel ground X, the artist's partly obscured initials, and W for white clay. Height 11½ inches. Crudely drilled. $600-800

1094 Very unusual high glaze vase with two loop handles decorated in 1884 by an unknown artist. The vase depicts a group of Greek warriors and has Greek key borders at top and shoulder. Marks on the base include Rookwood in block letters, the date, shape number 57 S, and G for ginger clay. Height 11½ inches. $700-900

1095 Large mat glaze vase decorated with iris flowers and leaves by Sallie Coyne in 1927. Marks on the base include the Rookwood logo, the date, shape number 324, the number X 896 and the artist's initials. Height 17⅛ inches. Several unobstrusive grinding chips on the base. $500-700

1096 High glaze vase decorated with doves and flowering vines by Kay Ley in 1945. Marks on the base include the Rookwood logo, the date, shape number 6919, the artist's initials and the number 4260. Height 12 inches. $600-800

1097 Standard glaze ewer with a single turtle swimming through large passages of goldstone effect. Decorated by M.A. Daly in 1886, the marks on the base include Rookwood in block letters, the date, shape number 26 and the artist's initials. Height 12¼ inches. $700-900

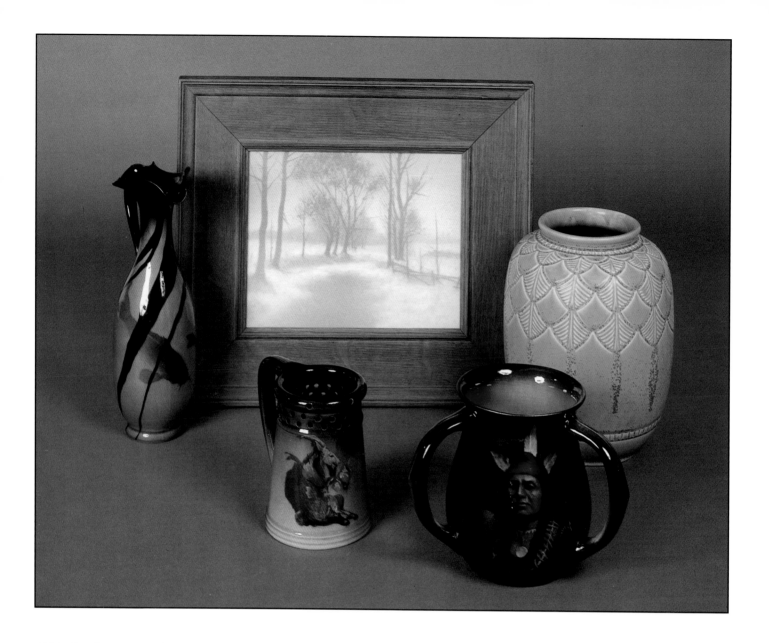

1098 Good Sea Green glaze ewer decorated with three fish swimming under black oriental style ribbons spiraling downward from the rim. This stunning piece was done in 1900 by Fred Rothenbusch. Marks on the base include the Rookwood logo, the date, shape number 608, the artist's initials and G for Sea Green glaze. Height 10¼ inches. $4000-6000

1099 Standard glaze puzzle mug decorated in 1894 by Bruce Horsfall, showing a seated goat eating a tin can. Marks on the base include the Rookwood logo, the date, shape number 711, W for white clay and the artist's monogram. Height 5 inches. $1250-1750

1100 Vellum glaze scenic plaque decorated by E.T. Hurley in 1915. The artist's initials appear in the lower right hand corner. Marks on the back include the Rookwood logo, the date, V for Vellum glaze body and the title, "Gray Reflections" on an original Rookwood paper label. Size 7⅛ x 9⅜ inches. $2500-3500

1101 Standard glaze three-handled mug decorated with a Native American portrait by Hariet Wilcox in 1896. Marks on the base include the Rookwood logo, the date, shape number 729 and the artist's initials. Heigth 5¾ inches. $2500-3500

1102 Mat and crystaline glaze vase decorated with repeating incised stylized acanthus leaves by Rubin Earl Menzel in 1937. Marks on the base include the Rookwood logo, the date, shape number 6197 C and the artist's initials. Height 8⅝ inches. $400-600

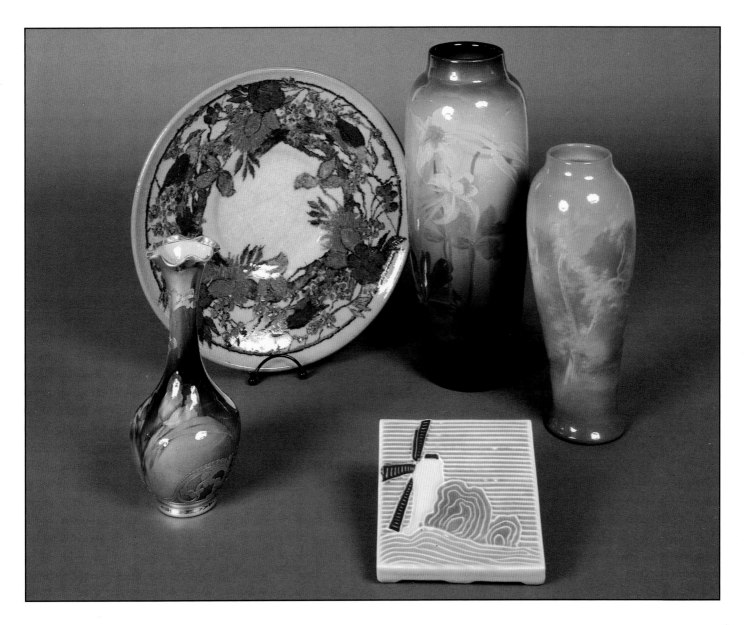

1103 Standard glaze vase with silver overlay decorated with tulips by Amelia Sprague in 1892. Marks include R 241 and Gorham Mfg. Co. on the silver at the base, and on the pottery base, the Rookwood logo, the date, shape number 557, W for white clay, the artist's initials, and L for light standard glaze. Height 9½ inches. $2500-3500

1104 High glaze charger decorated with exotic foliage and birds in a repeating band by E.T. Hurley in 1922. Marks on the base include the Rookwood logo, the date, shape number 2570 C and the artist's initials. Diameter 13 inches. $800-1200

1105 Rookwood trivet decorated with a Dutch scene. Marks on reverse include the Rookwood logo, the date, a wheel ground X, and shape number 1201. Size 6¾ x 6¾ inches. Crack at edge. $50-100

1106 Standard glazed vase decorated with columbine by John Dee Wareham in 1902. Marks on the base include the Rookwood logo, the date, shape number 907 C, a wheel ground X and the artist's initials. Height 14¼ inches. Small glaze bubbles. $1500-2000

1107 Rare and impressive high glaze vase, decorated by Fred Rothenbusch in 1922 with a restful woodland scene. Marks on the base include the Rookwood logo, the date, shape number 1667 and the artist's initials. Height 10¼ inches. Extremely clean example of a rare combination of glaze and style. $3000-5000

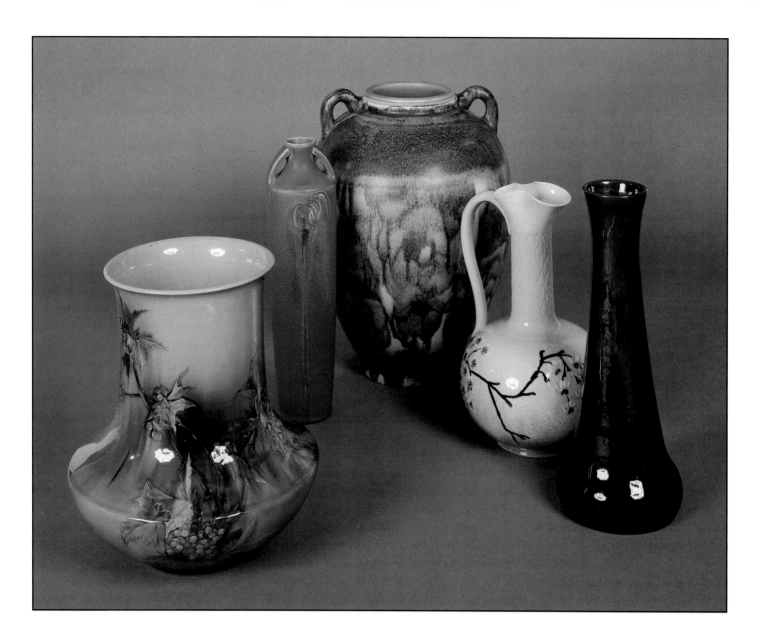

1108 Good Standard glaze vase decorated in 1890 by Kataro Shirayamadani. Naturalistic berries, leaves and stems encircle the vase. Marks on the base include the Rookwood logo, the date, shape number 491 B, S for sage green clay, the artist's cypher and L for light Standard glaze. Height 10¼ inches. Several burst glaze bubbles appear mostly on the back side of the vase. $2500-3000

1109 Tall mat glaze vase with two small handles, decorated by C.S. Todd with stylized flowers. Marks on the base include the Rookwood logo, the date, shape number 2011 and the artist's initials. Height 12½ inches. Small chip on base. $400-600

1110 Large mat glaze urn with two small loop handles, decorated overall with multicolored flowers by Jens Jensen in 1930. Marks on the base include the Rookwood logo, the date, shape number 2460 C, a small esoteric mark, a 50th Anniversary kiln mark and the artist's monogram. Height 13½ inches. Several small unobtrusive grinding chips on base. $1000-1500

1111 Limoge style glaze ewer decorated with cherry blossoms by L. Welterer circa 1882. Marks on the base include the name L. Welterer, shape number 101 and S for sage green clay. Height 11 inches. $300-500

1112 Fine Standard glaze vase by Kataro Shirayamadani, decorated with incised leaves and berries in 1899. Most of the glaze has a luminous Tiger Eye effect. Marks on the base include the Rookwood logo, the date, shape number 807 and the nearly obscured artist's cypher. Height 12½ inches. $1500-2500

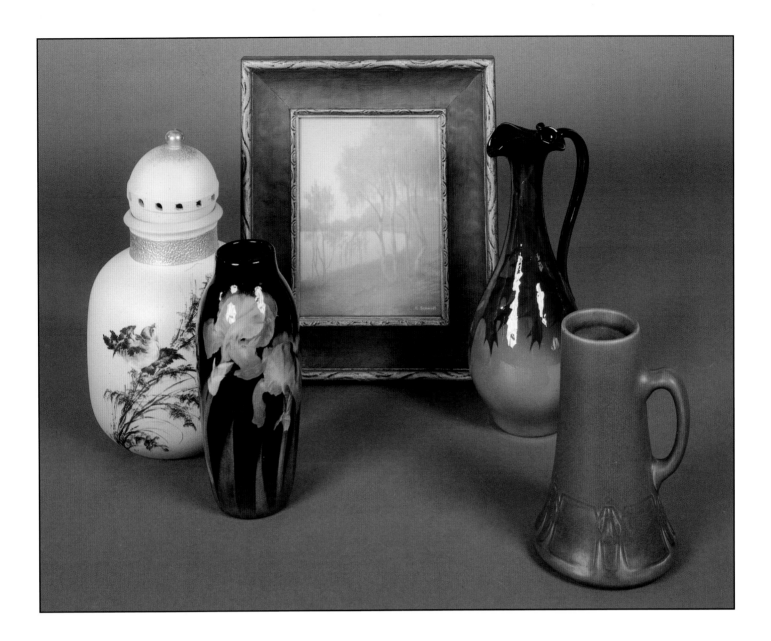

1113 Bisque glaze rose jar with reversible lid decorated with oriental grasses and a small bird by Albert Valentien in $1500-2000
1886. Marks on the base include Rookwood in block letters, the date, shape number 283 A, Y for yellow clay and
the artist's initials. Height 11⅛ inches.

1114 Rare Black Iris glaze vase with iris decoration by Carl Schmidt, done in 1904. Marks on the base include the $1500-2500
Rookwood logo, the date, shape number 932 D, the artist's monogram and W for white glaze. Height 8⅝ inches.
Two inch hairline runs downward from the rim.

1115 Vellum glaze scenic plaque decorated by Carl Schmidt in 1915. The artist's name appears in the lower right hand $2500-3500
corner. Marks on the back include the Rookwood logo, the date, V for Vellum glaze body and a title in pencil,
"Birches by the Lake". Size 8¼ x 6¼ inches.

1116 Standard glaze ewer decorated with oak leaves by E.T. Hurley in 1900. Marks on the base include the Rookwood $400-600
logo, the date, shape number 851 B, a wheel ground X, and the artist's initials. Height 11⅛ inches.

1117 Mat glaze pitcher decorated with repeating abstract design near the base, by William Hentschel in 1911. Marks on $300-400
the base include the Rookwood logo, the date, shape number 1014 D and the artist's initials. Height 7¼ inches.

1118 Large carved gesso advertising plaque colored with pastel and gouache, made by John Dee Wareham and William McDonald for Rookwood at the time of the Paris International Exposition in 1900. The artists' names appear on the front of the plaque as does the following inscription, "Rookwood Paris Exhibit on View Here Feb. 6, & 7." One of several such plaques Wareham and McDonald created for Rookwood and other Cincinnati Businesses, this piece has been broken and repaired and is marked on the back, "Duplicate." $20000-30000

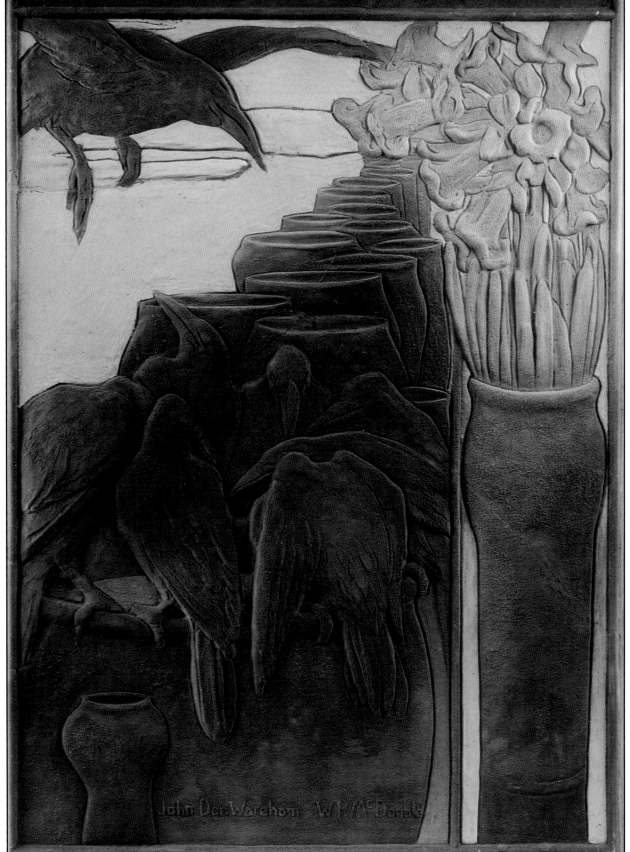

ROOKWOOD PARIS EXHIBIT ON VIEW HERE FEB. 6. & 7.

John Dee Wareham W. P. McDonald

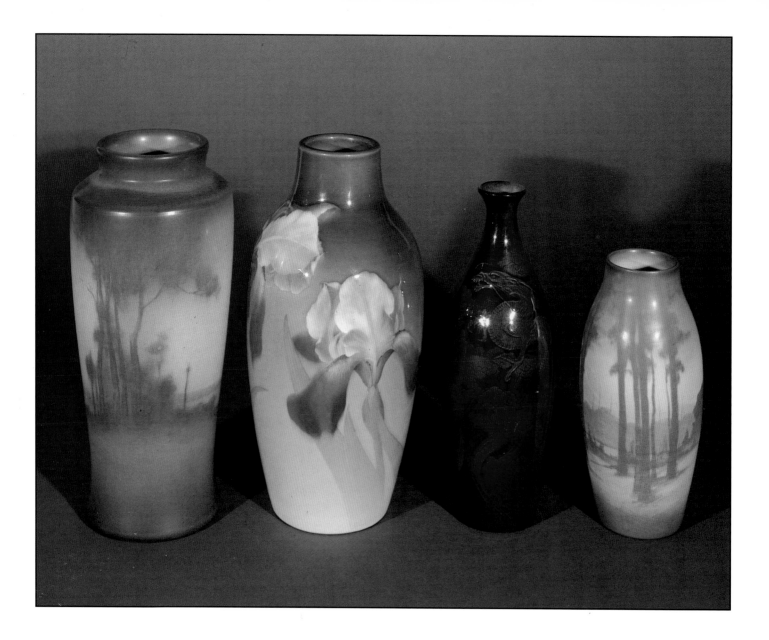

1119 Large Vellum glaze vase with woodland scene and lake decorated by Lenore Asbury in 1916. Marks on the base $1250-1750
include the Rookwood logo, the date, shape number 1664 D, V for vellum glaze body and the artist's initials.
Height 11¼ inches.

1120 Spectacular Iris glaze vase decorated with a group of large blue irises and buds by Carl Schmidt in 1903. Marks $6000-8000
on the base include the Rookwood logo, the date, shape number 940 C, the artist's monogram, and W for white
glaze. Height 11⅛ inches.

1121 Standard glaze vase decorated with a chinese dragon and clouds by Carl Schmidt in 1898. Marks on the base $1000-2000
include the Rookwood logo, the date, shape number 796 B, and the artist's monogram. Height 9⅞ inches. Cracks
at lip.

1122 Vellum glaze vase with scenic decoration done by Sallie Coyne in 1919. Marks on the base include the Rookwood $1200-1500
logo, the date, shape number 939 D, V for Vellum glaze body and the artist's initials. Height 7⅞ inches.

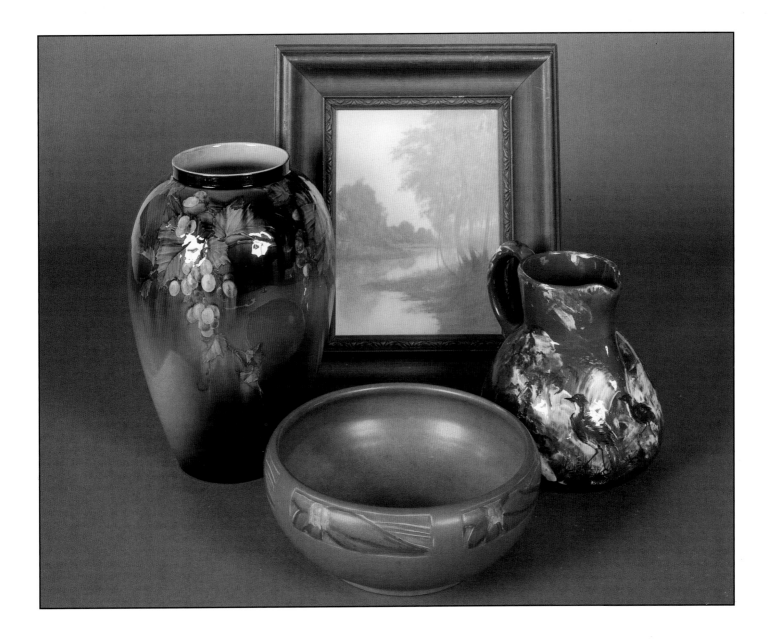

1123 Large Standard glaze vase with decoration of white grapes, leaves and stems, done by Albert Valentien in 1891. Marks on the base include the Rookwood logo, the date, shape number S 950, W for white clay, the artist's initials and L for light standard glaze. Height 12½ inches. Slight glaze scratches. $1750-2250

1124 Mat glaze bowl decorated with panels of arts and crafts flowers near the top, done by C.S. Todd in 1915. Marks on the base include the Rookwood logo, the date, shape number 1196 and the artist's initials. Height 4 inches, diameter 10⅜ inches. $400-600

1125 Vellum glaze scenic plaque decorated in 1912 by Ed Diers. Possibly signed, lower right hand corner. Marks on the back include the Rookwood logo, the date and V for Vellum glaze body. On the frame are an original paper Rookwood logo and an original paper label with the title, "Summer Day E. Diers". Size 10⅜ x 8⅜ inches. $2500-3500

1126 Limoges style glaze pitcher decorated in 1882 with oriental grasses, clouds and several walking birds in the style of Maria Longworth Nichols. Marks on the base include Rookwood in block letters, the date and what may be the initials of Mrs. Nichols. Height 8 inches. $1200-1500

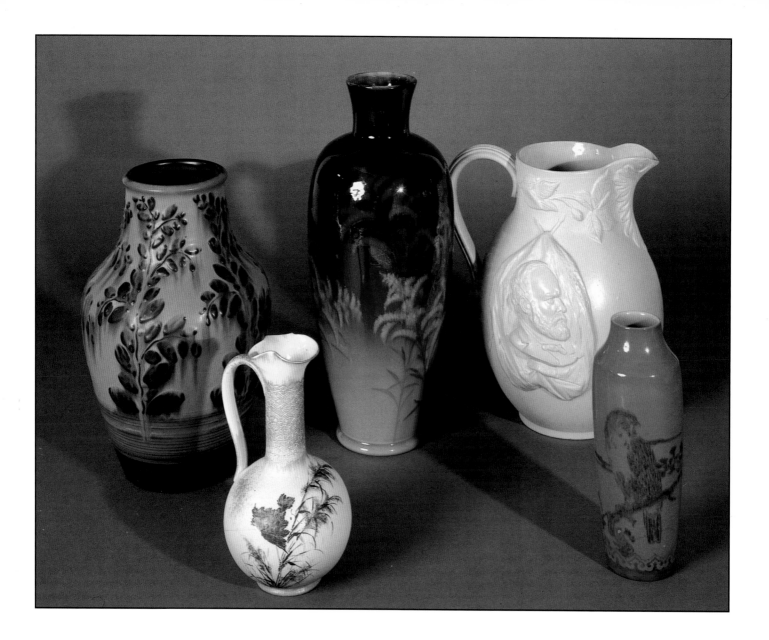

1127 Large Mat glaze vase covered with stylized flowers and concentric rings at the base. Decorated by Elizabeth Barrett in 1927. Marks on the base include the Rookwood logo, the date, shape number 270 and the artist's monogram. Height 12 inches. $600-800

1128 Bisque finish ewer decorated with grasses and a small bird by an unknown artist in 1886. Marks on the base include Rookwood in block letters, the date, shape 101 C and Y for yellow clay. Height 8⅛ inches. $300-500

1129 Good Standard glaze vase decorated with goldenrod by Albert Valentien in 1899. Marks on the base include the Rookwood logo, the date, and shape number 856 B on the base, and the artist's full name on the surface near the base. Height 15⅛ inches. $2000-3000

1130 Larger example of the Garfield memorial pitcher designed by Ferdinand Mersman and produced at Rookwood in 1881. No markings on the base. Height 11¾ inches. $1500-2000

1131 High glaze scenic vase with a single hawk on a branch, done in 1920 by Arthur Conant. Marks on the base include the Rookwood logo, the date, shape number 941 D and the artist's monogram. Height 8½ inches. $1000-1500

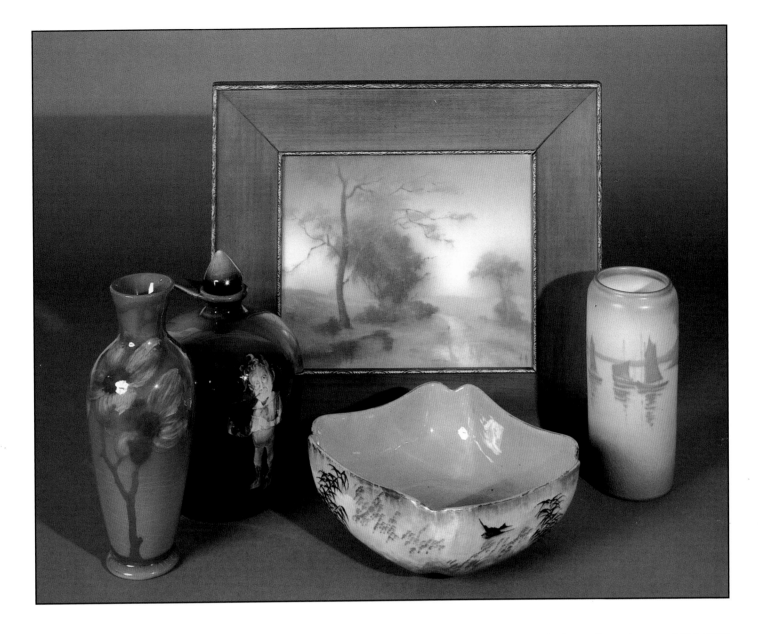

1132 Iris glaze vase with dogwood decoration done by E.T. Hurley in 1898. Marks on the base include the Rookwood logo, the date, shape number 562, the number 129, a wheel ground X, the artist's initials, and W for white glaze. Height 9⅜ inches. $900-1200

1133 Standard glaze stoppered jug decorated with the figure of a man by Anna Valentien in 1891. Marks on the base include the Rookwood logo, the date, shape number 512, S for sage green clay, the artist's initials and L for light standard glaze. Height 9 inches. Oral history indicates the figure to be John Jacob Menzel, a potter at Rookwood, who appears to be lecturing the viewer on a piece of Rookwood in his right hand. Minor chip on bottom edge of stopper. $3000-4000

1134 Vellum glaze scenic plaque done in 1913 by Lenore Asbury. The artist's initials appear in the lower right hand corner. Marks on the back include the Rookwood logo, the date and V for Vellum glaze body. Size 8½ x 10¼ inches. $3000-4000

1135 Limoges style glaze bowl decorated with oriental grasses and flying swallows by Martin Rettig in 1882. Marks on the base include Rookwood in block letters, the date, shape number 166, a small kiln mark, G for ginger clay and the artist's initials. Height 3⅜ inches, length 8⅜ inches. Burst ½ inch glaze bubble near base. $300-500

1136 Vellum glaze vase decorated with four sailboats by Lenore Asbury in 1910. Marks on the base include the Rookwood logo, the date, shape number 952 E, V for Vellum glaze body, the artist's initials and V for Vellum glaze. Height 7¾ inches. Tight line descends from rim. $500-700

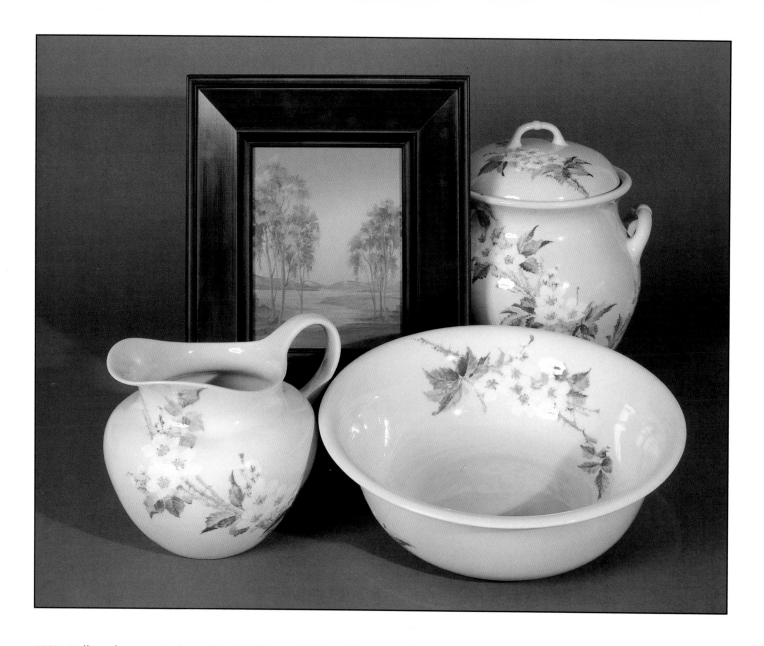

1137 Vellum glaze scenic plaque done by Margaret McDonald in 1943. The artist's initials appear in the lower right hand corner. Marks on the back include the Rookwood logo, the date and the size, 8 x 10. Uncrazed. $2000-3000

1138 Cameo glaze dresser set consisting of pitcher, bowl and waste jar with lid, decorated with wild roses by M.A. Daly in 1888. Marks on the various bases include the Rookwood logo, the date, shape number 206, and W for white clay. The pitcher also includes the artist's initials and a W for white glaze. Height of tallest piece is 13 inches. $3000-4000

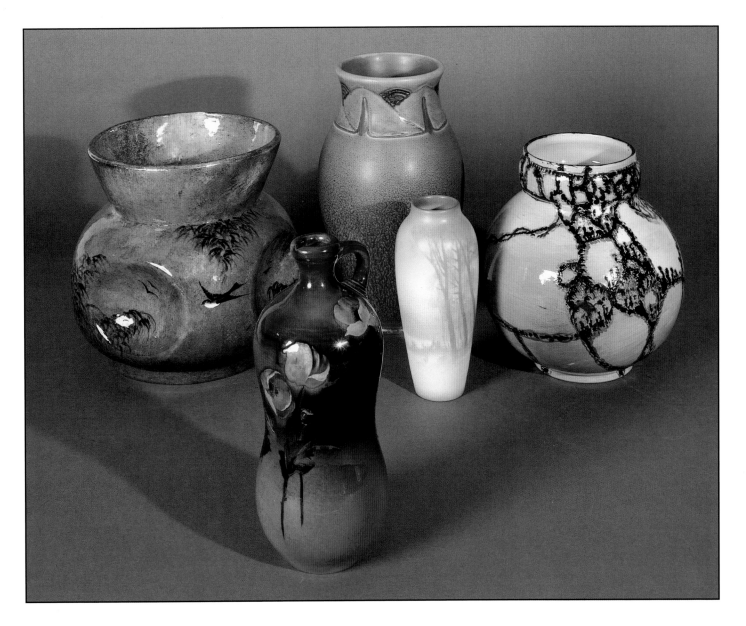

1139 Limoges style glaze vase with oriental grasses and several swallows in flight, decorated by Martin Rettig in 1883. Marks on the base include Rookwood in block letters, the date, shape number 187, R for red clay and the artist's initials. Height 9 inches. $1000-1200

1140 Standard glaze whiskey jug decorated with poppies by Luella Perkins in 1895. Marks on the base include the Rookwood logo, the date, shape number 677 and the artist's initials. Height 10⅛. Lip repair. $200-400

1141 Mat glaze vase with stylized decoration by William Hentschel done in 1915. Marks on the base include the Rookwood logo, the date, shape number 827 and the artist's initials. Height 11¼ inches. $400-600

1142 Vellum glaze vase with scenic decoration done by Sallie Coyne in 1928. Marks on the base include the Rookwood logo, the date, shape number 295 E, P for porcelain body, V for Vellum glaze body and the artist's initials. Height 7½ inches. Uncrazed. $1000-1500

1143 Limoge style glaze vase decorated with stylized fish nets by Mary Virginia Keenan in 1883. Full artist signature and date incised on side. Marks on the base include Rookwood in block letters, S for special shape and the date. Mary Virginia Keenan was an honorary member of the Women's Pottery Club in Cincinnati. This vase and several others by Mrs. Keenan were loaned to the Boston Museum of Fine Arts in the late 19th century. Height 8¾ inches. $400-600

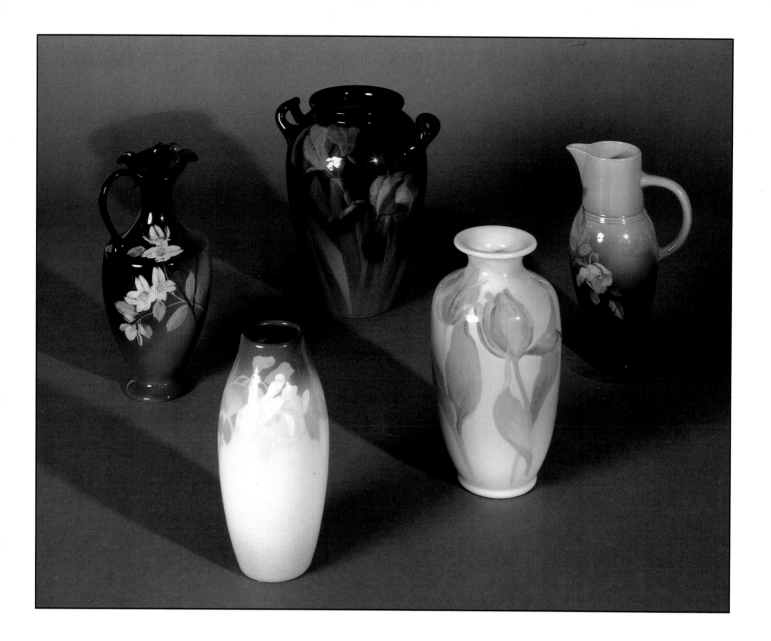

1144 Standard glaze ewer with dogwood decoration, done by John Dee Wareham in 1894. Marks on base include the Rookwood logo, the date, shape number 410, W for white clay, and the artist's initials. Height 9¼ inches. Chip on back edge of the lip has been repaired. $250-350

1145 Iris glaze vase decorated with a large white rose by Irene Bishop in 1908. Marks on the base include the Rookwood logo, the date, shape number 939, the artist's initials and W for white glaze. Height 7⅛ inches. $700-900

1146 Standard glaze vase with two loop handles decorated with irises by Lenore Asbury in 1902. Marks on the base include the Rookwood logo, the date, shape number 581 E and the artist's initials. Height 9 inches. $1200-1500

1147 Iris glaze vase decorated with tulips by Sara Sax in 1900. Marks on the base include the Rookwood logo, the date, a shape number which is obscured by a drill hole, the artist's monogram and W for white glaze. Height 8¼ inches. Drilled $400-600

1148 Standard glaze pitcher with yellow roses, decorated by Amelia Sprague in 1894. Marks on the base include the Rookwood logo, the date, shape number 699, W for white clay, a small wheel ground X and the artist's initials. Height 8⅜ inches. $500-700

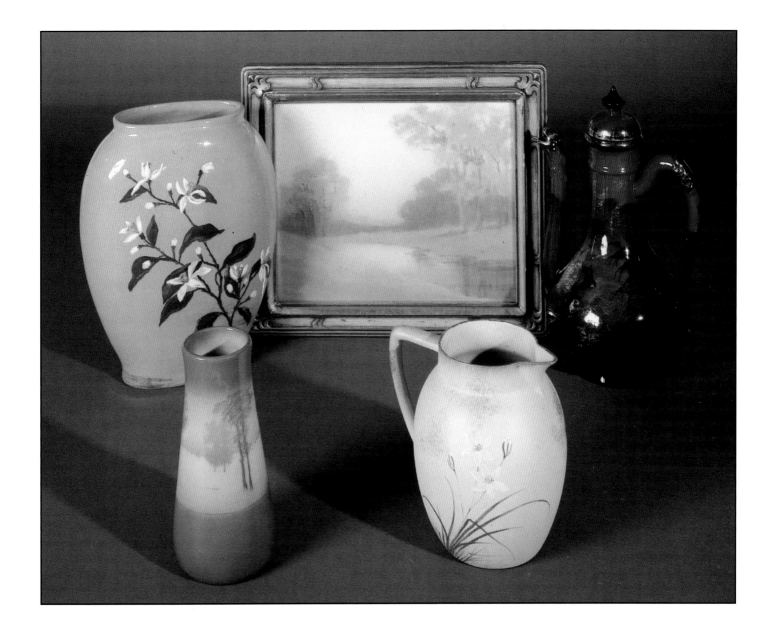

1149 Limoges style glaze pillow vase with floral decoration on one side and a faintly decorated swamp scene on the reverse, decorated circa 1881 by A.K.. Marks include Rookwood Pottery in raised script on the base and the initials A.K. inside the rim in block letters. Height 10⅛ inches. Tight one inch hairline on rim. $200-300

1150 Rare Iris glaze banded scenic decorated with a woodland motif by Sallie Coyne in 1909. Marks on the base include the Rookwood logo, the date, shape number 950 E, the artist's initials and W for white glaze. Height 6¾ inches. $1500-2000

1151 Vellum glaze scenic plaque decorated by Lorinda Epply in 1919. The artist's initials appear in the lower right hand corner. Marks on the back include the Rookwood logo, the date, V for Vellum glaze body and the title in pencil, "Rainy Morning". Size 8½ x 10½ inches. Pitting in the glaze. $1500-2500

1152 Bisque finish pitcher decorated with white jonquils by Harriet E. Wilcox in 1887. Marks on the base include the Rookwood logo, the date, shape number 18, 2W for a particular type of white clay, the letter S and the artist's initials. Height 6⅜ inches. $400-600

1153 Limoge style glaze Turkish coffee pot decorated with bamboo, clouds and small birds by Albert Valentien circa 1883. Marks on the base include Rookwood in block letters and the artist's initials. A large embossed anchor mark also appears on the base. Patches of goldstone appear on the surface. Height 11 inches. $1500-1800

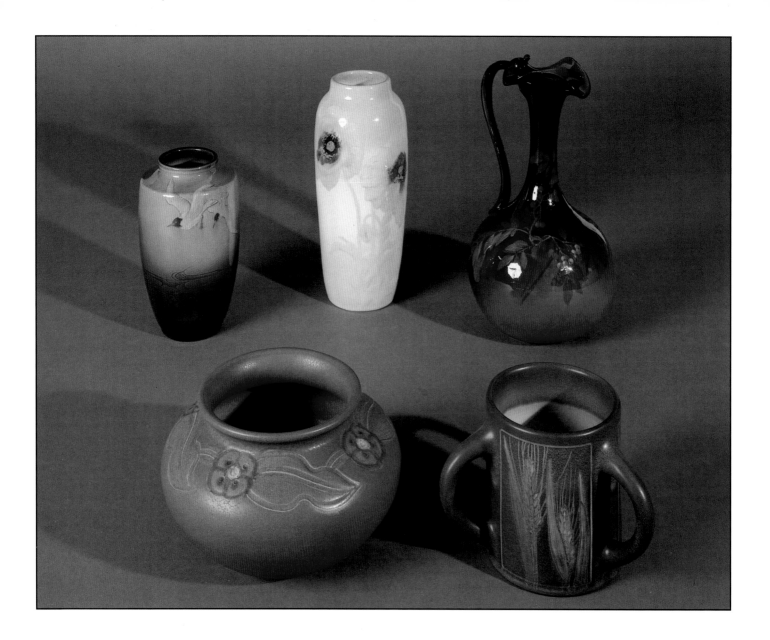

1154 Unusual Standard glaze vase decorated with flying sea birds and swirling oriental style sea by Kataro $1200-1500
 Shirayamadani in 1898. Marks on the base include the Rookwood logo, the date, shape number 735 D, a small
 star shaped esoteric mark, a small wheel ground X and the artist's cypher. Height 7 inches.

1155 Mat glaze bowl with incised and painted floral decoration on the shoulder, decorated by C.S. Todd in 1915. $300-500
 Marks on the base include the Rookwood logo, the date, shape number 494 B and the artist's initials. Height
 4⅝ inches.

1156 Iris glaze vase decorated with pink poppies by Rose Fechheimer in 1904. Marks on the base include the $2000-2500
 Rookwood logo, the date, shape number 907 DD, the artist's initials and W for white glaze. Height 9¼ inches.

1157 Rare Green Vellum glaze three handled mug decorated with wheat stalks by Elizabeth Lincoln in 1909. Marks on $500-700
 the base include the Rookwood logo, the date, shape number 830 E, a wheel ground X, V for Vellum glaze body
 GV for Green Vellum glaze and the artist's initials. Height 5 inches.

1158 Standard glaze ewer decorated with leaves and berries by Grace Young in 1896. Marks on base include the $500-700
 Rookwood logo, the date, shape number 387 C and the artist's initials. Height 10⅝ inches.

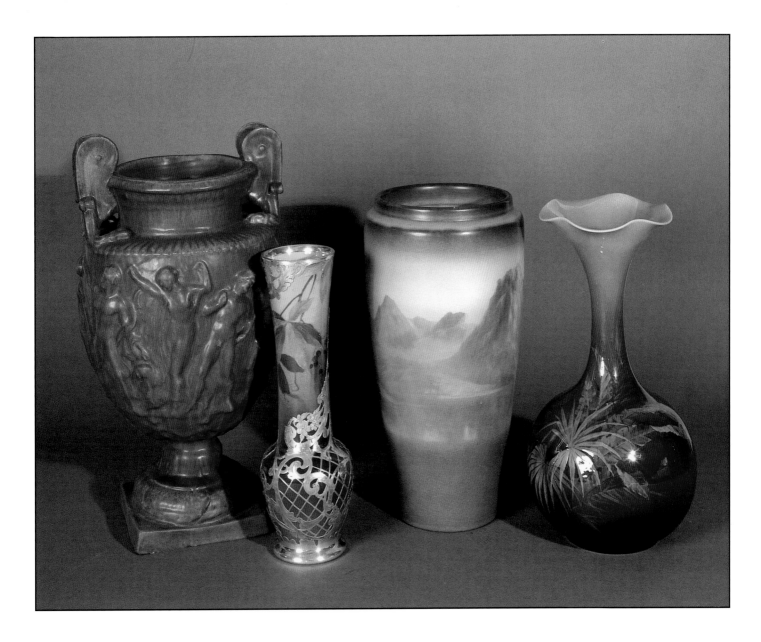

1159 Mat glaze urn with classical figures in high relief, done in 1912. Marks on the base include the Rookwood logo, the date, and shape number S 1836. Height 18¼ inches. Damage to one corner of the base. $400-600

1160 Standard glaze vase with silver overlay decorated with Virginia creeper by Amelia Sprague in 1892. The silver overlay is marked R 563 Gorham Mfg. Co. on the base. Marks on the pottery base include the Rookwood logo, the date, shape number 633 C, W for white clay, and the artist's initials. Height 13⅛ inches. $3500-4500

1161 Large banded scenic vellum vase decorated with snow covered mountains by Fred Rothenbusch in 1912. Marks on the base include the Rookwood logo, the date, shape number 1369 B, V for vellum glaze body, a wheel ground X and the artist's initials. Height 15 inches. Minor glaze chip at base. $1500-2500

1162 Large Standard glaze vase with fluted rim decorated by M.A. Daly in 1889 with palm fronds. Several areas of very fine Tiger Eye effect can be seen among the vegetation. Marks on the base include the Rookwood logo, the date, shape number 380 A, the artist's initials and L for light Standard glaze. Height 14¾ inches. All marks on the base appear to have been hand incised, possibly by the artist. $2000-3000

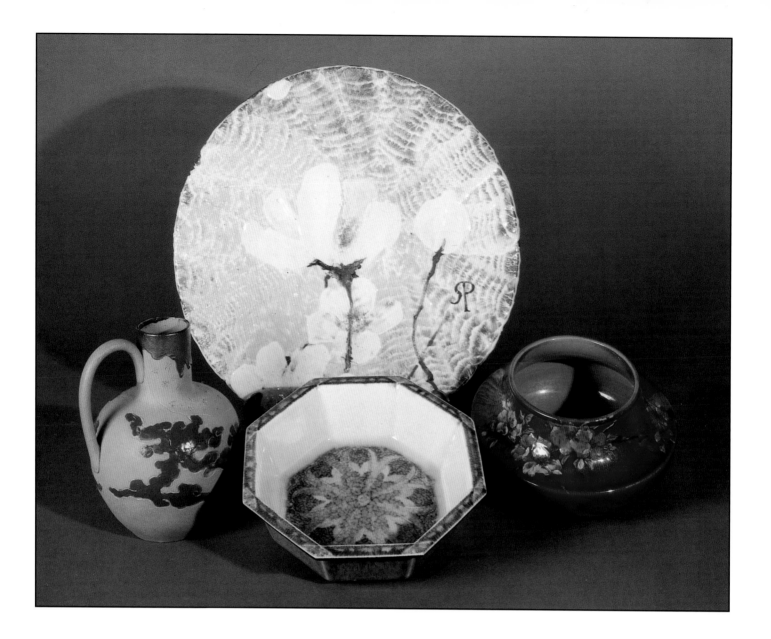

1163 Bisque finish ewer in the style of Chaplet with stylized clouds decorated by Albert Valentien in 1884. Marks on the base include Rookwood in block letters, the date, G for ginger clay, shape number 62, a small kiln mark and the artist's initials. Height 8⅛ inches. $500-700

1164 Large high glaze lunette decorated with magnolia and bearing the Rookwood logo on the face, done by an unknown artist in 1883. Marks on the back include Rookwood in block letters, the date, shape number 3 impressed two times, R for red clay and the number 459:00 which is possibly an accession number from the Cincinnati Art Museum. Diameter 16⅝ inches. There is an unimportant chip to the circular foot on the reverse and a circular firing crack halfway between the edge of the piece and its center. A small line extends from the edge. $500-700

1165 High glaze bowl decorated with stylized flowers by Lorinda Epply in 1925. Marks on the base include the Rookwood logo, the date, shape number 2706 and the artist's initials. Diameter 9⅛ inches, height 3 inches. Very tiny chip on rim edge. $200-300

1166 Standard glaze bowl decorated with wild roses by Luella Perkins in 1888. Marks on the base include the Rookwood logo, the date, the obscured shape number, the artist's initials, L for light Standard glaze and G for ginger clay. Patches of goldstone appear on the surface. Height 5 inches. $600-800

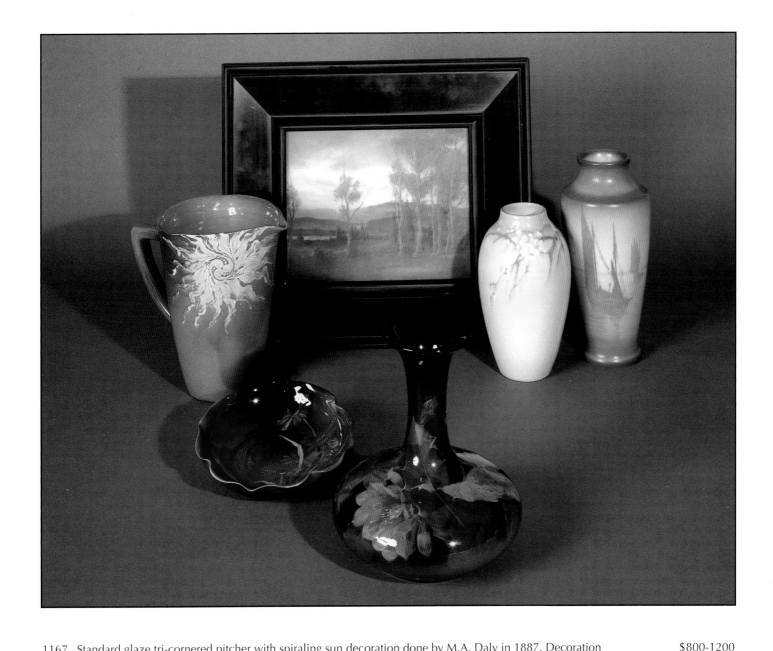

1167 Standard glaze tri-cornered pitcher with spiraling sun decoration done by M.A. Daly in 1887. Decoration $800-1200
 includes the Rookwood logo and one flame on the side. Marks on the base include the Rookwood logo, the date,
 shape number 259, G for ginger clay and the artist's initials. Height 8¼ inches.

1168 Standard glaze fluted bowl with daisy decoration by Olga Geneva Reed in 1890. Marks on base include the $200-300
 Rookwood logo, the date, shape number 549, W for white clay, the artist's initials and L for light Standard glaze.
 Height 1½ inches.

1169 Standard glaze vase decorated with cactus blossoms and leaves by Fred Rothenbusch in 1899. Marks on the base $500-700
 include the Rookwood logo, the date, shape number 433 B and the artist's initials. Height 7⅞ inches.

1170 Vellum glaze scenic plaque painted in 1922 by Ed Diers. The artist's initials appear in the lower right hand $2500-3500
 corner. Marks on the back include the Rookwood logo and date. On the frame is an original paper label with the
 title, "Mountain Scene E. Diers". Size 7⅞ x 9⅞ inches.

1171 Iris glaze vase decorated with cherry blossoms by Lenore Asbury in 1910. Marks on the base include the $900-1200
 Rookwood logo, the date, shape number 900 C, the artist's initials and W for white glaze. Height 7⅞ inches.

1172 Vellum glaze harbor scene vase decorated with several sailing craft by Sallie Coyne in 1913. Marks on the base $2000-2500
 include the Rookwood logo, the date, shape number 1920, V for Vellum glaze body, the artist's initials and V for
 Vellum glaze. Height 10 inches.

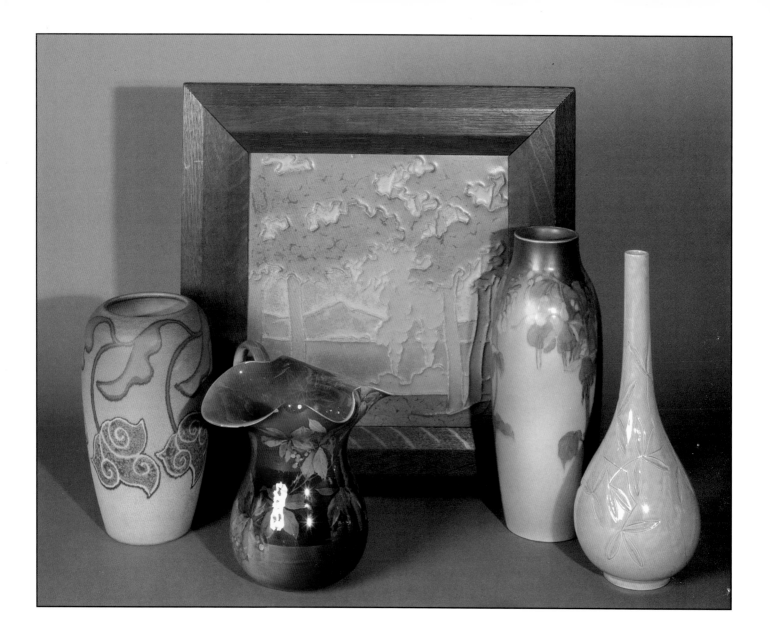

1173 Mat glaze vase decorated with stylized tulips by C.S. Todd in 1922. Marks on the base include the Rookwood logo, the date, shape number 1126 C and the artist's initials. Height 9¼ inches. Cast hole in the base. —— $300-500

1174 Standard glaze pitcher with Virginia creeper vines and berries decorated by Artus Van Briggle in 1889. An incised leaf and berry motif appears inside the pitcher. Marks on the base include the Rookwood logo, the date, shape number 332A, W for white clay, the artist's initials and L for light Standard glaze. Height 8 inches. Two ¼ inch chips appear on the underside of the rim. —— $300-400

1175 Rookwood Architectural Faience scenic tile in mat glaze made circa 1915. Impressed on the back are the words, "Rookwood Faience 1226 Y2". Size 12 x 12 inches. —— $1000-1500

1176 Vellum glaze vase decorated with fuscia by Elizabeth McDermott in 1919. Marks on the base include the Rookwood logo, the date, shape number 932 C, V for Vellum glaze body and the artist's initials. Height 12¼ inches. Small repair to the lip and some minor abrasions. —— $500-700

1177 Yellow tinted high glaze vase with incised leaf decoration by Anna Marie Bookprinter done in 1884. Marks on the base include Rookwood in block letters, the date, shape number 126 A, S for sage green clay, and the artist's initials. Height 12⅜ inches. —— $400-600

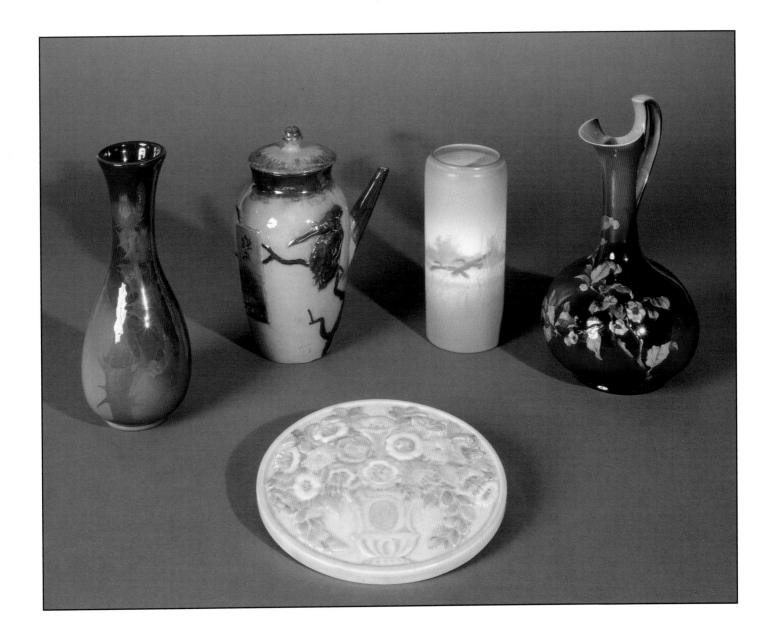

1178 Standard glaze vase decorated with thistles by Sallie Coyne in 1900. Marks on the base include the Rookwood logo, the date, shape number 895 and the artist's initials. Height 10 inches. $400-500

1179 Early high glaze molded chocolate pot with kingfisher and oriental plaque cast on surface. Marks on the base include Rookwood in block letters, an impressed anchor mark and the date. Height 9⅛ inches. Repair to rim. $400-600

1180 High glaze molded circular plaque with multicolored floral decoration, made at Rookwood in 1937. Marks on the back include the Rookwood logo, the date and the inscription, "Mr. & Mrs. Arthur Espy accept with pleasure your invitation for luncheon on Monday April nineteenth". Diameter 8½ inches. This appears to be a commercial plaque that on special order, was inscribed for the purchaser. $400-600

1181 Vellum glaze vase decorated with three geese in flight over water by Kataro Shirayamadani in 1911. Marks on the base include the Rookwood logo, the date, shape number 952 E, V for Vellum glaze body and the artist's cypher. Height 7¾ inches. $1250-1750

1182 Standard glaze ewer decorated with Japonica flowers and leaves by Albert Valentien in 1889. Marks on the base include the Rookwood logo, the date, shape number 462, S for sage green clay, the artist's initials and L for light standard glaze. Height 11 inches. $700-900

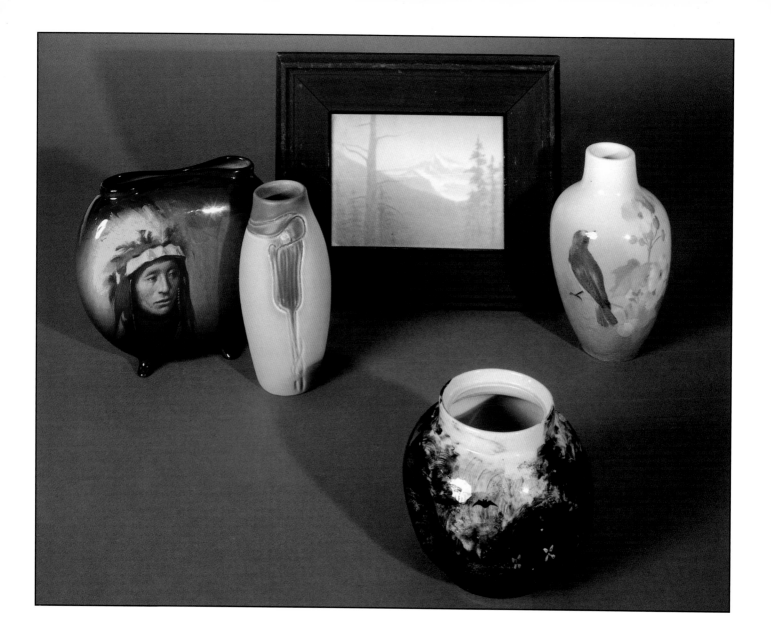

1183 Fine Standard glaze footed pillow vase decorated with the portrait of Eagle Deer, son of Little Bald Eagle (Sioux) by Grace Young in 1901. Marks on the base include the above title, the Rookwood logo, the date, shape number 90 A and the artist's initials. Height 7⅛ inches. $2500-3500

1184 Unusual carved and painted mat glaze vase featuring one stylized jack-in-the-pulpit flower, done by Rose Fechheimer in 1906. Marks on the base include the Rookwood logo, the date, shape number 939 D and the artist's initials. Height 7 inches. $1000-1500

1185 Vellum glaze scenic plaque decorated in 1913 by Sara Sax. The artist's name appears in the lower left hand corner. Marks on the back include the Rookwood logo, the date, V for Vellum glaze body and the title in pencil, "Mt. Baker". Size 5¼ x 7⅝ inches. $1200-1500

1186 Limoges style glaze jar with oriental grasses, birds and a bat, decorated by M.A. Daly in 1882. Marks on the base include Rookwood in block letters, the date, shape number 97, Y for yellow clay, an impressed anchor mark and the artist's initials. Height 4¾ inches. Possibly missing lid. $200-300

1187 Iris glaze vase with a robin prominently perched in a rose of sharon bush. Marks on the base include the Rookwood logo, the date, shape number 905 D and the artist's initials. Height 7⅜ inches. $1500-2000

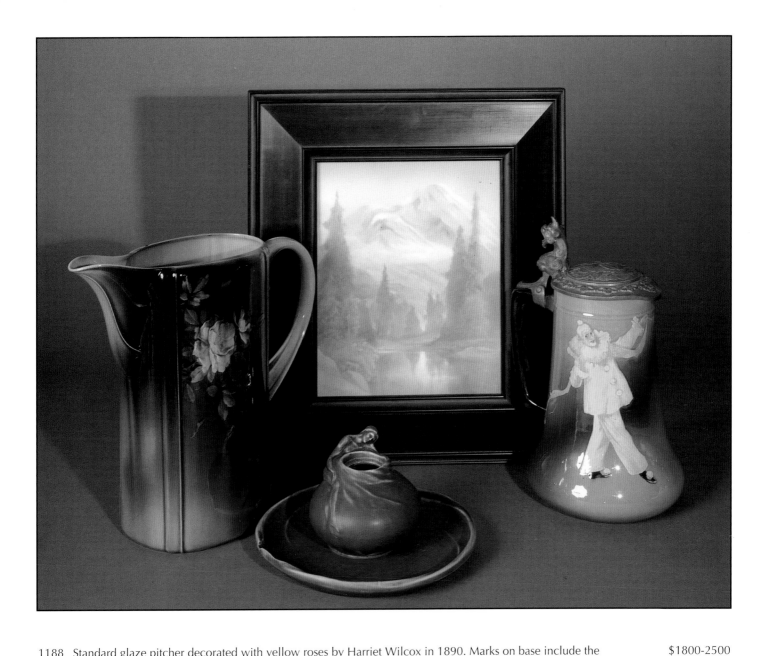

1188 Standard glaze pitcher decorated with yellow roses by Harriet Wilcox in 1890. Marks on base include the Rookwood logo, the date, shape number 540, S for sage green clay, the artist's initials and L for light Standard glaze. Height 12 inches. $1800-2500

1189 Mat glaze inkwell on a tray with modeled nude encircling the upper section, done in 1902 by Anna Valentien. Marks on the base include the Rookwood logo, the date, shape number 245 Z and the artist's initials. Height 4". Lid missing. $1200-1500

1190 Good Vellum glaze scenic plaque decorated by Fred Rothenbusch in 1929. The artist's initials appear in the lower right hand corner. Marks on the back include the Rookwood logo, the date and an original Rookwood label with the title, "Mt Rainier F. Rothenbusch". Size 11⅜ x 9⅝ inches. Uncrazed. $4000-6000

1191 Important Standard glaze stein decorated with a full length portrait of a clown by William McDonald in 1894. The piece is fitted with a pewter lid with hops decoration and a gargoyle thumb rest. Marks on the base include the Rookwood logo, the date, shape number 656, W for white clay and the artist's initials. Height 12¼ inches. $6000-8000

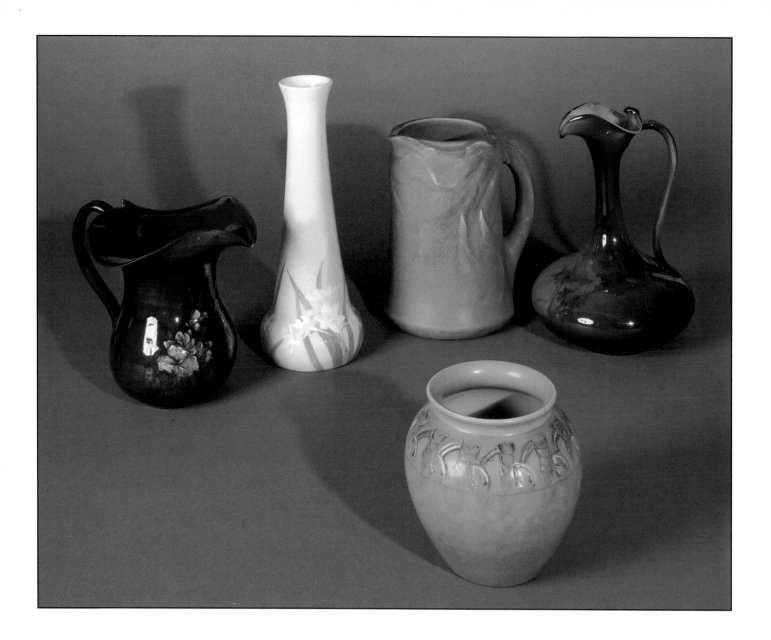

1192 Standard glaze pitcher decorated with prunus blossoms by Albert Valentien circa 1887. There is a great deal of goldstone and Tiger Eye effect present in this piece. Marks on the base include the Rookwood logo, the partially obscured date, shape number 382, R for red clay, the artist's initials and D for dark Standard glaze. Height 8 inches. $1500-2500

1193 Iris glaze vase decorated with jonquils by Artus Van Briggle in 1897. Marks on the base include the Rookwood logo, the date, shape number 807, a small triangular esoteric mark, W in a circle for white glaze and the artist's initials. Height 12⅞ inches. Tight one inch hairline at rim. $800-1000

1194 Large mat glaze pitcher with molded corn design, done in 1906. Marks on the base include the Rookwood logo, the date, shape number 992 and a small inverted V shaped esoteric mark. Height 9⅝ inches. $300-400

1195 Mat glaze vase with repeating incised decoration about the neck. Decorated by C.S. Todd in 1918. Marks on the base include the Rookwood logo, the date, shape number 130, P for soft porcelain and the artist's initials. Height 6 inches. $350-450

1196 Standard glaze ewer with black eyed susans done by Kataro Shirayamadani in 1897. Marks on the base include the Rookwood logo, the date, shape number 611 A, a small triangle esoteric mark, a wheel ground X and the artist's cypher. Height 11 inches. $900-1200

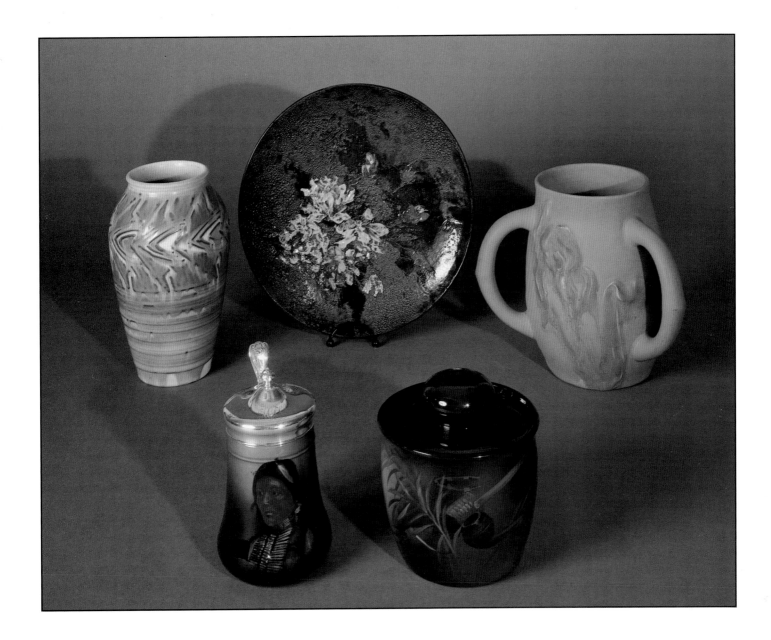

1197 Mat glaze vase with geometric patterning, done by Elizabeth Barrett in 1930. Marks on the base include the Rookwood logo, the date, a partially obscured shape number, a small wheel ground X and the artist's monogram. Height 9½ inches. Vase is drilled through the base. Chip on base. — $300-400

1198 Standard glaze mug with a silver lid, decorated with a Native American portrait by Bruce Horsfall in 1895. Marks on the base include the Rookwood logo, the date, shape number 656 and the artist's monogram. Height 6¾ inches. — $1500-2500

1199 Limoge style glaze charger decorated with roses by Mary Louise McLaughlin in 1883. Marks on the reverse include Rookwood in block letters, the date and "M.L. Mclaughlin Cinti. 1883". Diameter 11½ inches. This piece has a tight crack across 75% of its face but has never separated. — $400-600

1200 Standard glaze humidor with decoration of matches, pipes, a cigar and cane fronds, by Elizabeth Lincoln in 1897. Marks on the base include the Rookwood logo, the date, shape number 812 and the artist's initials. Height 6⅛ inches. Hairline across one side of the lid. — $400-600

1201 Mat glaze three handled loving cup with carved iris flowers and leaves done by Albert Pons in 1907. Marks on the base include the Rookwood logo, the date, shape number 659 B and the artist's initials. Height 8½ inches. — $400-600

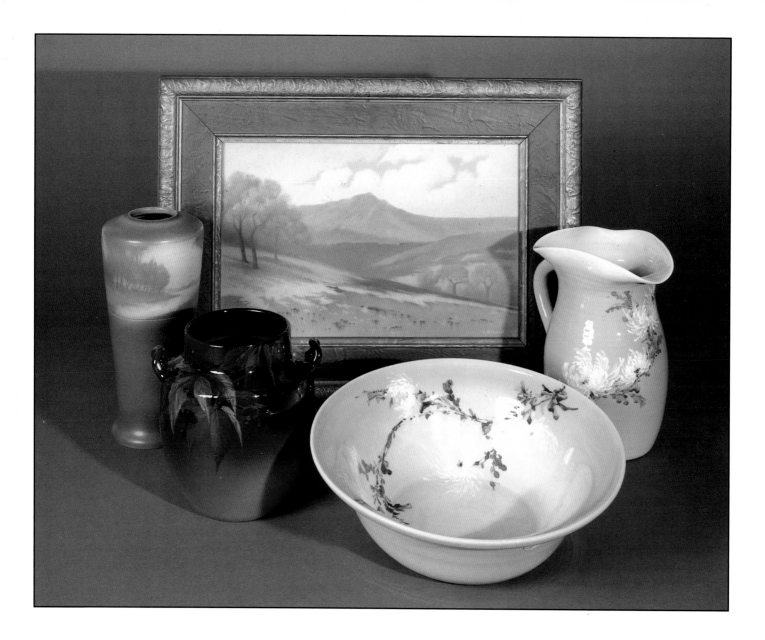

1202 Vellum glaze vase decorated with a banded woodland scene by Lenore Asbury in 1917. Marks on the base include the Rookwood logo, the date, shape number 1652 D, a wheel ground X and the artist's initials. Height 9¾ inches. Drilled. $400-600

1203 Standard glaze vase with small loop handles decorated with Virginia creeper vines, leaves and berries by Lenore Asbury in 1899. Marks on the base include the Rookwood logo, the date, shape number 459C and the artist's initials. Height 7 inches. $400-600

1204 Vellum glaze scenic plaque done by Carl Schmidt in 1916. The artist's name appears in the lower right hand corner. Marks on the back include the Rookwood logo, the date and V for Vellum glaze body. On the frame is an original paper label with the title, "California Mountains C.Schmidt". Size 9¼ x 14¾ inches. $4000-6000

1205 Cameo glaze pitcher and bowl set decorated with crysanthemums by M.A. Daly in 1887. Marks on the base include the Rookwood logo, the date, shape number 633 S which is perhaps a special, 7W which is thought to be for a particular white clay body, the artist's initials and W which refers to white (Cameo) glaze, a forerunner of Iris glaze. Height of pitcher 9 inches, diameter of bowl 12 inches. $1200-1500

1206 Standard glaze ewer with decoration of prunus blossoms and undulating ribbons by Albert Valentien, done in 1888. Marks on the base include the Rookwood logo, the date, shape number 101 A, W for white clay, the artist's initials and L for light standard glaze. Height 11 inches. $700-900

1207 Black Opal glaze vase decorated with stylized floral designs by Sara Sax in 1924. Marks on the base include the Rookwood logo, the date, shape number 2790 and the artist's monogram. Black Opal is a recently identified glaze of the mid 20's which consists of a black glaze, usually over a reddish ground. Height 11½ inches. Chips on base. $300-500

1208 Good Vellum glaze scenic plaque, decorated by E.T. Hurley in 1943. The artist's initials appear in the lower left hand corner. Marks on the back include the Rookwood logo and date impressed twice and the size 10 x 12. This plaque is uncrazed. $5000-7000

1209 Rare and important bisque finish ewer with extensive fired on gold and an elaborately carved and applied nest with several eggs and a parent bird. Decorated circa 1882 by Rookwood's founder, Maria Longworth Nichols. Marks on the piece include Rookwood in block letters, the partially obscured date and the initials M.L.N on the side, also in fired on gold. $3000-4000

1210 Rare Standard glaze oil lamp and burner decorated with an encircling dragon by Kataro Shirayamadani in 1894. Brass rim and foot are part of the oil lamp fittings and appear to be original. Marks on the base include the Rookwood logo, the date, shape number 722, W for white clay and the artist's cypher. Height of ceramic portion, 10⅛ inches. $3000-4000

THE STAFF OF CINCINNATI ART GALLERIES

Ballard Borich Terry Boyle

Tim Boyle Edie Buschle

Riley Humler Jack Kircher

Pam Kirchner Michele Sandler

Randy Sandler

A pat on the back from us to us. We are very proud of this catalog and just wanted to tell ourselves that no matter what, the seemingly endless hours of packing, washing, cataloging, photographing, repacking, displaying, selling and delivering this much Rookwood has been an unusual experience and we are proud of the results. We have worked very hard to make it a success and hope the world agrees with what we have done. Let us all enjoy the fruits of that labor because an event like this will never happen again. Good luck to us and to you.

NOTES

NOTES

THE ROOKWOOD BOOKSTORE

Cincinnati Art Galleries is the largest publisher of classic books about Rookwood Pottery in the world. We have reprinted Herbert Peck's, *The Book of Rookwood Pottery* in soft cover and Virginia Raymond Cummins' informative, *Rookwood Pottery Poutpourri*.

We also offer copies of Herbert Peck's companion volume, *The Second Book of Rookwood Pottery* and will continue to make available, *The Glover Collection* for new collectors.

Should you wish copies of any of these Rookwood greats, you may purchase them at the Glover Collection Auction or use the handy order blank below for your convenience.

Author	Title

Peck — **The Book of Rookwood Pottery**

The first complete coverage of Rookwood, written in 1968 and still considered the best place to start your "Education." The most complete history ever with photos of Rookwood and some of its artists, lists of marks and lots and lots of information.

Soft Cover $19.95 + $2.00 Shipping

Peck — **The Second Book of Rookwood Pottery**

A companion to the original Rookwood book with new findings and marks. Also a complete reproduction of Rookwood's Shape Record Book showing the profile and size of over 4,000 different Rookwood production items.

Hard cover $19.95 + $2 Shipping

Cummins — **Rookwood Pottery Potpourri**

A complete and sensitive look at the lives and histories of the artists and craftspersons who made Rookwood internationally famous. Many photos of the artists and 11 pages in full color of important pieces of Rookwood.

Soft Cover $26.00 + $2.00 Shipping

CAG — **The Glover Collection**

Destined to become the standard by which Rookwood is measured for years to come. The Glover Collection features over 1,200 items in full color with prices realized at the largest and most important auction of Rookwood ever held. The most complete compilation of Rookwood ever undertaken, with very accurate descriptions of each piece in the sale.

Soft Cover $45.00 + $3 Shipping

ORDER FORM

Author	Title	Unit Price	Shipping	Total
Peck	The Book of Rookwood Pottery	$19.95 @	$2.00 @	_____
Peck	The Second Book of Rookwood Pottery	$19.95 @	$2.00 @	_____
Cummins	Rookwood Pottery Potpourri	$26.00 @	$2.00 @	_____
CAG	The Glover Collection	$45.00 @	$3.00@	_____
		All shipments within the State of Ohio add 5.5%		_____
			Grand Total	_____

ABSENTEE BID ORDER FORM

I would like to place the following bids with Cincinnati Art Galleries to be executed during the auction of the Glover Collection, June 7, 8, and 9, 1991.

I understand that Cincinnati Art Galleries will execute my absentee bids as a convenience and will not be held responsible for any errors or failure to execute bids. I also understand that my absentee bids are subject to all parts of the "Conditions of Sale" which appear in this catalog, and that I am responsible for the purchase price and 10% buyer's premium and the 5.5% Ohio State Sales Tax for all items purchased.

I understand that I am responsible for packing and shipping cost of my purchases. Cincinnati Art Galleries will ship my purchases in the best way possible as soon as full payment has been received, and I understand that four to six weeks should be allowed for delivery.

Lot #	Description	Bid Price
_____	_____	_____
_____	_____	_____
_____	_____	_____
_____	_____	_____
_____	_____	_____
_____	_____	_____
_____	_____	_____
_____	_____	_____
_____	_____	_____
_____	_____	_____
_____	_____	_____
_____	_____	_____
_____	_____	_____
_____	_____	_____
_____	_____	_____
_____	_____	_____
_____	_____	_____
_____	_____	_____
_____	_____	_____
_____	_____	_____

Cincinnati Art Galleries will always attempt to purchase designated lots for the lowest possible amount in competition with other bidders, but we cannot be held responsible for errors or failure to bid. All terms of "Conditions of Sale" apply to absentee bidders as well as those present.

Name _____

Address _____

Phone Number _____

Ohio Resale Number _____

Signature _____ Date _____

Cincinnati Art Galleries
635 Main Street
Cincinnati, OH 45202
513-381-2128